IMAGES OF WALES

LLANTRISANT
REVISITED

In Memoriam
of the Noble Dead.

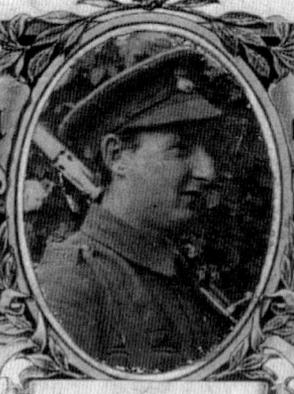

Private Ivor Jenkins.

In Loving Memory

OF

Private Ivor Jenkins

17276, Royal Welsh Fusiliers,

The Beloved Brother of Mrs. J. Griffiths,

27 Newbridge Road, Llantrisant,

Who Fell in Action

MORTALLY WOUNDED IN FRANCE

On July 13th, 1916,

While Serving with his Regiment in

The Great European War

Died in England, and was Interred at Llantrisant
on July 18th, 1916.

Aged 22 Years.

Bravely he strove to bear our banner,
Leaving home and friends to fight,
To uphold his country's honour
With his strength and manhood's might.

Presented by the
Llantrisant Soldiers' and Sailors'
Reception Committee and their
many patrons.

THE LAST POST

IMAGES OF WALES

LLANTRISANT
REVISITED

DEAN POWELL

TEMPUS

This book is dedicated to my loving family; my parents, Carole and David and also Jeff, Dawn, Paula and Alicia for all their love and support.

Frontispiece: Memorial to Private Ivor Jenkins of Newbridge Road. Born in 1894, Ivor, whose sister was married to fish and chip shop owner Isaiah Griffiths, served in the Royal Welsh Fusiliers during the First World War. At the age of twenty-two, he was wounded in France and died on his return to England. He was buried at Llantrisant Parish Church on 18 July 1916. This memorial was presented to his sister, Jennie Griffiths, by the Llantrisant Soldiers' and Sailors' Reception Committee.

First published 2004

Tempus Publishing Limited
The Mill, Brimscombe Port,
Stroud, Gloucestershire, GL5 2QG
www.tempus-publishing.com

© Dean Powell, 2004

The right of Dean Powell to be identified as the Author
of this work has been asserted in accordance with the
Copyrights, Designs and Patents Act 1988.

British Library Cataloguing in Publication Data.
A catalogue record for this book is available from the British Library.

ISBN 0 7524 3216 8

Typesetting and origination by Tempus Publishing Limited.
Printed in Great Britain by Midway Colour Print, Wiltshire.

Contents

Introduction 7

one People and Places 9

two Celebrations and Customs 87

three Education and Culture 131

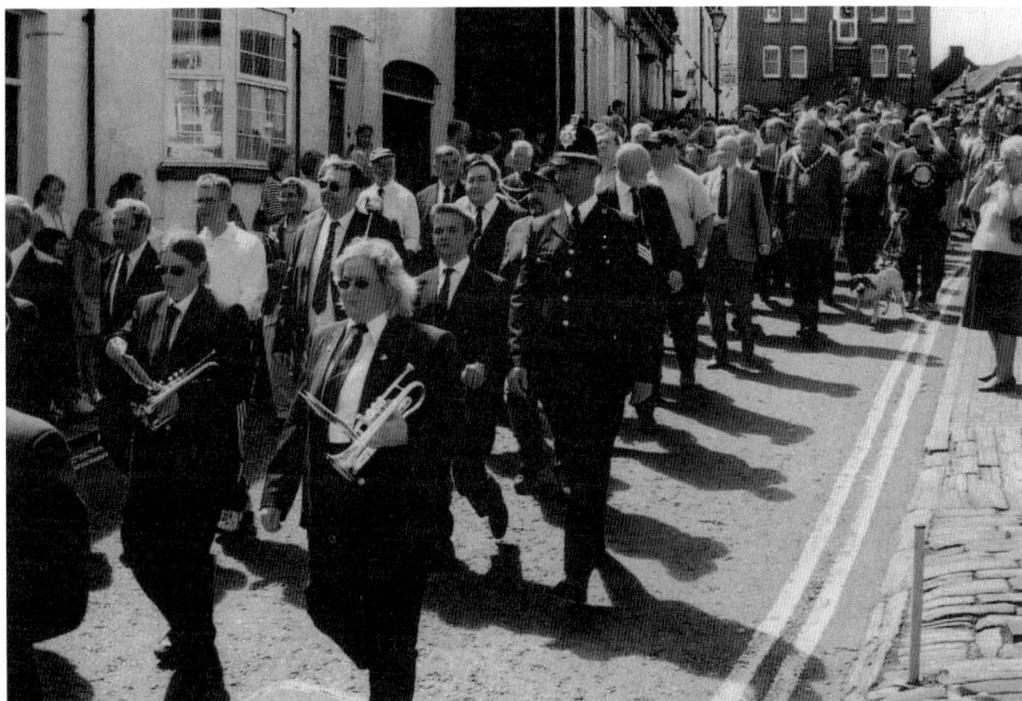

Above: Author Dean Powell (left of the policeman) at the Beating of the Bounds, June 2003. Llantrisant–born Dean is a Freeman of the town and a Trustee of Llantrisant Town Trust. Dean is the editor of the *Pontypridd & Llantrisant Observer,* literary editor of the *Western Mail* and literary editor of *One Wales* magazine. A member of Treorchy Male Voice Choir for the past fifteen years, Dean is also their publicity officer and honorary archivist. He has undertaken a series of successful trips to Australia, canada and the USA as their tenor soloist. This is his fourth book for Tempus.

Right: Arthur Edward John Hooper (1910-1974) of Park Terrace, Treforest, married Gwyneth Davies (1911-1996) of Newbridge Road, Llantrisant in June 1935.

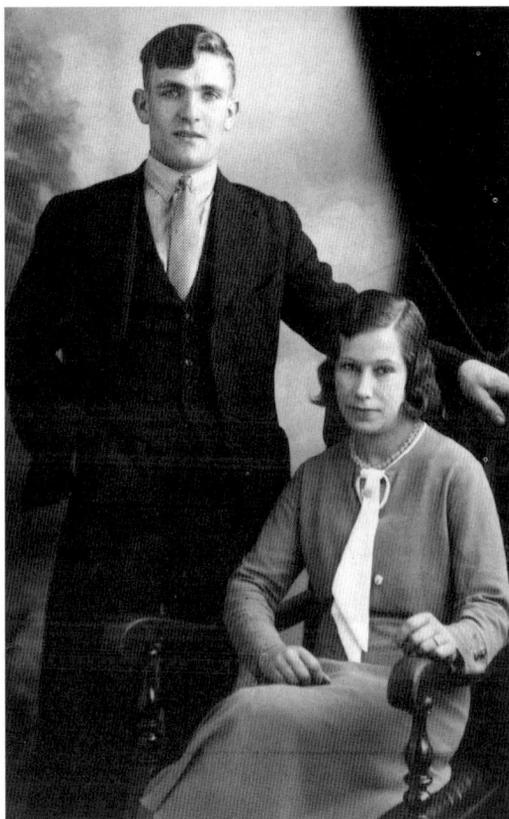

Introduction

Dinas a osodir ar fryn, ni ellir eu chuddio.

Llantrisant stands proudly in its saddle between two hills, allowing breathtaking views like a dominant city from biblical times. Its majesty is easily recognisable as it towers over the surrounding landscape, standing as a testimony to more than 1,400 years of history. Yet the town is more than just a shrine to the many battles fought there or a memorial to a bygone age of chivalry to be visited like a museum. It is a living, thriving home to generations of large families, fiercely proud of their town, and it is with them in mind that the second photographic history of Llantrisant was compiled.

Llantrisant has survived its tumultuous history because people desired to reside amongst its many charming, unplanned cobbled streets. They repeatedly rebuilt its battle-scarred buildings, developed its trading opportunities and established law courts and religious centres. Those people weaved the history of this little town and became synonymous with its reputation as the home to so many colourful, unique characters. The Llantrisant of today has seen many changes, but it is still recognised as a jewel in the crown of South Wales.

The security of its positioning saw the development of the original Celtic society during the sixth century, some 400 years after the Romans established a fort at nearby Caergwanaf. With the advent of Christianity, the creation of the 'llan' began, and by the early twelfth century the Normans breached the wooden fort-like enclosure to create a new stronghold. They developed Llantrisant as a military base between the conquered vale and the barren mountain terrain of the north where the exiled Welsh warriors lay in waiting for an opportunity to revolt. The first Norman castle was completed sometime before 1100 to protect a community of smallholdings, but the early Norman lords faced fierce opposition from the Welsh, who periodically raided the town, eventually driving the enemy out by 1127.

Inevitably, Llantrisant proved all too attractive for the Normans, and they re-emerged to claim the town once more, creating a stone-built castle in 1246. For the next two centuries

the town witnessed a series of bloodthirsty rebellions. So attractive was Llantrisant that it was believed the exiled King Edward II had considered making it his safe retreat in 1326, only to be caught and ultimately executed. The growth of an agricultural community was inevitable and so too the community of traders on the hilltop. They welcomed the presentation of a Charter in 1346 to give those Burgesses, or Freemen, the freedom to trade in the town without paying for the privilege. The new borough gave Freemen a measure of self-government, courts of law and control of markets and fairs, as well as grazing rights over the common, sanctified by the custom of Beating the Bounds to ensure no tradesmen were operating within the boundary without paying. The presentment of the Charter took place five months before the famous Battle of Crécy, when it was said the legendary longbowmen of Llantrisant played a significant role in its victory, and it would be nice to believe those veterans were the first to be bestowed as Freemen.

Despite a rapid decline during the sixteenth century, the farming district was later dominated by the market town where epidemics were frequent, and the growth of paupers in the town in 1783 reached such a degree that first Workhouse in Glamorgan opened there. The town 'where pigs roam streets without rings in their snouts,' was the hub of all factions of society, from the ruling gentry and corrupt vicars to quarrelsome families and prostitutes who frequently witnessed incidents of brutality owing to the mass of public houses.

During the nineteenth century, coal pioneers indiscriminately penetrated the South Wales valleys with an accelerated pace, creating a form of black Klondyke. By the 1850s the coalfield touched the borders of Llantrisant and attracted workers from Somerset, Cornwall and Bristol, who infiltrated the area and brought all the economic benefits of an increased population. The Victorian era witnessed the appearance of many landmark houses, shops, chapels and inns. As the hometown of David Evans, the future Lord Mayor of London, it was also a little community prone to bouts of eccentricity, particularly when one considers tales of bull-baiting on the town square. It was probably such idiosyncracies that attracted the renowned Dr William Price to settle here. The episode relating to the cremation of his infant son on Caerlan fields remains one of those passages in history retold with enthusiasm by the townsfolk.

Ultimately, further development and industry coming to the region resulted in post-war estates being built in the town, but, unable to cope with such a massive influx of population, Llantrisant reached saturation point. Steadily, its stance as a trading centre diminished, its market waned in favour of Pontypridd and further amenities moved to Talbot Green. The twentieth century also witnessed the completion of the M4 motorway close by, the relocated Royal Mint and the Royal Glamorgan Hospital, along with new businesses in the town itself.

Today, despite the influx of new residents, large families dominate the population. In a town where illegitimacy was rife and where the honour of inheriting the rights of the Freeman's legacy predominates, the ability to truly identify family connections remains impossible. Yet as different as they may be, their unifying common interest is obvious, and that lies in the respect, pride, love and, more importantly, security of living in a beautiful little hilltop town, just as those early Celtic followers felt more than a thousand years ago. Quite simply, we are proud to call Llantrisant our home.

Dean Powell
December 2003

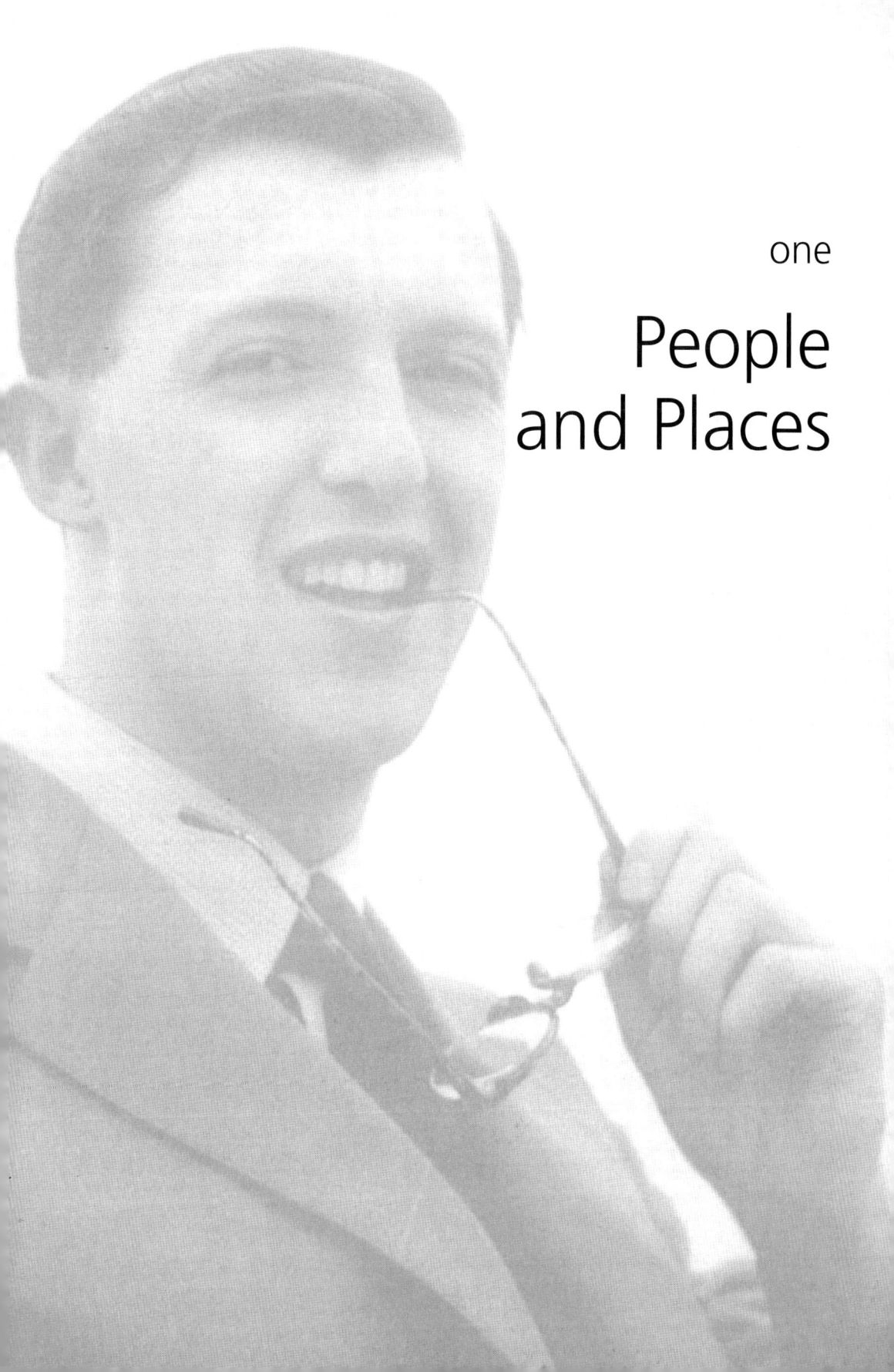

People and Places

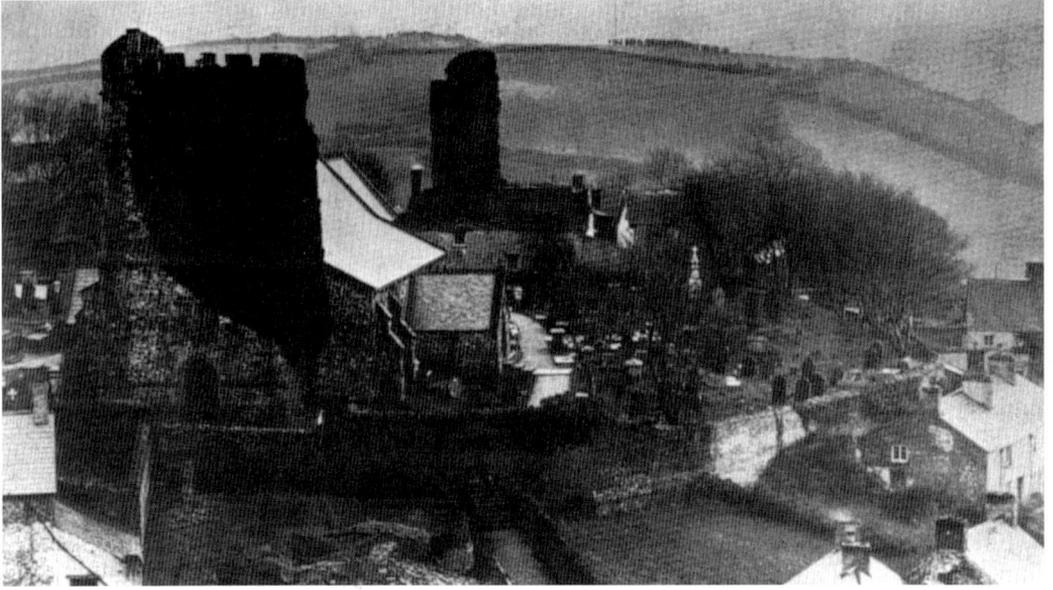

Llantrisant Church and Castle pictured from West Caerlan, January 1893. Apart from the strange spectacle of ivy growing on the church tower, the most fascinating part of this photograph is the group of people seen on the opposite hill of East Caerlan. They were part of the crowd of 20,000 who visited the hilltop town on 31 January to witness the cremation of its most notorious resident, surgeon, Chartist, Archdruid and champion of cremation, Dr William Price.

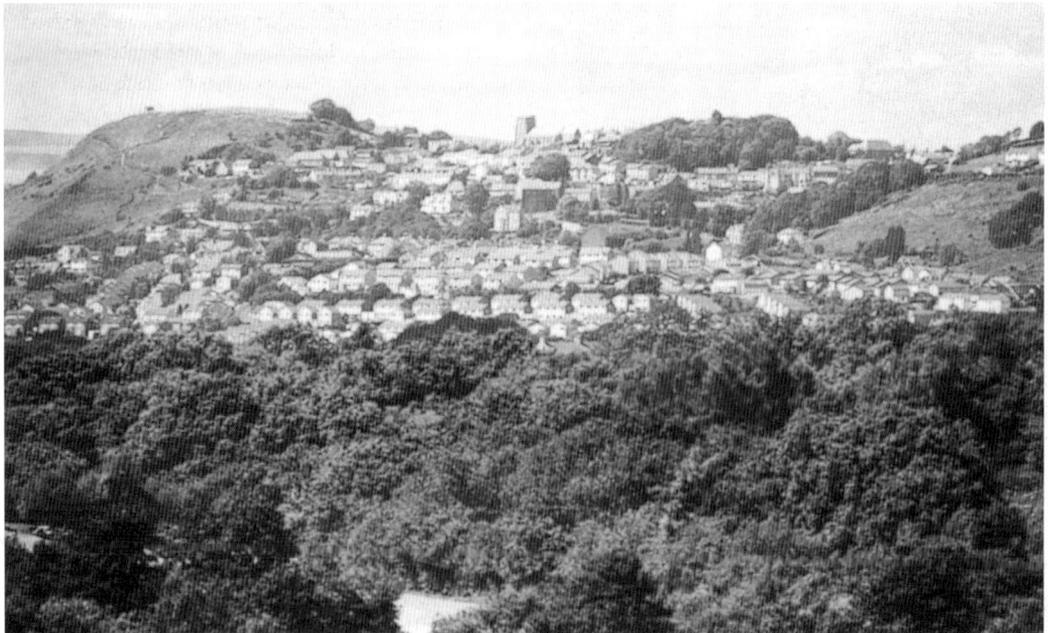

Llantrisant, c. 1998. For more than 1,400 years this little hilltop town has attracted the attention of generations of rather unique, sometimes eccentric, characters. Despite the passing of time, there is no doubt that Llantrisant remains an extraordinary place to live.

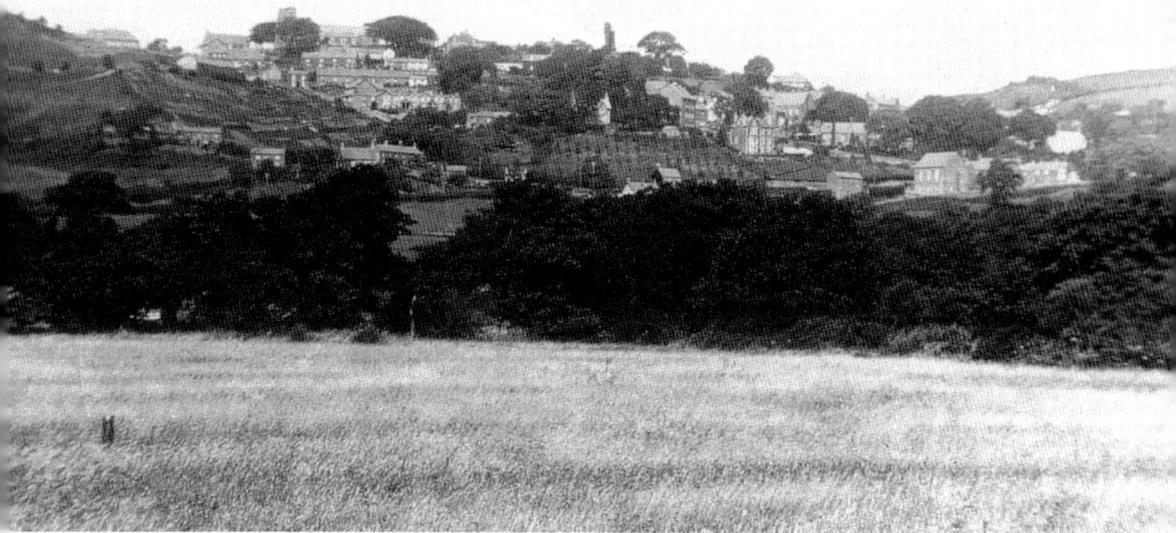

Above: Llantrisant pictured from New Parc Farm, *c.* 1910. The historic market town was immortalised in verse in 1888 by Julia John, whose husband, naturalist Evan John JP, was the first Clerk of the Town Trust when it was founded in 1889. Mrs John lived on the Graig with her daughter, Lilian, who married the Revd Daniel Fisher, the officiating minister at Dr Price's cremation. She wrote: 'I know a pretty little town, Tis built upon a hill; Its streets run crooked up and down, Walk any way you will.'

Left: The approach to Southgate, *c.* 1920. The Wesleyan Chapel on the right was built in the spring of 1884 by English speakers of the Nonconformist movement. They departed from the congregation of Zozobabel Chapel on Swan Street (once opposite the New Inn) a few years earlier, leaving the Welsh-speaking members to run the chapel alone. Sadly, interest waned and after failing to appoint trustees, the Zozobabel was sold to the Llantrisant and Llantwit Fardre Rural District Council in 1918. The chapel pictured, which was also used by the Llantrisant Male Choir for rehearsals, was eventually demolished during the 1990s, again due to a dwindling congregation.

11

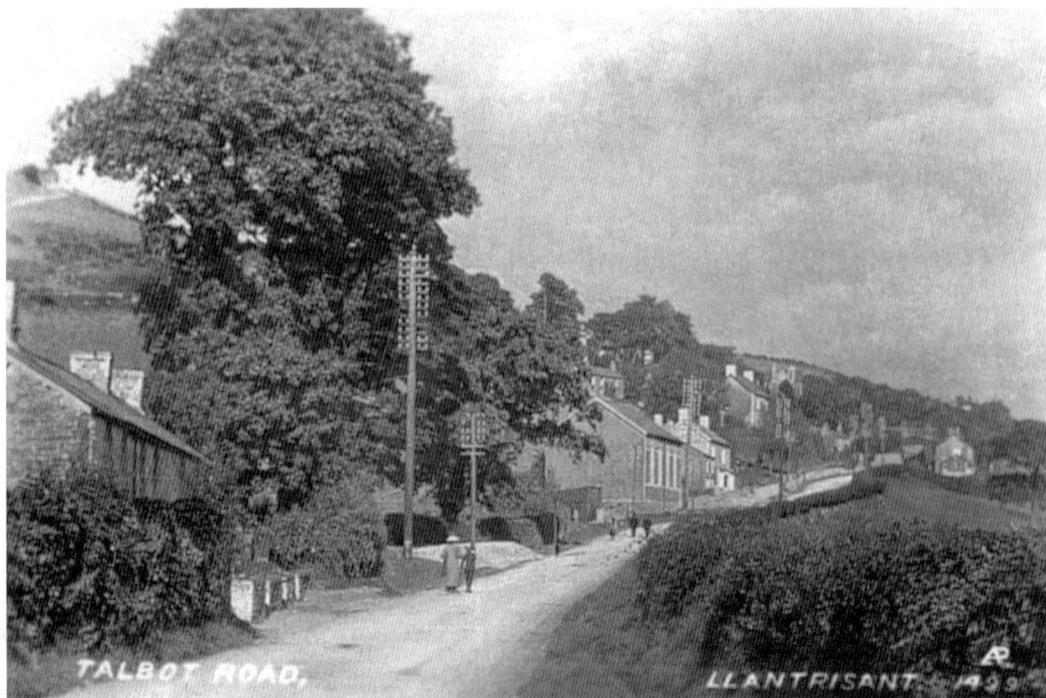

Above: Talbot Road towards Llantrisant with the Salem Christian Bible Chapel on the left, *c.* 1910. A century earlier in 1807, the Revd B.H. Malkin of Cowbridge walked the same route and observed: 'The situation of Llantrisant, which fills with its white buildings the lofty pass between two craggy peeks, excites some curiosity and surprise. The ascent is steep, but prospects become more and more striking as you advance, till on gaining the churchyard you comprehend the magnificent whole at one view.'

Opposite above: The building of council houses at Penygawsi, *c.* 1920. The 1920s brought a period of expansion in industry to the area and the Llantrisant and Llantwit Fardre Rural District Council was empowered to build more houses. Schemes were started in Beddau, Pontyclun and in Penygawsi to accommodate a growing population. The land at Penygawsi was sold to the council by Revd Samuel of Penuel Chapel, High Street. Within the next year families occupied all the new houses at Heol Pen y Parc and Park View.

Opposite below: Llantrisant Bowling Green and Tennis Courts *c.* 1940. With the expansion of Llantrisant and Talbot Green during the early part of the twentieth century, the need for leisure facilities was greater than ever. On building the new houses at Penygawsi, the council opened a new bowling green and tennis courts at Southgate. Llantrisant Bowls Club was formed in 1931 and forty years later an indoor swimming pool was built, which was eventually replaced by Llantrisant Leisure Centre in 1985.

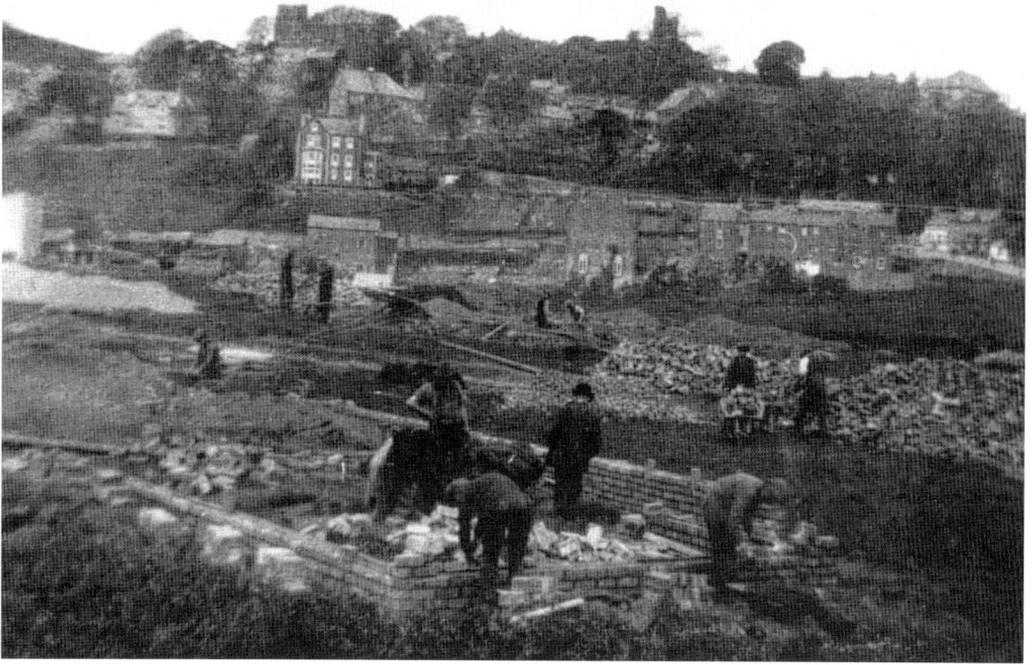

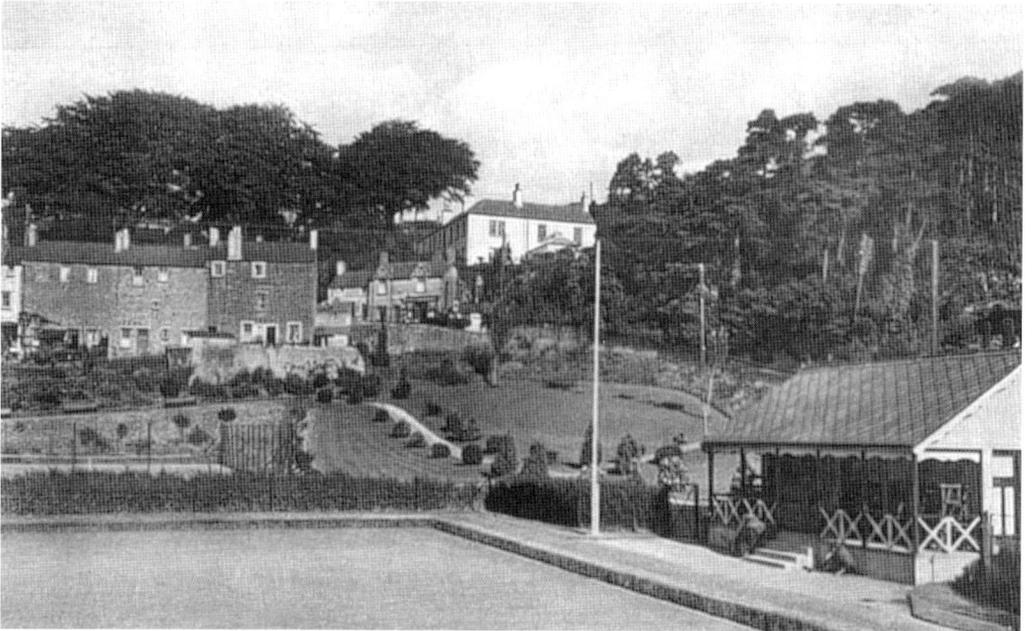

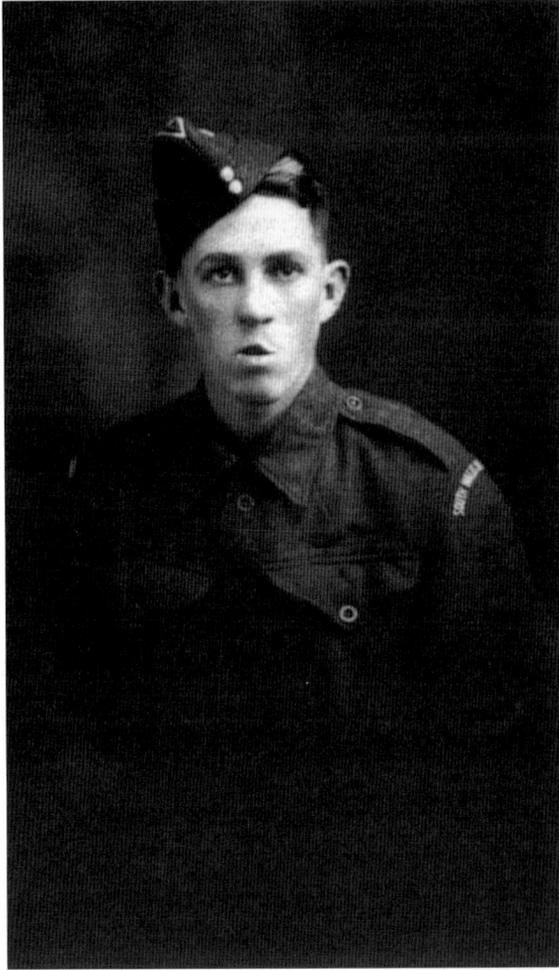

Gwyn Williams in the South Wales Borderers, c. 1944. Born in 1926 at Tŷ Gwyn on Cardiff Road, Gwyn was the son of Glyn Williams from Heol y Sarn and his wife Edith of Pontyclun. His parents bought the house, formerly a pub, during the early 1920s. Gwyn attended Llantrisant School and later worked for a shop on High Street, riding a Penny Farthing bicycle to deliver groceries. He became a carpenter and joiner and in 1944 was enlisted in the South Wales Borderers, where he fought in France and Belgium. Following a period in Palestine, he was demobbed in 1947 and returned to Llantrisant to work at the Llanharry Iron Ore. After working for the local council he spent the rest of his working life in the Royal Mint before retiring in 1987. He married Moira Collins in 1955 and they had a son, Phillip.

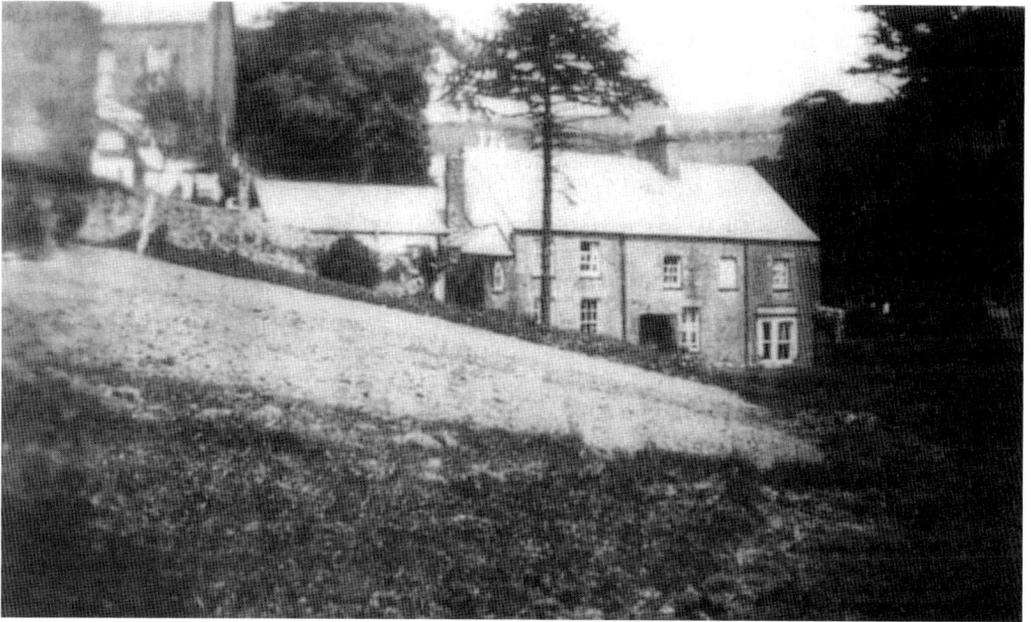

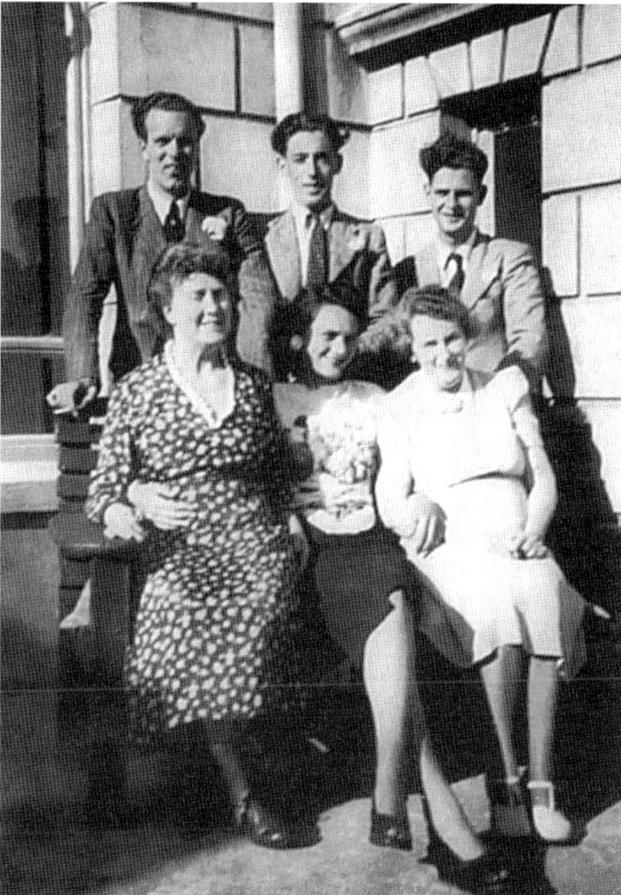

Above: Llantrisant Cottage, *c.* 1932. Built in the mid-eighteenth century, it was once a pub and was bought by the Morgan family in 1930. Tudor Aston Morgan (1896-1962), a dentist, and his wife, 'Mamie' Morgan (1886-1972), bought the house from Llantrisant GP Dr Willy Davies' widow and remained there until the late 1950s. Dr Morgan had a dental surgery in the home during their years there.

Left: Family and friends at Llantrisant Cottage, *c.* 1942. Back row from left: Viv Davies, Graham Jenkins, Tom Morgan. Front row from left: Mary (Mamie) Morgan, Dolly Morgan and Nancy Davies. Tom and Dorothy were the children of Tudor Aston and wife Mamie Morgan who moved to the Cottage in 1930. Graham, an electrician engineer, was the son of Alf Jenkins. Mrs Davies was the widow of Mr E. Davies and their son, Viv, became a solicitor. Tom became a dentist before emigrating to Perth, Australia in 1966. Dolly (Dorothy) spent time in Malawi before settling in North Yorkshire.

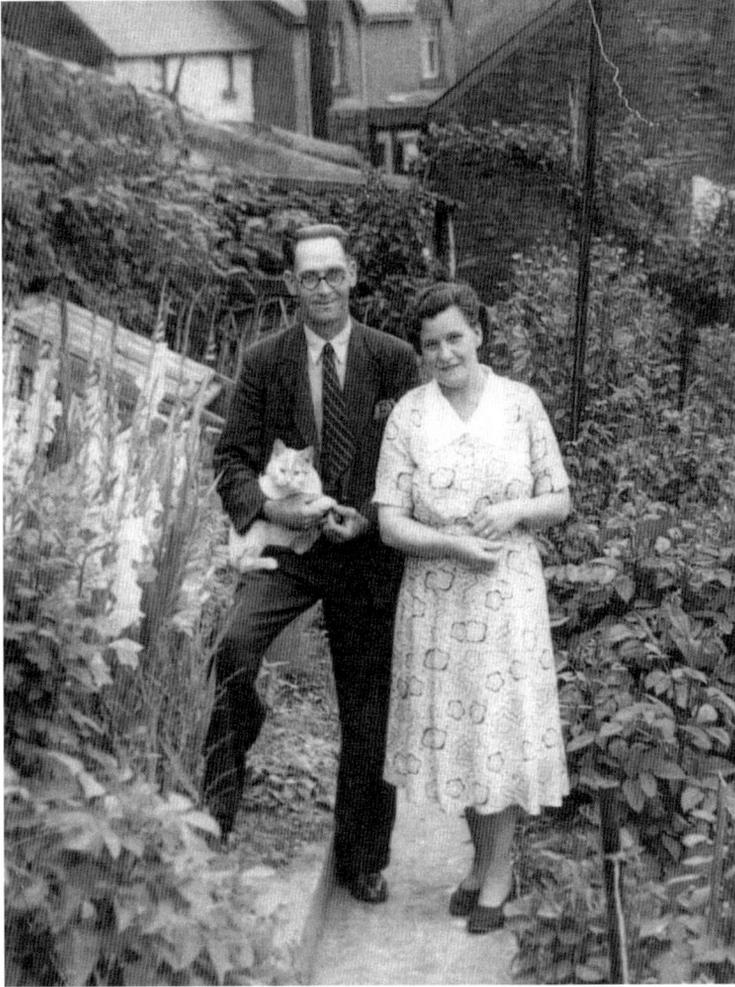

Ellen and Alfred Phillips in the back garden of their home at 1, High Street in July 1952. Ellen (1905-1963), from Miskin, and Alf (1905-1988), from Cross Inn, lived in Southgate Cottage, seen behind them, before moving onto High Street. Alf was the head gardener at Rhydlafar Hospital following an accident in the Bute Quarry at Mwyndy. The couple had one daughter, Yvonne, who married Gordon Miles and settled in the nearby terrace alongside Llantrisant House.

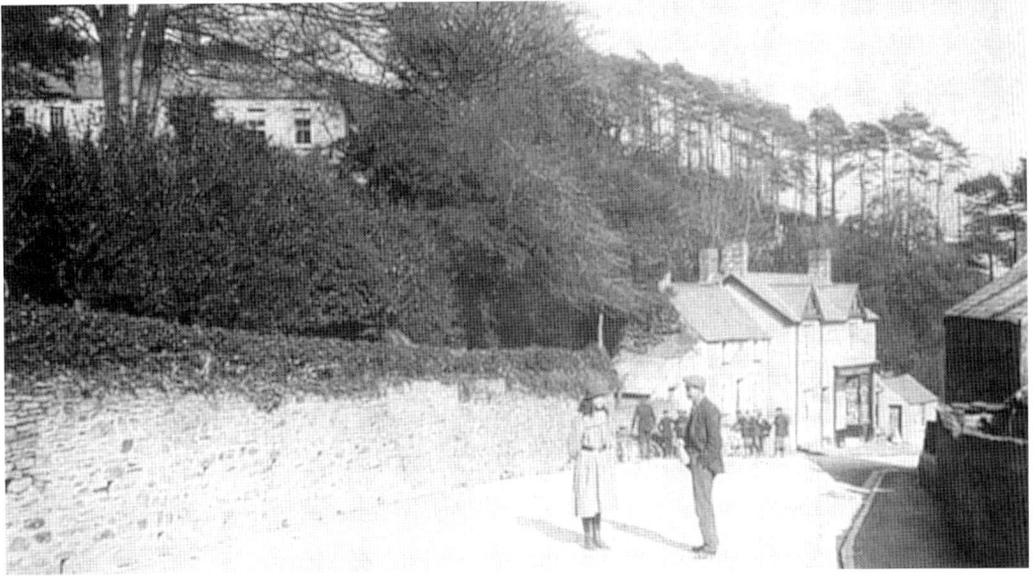

Above: The lower part of High Street and Southgate, *c.* 1940. Notice the houses on the right that were demolished in the 1960s. On the opposite side of the road is Southgate Cottage, built in 1785, alongside James' Grocers and Dairy. Behind the trees can be seen part of Llantrisant House that was built, with adjoining stables, during the early nineteenth century.

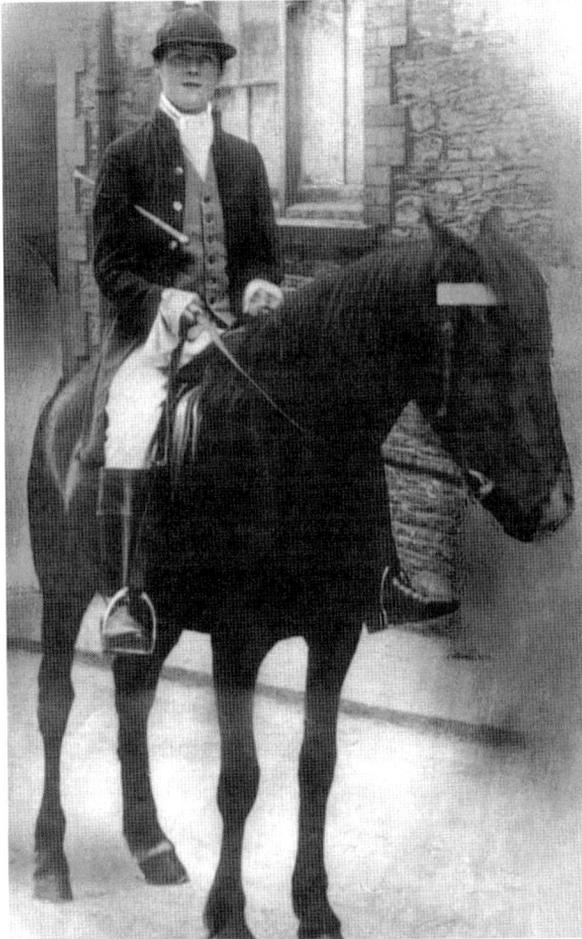

Left: Margaret Dobbin (1890?-1970) on horseback outside her home, the Greyhound public house, *c.* 1910. The daughter of Catherine Dobbin (née Harry) and engine driver Joseph Dobbin, she married Harry Bailey who worked at W.E. Jones' Fruiterers' in Tonyrefail. Llantrisant has always enjoyed a varied and sometimes rather unique set of residents, two of which appeared in the Guinness Book of World Records. Hopkin Hopkins is referred to as the world's smallest man. He died at the age of eighteen in 1754, weighed just 13lbs and was 2ft 7ins tall. The second famous resident was Miss Jeannetta Thomas, the oldest person ever recorded in Britain at the time. Born on 2 December 1869, she ran a business at Commercial Street, Tynant. She died in Cowbridge on 2 December 1981 aged 112.

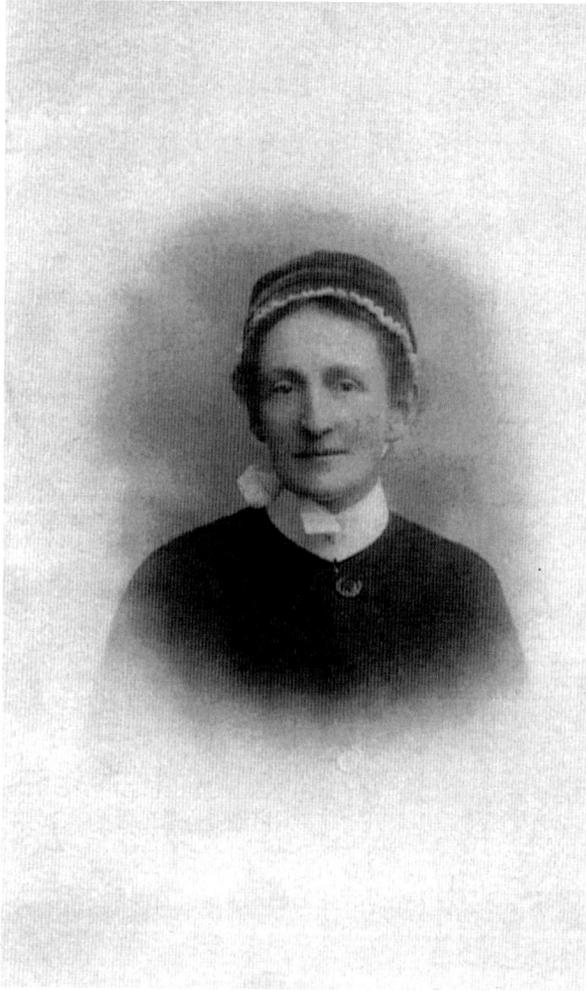

Midwife Annie Taylor, c. 1915. One of thirteen children born to the Evans family of Cefn Parc Farm, relatives of Llantrisant-born Lord Mayor of London Sir David Evans, Anne followed in her sister Jane's footsteps and became a midwife. Working during the 1920s, '30s and early '40s with Dr J.C.R. Morgan, she was well known throughout the district as she rode around on her bicycle. She married and settled in Heol Pen y Parc, where the couple had four children named Gwen, Fred, Dan and Lewis. She died in 1946.

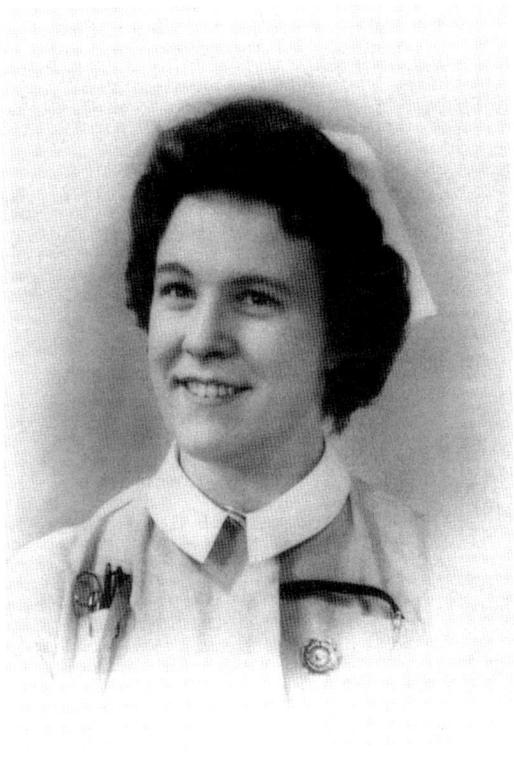

Midwife Shirley Wilkins, 1960. One of twins born in February 1939 to William and Gwladys Wilkins of Ceridwen Terrace, her grandmother was also a midwife and died on duty in Newbridge Road after delivering five babies in a matter of hours. Shirley studied at Bridgend Technical College and in 1956 trained at the Royal Infirmary, Cardiff where she became a State Registered Nurse. Working as a senior staff nurse, she was accepted into the Radcliffe Maternity Hospital, Oxford in 1961, but did not take up the position. Joining the Queen's Nurses, Cardiff as a midwife, she was invited to nurse at Toronto General Hospital in Canada in 1962 but with the smallpox epidemic still raging, remained in Wales. She married Ken Penhallurick in 1965 and worked as a midwife for Llantrisant and its surrounding communities. In 1975 she was the first Welsh midwife to attain the Advanced Diploma in Midwifery at South Meads Hospital, Bristol. Shirley retired in 1998.

Dr David Rowland Morgan (1923-1986). One of two children of Dr John Clifford Rowland Morgan and Sybil Magnola Morgan, he was born on 26 December 1923. David attended the local school, followed by Sherbourne Boarding School in Dorset. He studied at Trinity Hall, Cambridge, where he won a Blue due to his prowess in athletics, before attending St Thomas' Hospital, London to complete his medical training. He met and married nurse Marion Turner in 1947 and the couple had four children. David enlisted in the Royal Army Medical Corps, becoming a captain. Following his father's retirement as the Llantrisant GP in 1953, he took over the practice. Fluent in French and German, he attained a Fellowship of the Faculty of Anaesthetists at the Royal College of Surgeons. In partnership with Dr Michael Jones, a surgery was opened in Beddau followed by a new surgery in Talbot Green and a third doctor, Ijaz Abbasi, joined them.

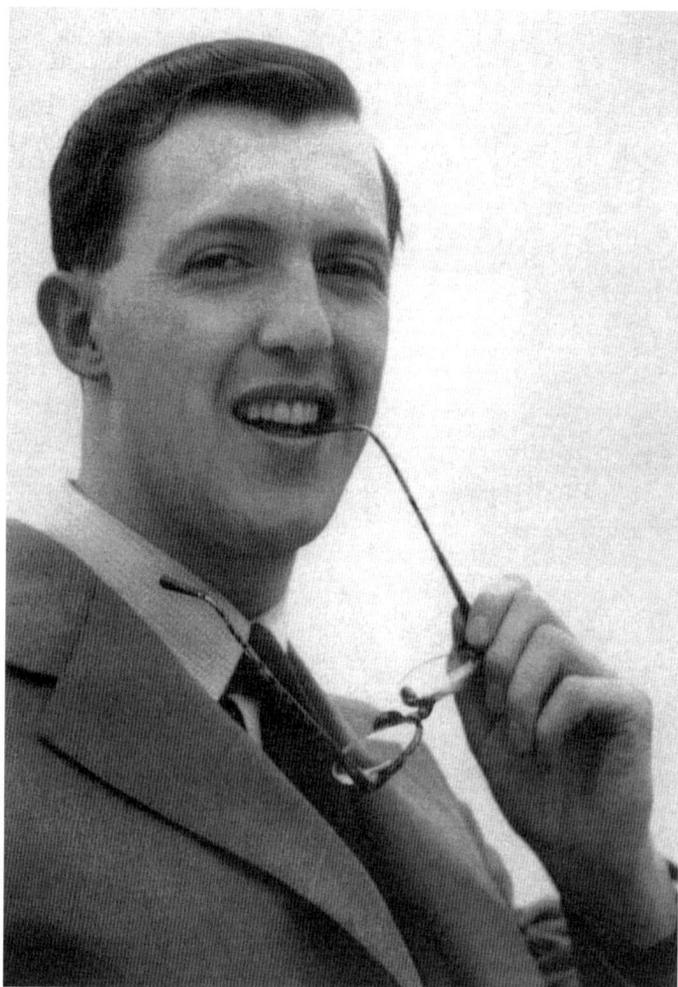

Dr Michael Llywellyn Jones, *c.* 1955. Born in London in 1933, his mother was Mollie Llywellyn, the daughter of Welsh rugby international Willy Llywellyn, while his father, Dr Gordon Jones, was a Bridgend-born medic. In 1934 Dr Jones worked as an assistant to Dr J.C.R. Morgan at the surgery in Southgate, before moving to a new practice in Pontyclun. J.C.R became godfather to Michael, who attended Cowbridge Grammar School before studying at the Royal Medical Benevolent College in Epsom. An outstanding athlete, he attended Clare College, Cambridge and ran competitively for the University before undertaking his clinical training at the London Hospital, Whitechapel. He later captained Llantrisant Golf Club and became President of Pontyclun Rugby Club. He qualified in 1958, was enlisted in the Royal Army Medical Corp, and married Mary Evans. On 1 October 1963 he joined the practice of Dr David Morgan and after five years he became a full partner. Dr Jones retired in 1992.

SOAR, CAPEL YR ANNIBYNWYR
LLANTRISANT

GWYL DATHLU
CANMLWYDD A HANNER
Achos yr Annibynwyr Cymraeg
yn Llantrisant

BETHEL **1809-1959** SOAR

DYDD MERCHER A DYDD IAU, MEHEFIN 3 A 4

DYDD MERCHER, am 2-45—Cymraeg a Saesneg

Pregethir gan **Y Parch. D. STANLEY JONES, Gowerton**
Hanes yr Achos: **Y Parch. R. T. GREGORY, Caerdydd**

Dadorchuddir Tabled a dodrefn yn ystod y cyfarfod,
er cof am G. T. Davies, ysgrifennydd cyntaf Eglwys Soar

Darperir Te ar ol y Gwasanaeth

NOS FERCHER, am 6-30—Gwasanaeth Cymraeg

Pregethir gan **Y Parch. R. J. JONES, Caerdydd**

THURSDAY, JUNE 4th—English Service at 6-45 p.m.

Preacher:
Rev. R. E. LEYSHON, B.A., B.D., Milford Haven

History of the Cause (in English) by the Secretary

**A very cordial Invitation Is extended to all Churches to join
us in the Celebrations**

A notice advertising a festival at Zoar Chapel commemorating the 150th Anniversary of the Welsh Independents movement in Llantrisant, 1959. Held over two days, the festival attracted a variety of preachers from Cardiff, Gowerton and Milford Haven along with a series of talks in both English and Welsh relating to the history of the movement. Originally the Welsh Independent movement in Llantrisant started in Bethel Chapel on Swan Street and by 1851 had an average Sunday attendance of 400 people. In 1862 a disagreement broke out and disenchanted members left for a room at Mwyndy Farm. Eventually they built a new chapel called Soar in Penygawsi and in 1902 they bought Dr William Price's home, Tŷ'r Clettwr on High Street, to build Zoar Chapel by which time both fractions of the congregation had reunited. Bethel was sold to the church and became the church hall, while its cemetery remains next to the building.

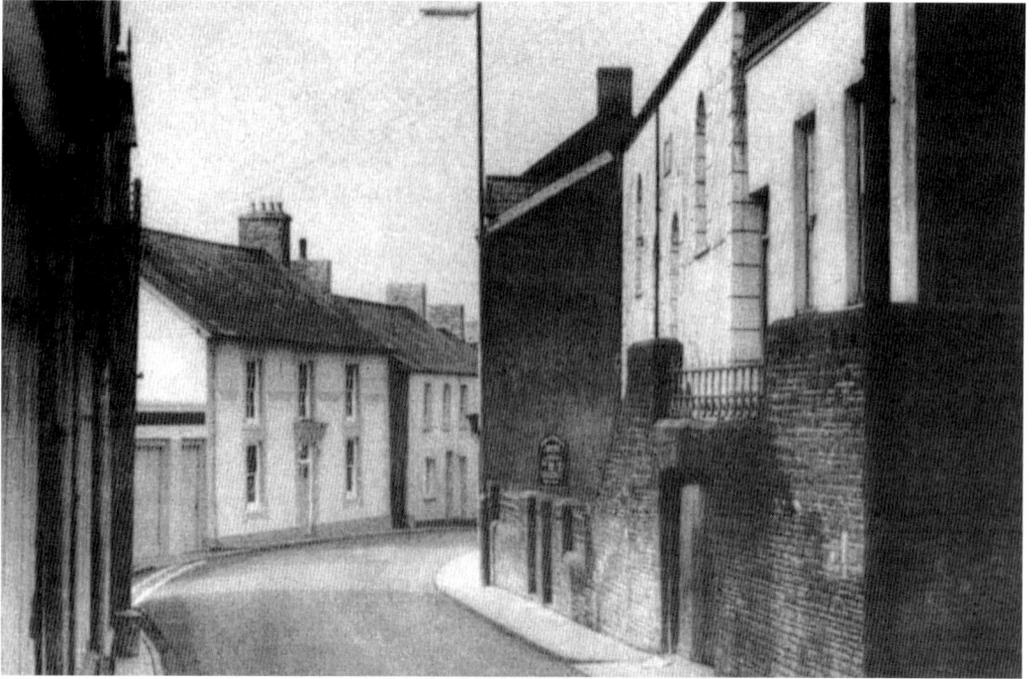

Above: High Street towards the Wheatsheaf Hotel with Penuel Calvinistic Methodist Chapel on the right, *c.* 1960. Penuel (originally referred to as Bethlehem) was built in February 1775 after a congregation of some 500 regular Sunday members secured a lease of a house, stables and garden at Ffynnon Newydd on High Street. It was rebuilt in 1826. Damage was later caused to the vestry floor when a fire broke out in a car parked in the old stables below the building.

Above: Enid Griffiths (1915-2003) outside a shop on High Street, *c.* 1925. One of two children born to William Griffiths (1887-1972) and Elizabeth Ann Griffiths (1891-1985), her younger sister was Betty (Green). Enid will be best remembered as the local piano teacher. She was born on Roam Road, and at an early age received piano tuition from Danny Francis of Pontyclun and achieved both the Associate of London College of Music and the Licentiate of the London College of Music. She was married in 1948 to Eric Lewis and the couple settled in High Street. For fifty years she taught piano lessons to local children, and she was organist at Llantrisant Parish Church for sixty years. She was also totally involved in all aspects of the church, taking part in every one of their variety shows and becoming a stalwart member of the Mother's Union. In 2000, she received the MBE for her services to the community.

Opposite below: Ivor Morgan James (1907-1994) at Gwalia Stores, High Street, *c.* 1950. Ivor was the son of Walter (1872-1958), a Church Warden, and his wife Ceridwen James (1877-1932), organist at Penuel Chapel. Walter's brother, Harry, ran the shop at Southgate, while Walter, who was made a Freeman in 1906, ran the hugely popular Gwalia Stores, a grocery and provision merchant. It was inherited by his son, Ivor (also made a Freeman in 1929), who married Rachel Williams (1909-1994) of Cardiff in 1934. They had one son, Godfrey (born 1936), who later became Canon Godfrey James and retired as vicar of Kenfig Hill in 2001.

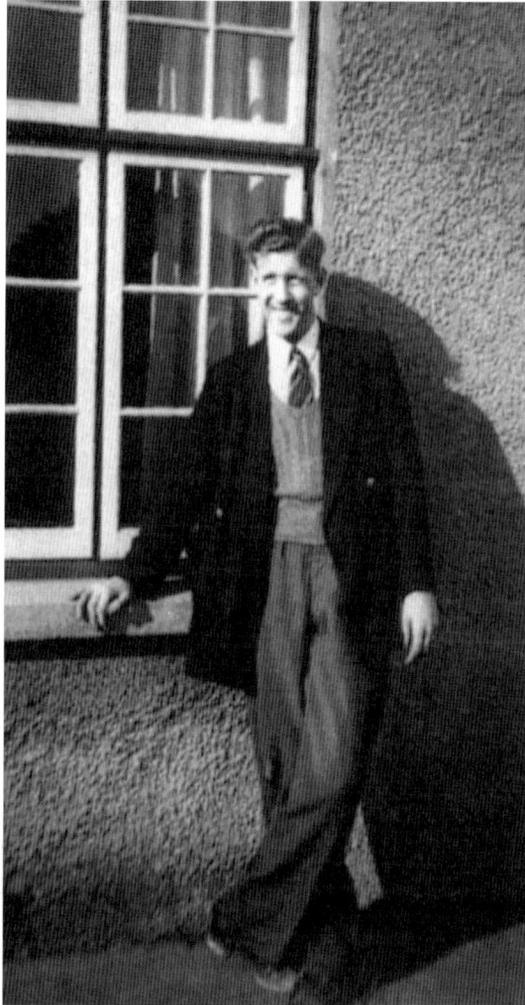

Above: Gordon Miles (1934-2002), *c.* 1952. Born in Talbot Green, the son of Ethel and John Miles, he studied at Cowbridge Grammar School and owned Cowbridge Travel Agents. A devoted chorister at Llantrisant Parish Church, which he joined at the age of seven, he was a Sunday school superintendent from 1952 to 1964 and licensed by the Bishop of Llandaff to administer the sacrament in 1964. He met his future wife, Yvonne, in Sunday school. He became a member of the Parochial Church Council and later a Justice of the Peace. He was the choirmaster of the parish church and a dedicated life member of Llantrisant Male Voice Choir, serving as treasurer for twenty-six years. Gordon worked for the British Red Cross for more than twenty years and was the director for Mid-Glamorgan. He was awarded the Red Cross Badge of Honour and Life Membership. His list of other local organisations included the Parish Council, Town Trust, Community Health Council and the Association of Voluntary Organisations.

Opposite above: A view towards Cross Inn from Erw Hir, *c.* 1924. Judge Falconer said in 1866, 'The town and borough of Llantrisant is perched upon the mountains and by position is like one of the Italian towns of the middle ages. It is a place where it can easily be imagined that men would have rested at an early period and have settled for mutual defence.' With such a commanding viewpoint, there is little doubt why Llantrisant became such an important strategic military town.

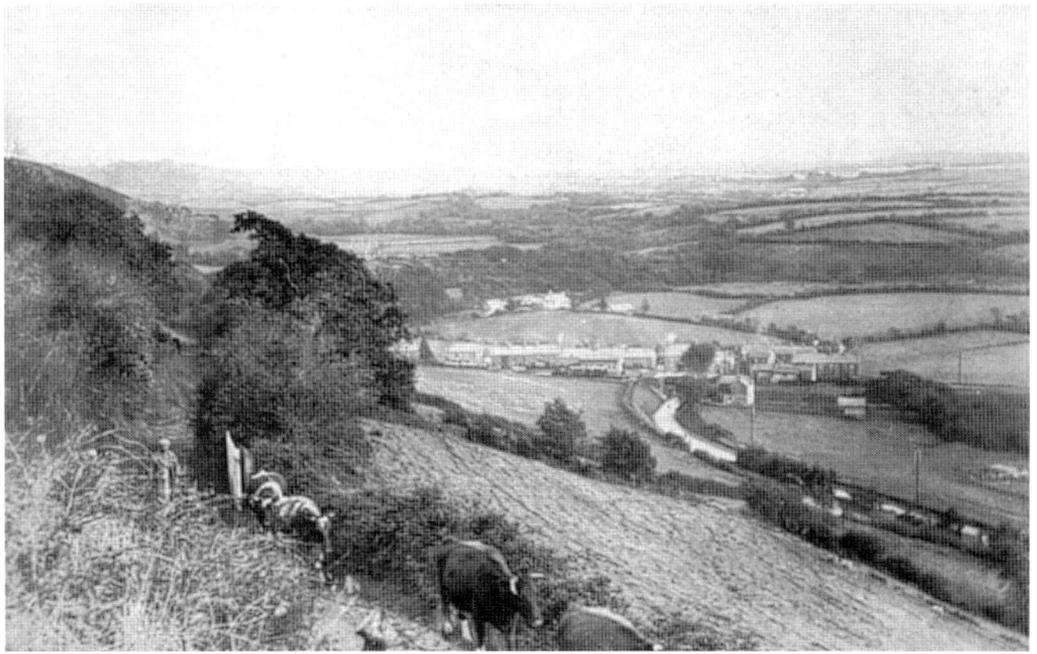

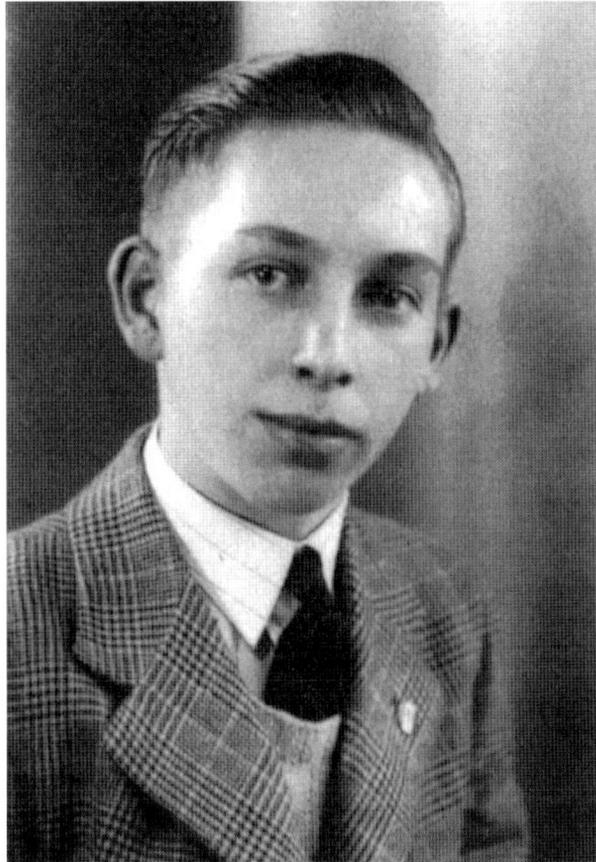

Left: Peter Little (1927-1995), *c.* 1945. Born in the post office on Commercial Street, his father, schoolteacher James Little, was also the subpostmaster assisted by his second wife, Katie. Peter attended Llantrisant School, before studying at Cowbridge Grammar School where he excelled in cricket. He was called up for National Service at the end of the Second World War and served in the navy, based mainly on an Algerian-class minesweeper. Once home in Llantrisant, he worked in the Treasurer's Department at County Hall, Cardiff and Lanelay Hall, Talbot Green where he met his future wife, schoolteacher Edna Aldworth. The couple settled in Tonyrefail, where he played for the local rugby team. After an attempted robbery at the post office in 1970 where his sister Nesta Little and colleague Muriel Thomas beat off the intruders, Peter became subpostmaster. He remained there until his retirement due to ill health in 1990.

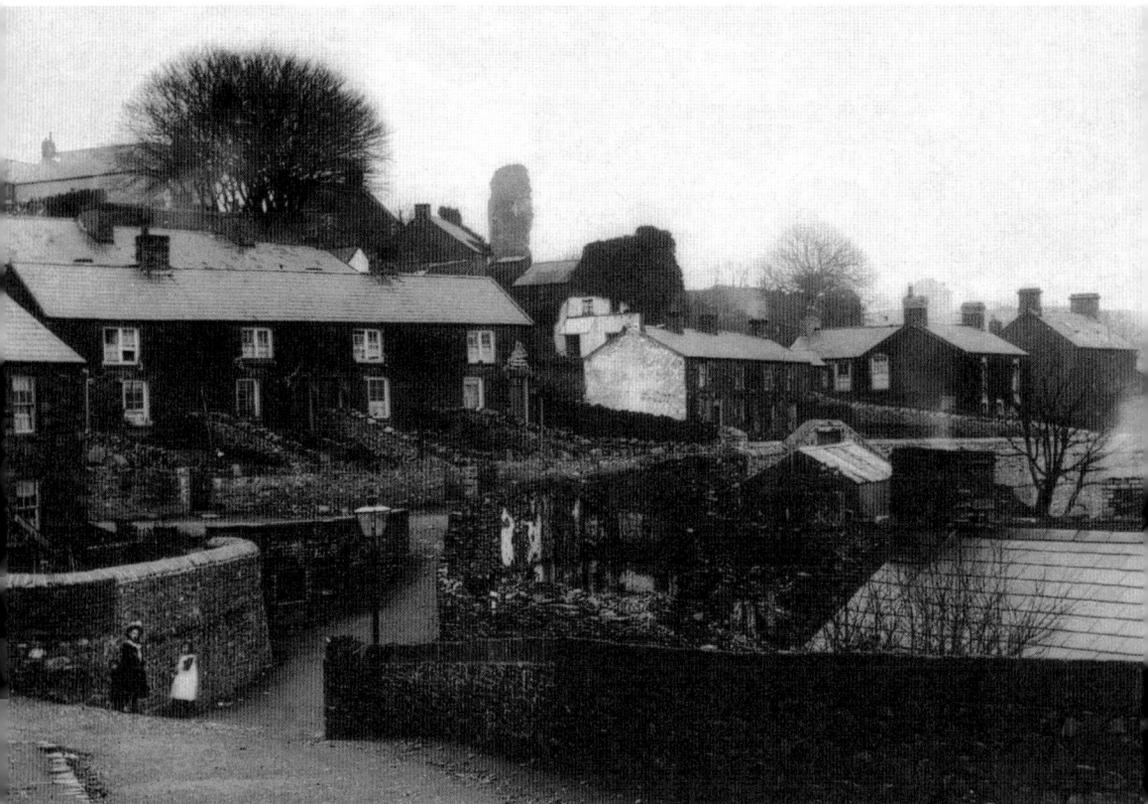

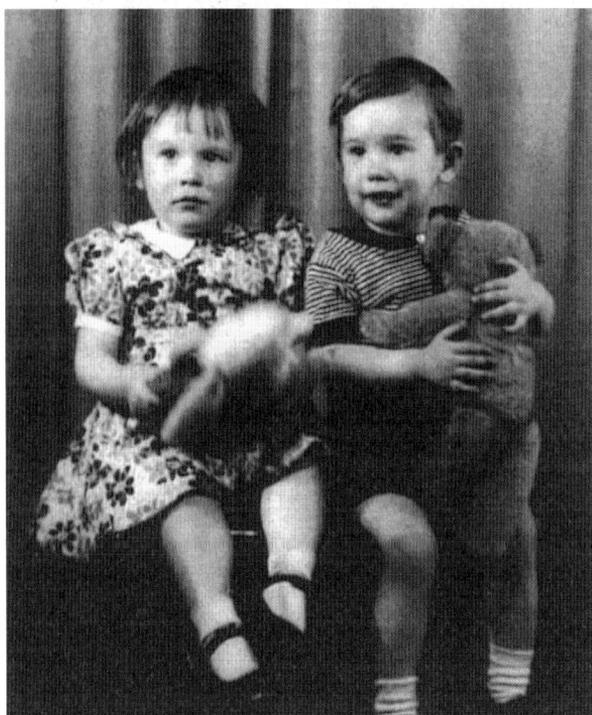

Above: Church Street, *c*. 1905. Twenty years later, the churchyard wall collapsed on South Parade, the small terrace of cottages behind Church Street. Ultimately, they were demolished. During the 1980s, the wall collapsed a second time close to Yr Allt, resulting in the demolition of a bungalow.

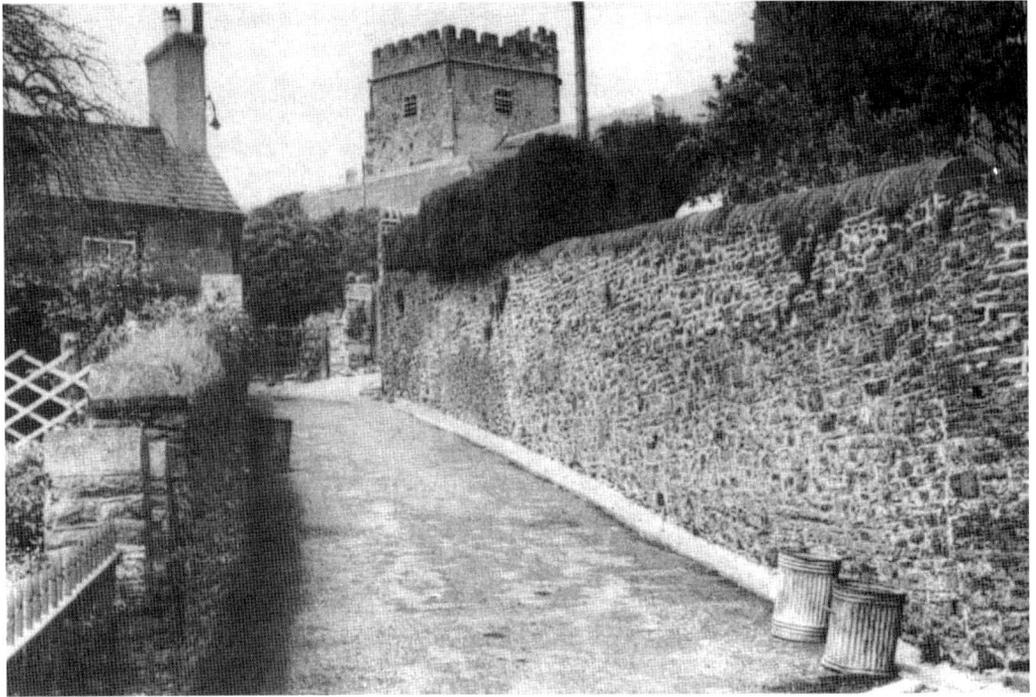

Above: The lane leading to Yr Allt from Church Street. There is little doubt that Yr Allt cut through the centre of the oval-shaped enclosure of the original parish, or Llan, established 1,400 years ago.

Opposite below: Twins Islwyn and Shirley Wilkins, *c.* 1940. Born in 1939, they were the children of William and Gwladys Wilkins of Ceridwen Terrace. After finishing Llantrisant School, Islwyn and Shirley, like all local children, spent a year at Pontyclun until the age of fifteen. Afterwards, Shirley began her studies to become a midwife and Islwyn started working in the Cwm Colliery as a miner until the age of twenty when he joined Thyssen Contractors. He also worked on the area tunneling teams and in 1968 joined the Wella Factory in Talbot Green where he worked as a chauffeur and became instrumental in the Trades Union. He was made redundant at the age of fifty-six and devoted his time to local politics, becoming elected as a Plaid Cymru councillor to both Taff Ely Borough Council and Llantrisant Community Council in 1990. Islwyn also became a councillor in the new Rhondda Cynon Taf Council and was made their chairman for a year in 2002.

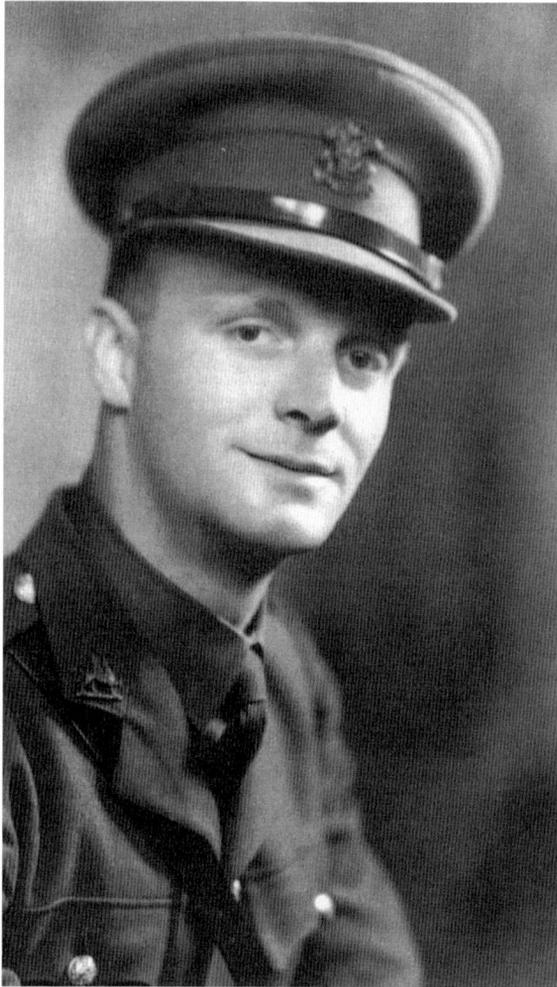

Lieutenant Thomas James Wilkins (1917-1944). The son of David and Margaret Wilkins of Church Street, Tom was the youngest of seven children. He attended Llantrisant Town School and Pontypridd Grammar School and became well known as an accomplished tennis and rugby player. Two weeks after marrying Sylvia Preece of Pontyclun, he was called up to serve in the Welch Regiment. On Monday 3 July, 1944, a month after the D-Day Landings in Normandy, he was shot in friendly fire in Caen, France. According to his family, the medical officer who attended to him was none other than his friend, Ruben Jewell from St David's Place. While dying in his friend's arms, he told him he was thinking of the Wheatsheaf Hotel back home and could almost hear the drinkers singing *Calon Lan*. It wasn't until Ruben returned to his hometown that he informed Tom's parents of his death. Tom was buried at Ryes War Cemetery in Bazenville, France.

The Dickasons at home in Church Street, June 1940. Pictured from left: Gwyneth (born 1925), Louise (1896-1968), Mary (born 1928) and Jack (1931-1991). Louise Dickason, (née Evans) joined a medical team to work in Johannesburg where she met John Alfred Dickason (1902-1930). They married and had three children in South Africa before John died from meningitis, aged twenty-eight. Louise brought the children home to Llantrisant, where her siblings, William, Richard, David, Annie and Beatrice still resided. Another brother, Glyn, was killed on HMS *Glorious* in 1940. She raised her children on Newbridge Road before moving to Castle Cottage, next to Castle House. Gwyneth and Mary, who later lived at Highfield House, Erw Hir, attended Swansea Training College to become teachers and worked in Oldbury, Worcestershire. Gwyneth, a former Justice of the Peace, taught in Tonyrefail and Beddau while Mary later became the headmistress of Rhydyfelin Nursery School. Their brother, Jack, worked for a bank and lived with his wife and two sons in Coity.

Elizabethan House in ruins, Yr Allt, *c.* 1955. Since the mid-nineteenth century, historians have compiled various history books relating to the town, including Sem Phillips in 1866 and Taliesin Morgan in 1898. Today they are regarded as charming romanticised documents of the age, but hardly reliable sources since both authors seem to have indulged in the trend of arch-forger Iolo Morgannwg. However, they are filled with fascinating items relating to the Llantrisant of their time, particularly letters from 'The Old Black Cock' in the 1866 edition. Phillips says the town at the time was 'situated between two lofty hills, and its whitewashed houses, with the dismantled towers of its castle, form a conspicuous and interesting feature in the scenery on approaching the mountain. The vicinity is indescribably beautiful and highly picturesque, and the views embrace a tract of country abounding with features of romantic character and almost unrivalled magnificence.'

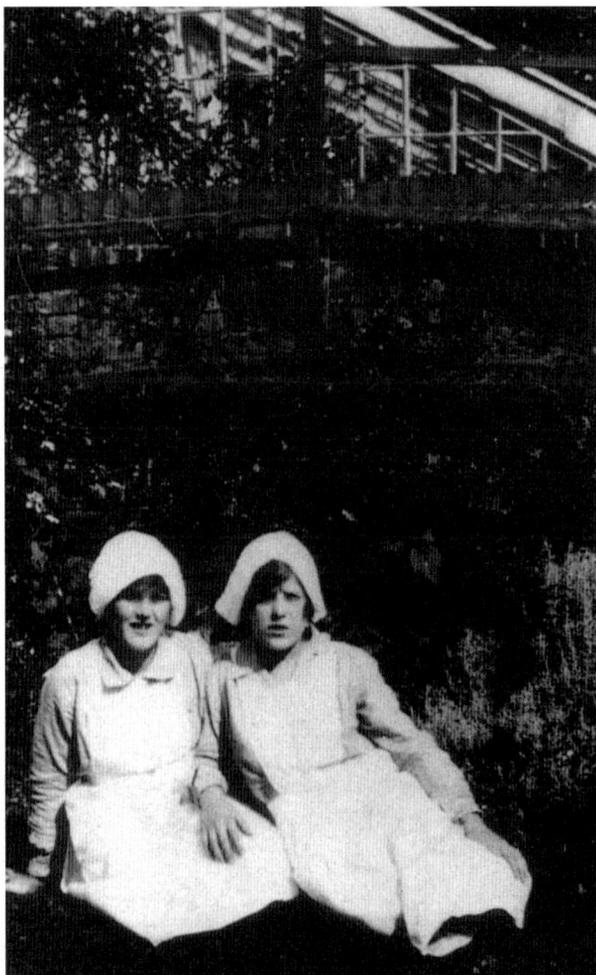

Elizabeth Claudia Evans (1912-1988) with Julia Evans (born 1912) at Brentwood Boys' Grammar School, Essex, 1926. Claudia was born on Yr Allt and was the fifth child of Illtyd and Gwladys Evans. She went into service at Brentwood with her friend Julia, travelling to London on a £1 fare. She later met Vernon Asquith Phillips whilst working at Primrose Hill House, Llantrisant, which was occupied by solicitor Edward Davies. They married on 30 October 1920, settled in Penygawsi and had four children called David, Muriel, Audrey and Raymond. Julia Clark was one of four children born to Kate and George Clark of Barry. George brought the family to Marrah Cottage, Penygawsi in 1912 where he worked in the local colliery and raised his family, which also included daughter Alma, son Leighton, Julia's twin, Kate and another child who they raised called Syd Phillips. Julia married William Evans of Swan Street in 1933 and the couple moved to Heol Pen y Parc to raise daughters Anne, Margaret and Julia.

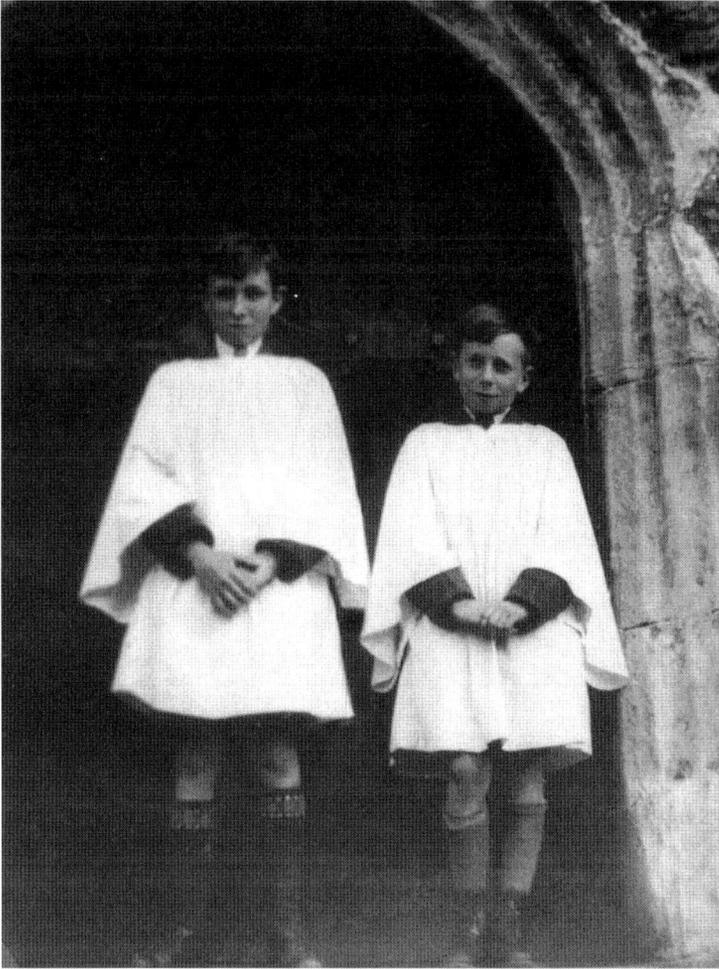

Cecil and William Taylor, *c.* 1930. Along with their sister Mary, the three children were born to William Henry Taylor and Rosina Taylor (née Rees). They lived on Roam Road, before settling in Talbot Green. Cecil (left) married Rosie Lloyd and lived on Greyhound Lane with their two children, Linda and Hazel. He worked for Cooks' Grocery Shop at Talbot Green, which was destroyed by a bombing raid in the Second World War that killed the owner's daughter, and later worked at the Mwyndy Iron Ore, but died aged forty-two. Bill, born in 1918, worked at Hendy Quarry for thirty-five years before starting his own business making foundation stones for graves on Church Street. He served in the Medical Corps throughout the whole of the Second World War, married Gwyneth Williams in 1940 and they had one daughter, Carole. A former parish councillor, he also played a leading role at the local rugby club and was a founder member of the Rotary Club.

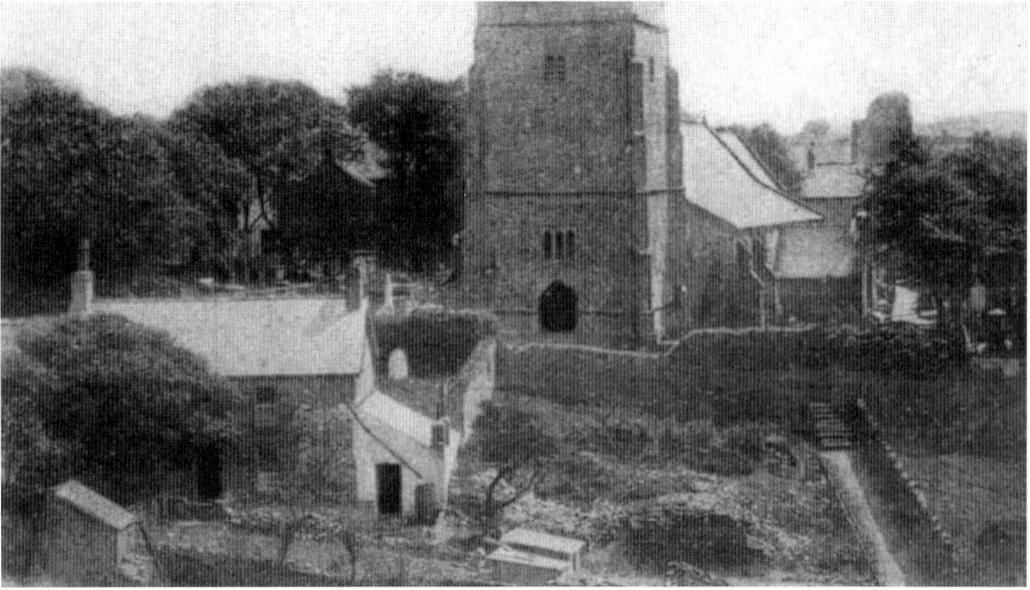

Above: Llantrisant Church and West Caerlan Farm, *c.* 1900. The church stands as a testimony to 1,400 years of Christian worship. It was dedicated to the patron saints of Illtyd, Gwynno and Dyfodwg by the monks of Llantwit Major, giving the town its name. The graveyard allows an insight into the social status of the Welsh language, used extensively until the First World War. Welsh language services were held there until 1939, but hardly any Welsh inscriptions appear in the church yard until 1830, when it attained the dignity of an accepted literary language.

Opposite above: The David brothers of Swan Stores as choirboys at the parish church, *c.* 1958. Pictured from left are Richard, Howell and John. The vicar at the time was Revd J.J. Thomas, while the organist was Enid Lewis and the choirmaster was Howard George. Living so close to the church, there was little escape for the David boys but to join the church choir. All three boys attended Cowbridge Grammar School. John (born 1941) worked for BOAC at London Airport and eventually settled in Miskin. Howell (born 1946) studied at Aberystwyth University before settling in Reading where he worked for British Steel and later as the director of the Rank Hovis McDougal Group. Richard (born 1949) remained in Llantrisant to run a haulage business and settled in Bryn Awelon, Swan Street, the family home. His three sons, Owen, Huw and Alun all play for Llantrisant RFC.

Opposite below: The thirteenth-century Norman font at Llantrisant Parish Church. The original Romanesque-style church, built in 1096, underwent further rebuilding by the Norman lords at the same time as the castle in 1246. Only the font and a section of the south door remain from the original building which became the mother church of a parish that extended to Brecon. In 1490 the tower was added, probably on the spot of a medieval tower, and a peal of six bells was hung in 1718. The whole interior was rebuilt in 1873 in a Victorian Gothic design. With the completion of the west end of the church in 1894, a white marble baptistry for baptism by immersion was placed under the floor of the choir vestry. The first to use the baptistry on Thursday, 4 November 1897 was Grace Williams, who was baptised by Revd Daniel Fisher.

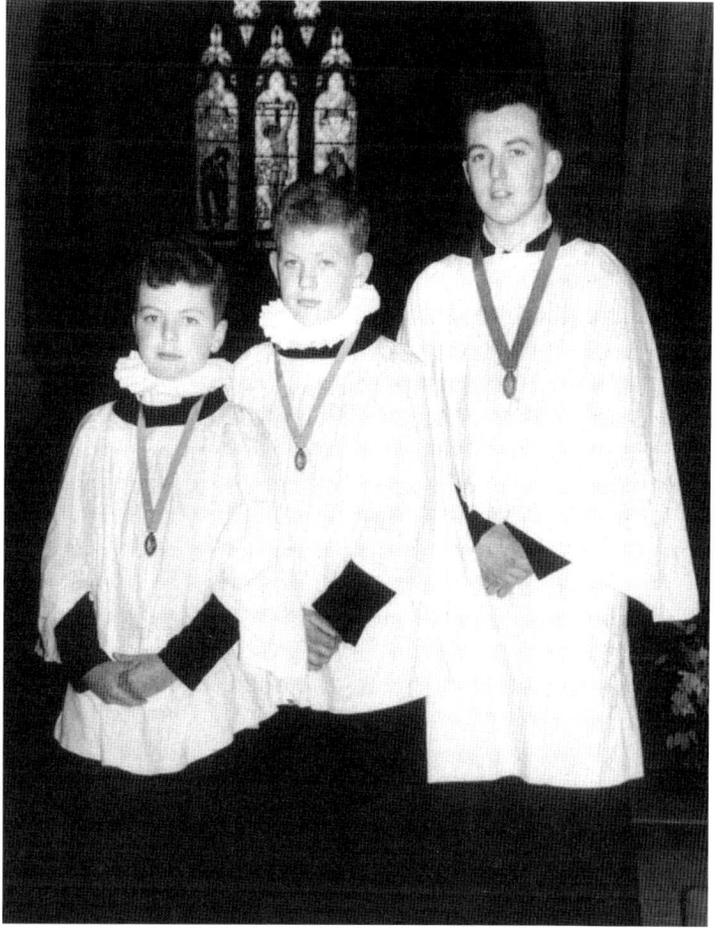

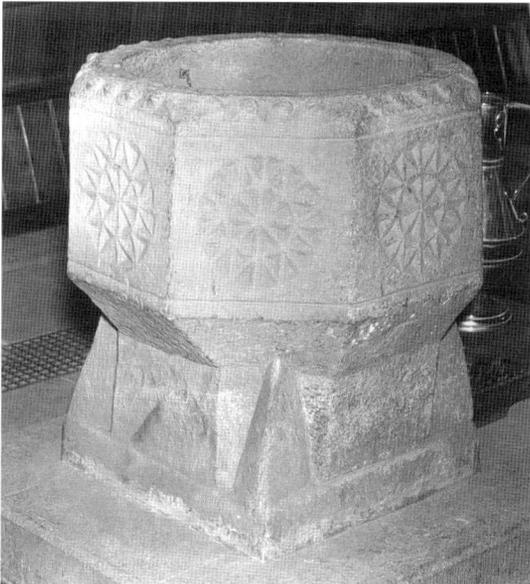

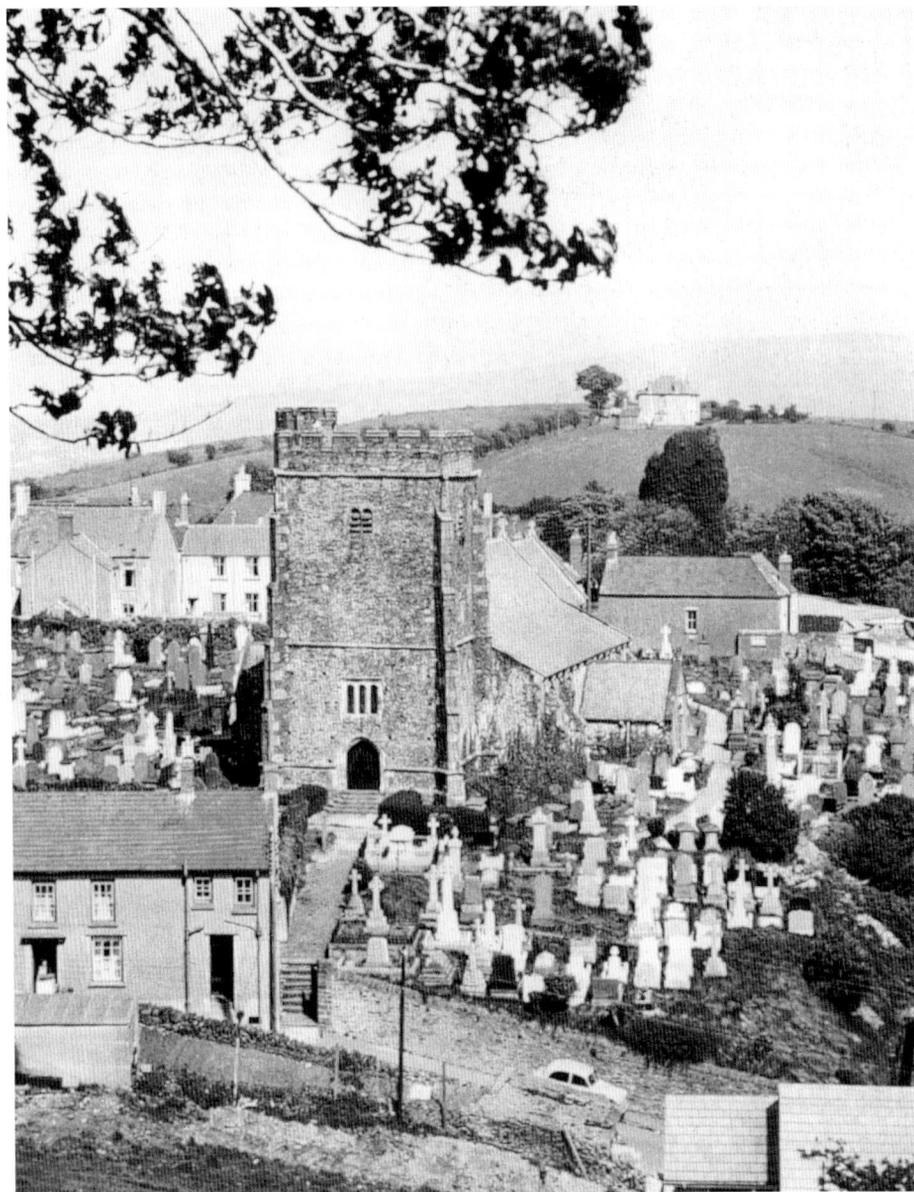

Llantrisant Parish Church, *c.* 1965. Inside, visitors cannot but fail to be impressed by the splendid candelabra hanging over the chancel step. It is a fine example of Georgian workmanship and was brought by sea across the Bristol Channel to Aberthaw and then to the church by horse as a gift of the Bassett family from Miskin. There are also armorial bearings of Captain Sir Christopher Cole RN, who commanded a squadron at the capture of the Island of Banda Neira in 1813. With a squadron of 180 men, he stormed through to capture the castle of Belgica, complete with 150 guns, 750 regular troops and 500 militia. There are a few memorials of local interest in memory of families such as the Rickards who provided the vicar of the parish from 1766 to 1816. Wall plaques also commemorate those who paid the ultimate sacrifice during both world wars. There are forty-one names from the First World War and fourteen names from the Second World War.

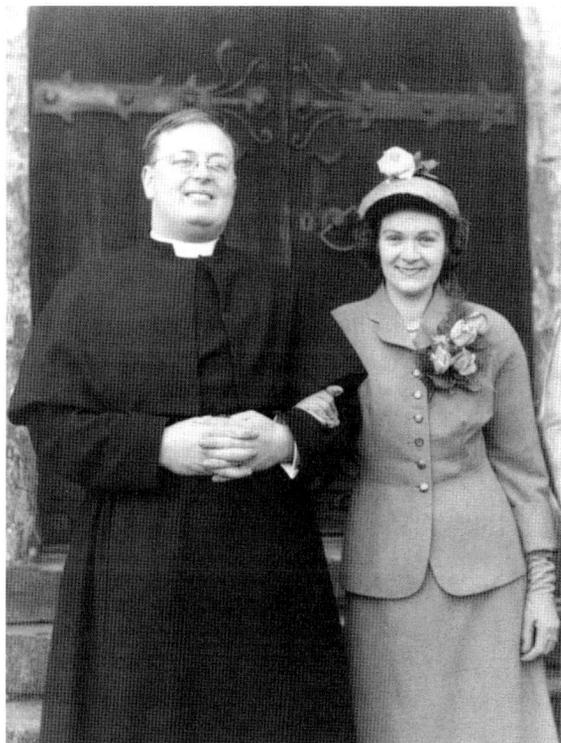

Revd David Thomas and wife Marion. Born near Bridgend in 1929, David was the son of Revd John James Thomas (vicar of Llantrisant 1946-1956) and schoolteacher Edith Rose. After attending Bryntirion School, David went to Christ College Brecon and, following two years of national service, studied at Pembroke College, Cambridge in 1948. His first curacy was at St Margaret's in Roath and in 1954 he married Marion Wescott. The couple met in the Llantrisant Church Youth Club when they were teenagers. They lived in Port Talbot for five years where their daughter, Katharine, was born before moving to Grangetown, Cardiff and finally to St Saviour's, Splott. In 1976, aged forty-seven, David passed away. Marion was the daughter of Reg and Blodwen Westcott. The family lived on Yr Allt, where their son Brian was born, before moving to Newbridge Road and settling in the Castle Inn to run a grocery business.

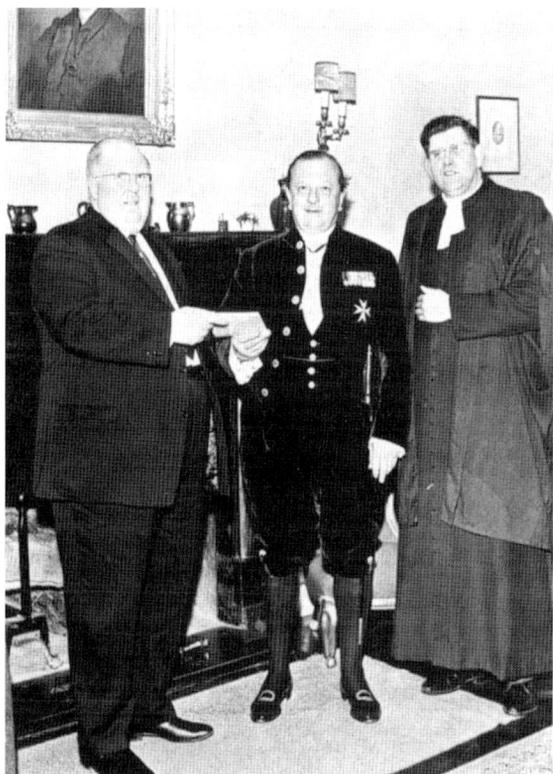

Dillwyn Lewis, presenting a copy of his booklet, 'Investiture of the Prince of Wales: Souvenir of Llantrisant Celebrations April–September 1969' to Lieutenant Colonel John Traherne at Castellau Fawr, 1969. Mr Lewis, a history teacher at the County Secondary School in Beddau, was also known as a local author. He rewrote and updated Taliesin Morgan's *A History of Llantrisant* in 1975. Also pictured is Revd Edwin Isaac Davies BA, vicar of Llantrisant from 1957 to 1979.

O ALL embracing mercy,
 Thou ever open door,
What should we do without Thee
 When heart and eyes run o'er.
When all things seem against us
 To drive us to despair ;
We know one gate is open.
 One ear to hear our prayer.

In Affectionate Remembrance

OF

Charles,

Beloved Son of Thomas and Elizabeth John,
Ty-y-Gog, Graig, Llantrisant,

Who departed this life January 28th, 1926.

Aged 23 years.

Interred at Bethel Burial Ground, February 2nd.

" *Boast not thyself of to-morrow, for thou knowest not what a day may bring forth.*"

" *One thing have I desired of the Lord, that will I seek after, that I may dwell in the house of the Lord all the days of my life, to behold the beauty of the Lord, and to enquire in His temple.*"

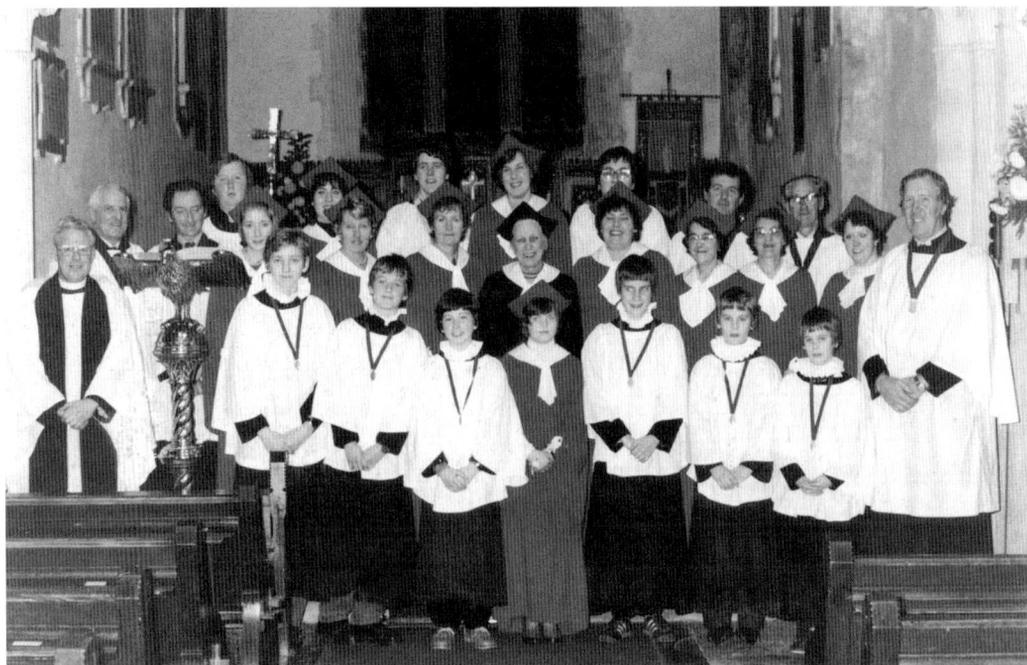

Above: Llantrisant Parish Church choir with Revd Peter Lews BA, (vicar from 1979 to 1990), *c.* 1983. Pictured back row from left: Doug Payne, Ron Colcomb, Ian Watkins, Phillipa Miles, David Golding, Carolyn Miles, Gareth Jones, Ray Jenkin, Alf Phillips. Middle row from left: Julia Colcomb, Marilyn Colcomb, Kay Jenkin, Enid Lewis, Yvonne Miles, Vi Westcott, Gwen Payne, Diana Jones, Gordon Miles. Front row from left: Mark Colcomb, Geraint Jenkin, Richard Jones, Lynfa Jenkin, Alun Parsons, Gareth Parsons and Rhys Parsons.

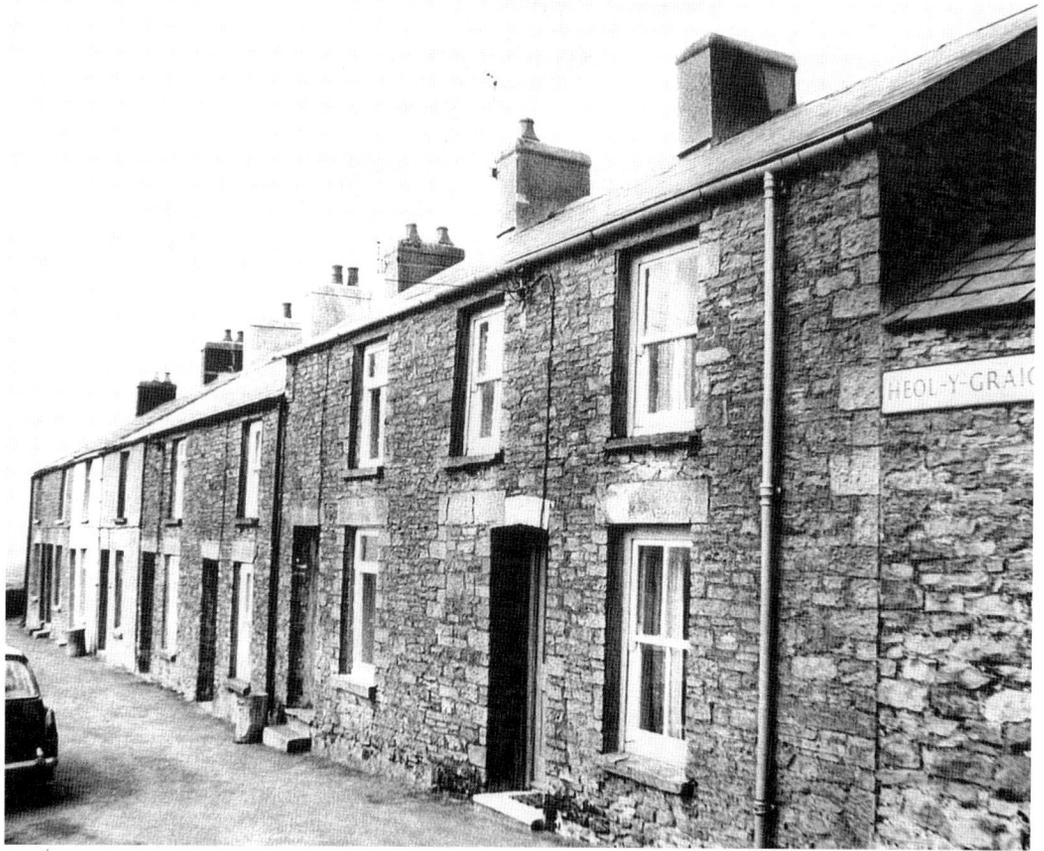

Above: Heol y Graig, *c.* 1960. Over the years many Llantrisant residents have occupied this terraced street, all enjoying outstanding views of the surrounding landscape. During the 1940s some of the families who lived there included George and Alice Williams, Bill Wally, Mrs Morris, Harriet Wally, Mrs 'Granny' Clark, Trevor Griffiths, Bessie O'Connor and Billy Williams. One of the grandchildren of the Wally family, Paul Henke, later enjoyed a career as a successful author.

Opposite below: Memorial Card to Charles John of Tŷ y Gog, Graig who died in 1926 just days after starting work at the local colliery. The son of Thomas and Elizabeth John, he was killed on 28 January at the age of twenty-three. Four collieries opened in the area during the early part of the century at Coedely, Cwm, Llanharan and Ynysmaerdy. The latter was sunk by the Powell Dyffryn Co. in 1922 and completed in 1926 but was never a success. It employed 300 men in 1931 but due to major water problems, the operation was halted from 1934 to 1937. On Whit Monday in June 1941, disaster struck when an explosion on the surface killed four men, although the miners underground were unharmed. Those killed were John Gregor (agent), Noah Fletcher (winding engineman), David Thomas (switchboard attendant) and Ernest Evans (banksman). The colliery never re-opened.

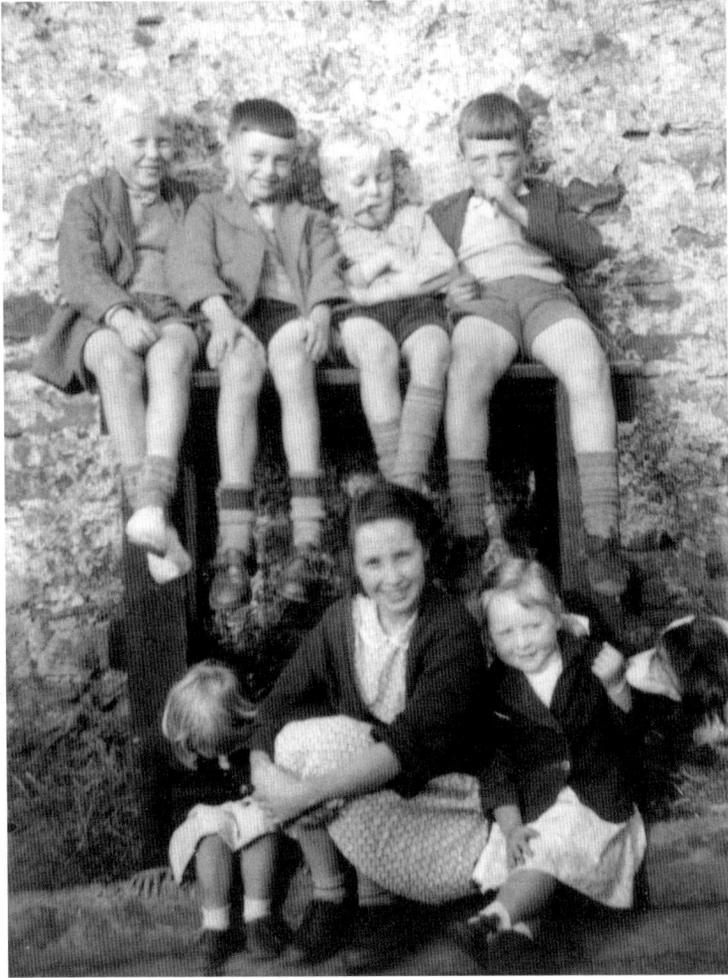

Schoolchildren on Heol y Sarn pictured in June 1950. Pictured back row from left: Gwyn Thomas, Henry Alexander, David Thomas and Malcolm ('Sam') Evans. Front row from left: Joanne Lynn with sister Lyndie Lynn and Beryl Thomas. The children were all neighbours on what was better known as its English translation of 'Common Road'. On travelling down this busy road, the Butcher's Arms, the Bear Inn and a blacksmith's were on the right. There was also a dairy on the left of the road, followed by Cae Ysgubor Farm on the right. The Common housing estate was built on the land of Pantyscawen Farm during the 1950s and two prominent buildings on the road were later demolished – the Welcome to Town pub and Northgate Cottage on the entrance to the common.

Twr y Gigfran (Raven's Tower), Llantrisant Castle, c. 1900. A stone defence, it may have been formed on an earlier stronghold built by Welsh lord Gwrgan ap Ithel. Following the second Norman invasion of the town, it was fortified in 1246 by Earl of Gloucester, Gilbert de Clare, and regarded as second only to Cardiff in military importance. Continually raided by the overthrown Welsh lords, destroyed and rebuilt, it was used as an overnight prison for the captured King Edward II before falling into ruin by 1404 (possibly following another invasion) and its stonework was used to repair Cardiff and Caerphilly castles. Before the neighbouring police station was built in 1876, a cell in the tower was still used to hold prisoners.

Evan John (1839-1931). Born in High Street, he was the only child of William John, a magistrate's clerk, and his servant, Leah. Evan and his poet wife, Julia, lived in Castle House, Church Street. A Justice of the Peace at the age of twenty-one, he became a senior magistrate for Glamorgan. In 1861 he was made a Freeman and became the first clerk of the new Town Trust in 1889. His close friend, pharmacist Robert Drane, designed the Town Trust crest. Devoted to the study of insect life, Evan was encouraged by the Cardiff Naturalists' Society to study local butterflies and moths. His most striking discovery was a new moth, introduced to the British list as Xylina Conformis, found in Llantrisant. Made a Fellow of the Entomological Society of London, he was the principal collector of the extinct Mazarine Blue butterfly and kept an uncut hayfield on the outskirts of the town in the effort to preserve the species.

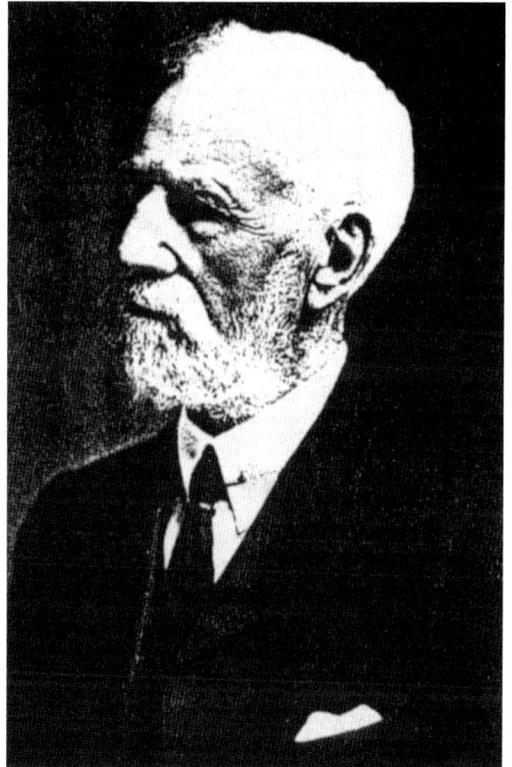

Above: Llantrisant Guild Hall, *c.* 1900.
Now the home of the Llantrisant
Town Trust, who bought the building
in 1957, it is regularly used for the
Freeman's Court Leet. The
fourteenth-century hall was rebuilt in
1773 by Lady Windsor, the
Marchioness of Bute, for the sum of
£100 due to the fall in the nearby
market's popularity. It once served as
the town's first national school and
became a magistrates' court until 1957
when the property went on sale.

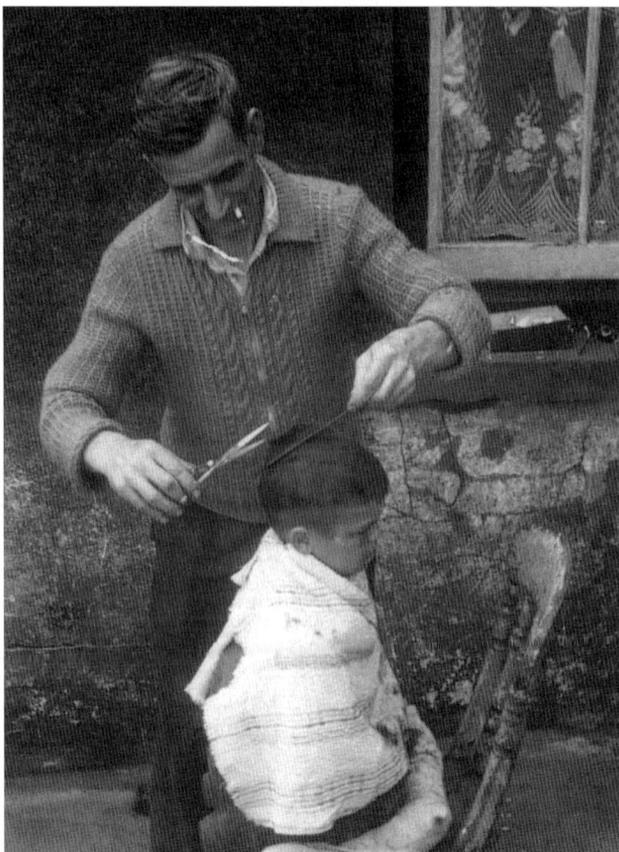

Right: William James John (1910-1988)
cutting Bryn Alford's hair at Heol Las,
c. 1948. Bill John, who originated from
Penygraig before his family settled in
Miskin, married Eileen Francis (born
1914) at St David's Church, Miskin in
1936, Mr John worked as a gardener
on Cathedral Road, Cardiff before
becoming a bus driver in the Rhondda
and finally working in the Iron Ore at
Llanharan. The couple lived on Yr Allt
before moving to Heol Las to raise
their five children.

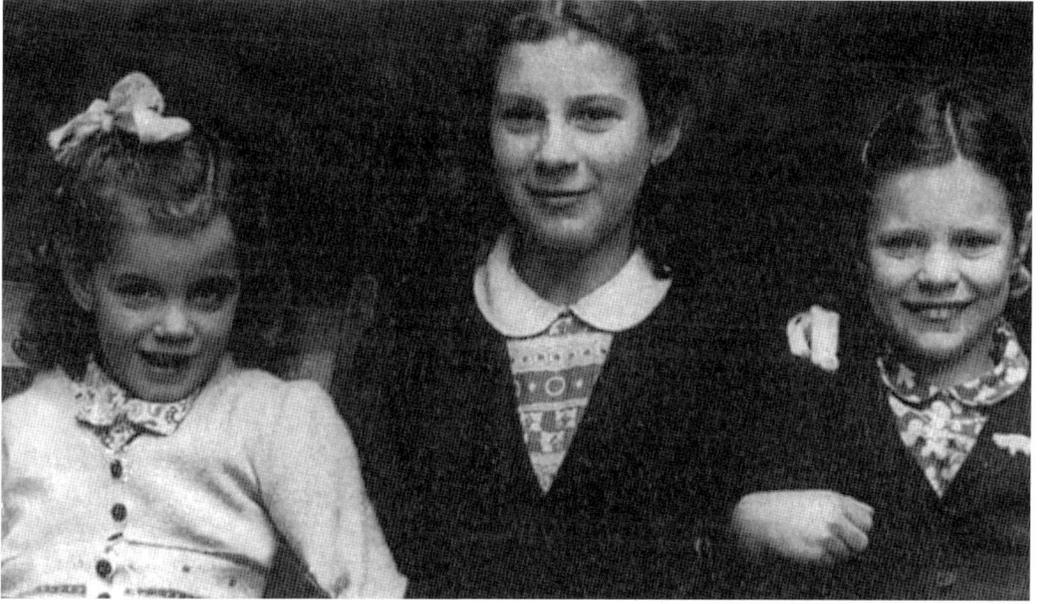

Patricia, Dorothy and Margaret John, the three daughters of William James John and Eileen John (née Francis), 1949. The girls also had two brothers called Brynley and Gwyn and grew up on Heol Las.

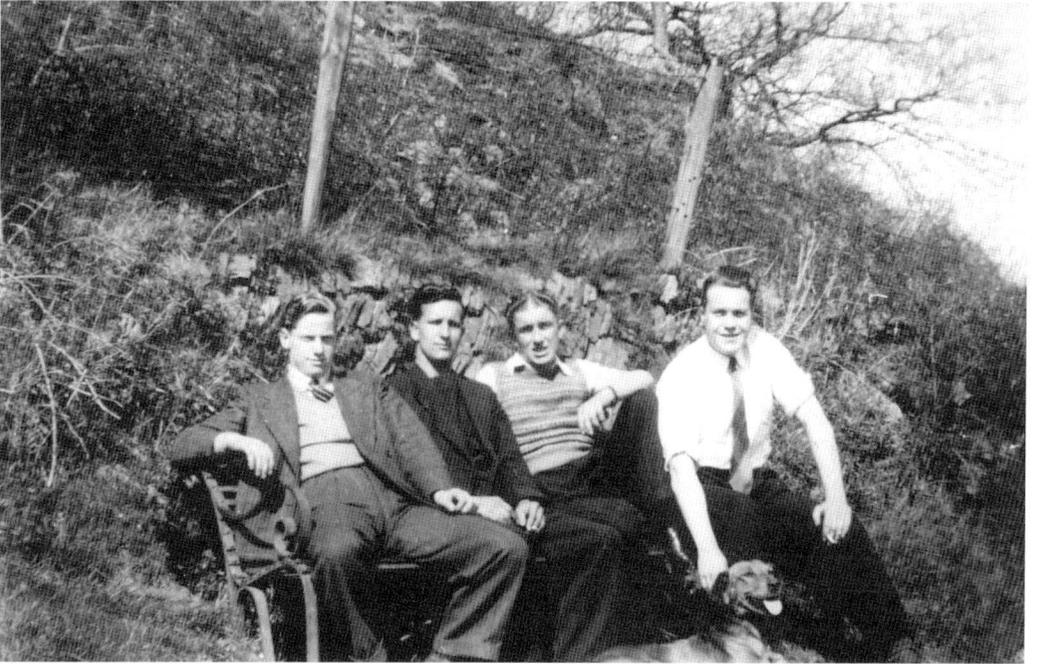

A group of friends sat on the bench at Long Acre, *c*. 1947. Pictured from left are David Rees, Len Hurley, Norman Doster and David Griffiths.

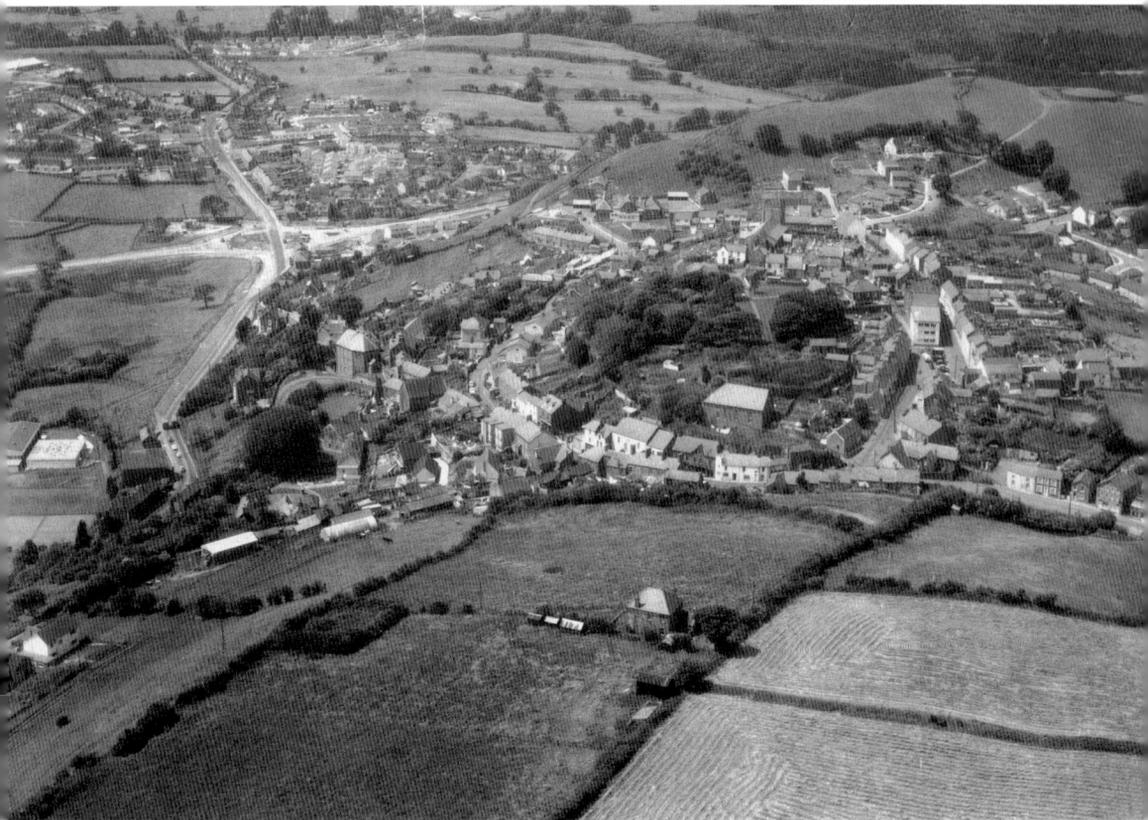

An aerial view of Llantrisant, February 1974. It is interesting to note the huge amount of development which has taken place in Talbot Green since this date. New Parc farm is still in operation before the building of the first Tesco store. The Joshua family once lived there and one of the sons helped compose the famous Welsh song, *We'll Keep a Welcome in the Hillsides* in 1949. In this picture, work is being carried out on the large roundabout that once existed on the main junction of Talbot Road. Llantrisant Swimming Pool is visible on the left.

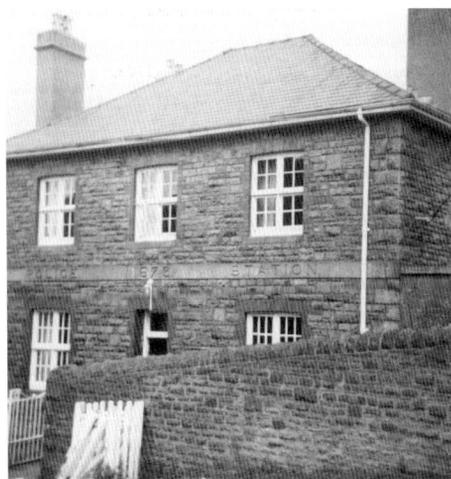

Llantrisant Police Station, *c.* 1965. In January 1840, Thomas Morgan Lewis of the Metropolitan Police Force became Llantrisant's first superintendent with six constables, and by 1848 a sergeant's station was built on Swan Street. In 1876, a new police station with cells was built on the site of the old corn market next to the town hall. A new police station was later built in Talbot Green, and this building is now used for residential purposes.

Mary Llewellyn (1853-1925). Her parents George (1810-1893) and Elizabeth Morgan (1809-1902) bought Swan Fawr, later Swan Stores, in 1868 for £150. They developed the grocery business and each of their children enjoyed success as shopkeepers. Their eldest daughter, Ann (1846-1911), further developed the Swan. The third daughter, Elizabeth, set up a grocery business in Nantymoel, while her brother Thomas owned the Castle Shop in Llantrisant. Mary married William Llewellyn (1847-1923), an accountant and the son of a Llantrisant family of butchers and chemists in 1874, and together they set up the famous Gwalia Stores at Ogmore Vale in 1877. The couple brought the first car to the Vale, which once belonged to Edward VII. Their enterprise became well known and Ogmore Vale Store's building is now erected in the Museum of Welsh Life at St Fagans. The couple had eight children, one of whom, George, was a blind vicar whose grandson was Dr David Owen, former leader of the SDP.

Advertisements for local business, 1906. The town was a thriving commercial centre from the Victorian era through to the early 1930s. With fairs held regularly throughout the town and at one time a regular market next to the Town Hall, a growing number of properties operated commercially. From grocery and sweet shops to cobblers and banks; from hairdressers and chemists to drapers and butchers, every conceivable shopping item could be bought in this little hilltop town. The opening of local iron ore and collieries in the area brought further economic benefits to the town but the markets failed to compete with growing Newbridge (later Pontypridd).

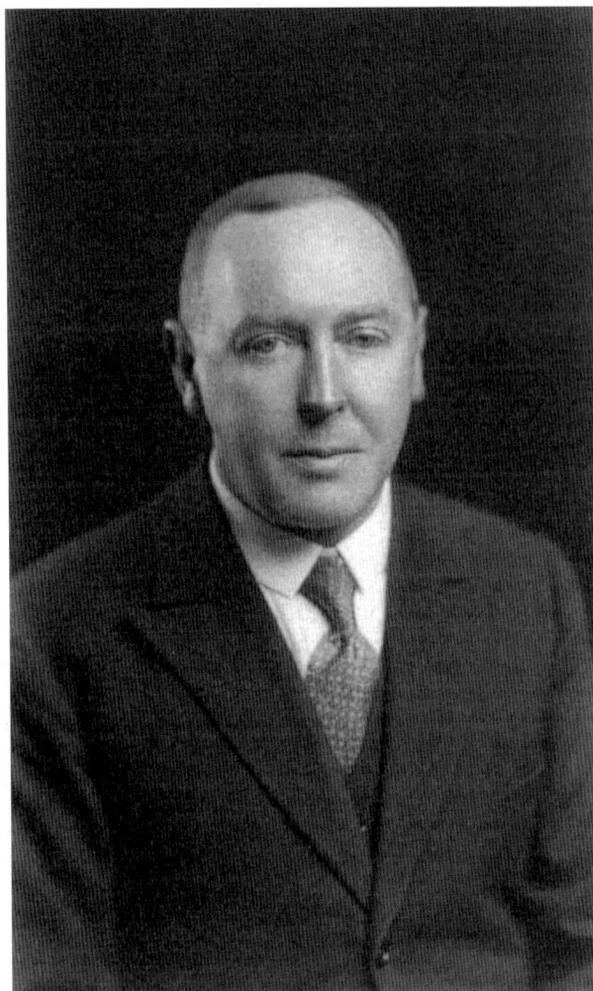

William Morgan David (1880-1952) of Swan Stores. He was the fourth child of John David, a miner originally from St Hilary and his wife Ann Morgan. It was during Ann's ownership of the Swan that the building was developed. Her husband was a Welsh-speaking lay preacher at Penuel Calvinistic Methodist Church on High Street who died after falling down the cellar stairs at the Swan Stores. Their son spent much of his time with the Llewellyns at the Gwalia Store in Ogmore Vale, learning the grocery trade before returning in Llantrisant in 1903 to help run the Swan. He married Mattie Griffiths of Blackmill and they had a daughter, Iris, but a year later Mattie died. In April 1920, he married Priscilla Hopkins, who would take a leading role in the grocery business. William was admired by residents for his kindness in allowing extended credit facilities during the difficult war years.

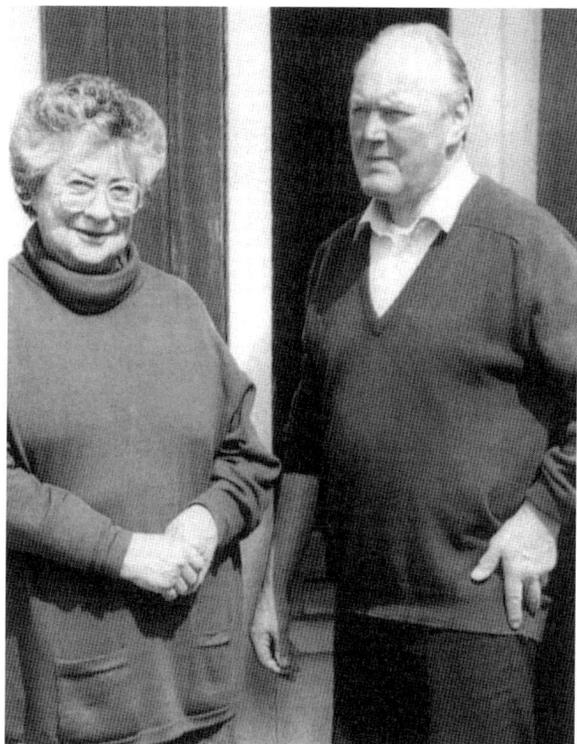

William Morgan David (1921-1995) and Kathleen (1922-1998). Billy David and Kathleen Thomas met as teenagers. He was a keen rugby player and after leaving school worked as an assistant chemist at the Coed Ely Coke Works. He joined the RAF at the outset of the Second World War as a ground crew aircraftsman. Shortly after his marriage he was dispatched to North Africa and stationed in Egypt. Kathleen trained as a secretary and the couple had three sons, John (born 1941), Howell (born 1946) and Richard (born 1949). Initially they lived in Penygawsi with her parents and later moved to the new council houses in Dancaerlan. In the early 1950s they moved to the Swan Stores after Billy's father built Bryn Awelon, replacing the three adjacent cottages. Billy and Kathleen later took over the village shop at Miskin when Kathleen's aunt retired. They worked together in the grocery business for more than forty years.

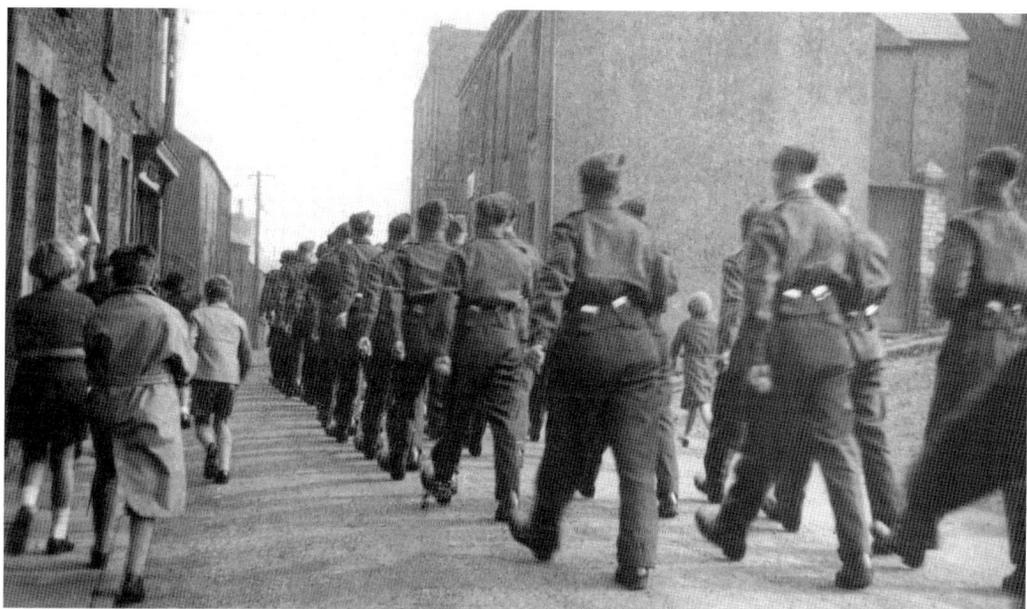

American GIs marching along Swan Street, c. 1944. American troops were encamped on Llantrisant Common prior to the D-Day Invasion in June 1944. The bulk of the American Divisions in the eastern half of South Wales were elements of the V11 Corps commanded by Major General J. Lawton (Lightning Joe) Collins. The V11 Corps were to battle across Europe from Normandy to the Elbe, crossing the Rhine over the famous Remagen Bridge.

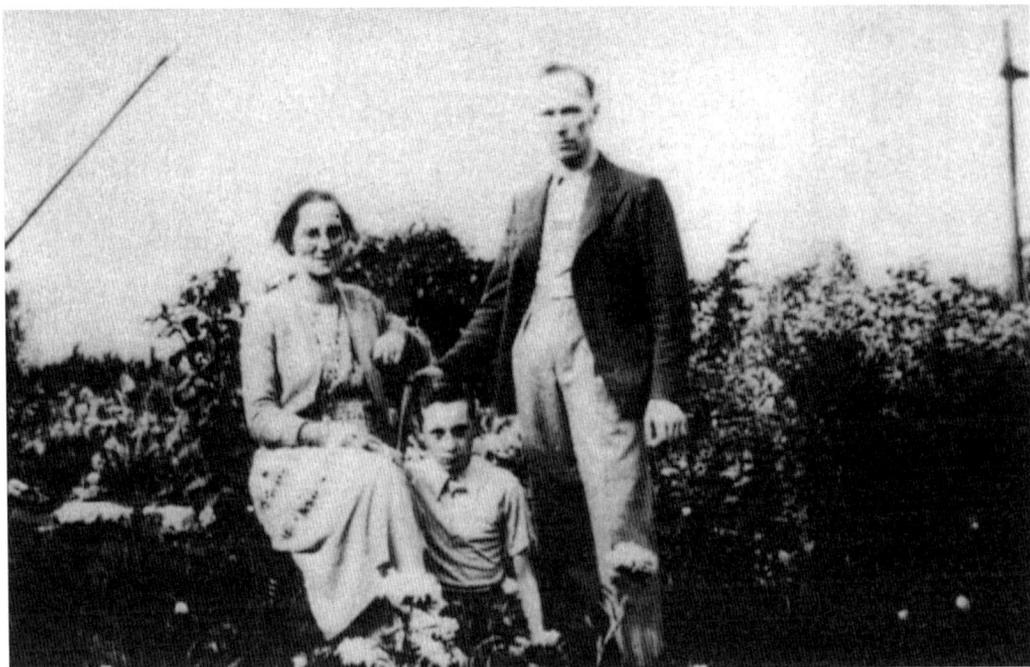

Above: Margaret (1897-1946) and Haydn Davies (1895-1966) with son Howard (born 1922) outside their home next to the former Rickards Arms, Swan Street in 1932. Haydn, from Maesteg, was a miner at the Cwm Colliery, while his wife ran a sweet shop on Swan Street. The family later owned Dyffryn Farm and then ran the newsagents on Commercial Street before Margaret died aged fifty-three and the Tampling family took over. Howard married Adelaide (Addie) Broad and settled on Church Street.

Opposite above: Workingmen's Club group at Christmas, *c.* 1958. Pictured from left are Ivor Watkins, Sadie Watkins, Morgan Watkins, Olwen Ashcroft, Harold Ashcroft, Myrtle Montague and Mickey Montague.

Opposite below: Llantrisant Workingmen's Club Committee, *c.* 1956. Pictured back row from left: Mickey Montague, Wyndham Edwards, Ivor Watkin, Christopher Williams, Trevor 'Chippo' Davies. Middle row from left: Cliff Harrison, Frank Collins, Gordon Jenkins, Mr Bendle, Evan Harry. Front row from left: Garfield James, Bill Maslin, David Harrison, Harold Aschroft, Seth Morgan and Cliff O'Neill. The club was opened in the former Rock and Fountain Inn on the Bull Ring in May 1953 after an application to the local magistrate. It needed twelve men with no criminal records to stand as signatories, something of a difficulty in a town renowned for its Saturday night brawls!

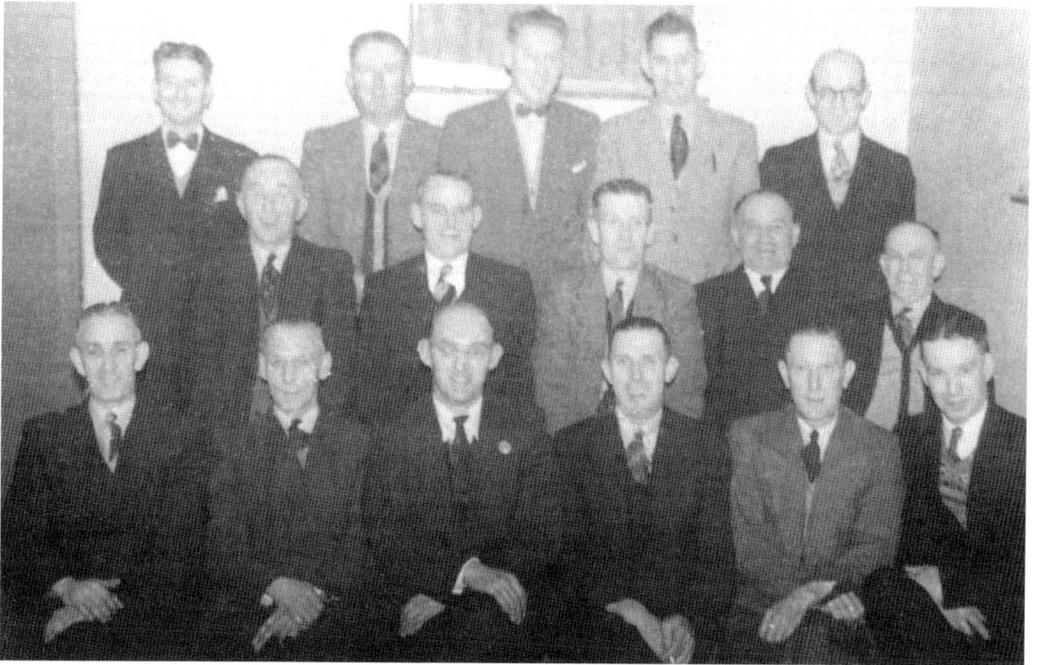

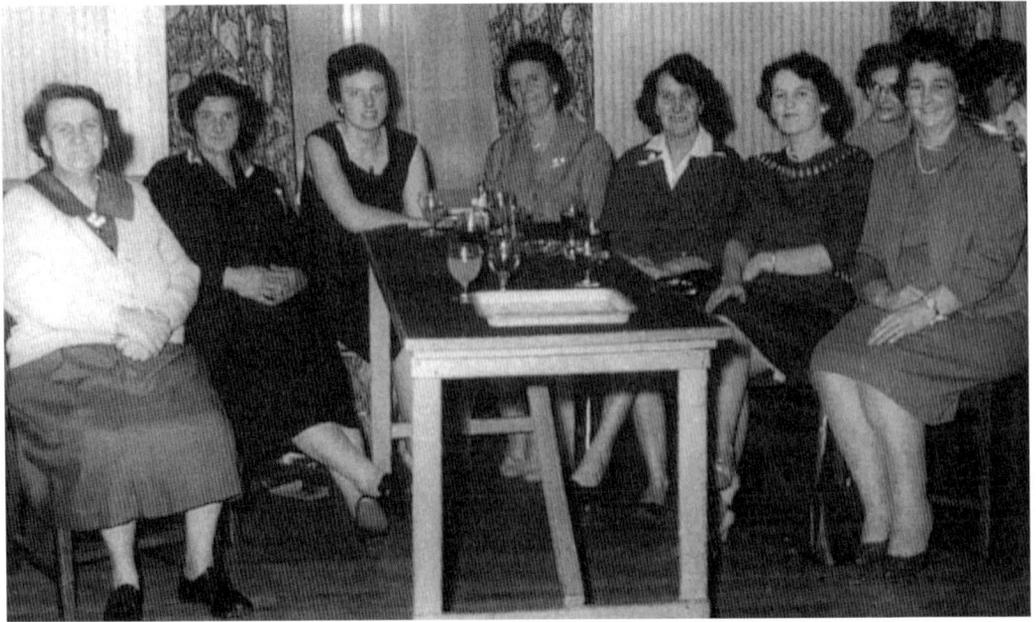

A group of Llantrisant women on a supper evening at the York Hotel in Bridgend, *c.* 1958. Pictured from left are: Gwen Rees, Mari Watts, Menai Perkins, Katie Perkins, Lily Hurley, Beryl Rees, Mrs Sloper, Mrs Thomas and Katie Evans.

Regulars at the 'Top Club', pictured from left: Edward Williams, Sam Beech, Cyril Harrison, David Grifiths, Herbert Bryant and Trevor 'Jock' Williams in around 1965. Within a short time of opening in the old Rock and Fountain, it became obvious the premises were too small. A cottage on Swan Street, formerly the Rickards Arms, went on sale in 1956, and the committee raised £20 to place a deposit on the property which later became the Workingmen's Club.

Members of the Workingmen's Club, *c.* 1965. Pictured from left: Tudor John, -?-, Billy Thomas, Glan Jones, Watcyn Jacob and David Harrison. On one occasion an up-and-coming Treforest singer performed in the main hall with his band, the Senators. He would later become known as Tom Jones.

Husbands and wives pictured in the Workingmen's Club, *c.* 1955. Over the years the devotion of its members and particularly stalwart committeemen have ensured the club's continued success, with some even paying the electricity bill when times were difficult.

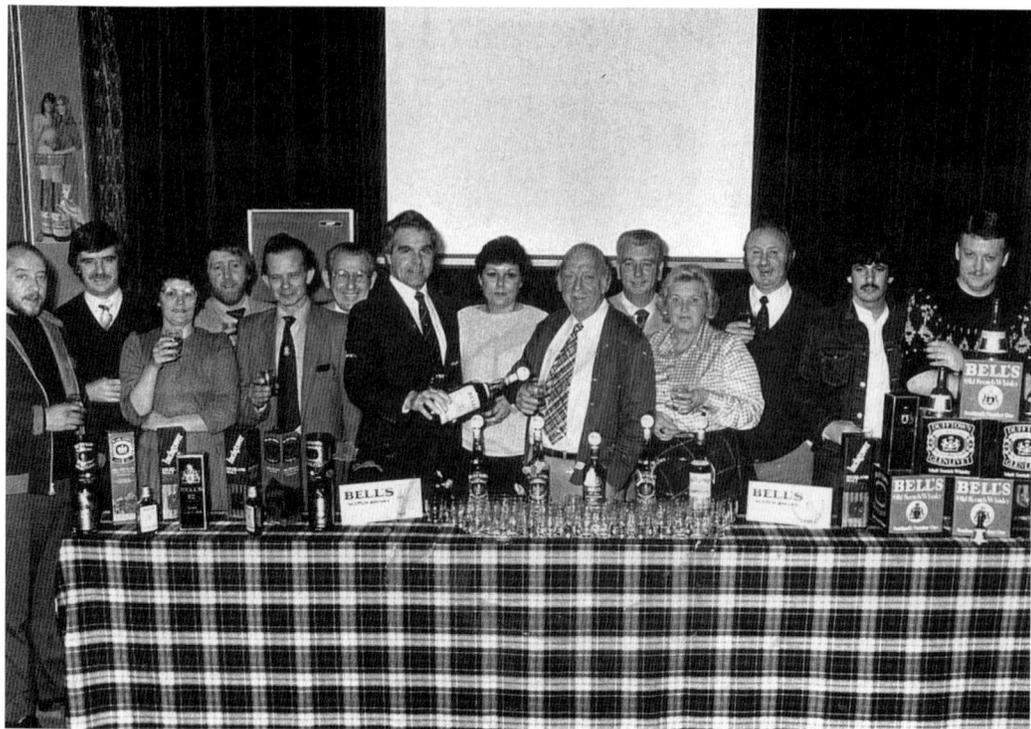

Above: Promotion at the Workingmen's Club, *c.* 1985. Pictured from left: Ray Banwell, Selwyn Shaw, Barbara Shaw, Ceri Roberts, John Alford, Wyndham Edwards, brewery rep, brewery rep, Ken Booth, Ken Lydon, Lorna Lydon, Brian Evans, David Jordan and Steve Watkins.

Opposite above: Llantrisant children, *c.* 1925. Some of the youngsters belong to the Hicks family and also the John family of the Bear Inn. Also pictured is Priscilla, later to become Cilla David 'The Swan', along with Harriet Watkins (later Alexander) and the girl in the centre was known as Mary 'Crutches' because of her disability.

Opposite below: Marriage of Marlene Williams and Reginald Davies at the parish church, November 1960. Born on Yr Allt in 1938, Marlene's parents were Edith and Charlie 'Rockman' Williams. She attended the local school before working in the Planets Glove Making Factory. She trained as a seamstress at Alexon House in Treforest and worked in the Sherman's Pools Office in St Mary's Street in Cardiff. At eighteen she moved to London to live with an aunt and worked in a dye factory alongside Bill Owen, who later found fame in Last of the Summer Wine. She returned to Llantrisant and married train driver Reg and the couple had three children named Cheryl, Tracey and Gareth, (Jay). Tragedy hit when Reg died at the age of just thirty-seven. Marlene, who moved to Heol Illtyd on the Common, also lost her son, Gareth, in 1998 at the age of just thirty-three. Despite the heartache, Marlene remains one of the last of the great characters of Llantrisant.

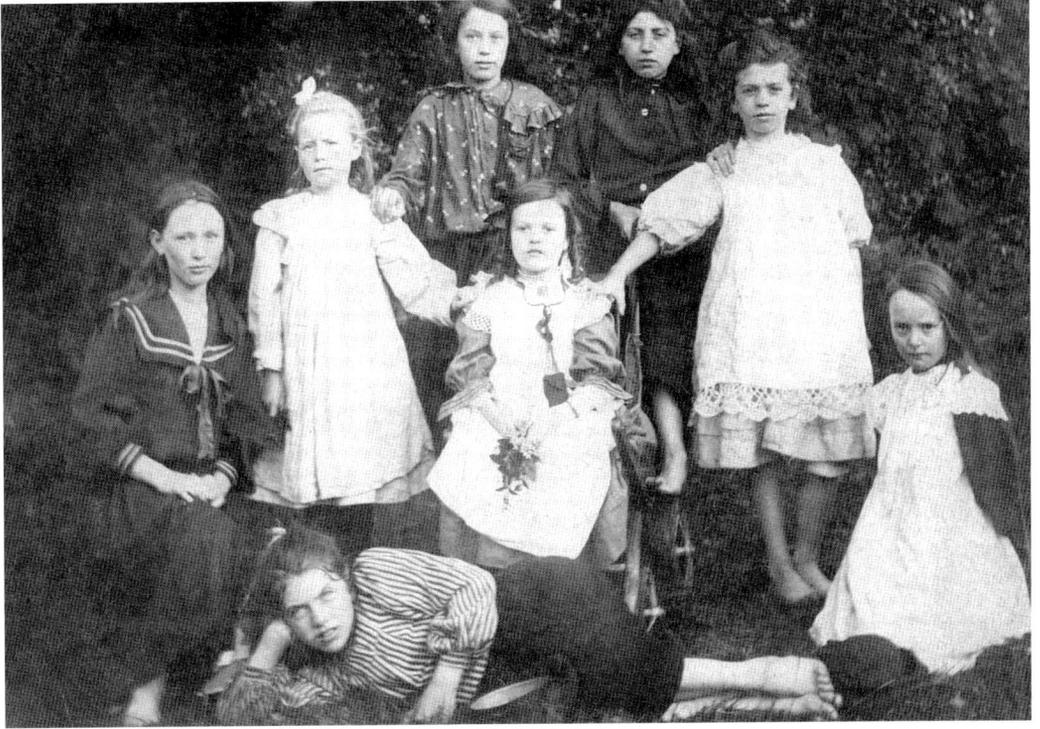

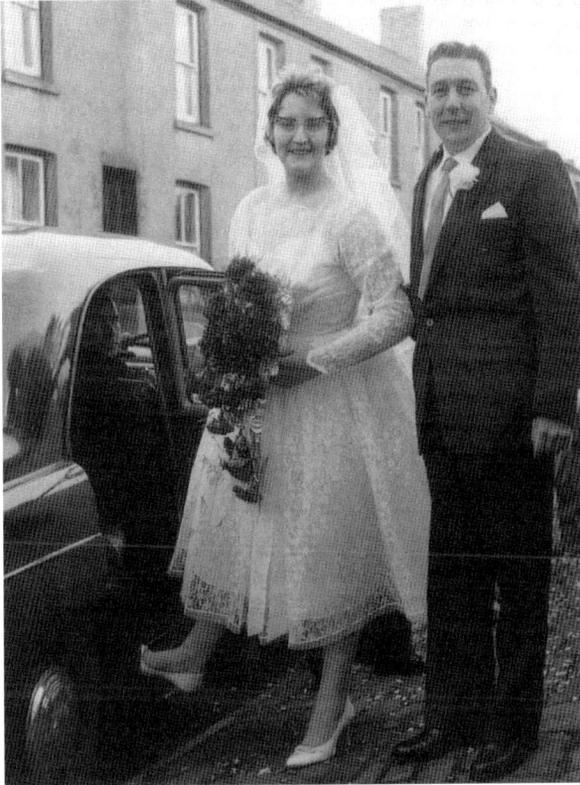

Above: Y Pwysty, George Street, 1975. This was one of the most important buildings in the town during the eighteenth and nineteenth centuries. It was basically an excise house, used for weighing goods on market day in the town. The town scales were kept there for farmers and traders to ensure a fair sale of their goods according to weight. The house was later a pub called the Angel Hotel.

Opposite above: Collwyn Davies (1916-1991) serving in the Royal Army Service Corp and wife Margaret Eleanor. Collwyn was the son of Thomas Hopkin and May Elizabeth Davies, who ran County Stores on the Bull Ring before buying Crown Stores on High Street. Better known as 'Cochie Lloyd' (taking his grandmother's maiden name) he was probably the best known shopkeeper in the town for more than fifty years.

Opposite below: Councillor David Harrison on George Street, November 1980. Mr Harrison argued that new tarmacadam road surfaces placed over the cobblestones on the street in 1970 made it lose its old-fashioned charm. The road was later re-paved and the cobblestones left on each side. At the top of the road is the Pwysty, once the Angel pub and one of many taverns in the village which enjoyed a dubious reputation for its drunken inhabitants. The list of pubs which operated in its streets included the Wheatsheaf, the Cross Keys, the Shrewsbury Arms, the Swan Inn, the Red Lion, the Tennis Courts, the Castle Inn, the Star, the Angel, the George Inn, the White Hart, the Bear, the Rickards Arms, the Welcome to Town, the Black Cock, the Blue Bell, the Fox and Hounds Inn, the White Horse, the Irish Harp, the New Inn, the Butchers Arms, the Llantrisant Arms, the Mount Pleasant, the Horse and Groom and the finally a rather unique temperance hotel, the Red Dragon!

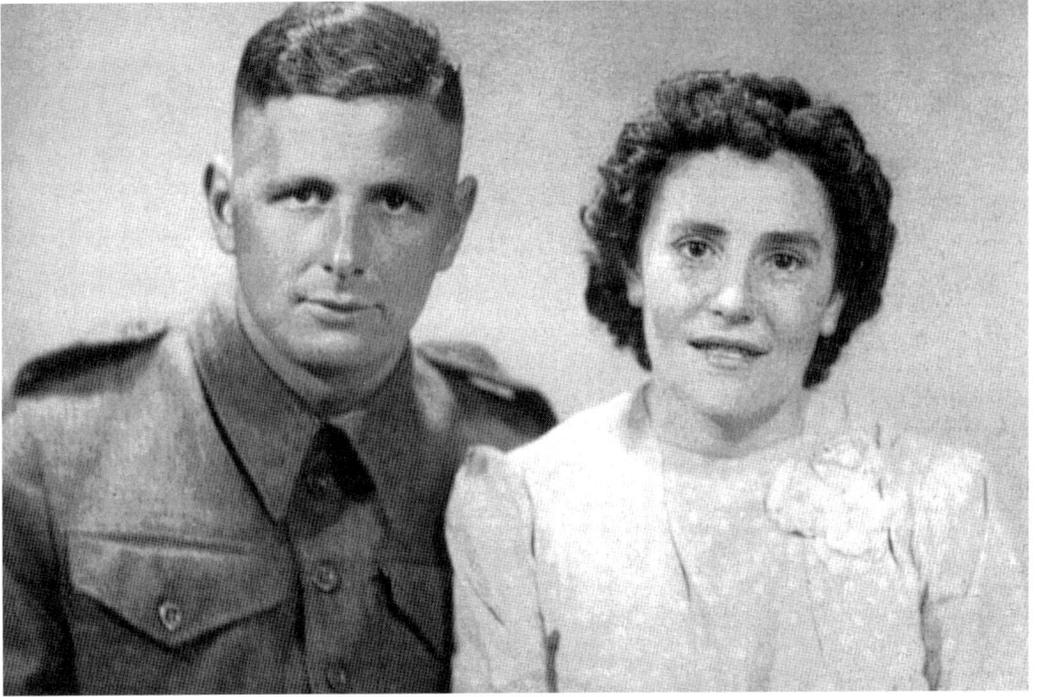

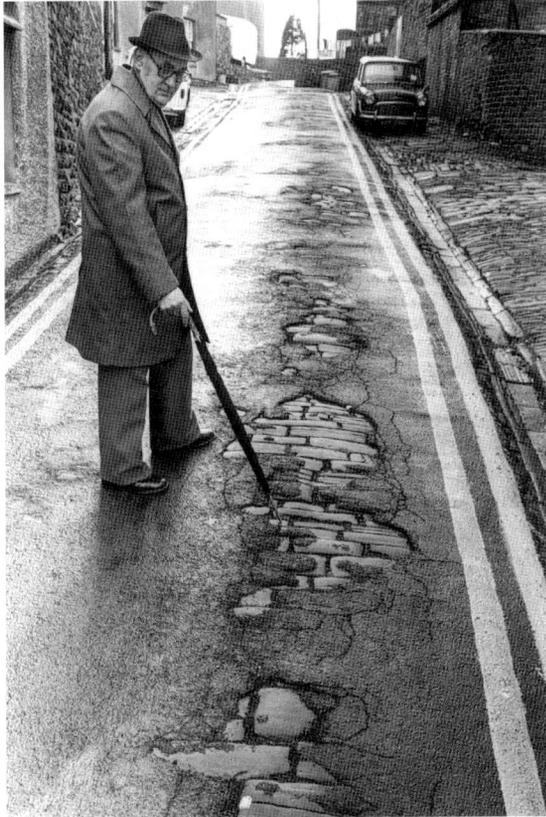

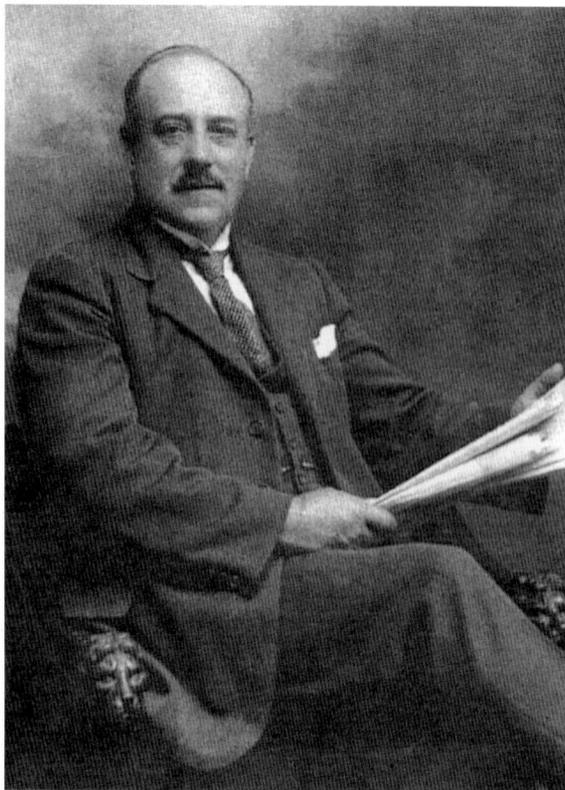

Above: David Keskeys Lukey (1878-1951). Born in Ruperra Street on 28 December 1878, David was the son of collier Benjamin and Martha Lukey (formerly Keskeys) from St Hilary, Cornwall. He married Katie Davies and settled on High Street where the couple had two children, Ninian (who died in childbirth) and Betty. David was best known as the local school attendance officer or 'whipper-in' as well as being a special constable. He captained Llantrisant RFC from 1899 to 1900 and was chairman of the club during the post-war years. He was made a Freeman through marriage in 1913 and also served on Llantrisant Town Trust where he was a prime mover in the establishment of the Llantrisant Freemen's Golf Club. He was also a founder member of the new golf club near Lanelay and devoted his time to the upkeep of the greens. He died in his home at Talbot Green at the age of seventy-three, following a fall.

Opposite above: Hannah Watkins (née David), the dressmaker and milliner outside her shop on George Street, the Bull Ring, *c.* 1920. She was the seamstress for Dr William Price's eccentric costumes. Hannah married late in life to avoid having too many children, but within nine years of marrying Edward Watkins of Tŷ'n Llwyn Farm, she produced ten! Some of those pictured include Susannah, Harriet and Amelia. Her shop was later a butchers owned by Johnny 'White Hart' and his children Mary and John David.

Opposite below: Llantrisant residents on a trip to Ogmore, *c.* 1940. Pictured from left are David Lukey, Katie Lukey, Lemuel Evans, Jennet Evans, Betty Lukey, Phyllis Eales and Stanley Thomas. Jennet was Katie's sister while Betty was the Lukey daughter and Phyllis was their niece. It is interesting to note that Lemuel Evans was clerk to the Town Trust from 1912 to 1942 and that later Stanley Thomas of Greenfield House, Heol y Sarn (pictured) also held the same post from 1946 to 1950.

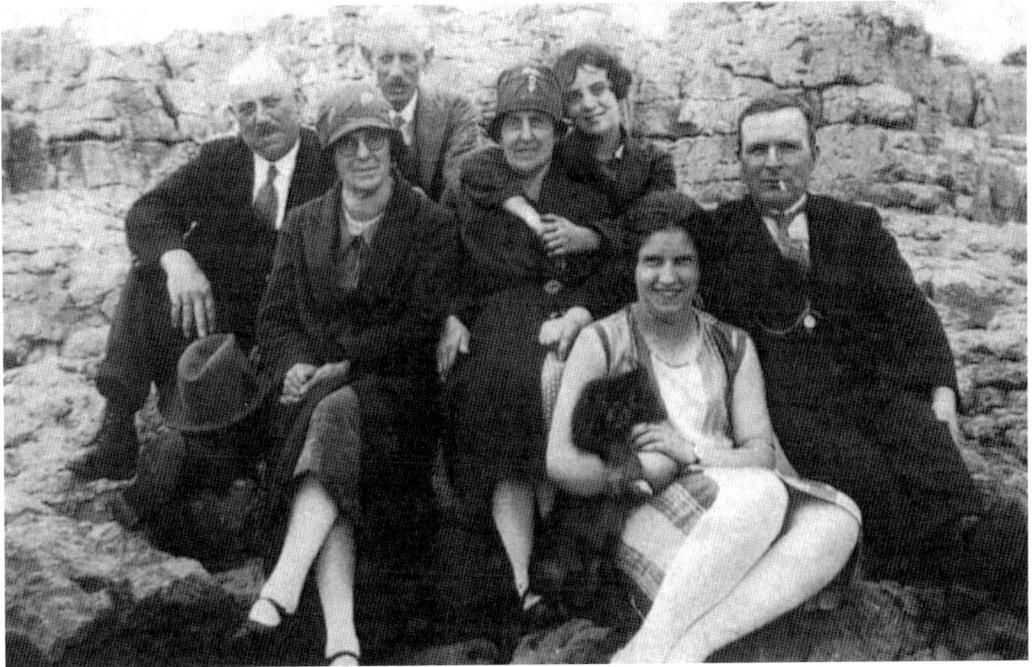

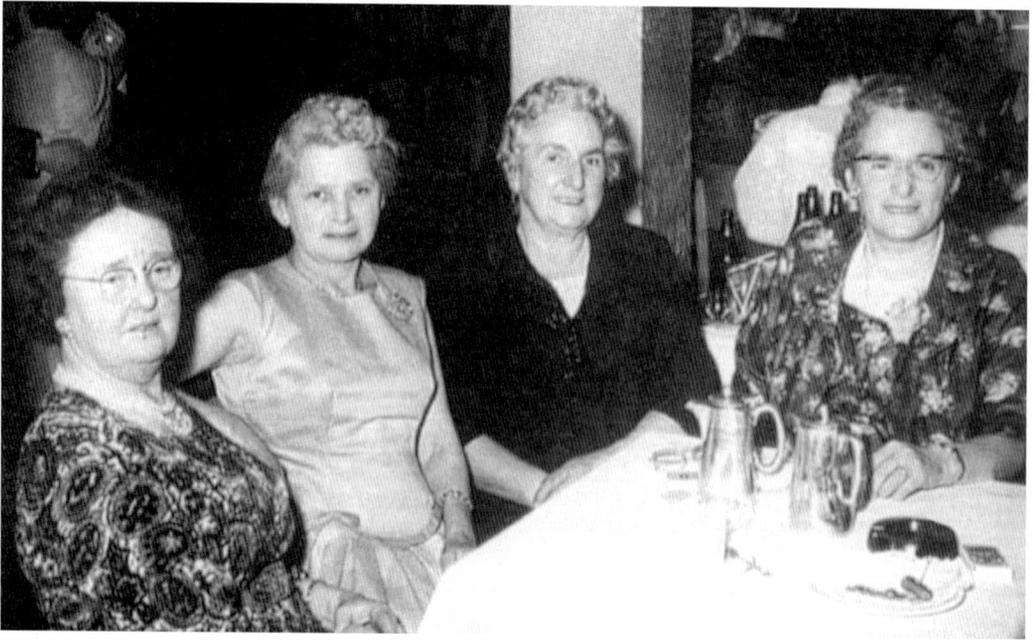

Llantrisant women enjoying supper at Bindles, Barry, *c.* 1965. On the left is Amelia Rees, formerly Watkins, who used to deliver milk throughout the town. She is seated next to Mary David, who inherited her father's (Johnny 'White Hart' David) butcher's shop on the Bull Ring which she ran with her brother, John. Also pictured is Violet Thomas and school teacher Ceinwen Bissett.

Mary Tintar, *c.* 1990. Better known as 'Mary Fish' or 'Mary Chips', she was born Mary Thomas in 1929 in Greenfield House on Heol y Sarn and was one of the five children to Stanley, Clerk to the Town Trust and his wife May Thomas (formerly Evans). Mary's siblings were William, Melvin, Gwynfor and Beryl. She worked in the nearby pencil factory but from 1963 to 1976 was said to have made the best fish and chips in town at her shop on the Bull Ring. She married Milan Tintar and settled in a cottage on Heol y Sarn where the couple had two children.

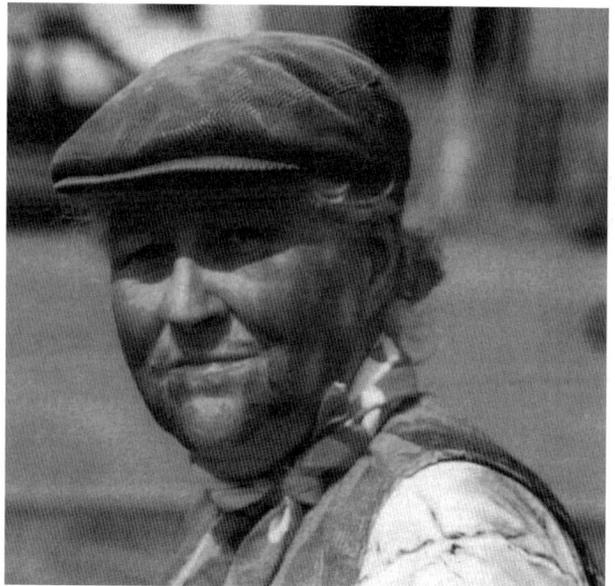

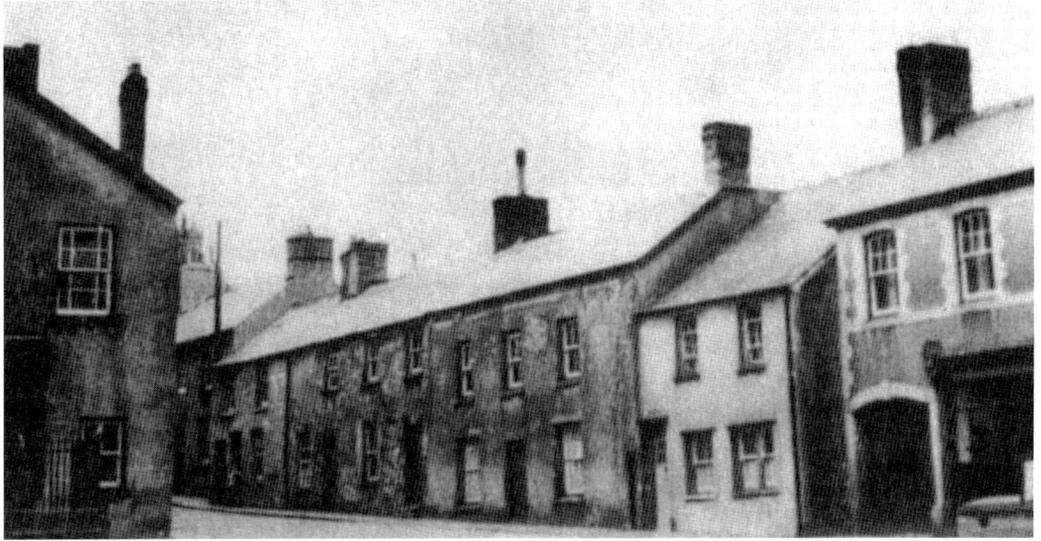

Swan Street and the Bull Ring, *c.* 1945. To the right is the first butcher's shop built by John David and two doors to the left is the Rock and Fountain public house which housed the original Workingmen's Club in 1953, later to become O'Sullivan's Restaurant.

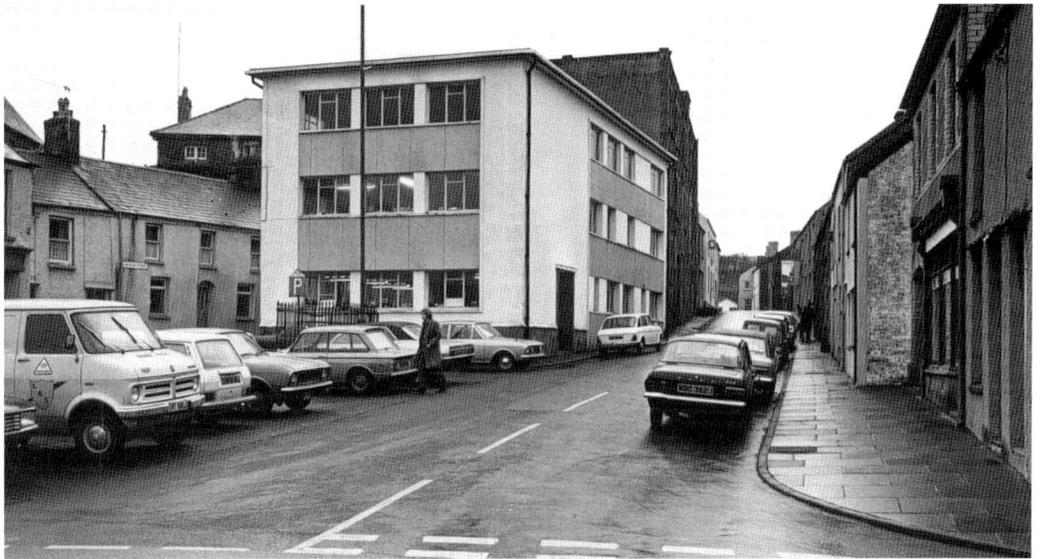

Swan Street and the Bull Ring with the former Planet Glove Making Factory, November 1974. The factory, which once produced nuts and bolts, was built on the site of the old County Stores. It was originally four premises, the main shop, behind which were two pubs, the White Hart and The George, with a cottage separating them. The buildings were demolished in 1912 and replaced by the workhouse.

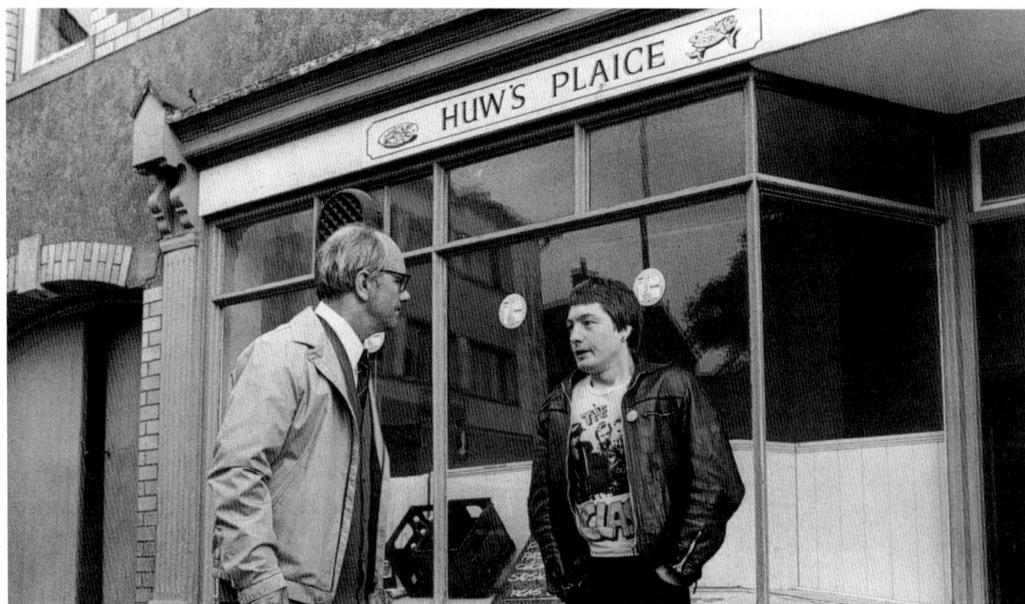

Above: Huw's Plaice, during the filming of *Taff's Acre*, 1981. During the early 1980s the HTV cameras descended on the town to make the racy new soap opera. Many of the buildings in the town were used, particularly the glove factory, which became the main studio, and the fish shop. Pictured are Richard Davies, who played Max, the head of the Johnson family, talking to his on-screen son Wayne, played by Stephen Davis. Llantrisant was later used as the location for a number of films, including the Christopher Walken and Brenda Blethyn comedy, *A Plot with a View* in 2001.

Right: David Thomas, *c.* 1975. Born in 1938 and brought up on Yr Allt, he was one of the three children of David and Irene Thomas. After leaving Llantrisant School he studied at Cowbridge Grammar School before joining the Royal Signals in 1956. On his return to Wales he worked in various firms, servicing television sets. In 1963 he became self-employed and for more than thirty years ran his own shop on the Bull Ring. Immortalised as 'Dai Telly' he took over the shop from the former Lloyds Bank and used their sign for some tongue-in-cheek humour by saying his premises was "Ye Olde Television Shoppe". It was a joke which appeared in the Daily Telegraph no less. His sister Marina emigrated to the United States after marrying the colonel in charge of the President's Airforce One plane. His younger sister, Elaine, lives in Llanharan. A father of three, he served on Llantrisant Town Trust for thirty years and also played for Llantrisant RFC and Llantwit Fardre RFC.

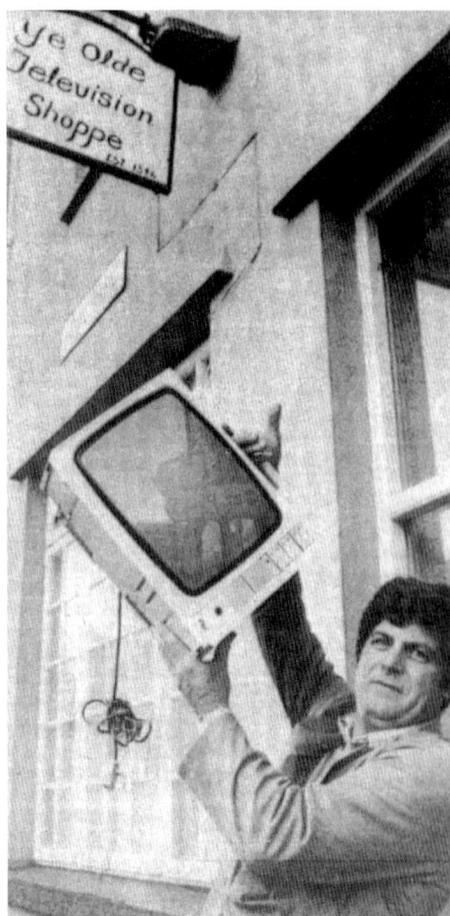

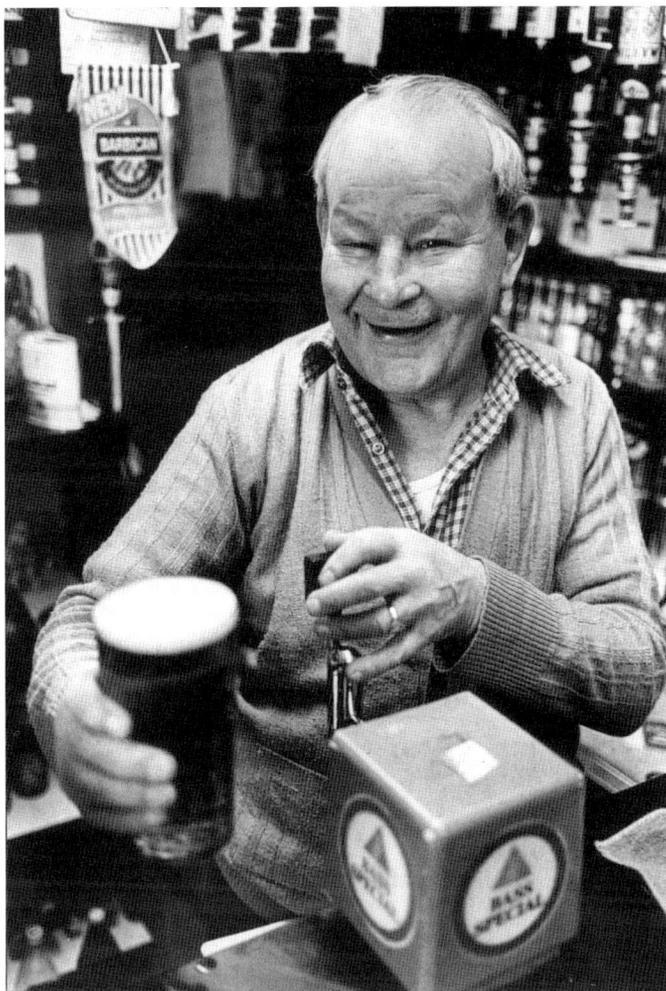

Syd Worgan (1917–1996) at the Bear Inn, 1981. Despite a spell as Welsh featherweight champion from 1944 to 1947, he continued to work as a miner. Born in Llanharan, his boxing career began when his sister Elizabeth bought him a set of gloves as a birthday present. At the age of nineteen, he was matched against George Williams of Treherbert in a final eliminator for the Welsh featherweight title. At the Pavilion in Mountain Ash, he fought fifteen gruelling rounds only to lose on points. In 1944, he outpointed Tommy Davies at Newport and the title was finally his. For the next five years, he defeated all challengers and was ranked number eight in the world, but retired in 1949, angry at being passed over for a shot at the British title. In 1960, he and his wife Dilys took over the Bear Inn. In 1976, he helped form the Welsh Ex-Boxers' Association which flourished with him as secretary and later president.

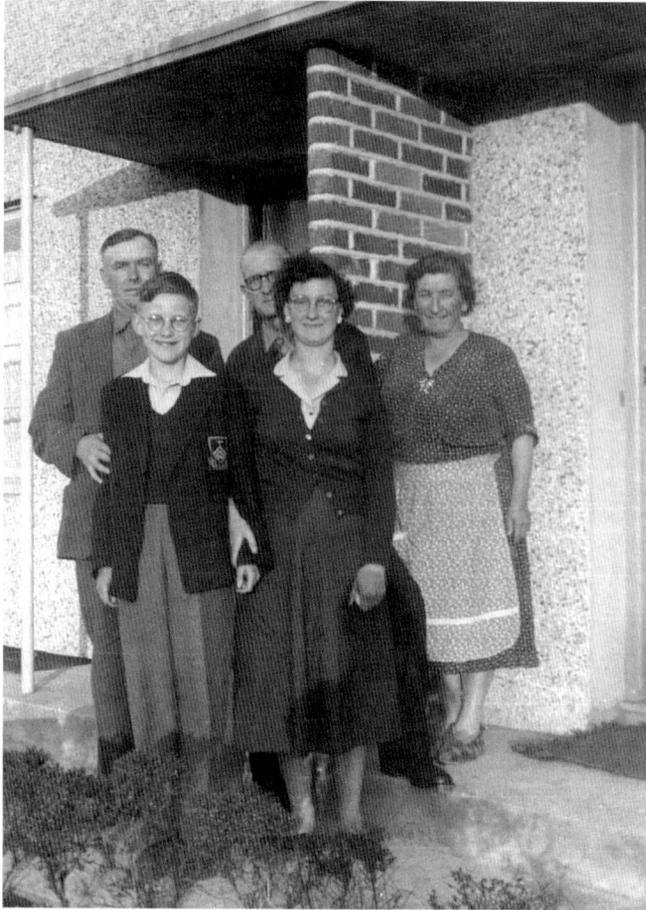

The Cale family with neighbours at Heol Gwynno, c. 1955. Pictured back row from left are: Ron Cale, Dan Davies and Ann Davies. Front row: Tony Cale and Gwyneth Cale. Ron (1914-1959) was born in Penygawsi and served in the Royal Artillery throughout the Second World War before becoming a groundsman for the St Athan aerodrome. He married Gwyneth Davies of Swan Street (born 1919) in Llantrisant Parish Church in 1941 and was made a Freeman through her family. Miss Davies, who nursed in a private home at Brynteg House before working in Bristol, settled in Heol y Sarn when Ron was demobbed. The couple also lived in Tynant before settling in Swan Street. Their son Tony was born in 1942. He attended Llantrisant School and Tonyrefail Grammar School. In 1959 he started work at the Inland Revenue before moving to the Royal Mint in 1975 and retired in 1996. He became a Freeman in May 1965 and was later made a trustee of the Town Trust.

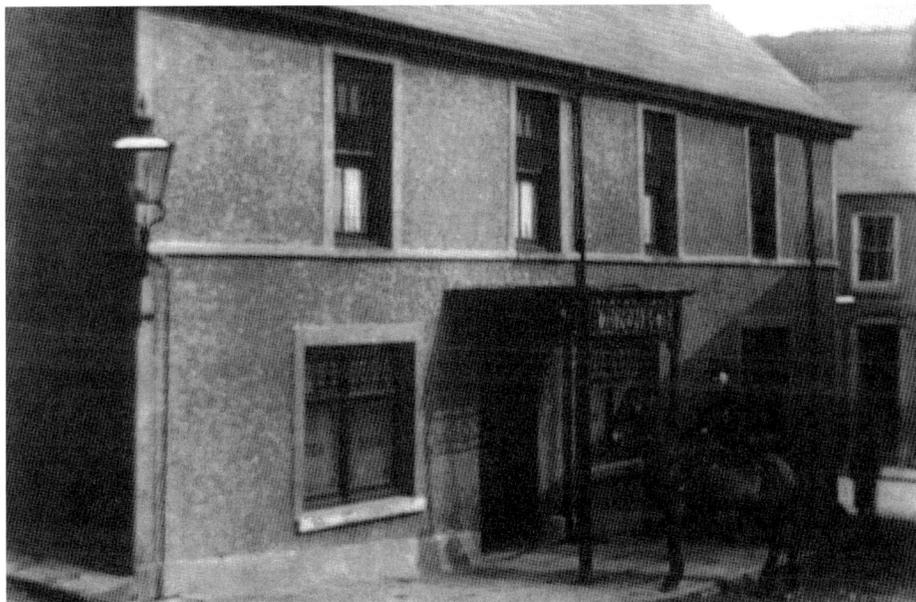

Cross Keys Hotel, c. 1900. Before the magistrates' court system was held in the Town Hall, petty sessions took place in the pub, where the court would meet every alternate Friday. The pub was also a popular venue for local music with the town band rehearsing there during the 1920s and '30s. It later became the home of Llantrisant Folk Club.

Regulars outside the Cross Keys Hotel, c. 1975. Pictured from left are: Jack Thomas, Dennis Regan, Edward 'Pongo' Williams, Glyn Doster, -?-. -?-. The landlord from 1972 to 1988 was Edwyn McGarr, renowned for his trumpet-playing performances when calling time.

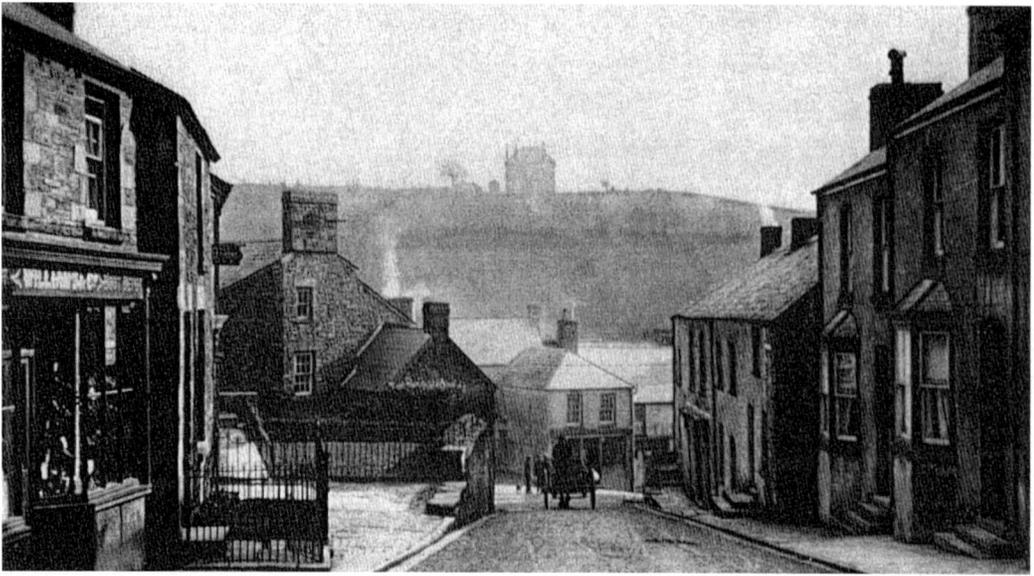

Above: High Street, 1930. This hive of activity was due to almost forty shops stretching from the Bull Ring, along High Street and Commercial Street during the early part of the twentieth century. What also makes this picture special is the sight of the building (Bristol House) at the foot of High Street, demolished in 1948, and also the cottages on the right-hand side. When they were demolished the plot of land was bequeathed to the people of Llantrisant by shopkeeper Miss Silkstone.

Opposite above: Post office, Commercial Street during the winter of 1982. The incredible snowfall of the Christmas season caused havoc to the country. For Llantrisant, it was a time when residents found refuge in many of the local drinking establishments, sharing bread and milk from those adventurous enough to reach the new Tesco store in Talbot Green. The post office closed in 1990 and was relocated in the former Swan Stores on Swan Street.

Opposite below: Guiseppe Di-Monaco (1929-1998). Born in Bellona, Southern Italy on 25 May 1929, he was one of sixteen children. In 1956 he married Maria Caruso, of the same family as the famed operatic tenor, Enrico Caruso, and within days of the marriage he left for Wales where he joined fellow Italians as the new workforce of the Iron Ore at Mwyndy. Maria was soon to follow and together they settled in Llantrisant and had four children, named Michael, Anna, Maria and Orsola (Lina). In 1975 his work at the Iron Ore ended and three years later he opened a gentlemen's hairdressers on High Street in Casey Kendall's old grocery shop. For almost thirty years he was better known as 'Joe the Barber', running the shop until his retirement in 1994. A keen football enthusiast, he brought a touch of Italian culture to Llantrisant with his frequent grape-crushing and winemaking techniques causing plenty of hilarity at the family home on High Street.

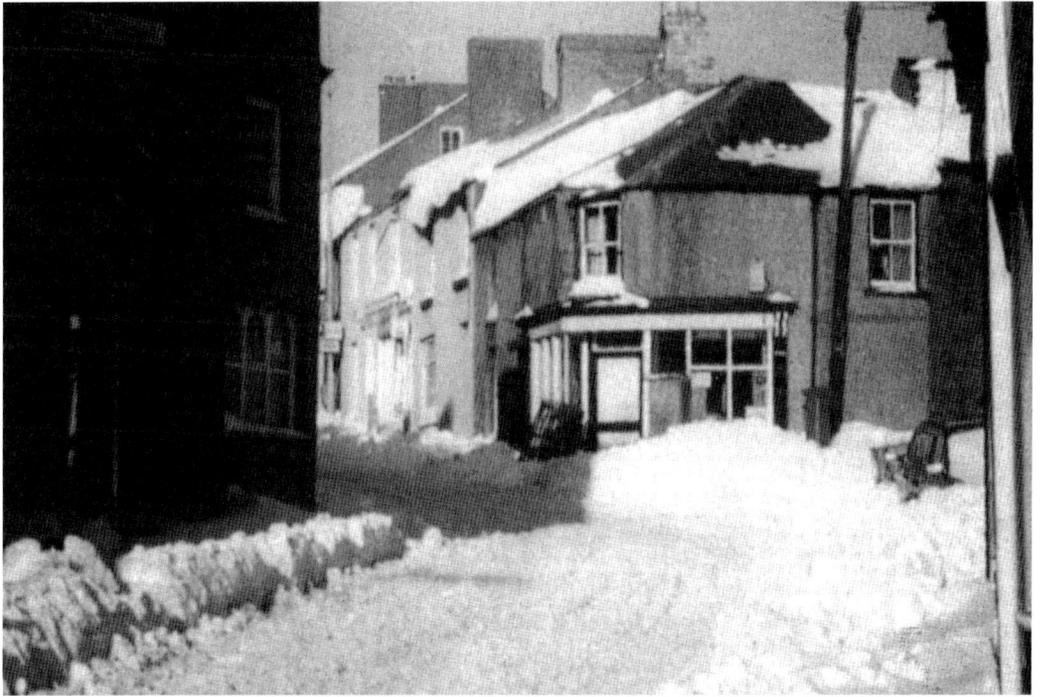

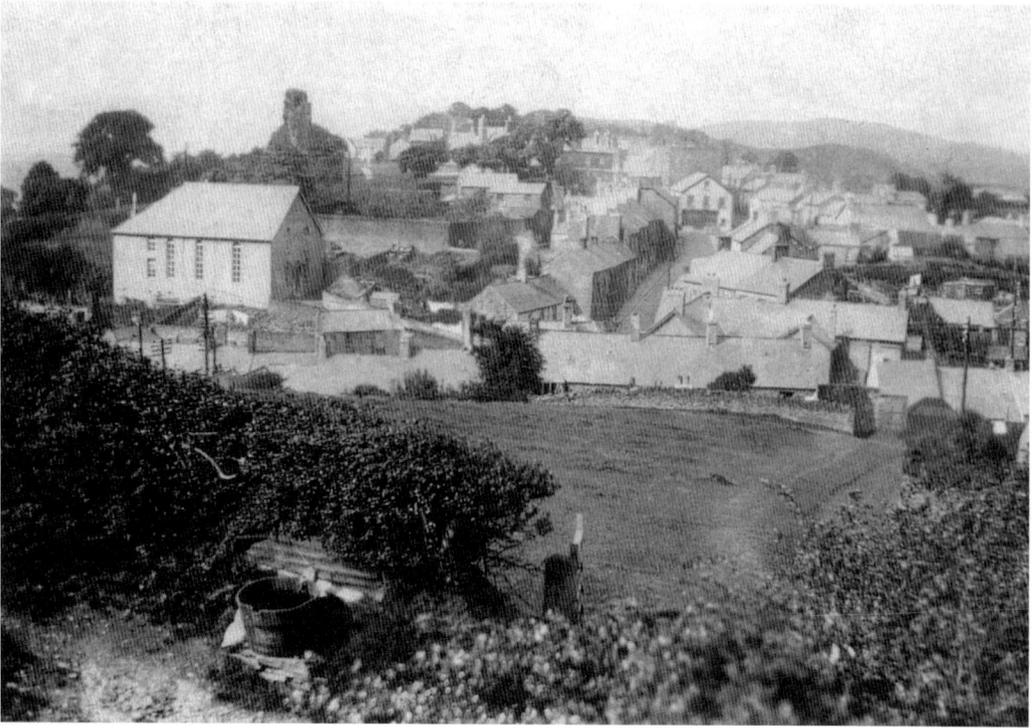

Above: Llantrisant from East Caerlan, *c.* 1933. This remarkable picture was taken just a few years after Tabor Baptist Church was rebuilt, a century after the original was constructed which faced East Caerlan rather than its present direction.

Opposite above: Newbridge Road, *c.* 1948. Pictured from left are: Trevor John of Boston, Massachusetts with son Ronnie, and relatives Paul and Patricia Treggoe of Weston-Super-Mare. On the right is their cousin, Carole Hooper of Dancaerlan, mother of the author. Notice the two cottages on the left which were built on the corner of Ruperra Street but later demolished due to subsidence. One was the home of Tom 'Butch' Davies, the local pig slaughterer and his wife Margaret, who were Carole's grandparents.

Opposite below: Penelopen Elizabeth Price (1886-1977). The second daughter of the famed eccentric Dr William Price, she was born when her father was eighty-six years old. He died in 1893 and eventually the family settled into their new home on East Caerlan where Penelopen remained for the rest of her life, accompanied by her half-sister Rachel Parry. A gifted musician and scholar, Penelopen became a qualified nurse and was recognised for her services to the Red Cross during the First World War. She was the local piano teacher for many years. In 1947 she unveiled a plaque on Zoar Chapel to commemorate her father's actions in cremating his infant son sixty years earlier and thereby leading the way for the legalisation of cremation in the British Isles. On 30 November 1953 she opened Thornhill Crematorium and in October 1966 unveiled a stained glass window at the North Chapel of Glyntaff Crematorium - where she was cremated in 1977, aged ninety-one.

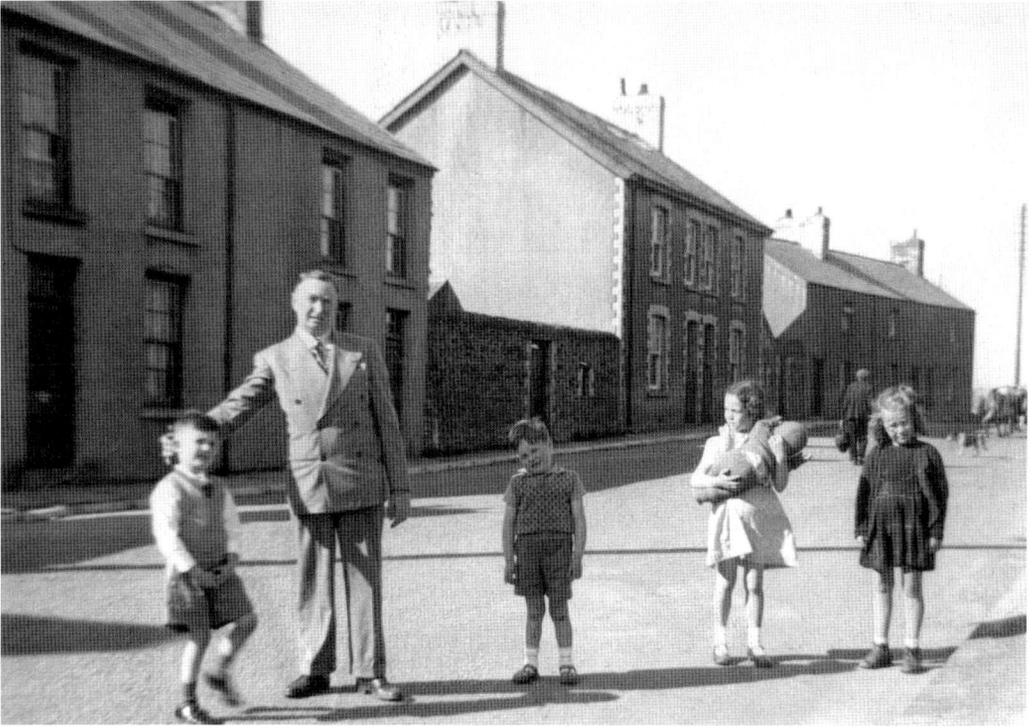

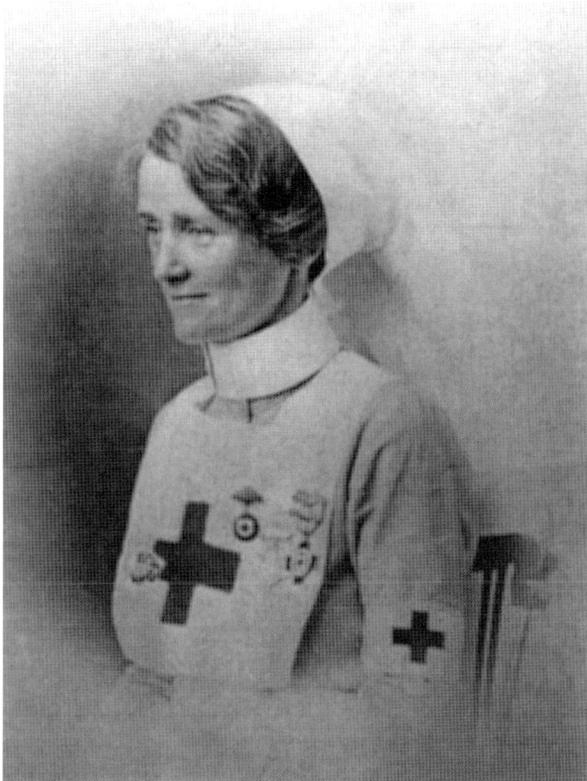

Above: Gwenhiolen Hiarhles Morganwg Price (1841-1928) and Gwenllian Llewellyn Parry (1859-1933) at East Caerlan, *c.* 1925. This rare picture shows Dr Price's housekeeper Gwenllian on the right. Following his death she married council road inspector John Parry of Llanharan and they had a daughter, Rachel, who remained faithful to the Price children. This picture also features the mysterious figure of Hiarhles. According to varying reports, Dr Price fathered her in 1841, with Ann Morgan of Pentyrch. The child was named Gwenhiolen Hiarhles Morganwg (Gwenllian Iarlles Morgannwg or Gwenllian, Countess of Glamorgan). When she was four years old, he belittled the majesty of the law by insisting the child was his assistant in a court case, naming her 'my learned counsel'. She lived most of her life in Cardiff, coming to Llantrisant to tend to her father in the latter months of his life and is said to have cut off a lock of his hair and kissed his cheek on the day of his cremation.

Opposite above: Iesu Grist II, or Nicholas Price (1884-1963). The second son of Dr William Price and his housekeeper Gwenllian Llewellyn, he was renamed Nicholas after his father's death in 1893. Nicholas briefly married Harriet Watkins of Tŷ'n Llwyn Farm, but the marriage failed. He lived in Detroit for a while around 1908 and avoided being enlisted during the First World War. He spent most of his life at East Caerlan and worked as a carpenter and builder for Will John at RAF St Athan before spending time in Newport. At one time he was also a policeman in Reading, difficult to imagine given his father's total disregard of the legal system.

Opposite below: Claudia Davies, *c.* 1895. Born in Ruperra Street on 11 February 1856, she was the daughter of Ebenezer and Mary Davies (formerly Morris). Ebenezer was a coal proprietor before becoming a local undertaker whose premises were at Talbot Green. In 1893 he organised the funeral of Dr William Price on East Caerlan, following the instructions laid down by the famous Archdruid. Claudia married a Cornish immigrant, John Jory and they set up home in Penygawsi. Her brother became headmaster of a school in Monmouthshire while her sister emigrated to America to further her nursing career.

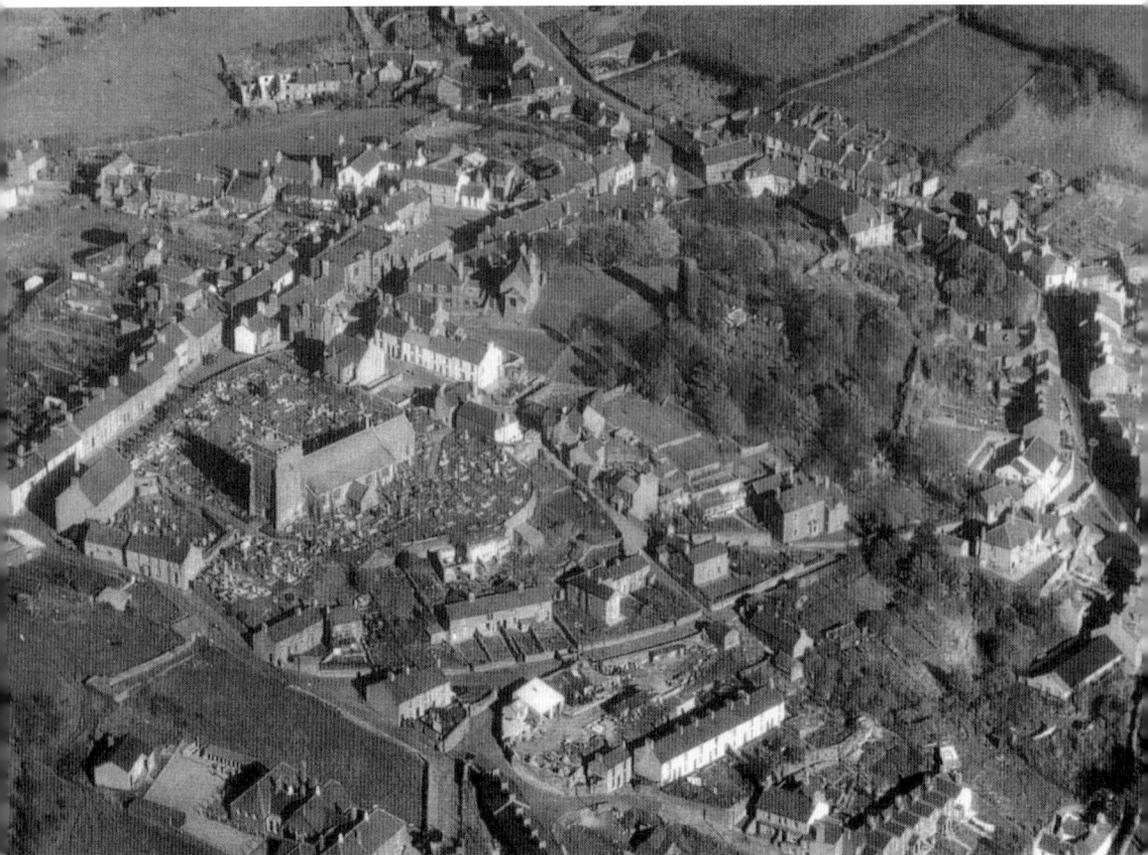

Above: Aerial view of Llantrisant, October 1955. On closer examination this picture shows the original oval enclosure of the early Norman fortress. Imagine the shape that incorporated the whole of the church and castle area, split through the middle by Yr Allt. It is not difficult to see the extent of the first Llan, probably running along Swan Street, School Street, Church Street, High Street and back to Swan Street again.

Opposite above: Ruperra Street after the cottages on the right and bottom were demolished, *c.* 1955. Better known as Cardiff Row, its residents included the Hurleys, Harrisons, Paulins and Dobbins. This road was well remembered on VE Day when neighbours painted jam pots, filled them with candles and hung the lights across the street. That night resident Sadie Williams led the communal singing, as always! The field below later became the Gwaun Ruperra Complex for the elderly.

Sadie Williams (1911-1985). Sadie was the only daughter of George and Alice Williams. The couple also had six sons named George, Harold, Charlie, Len, John and Edward ('Pongo') and the family settled in Ruperra Street. The family was well known for their singing prowess and on occasions clog dancing on the Bull Ring. Sadie married childhood sweetheart Richard Owen Williams who worked at Hensol Hospital and later Cwm Colliery. He was better known as 'Dicky North' because his parents came from North Wales. The couple had three children named Edwyn, Raymond and Merle and raised a niece called Myra. Sadie worked for the local railway during the Second World War before becoming a domestic in East Glamorgan Hospital. One of life's great characters, she was involved in so many aspects of the community. Whether organising weekend trips to Blackpool or singing every Sunday evening in the Cross Keys, she was loved by everyone in the town.

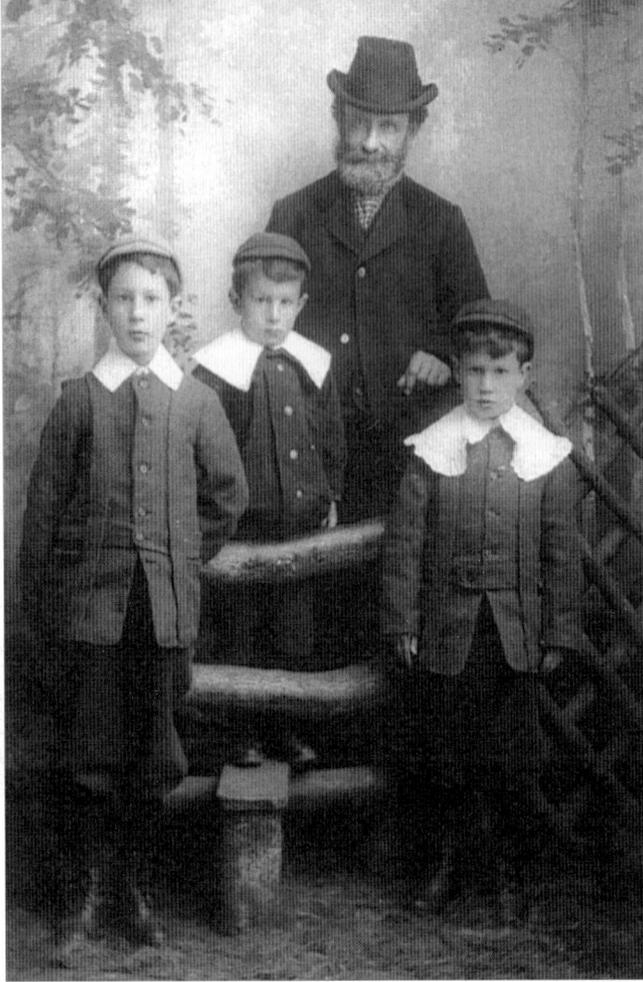

Jacob brothers Watcyn, Jack and Ivor of Cefn Mabley cottage with their grandfather, stonemason Evan Williams of Greyhound Lane, *c.* 1900. Of the three sons, Ivor was best remembered as a local councillor and member of the Town Trust in later life. He was born in 1892 at Vicarage Cottage, Heol Las, the second son of Lewis and Margery Jacob and also had a sister named Cassie. His great-grandfather, James Jacob, was Portreeve of Llantrisant in 1818. During his early years he was a coal miner before acting as the billeting officer for evacuees during the Second World War. He represented Llantrisant Town Ward on the Rural District Council and worked hard for the acquisition of Cefn Mabley field for the rugby club. He also took great pride in the part he took in the purchase of land now known as Dancaerlan. Ivor married Gwendoline Mary Williams of High Street and they had two children, Kitty and Watcyn.

Right: Watcyn Richard Jacob (1929-2003) as a member of Pontyclun Silver Band, *c.* 1946. One of two children born to local councillor Ivor and Gwendoline Mary at Cefn Mabley cottage, his sister's name was Kitty. Watcyn worked as a carpenter before becoming a motor mechanic at the Town Garage which was owned by Charlie Davies, a job interrupted by national service when he served in the Royal Signals. In 1955 he married Dorothy Thomas of Tynant and the couple had one son, Tim, who became the Senior Vice President of the Bank of America in London. Watcyn was made a Freeman in October 1950, becoming a Taff Ely Councillor for fifteen years. He also sang in Llantrisant Male Choir and served on the Town Trust for twenty-five years. He was a staunch member of Llantrisant RFC, and played a major role in the Workingmen's Club. He was a policeman in Barry during the early 1960s before running a shop in Tynant for twenty-three years.

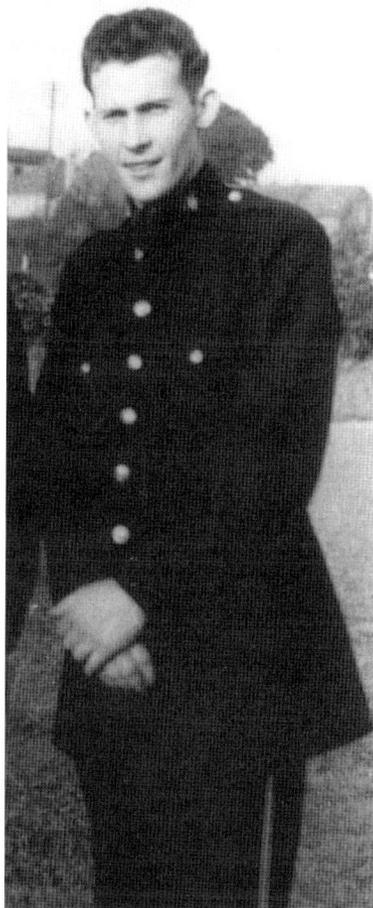

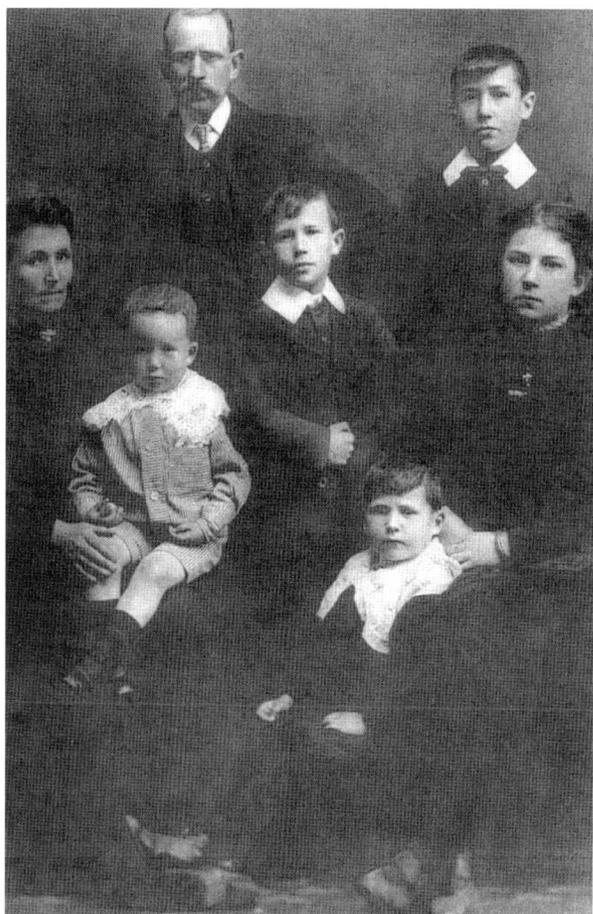

Left: Edward and Anne Rees (née Rosser) and children Percy, Tom, Len, Phillip and Gladys, *c.* 1910. Edward, who was made a Freeman in 1884, was one of eight children born to Edward Arthur Rees and Mary Davies of Cefn Mabley Farm. The couple pictured also had another daughter called Rowena, born after this picture was taken. The family lived in a cottage that stood next to Cefn Mabley before settling in a home next to the Castle Inn further along Newbridge Road.

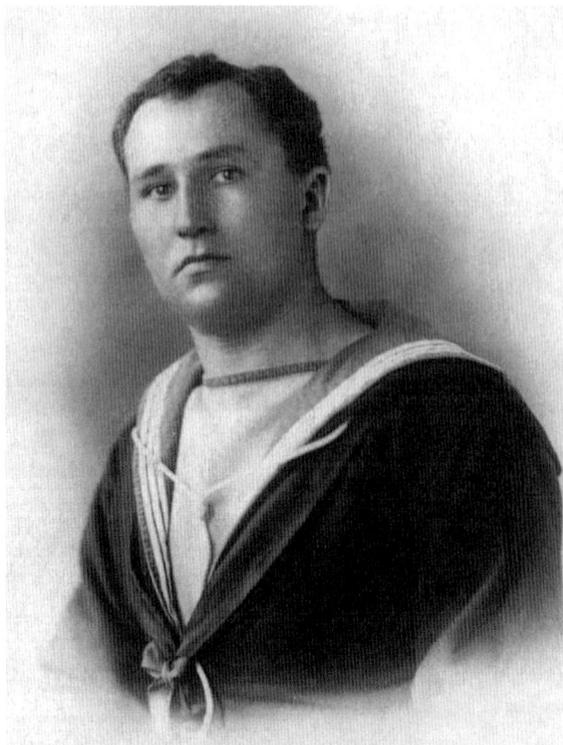

Right: Percy Rosser Rees (1898-1987). The son of collier Edward Rees and his wife Anne Rees (née Rosser) of Gilfach Goch. One of six children, Percy attended Llantrisant School but left at the age of thirteen to work in Coedely Colliery. He convinced his mother to sign documents allowing him to join the navy as a volunteer when he was only sixteen years of age, rather than eighteen. He served on HMS *Tiger* in the Red Sea and Indian Ocean during the First World War. Afterwards he continued working in the Cwm Colliery, became a Freeman in May 1920 and then worked in London where he met Helen Young of Tynant who was in service there. They married and eventually settled in St David's Place to raise six children. In 1948 they moved to Dancaerlan where Percy became a self-taught plasterer. He later settled in Tŷ Clwyta on the road to Castellau and continued undertaking manual work until his eighty-ninth birthday.

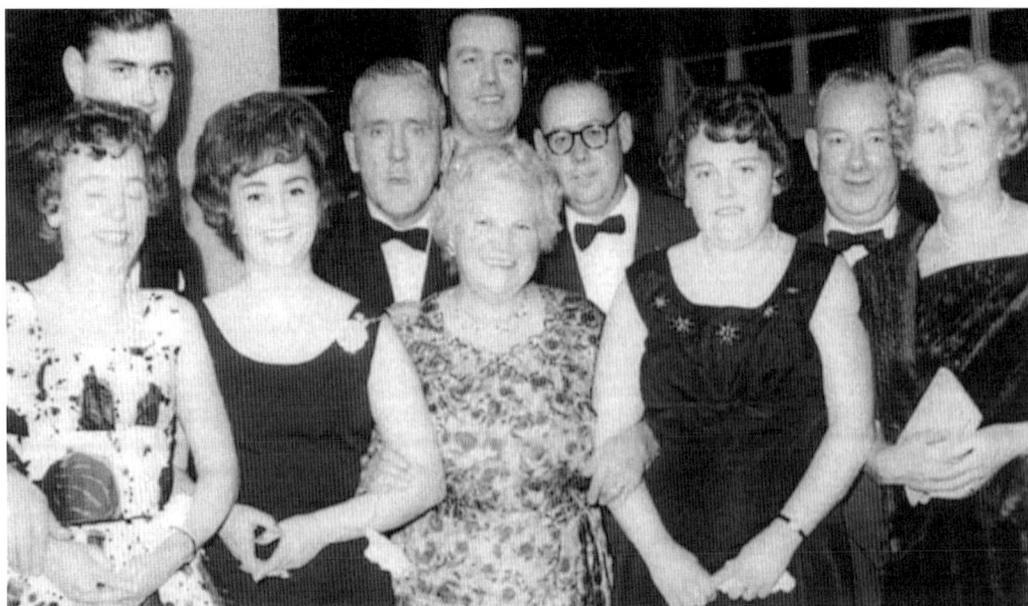

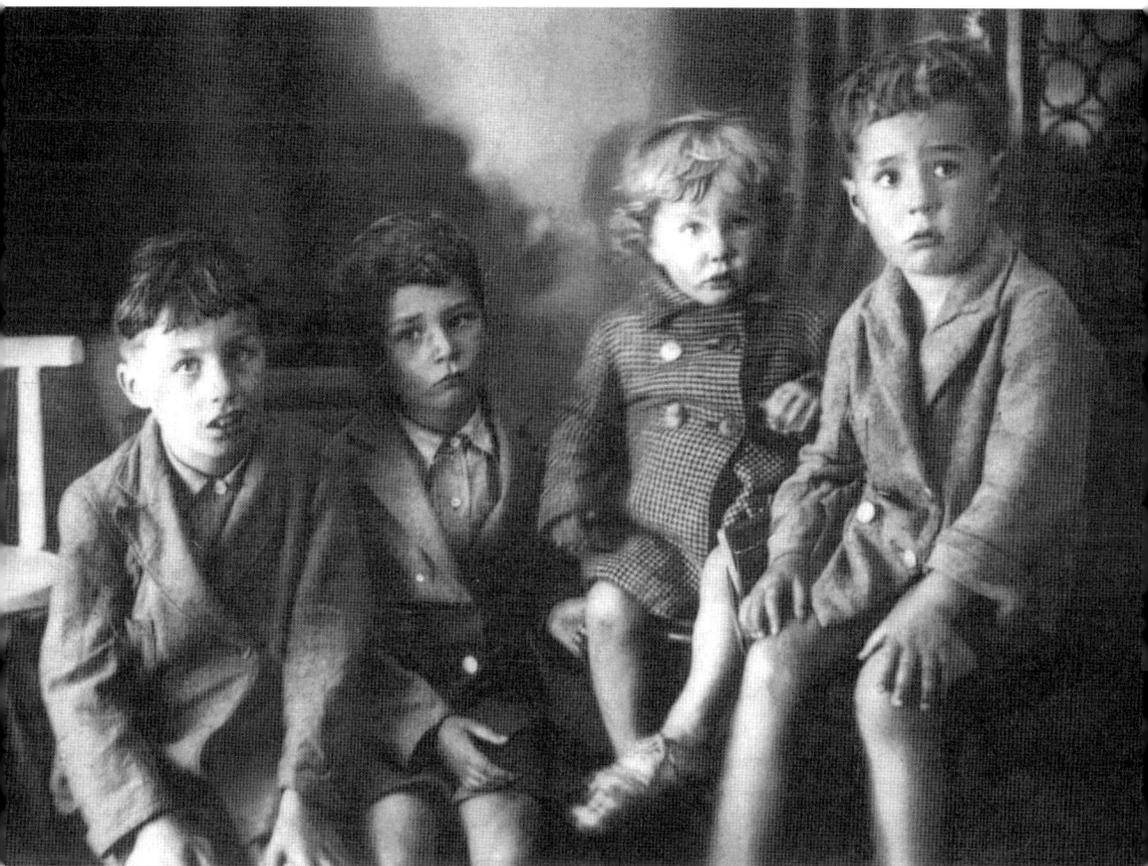

Above: Gwyn, Howard, Vernon and Allan Rees of St David's Place, *c.* 1937. They were the four remaining sons of Percy and Helen Rees. Their other brother, Melvin Douglas Rees, died in 1947 at the age of eight due to polio. They also had a sister named Elaine.

Opposite below: The Griffiths family at a dance, *c.* 1960. Pictured from left are: Enid, -?-, -?-, David, Emily, David, Edwyn John, Brenda John, Lyn Evans, Bessie Evans. Emily (née Hopkins) was one of twelve children from St David's Place. She was born in 1900 and died on her birthday in 1982. She married David Griffiths of Blaenclydach who moved to Llantrisant following an accident in the Cambrian Colliery. Emily opened a grocery shop in Henry Hopkin's (her father) building on Commercial Street in 1939. For the next forty years she was a successful shopkeeper in the town. The Griffiths family had three children called David (1929-1979), and twins Brinley (1932-1979) and Brenda.

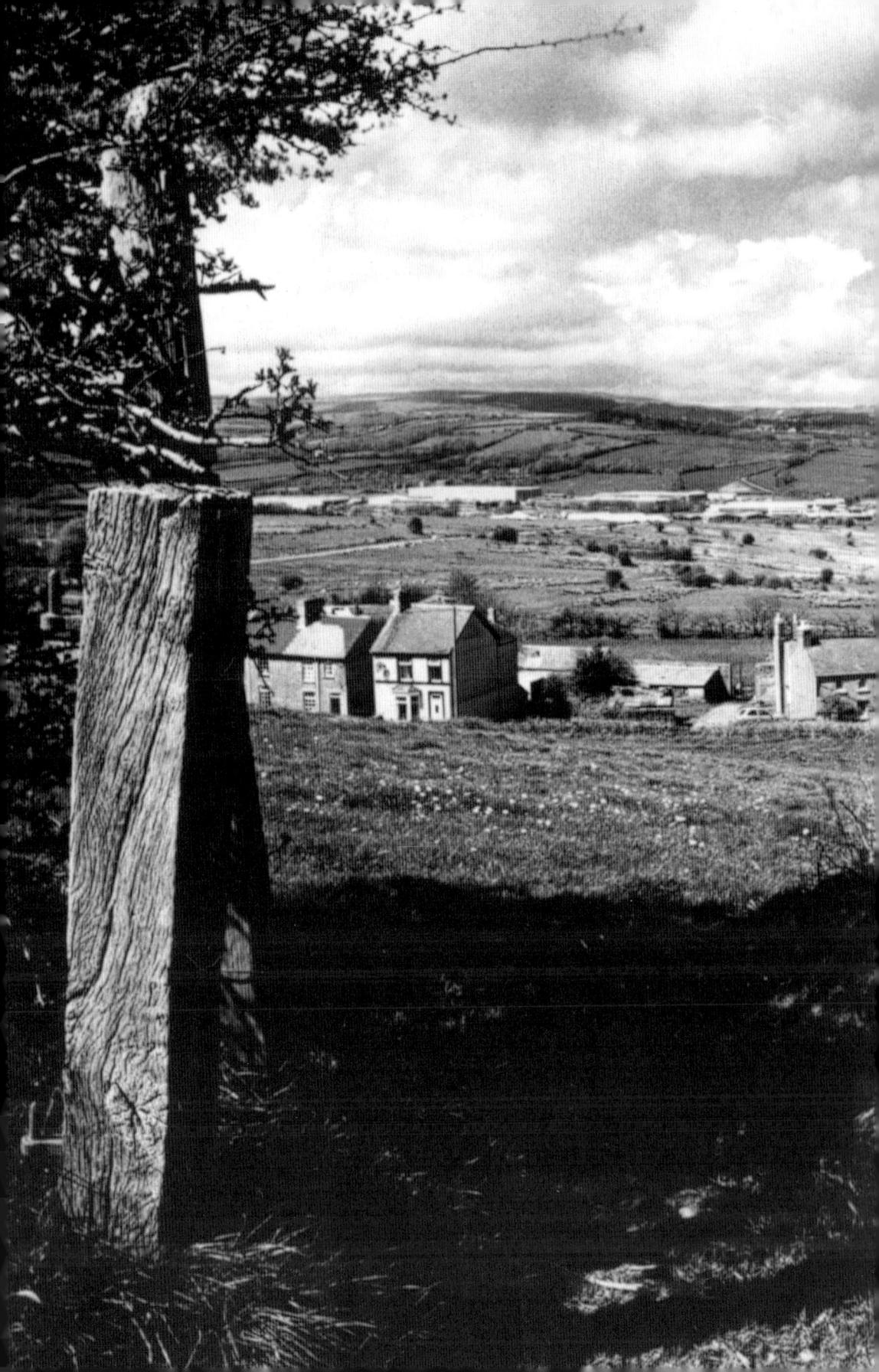

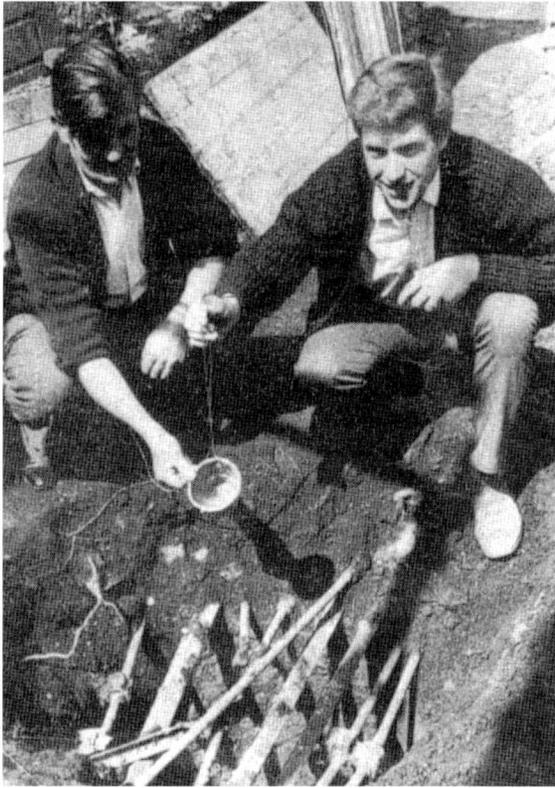

Above: Arthur Hooper and David Powell in Newbridge Road, May 1971. Mr Hooper (1910-1974) was watching his son-in-law (the author's father) working in the garden of the new home he bought with his wife, Carole and was shocked to discover a twenty-foot well dating from the eighteenth century. Mr Hooper, one of eleven children from Treforest, settled in Llantrisant after working in Canada but returned home to become a collier and married Gwyneth Davies. David Powell (born 1942) of Cilfynydd was one of six children to Tom (a prisoner of war to the Japanese) and May Powell. David joined the Welsh Guards and later worked for British Airways. He met Carole Hooper during an evening at the Workingmen's Club in 1966 and they married in 1970. They both devoted their time to the Rhondda Polar Bears Disabled Swimming Club and sent more than 200 children on holidays to Disneyworld, Florida. David was awarded the Pontypridd Round Table Man of the Year Award and the Gerald L. Phillipe Award for his services to charity.

Opposite: Cefn Mabley and Newbridge Road in around 1990 prior to the building of the Maes Cefn Mabley estate of houses behind Cefn Mabley farm which was converted into a veterinary surgery. The uniquely patterned windows were carved by Edward Arthur Rees (1833-1913), a collier who occupied the farm during the latter part of the nineteenth century.

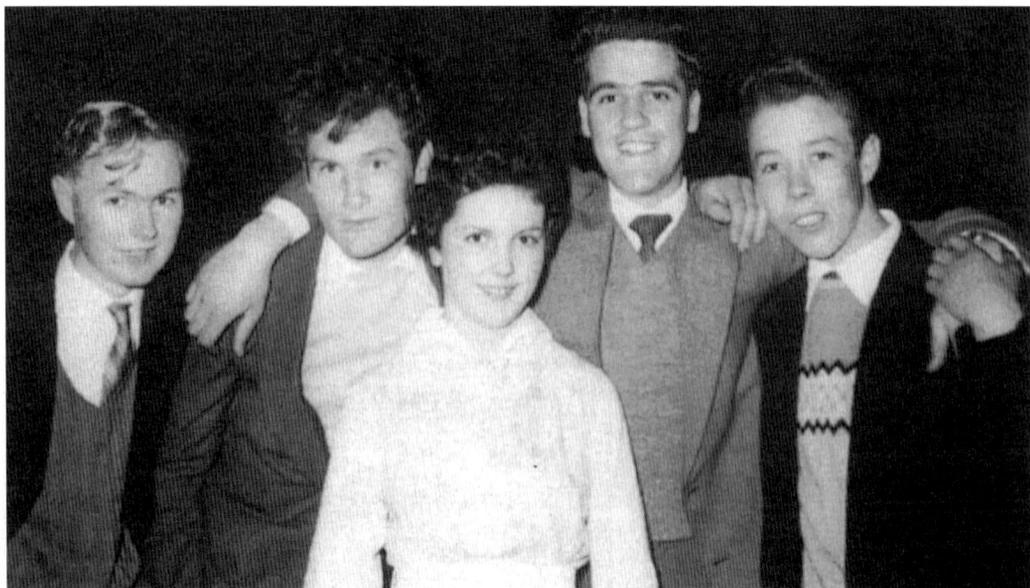

Above: Llantrisant youngsters at a dance in Pontyclun, *c.* 1957. Pictured from left: Gwynfor Thomas of Heol y Sarn, Ronald Williams of Yr Allt, Muriel Phillips of Penygawsi, Brian Williams of Dancaerlan and Terry Herbert of Newbridge Road.

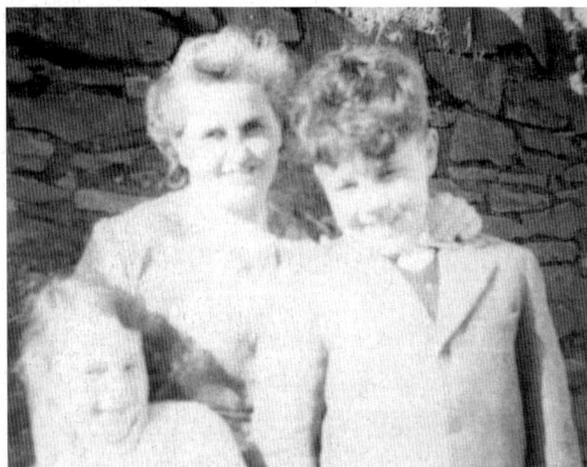

Left: Diane, Gareth and Diana Jones of Dancaerlan c. 1956. Born in Pontrhydfendigaid, Diana (1915-2003) came from farming stock and married Leslie Thomas Jones (1915-1961) of Edmondstown in 1939. The couple settled in Glanmyddlyn Farm near Beddau halt before moving into the new council houses in Dancaerlan in 1948. Their son Gareth was born in 1945, but tragically died in 1972 at the age of twenty-seven. Their daughter Diane (born 1949) later became clerk to Llantrisant Community Council.

Opposite above: Dinah Holmes (1917-1965) with husband Harold Holmes (1913-1976) and son Glynne. Harry, a bricklayer from Durham, served in the South Wales Borderers during the Second World War after coming to Wales for work. He married Dinah Robbins of Cross Inn in August 1940 and she spent a number of years working in the arsenal at Bridgend. An explosion at the factory, which killed many of her workmates, saw the heavily pregnant Dinah admitted to hospital where their son, Glynne, was born prematurely in 1944. The family moved to Dancaerlan in 1948 and lived at No.5. After finishing school Glynne became a bricklayer and studied to become an assistant building inspector and finally a chartered surveyor. He was made Chairman of the South Wales Branch of the Association of Building Engineers and later Regional Director of Wales. He married Jacqueline George of Talbot Green in 1970 and the couple had two daughters.

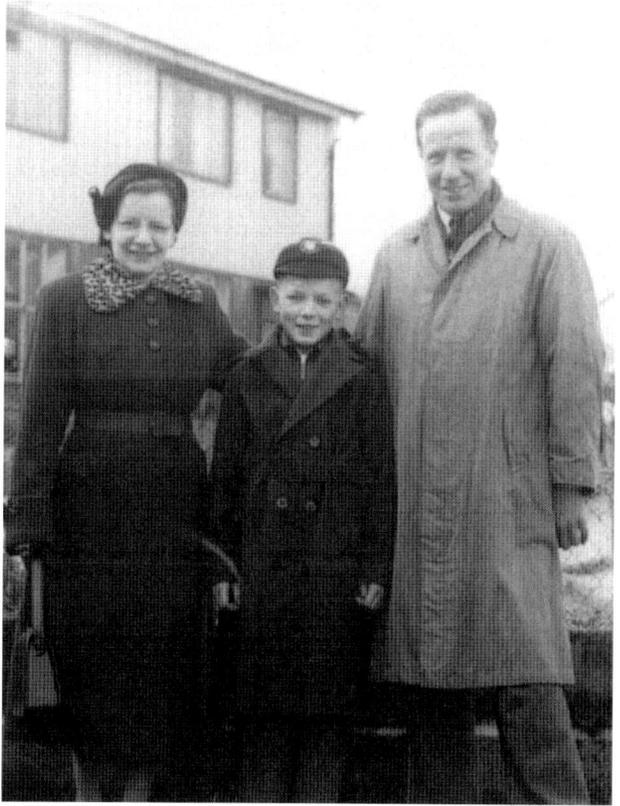

Below: Kelvin Eason, Terry Ward, Winford Rees, Keith Adams and two friends from Nottingham, August 1959. The photograph was taken outside the Holmes' household in Dancaerlan. At the rear is St David's Place and more clearly the Castle Inn stores which was run by Blod and Reg Westcott.

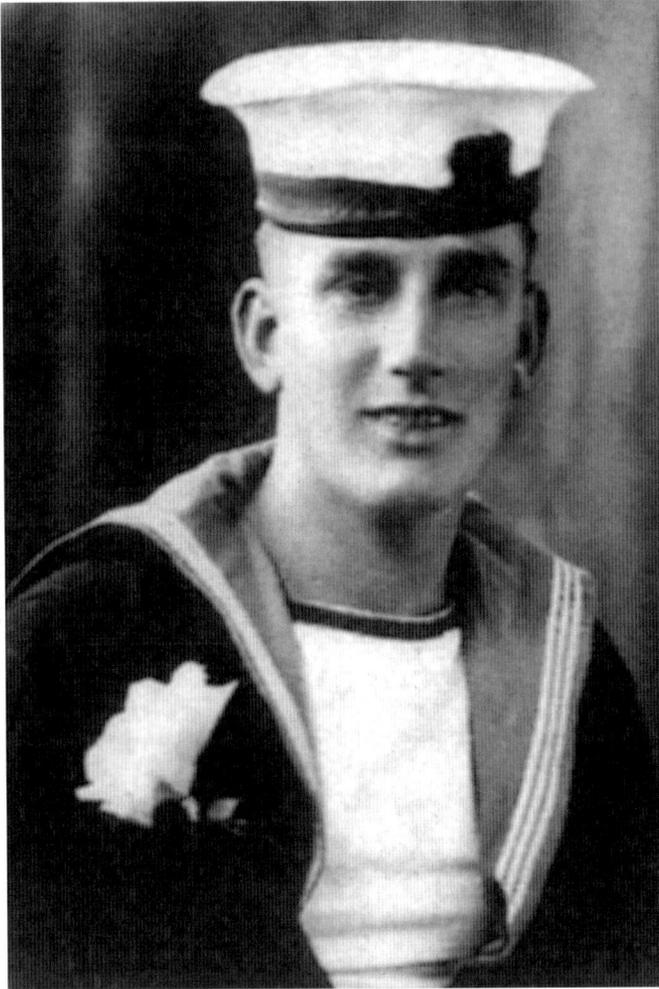

William Eason, 1942. Born in Tynant in 1919, he was one of four children of William and Elizabeth Eason. His father, who originated from Somerset, was one of the first to sink the Cwm Colliery in Beddau. In 1923 the family moved to Heol Las and following school Bill became a collier at the Ynysmaerdy Colliery. Renowned for its dreadful working conditions, he decided to become a volunteer in the Royal Navy, serving on board navy destroyers HMS *Centurion* and HMS *Bullfinch* during the Second World War. Less than a year after leaving the colliery some workmates were killed in an explosion which led to the closure of the pit. After the war Bill played for Llantrisant RFC and in 1947 he married Gladys Allan (1917-1998) from Tonypandy. The couple moved to Ruperra Street and Heol Las before settling in Dancaerlan in 1950. They had two sons called Kelvin, born in 1949 and Bryan, born in 1953.

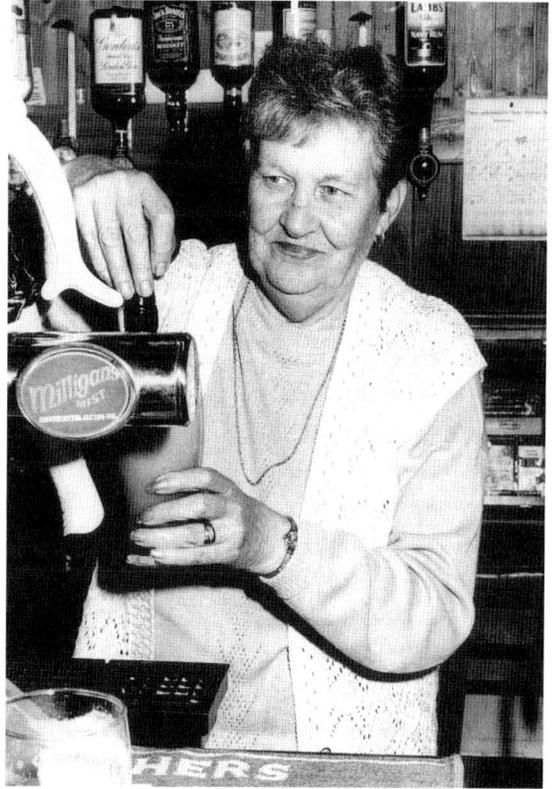

Ena Evans working behind the bar at the Bear Inn, *c.* 1987. Born in Newbridge Road in 1935, Ena was one of six children of Gwen (from the Francis family) and Evan Rees. The family moved to Dancaerlan in February 1948. Ena later worked in the Planet Glove Making Factory on the Bull Ring and spent twenty-two years as an assistant nurse at Hensol Hospital. In 1962 she married Elfed Evans, better known as 'Tex', because his father's name was Tecwyn. The couple had four children.

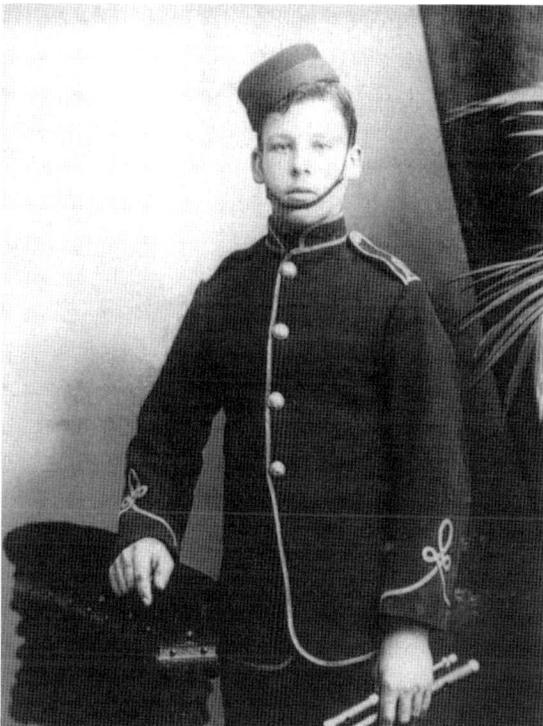

William Henry Jewell (1877-1936) pictured as a bandsman, *c.* 1900. William, of St David's Place, played the flute for the Llantrisant Town Band. He married Elizabeth and the couple had seven children called William, Ruben, George, Brynley, Phyllis, Enid and Alf. William Jewell was the last town crier in Llantrisant and died in 1936 at the age of fifty-nine.

Above: William John, William Morgan and Gwyneth Morgan outside Bull Ring Farm, *c.* 1930. William John was a local building contractor (and father of councillor Tudor John). He was married to Amy and they lived at Castle House (built 1900) on Church Street where he died in 1956 aged eighty-two. William Morgan (1885-1934), who died shortly after this picture was taken, was the son of James Morgan who bought Bull Ring farm in 1868. Also pictured is his eldest daughter Gwyneth 'Siams' (1914-1999), renowned for her singing prowess.

Left: The Jewell children pictured in the back garden of their home at St David's Place, *c.* 1935. Pictured from left are: Brynley, Phyllis, Alfred and Enid Jewell.

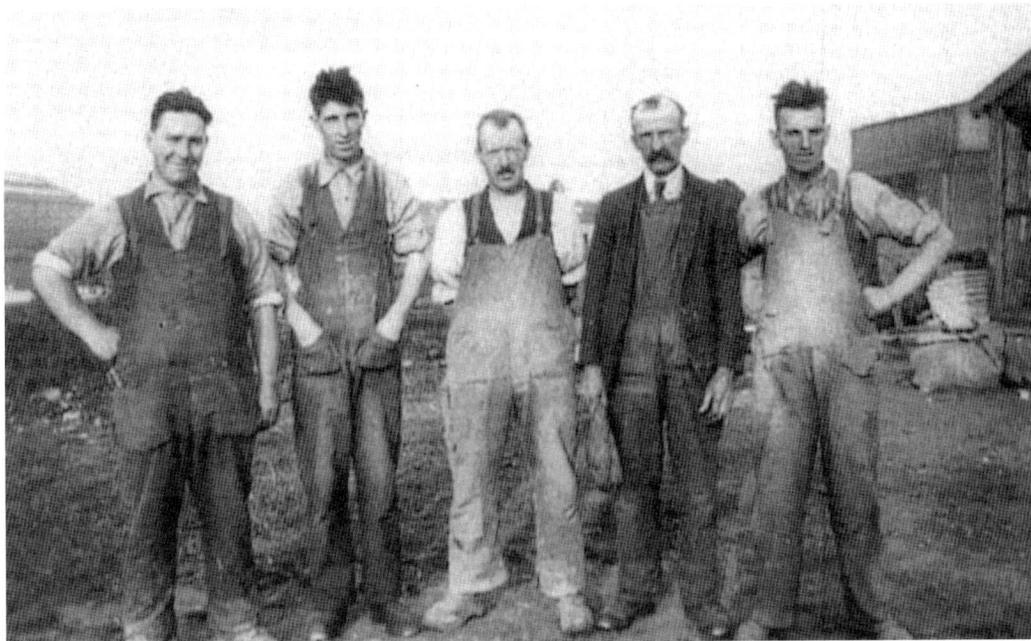

Above: Llantrisant builders and labourers pictured in Yeovil, *c.* 1935. From left are: Harquin Bevan, Ned Dyer, Frank German, Bill Page and Richard Evans. During the depression building contractor William John of Church Street took many of the unemployed men from Llantrisant to work on some of his projects to build council houses in Brighton and Yeovil.

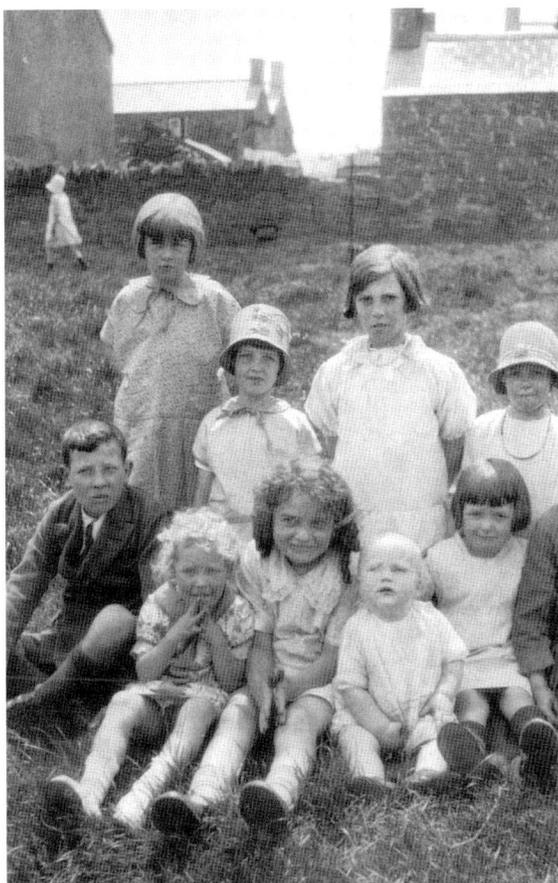

Right: School friends pictured at Bull Ring Farm, *c.* 1930. The photograph includes Freddie Hicks, Bryn Jewell, Mary Morgan of the farm, Maria Osborne and Queenie Croft.

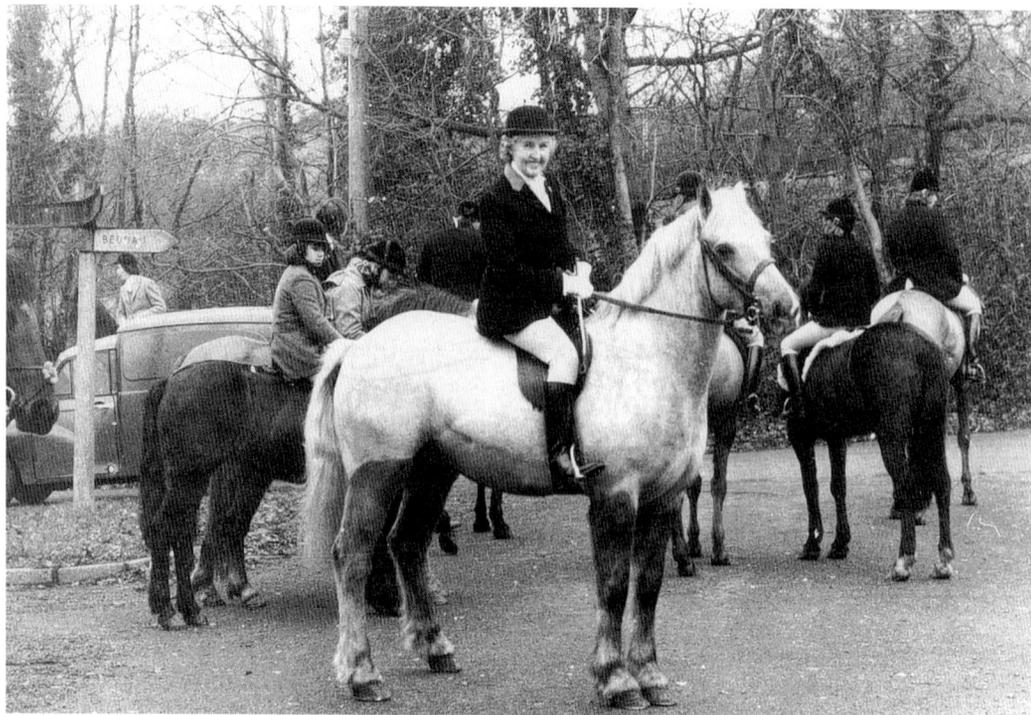

Above: Mary Morgan leading a hunt at Castellau, *c.* 1975. Born in 1924 at Bull Ring Farm to William ('Billy Siams') and Anne Jayne, Mary worked for the Inland Revenue at Pontypridd and while supporting the town's rugby team, met and married one of the players, Tom Williams, in 1950. Tom from Ynysybwl, was a former Wales International Rugby Schoolboy rugby international, before joining the navy during the Second World War. On his return he worked in the legal department of Glamorgan County Council. The couple settled in Talbot Green where Mary was later made the Lady Captain of Llantrisant and Pontyclun Golf Club.

Opposite above: The John family of Rhiwfelin Fach Farm, *c.* 1960. Pictured are Trevor William John (1916-1994) and Catherine John, née Williams, (1916-2001) with children Dewi, Gareth and Margaret. Trevor, of Tonyrefail and Catherine, of Rhiwfelin Fach, were married in 1945 while he was serving in the RAF and he enrolled as a Freeman through his wife's family in 1952. In 1963 the family moved to Talyfedw Farm, but left in 1974 to live in Llantrisant town. Dewi farmed at Talyfedw Newydd, Gareth became a Detective Chief Inspector and in later years Margaret became the landlady of the Bear Inn on the Bull Ring with husband Bryden Jones.

Opposite below: Edward Thomas of Heol y Sarn, Overseer of the Common, *c.* 1982. The Overseer of the Common enjoys one of the most important posts in the town. His role is to ensure only Freemen's animals use the common because there were many cases reported to the Court Leet of unlawful use of the common by non-Freemen. If an animal is found to be owned by a non-Freeman then the Overseer would take it to the pound - once found on Yr Allt - before either selling it or returning it to the owner for a fee. The Overseer also reports damaged ditches, hedges, fences and boundaries.

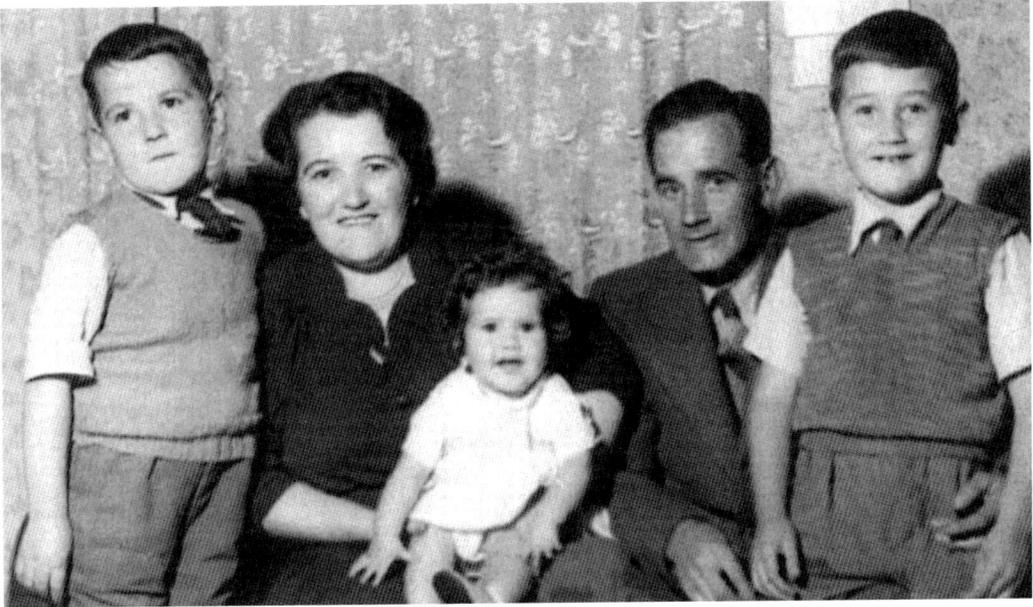

Site of the proposed Royal Mint, 1967. On April 25, 1967, James Callaghan, MP for Cardiff South-East and Chancellor of the Exchequer, announced in the House of Commons that a new Royal Mint would be built at Llantrisant on a thirty-acre site. Sir Alexander Gibb and Partners were appointed consulting engineers with Sir Frederick Gibbard as consulting architect.

The Royal Mint at Llantrisant, December 1968. With the opening of the new Mint in 1968, nine hundred years of history changed direction. The first Mint was built in the Tower of London where in 1696 Isaac Newton took up the post of Master and a century later it moved to nearby Tower Hill. On 17 December 1968 Queen Elizabeth, the Duke of Edinburgh and the Prince of Wales visited Llantrisant to witness the opening.

Lamb and Flag, Castellau, *c.* 1910. The original pub, called The Inn, was probably built in the early seventeenth century. Behind it once stood a blacksmith's shop and nearby a mill, kept busy by the many farms in the vicinity. The Inn stood on the side of the parish road to Llantrisant and was probably a coaching inn during its early days. The building was refurbished in the early 1920s and named the Lamb and Flag but was totally gutted in a fire during the late 1990s.

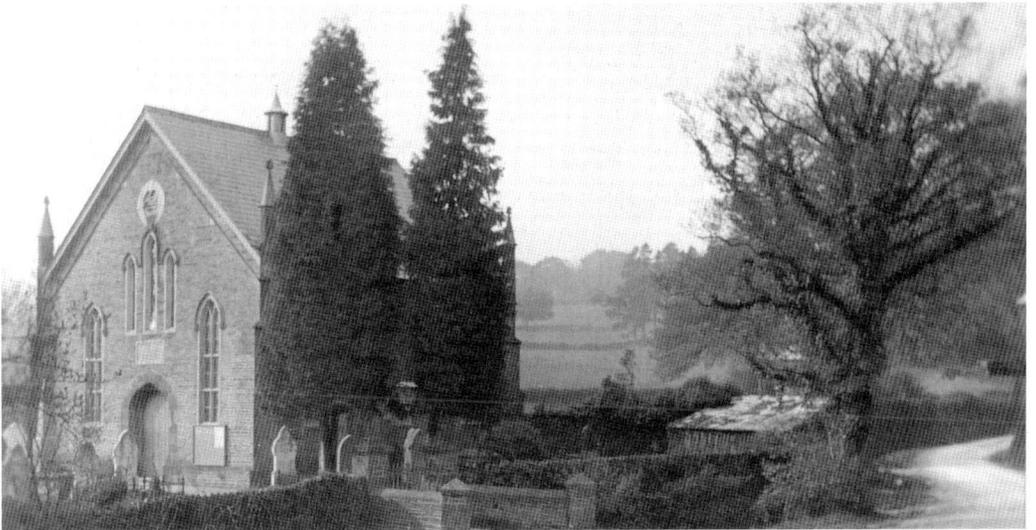

Castellau Welsh Independent Chapel, *c.* 1930. The chapel was originally built in 1843 and enlarged in 1877. Until 1939 the chapel was the centre of an annual eisteddfod and the nearby brook was even used for baptisms.

Billy Bevan outside the remainder of the Quaker's House at Tref y Rhyg, 1972. Known as Tŷ Cwrdd, it was built near a stream at Treferig on the Common. The original members were John Bevan (1636-1729) and his wife Barbara Awbrey (1637-1710). They both attended Llantrisant Parish Church until John had a religious experience in around 1668 and embraced the Quaker faith. He was excommunicated from the church in 1669 and in 1682 he built the house, with members including Thomas Howells David, Howell Thomas, Lewis Richard, Merrick David, Watkin Thomas and John Richard. The family sailed for America with over twenty followers and bought land to create the Welsh Settlement of Pennsylvania. John Bevan became a Judge of the Common Pleas and a Member of the Assembly at Pennsylvania. In 1707 the Tref y Rhyg and Monmouthshire quarterly meetings were united. Following Bevan's death the movement went into decline and the house was later bequeathed to the Society of Friends.

Northgate Cottage, Heol-y-Sarn, 1920. Owned by Llantrisant Town Trust, the tenant from 1906 was Edwin Francis, succeeded by Clydai Evans (1883-1954). It was not uncommon for children from the town to earn some extra pocket money by offering to open the gate for a penny from the very few motorists who travelled through the town. In 1961, three cattle grids were placed on the Common by the Town Trust, costing £175.

Celebrations and Customs

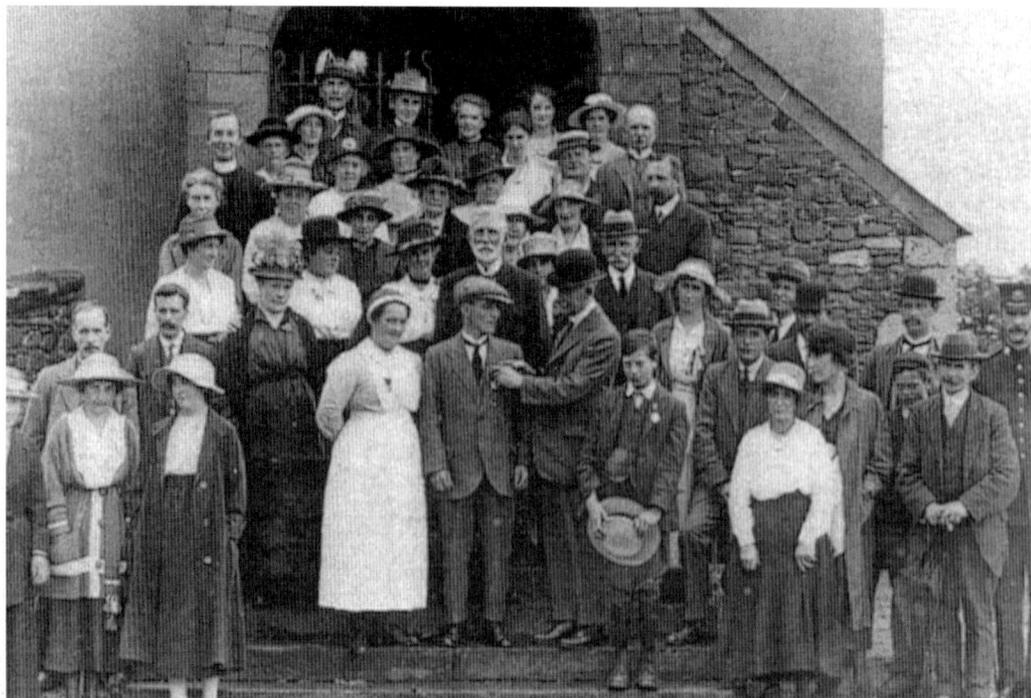

Above: Daniel Williams receiving the Distinguished Conduct Medal on the Town Hall steps in 1919. Born in Pont-y-Parc Farm, his mother was midwife Jane Evans and his aunt was fellow midwife Annie Taylor. He is being presented with the DCM from Dr Willy Davies, the local GP, for his gallantry during the First World War.

Opposite above: Llantrisant House Fête, *c.* 1930. This beautiful home was built by the Insole family, the well-known coal traders of the early 1830s. During the early part of the twentieth century, the house was occupied by local magistrate, Gomer Morgan, who played a significant role in the local golf and bowling clubs.

Opposite below: A souvenir programme of events to celebrate the Coronation of King George VI and Queen Elizabeth in May 1937. The festivities lasted three days and were organised by whipper-in David Lukey. Funds were found from a long list of patrons, including the Welsh Navigation Steam Coal Company, the Town Trust, the Malthouse, William John of Castle House, Llantrisant Motors in Talbot Green and D.C. Davies at the Town Garage. A group of collectors are listed in the brochure, along with catering committees and a page devoted to the donations of tens and over, with the likes of Gomer T. Morgan donating £5, Dr J.C.R. Morgan donating £2, Revd Sturdy donating £1, Supt MacDonald donating £1, James Little donating 10s 6d and Mrs Sparnon donating 10s. There was also a competition for the best decorated premises, including shop windows and private houses which were judged by the vicar's wife, Mrs Sturdy, and Mr Octavius Thomas.

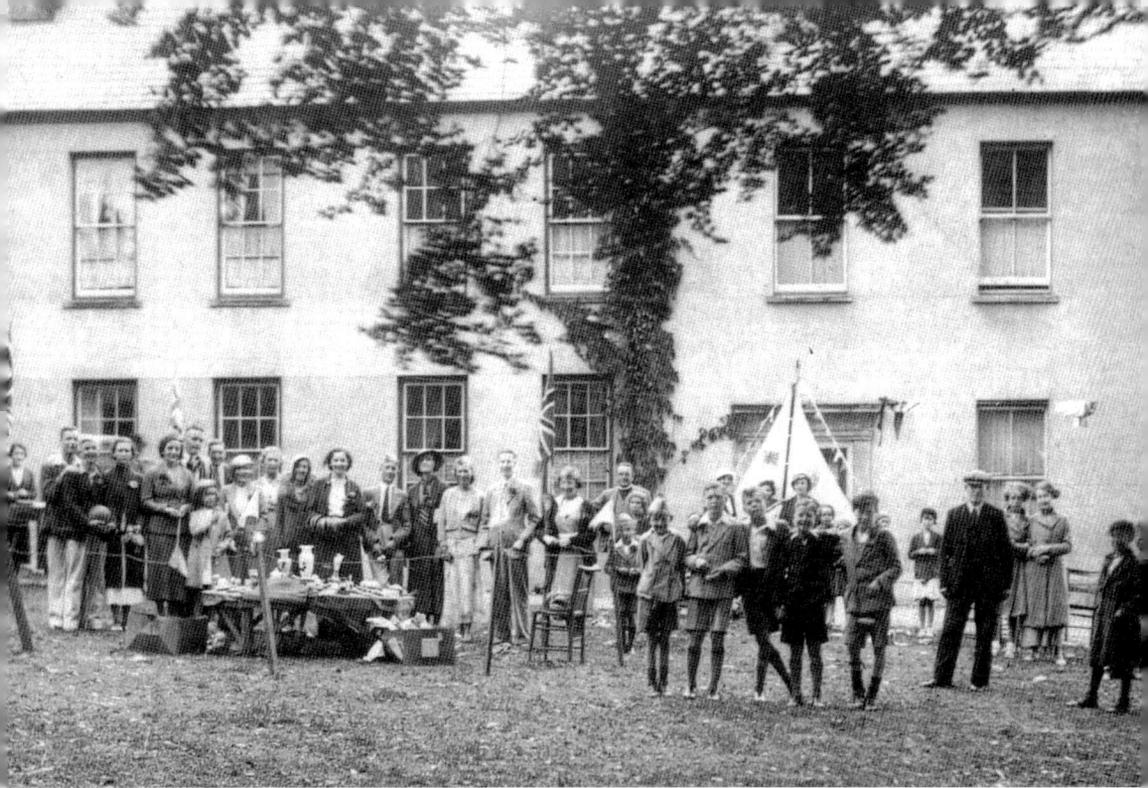

CORONATION OF KING GEORGE VI
AND QUEEN ELIZABETH.

Souvenir
Programme

LLANTRISANT CORONATION FESTIVITIES
——— 11th, 12th, 13th MAY, 1937 ———

President :
GOMER S. MORGAN, ESQ., J.P.

Treasurer :
D. R. LLEWELLYN, Esq.

Chief Marthal :
INSPECTOR J. PUGH.

General Secretary :
D. SALMON, Esq.

Organizer :
D. LUKEY, Esq.

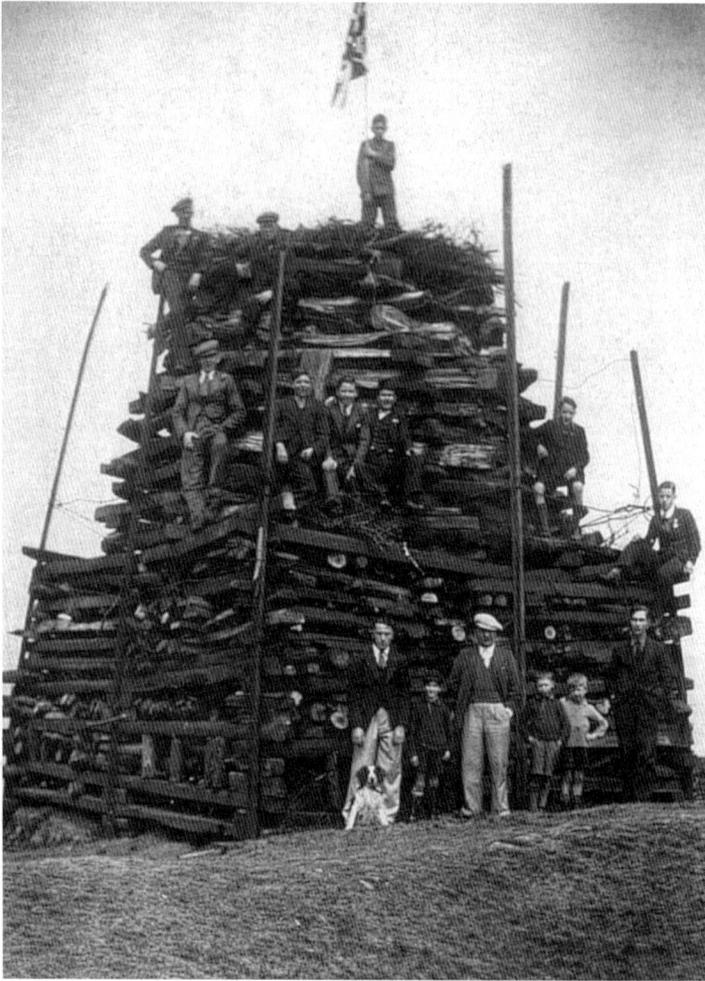

A bonfire on the Graig for the Coronation celebrations, Wednesday 12 May 1937. A church service commenced the three-day celebration to commemorate the royal event. A grand luncheon for people aged over sixty-five years followed, along with tea at the town hall for the children and the lighting of the bonfire at 10 p.m. The beacon was erected under the supervision of Councillor D.J, Davies, John Davies and Willian Banfield. Thanks were also given to a list of helpers, including the tractor owner Arthur Jones and the driver, William Powell. Bill Eason was the watchman for the event. On the following day the town came alive with a grand carnival parade from Talbot Green, led by the Llantrisant Town Band under the leadership of conductor W. Sayers. Finally, on the last day, sporting events were held on the old football field with T.C.Williams as chairman of the sports committee.

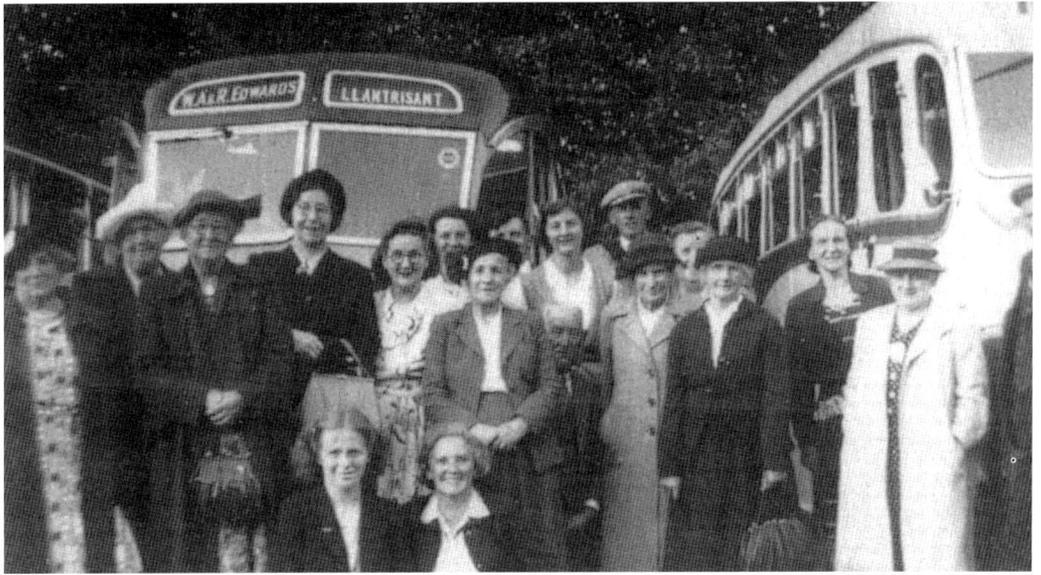

Penygawsi residents enjoying a bus trip, c. 1938. Some of those pictured include Sal Hayward, Miriam Hayward, Peggy Benyon, Mrs Tuck, Val Westcott, Fred Benyon, Mrs John, Mrs Blake, Dilys Williams, Mr Blake and Olwen Blake.

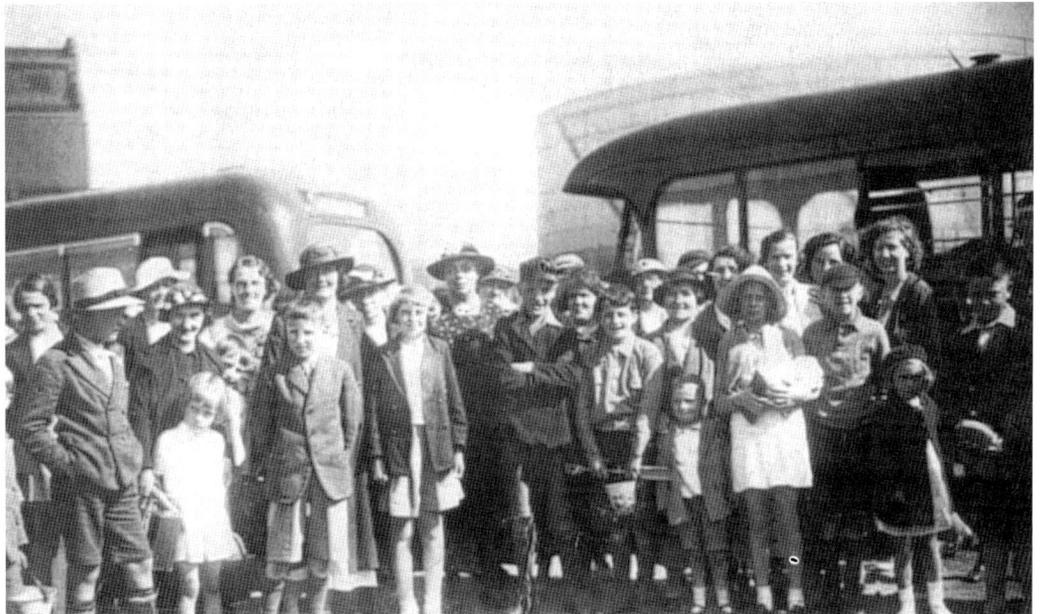

Tabor Baptist Church outing, c. 1945. The Baptist movement was first recorded in the town in 1650, but existed amidst great peril of persecution. In 1812 a group met in the Market Hall (the site of the old Police Station) and a request to the Marquis of Bute to use the Town Hall was granted. Increased membership saw them move from the Town Hall to a house and in 1824, land was acquired at the rear of High Street, opposite the Cross Keys, to build Tabor, which was opened in 1826 and rebuilt in 1924.

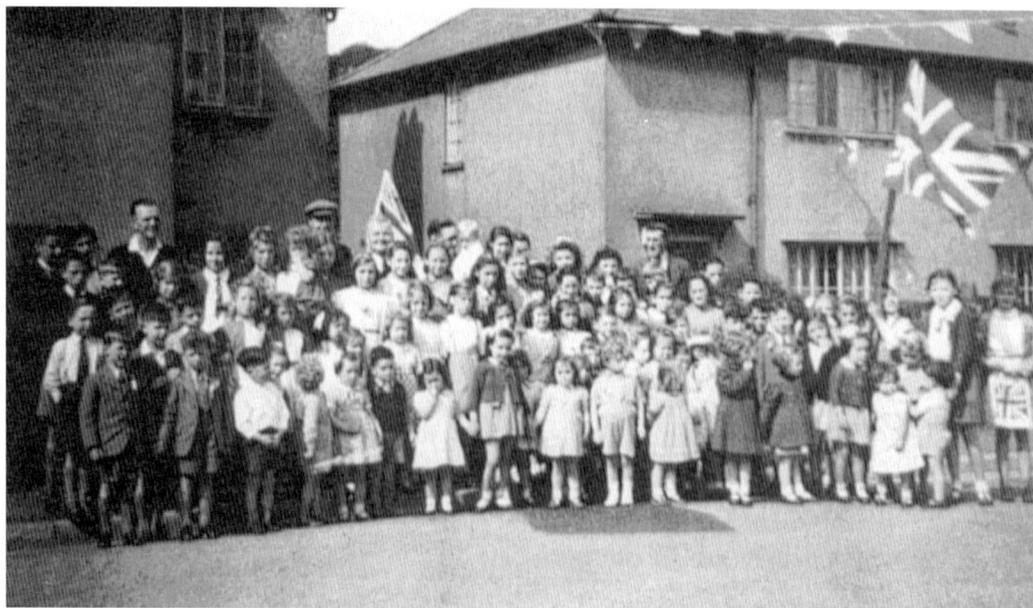

VE Day celebrations at Penygawsi featuring many of the residents of Cardiff Road, Heol Pen y Parc and Park View in 1945.

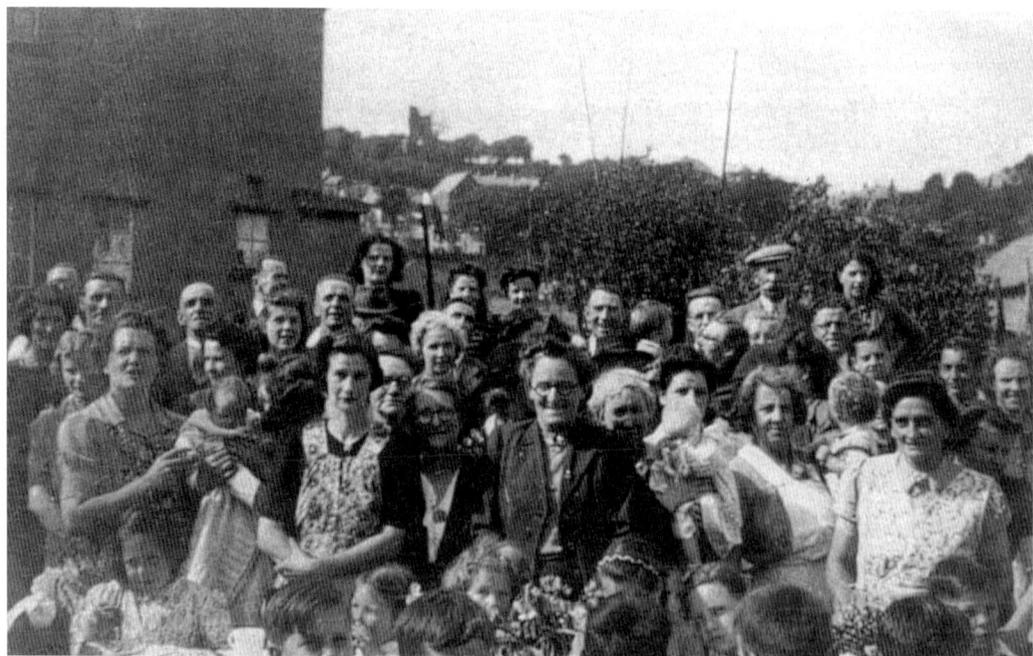

VE Day celebrations at Heol Pen y Parc, Penygawsi in 1945. This large group of neighbours and friends includes Mrs Cale, Mrs Robins, Mrs Austin, Pam Osborne, Yvonne Philips, Ernie Rex, Jean Holloway, Mrs Bissett, Mrs Clarke, Mrs Wareham, Mrs Tozer, Albie Davies and Mr Robins.

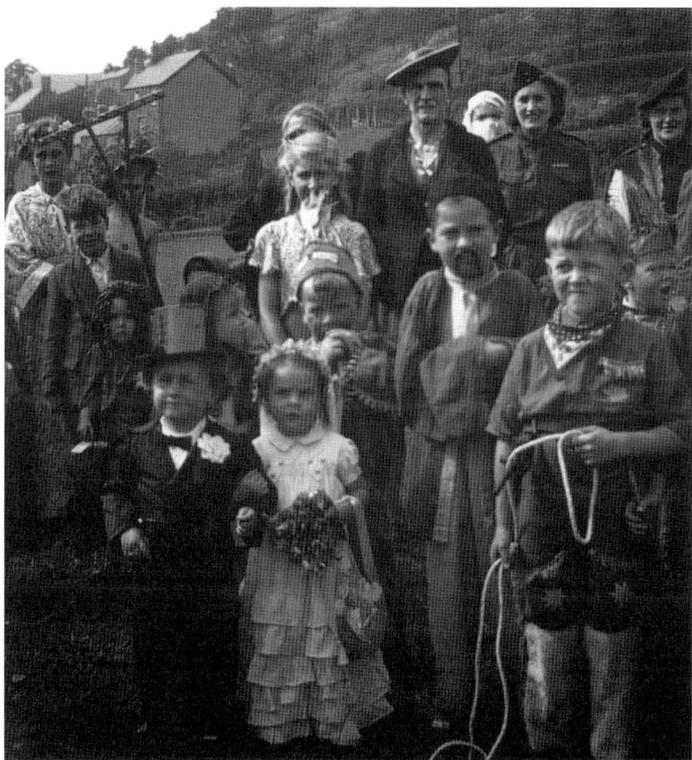

Left: A carnival at Talbot Green featuring youngsters from Penygawsi and Southgate, *c.* 1945. Pictured are Mr Tozer, Margaret Coles, Joan Wareham, Brian Cale, Nancy Williams, Marjorie Owen and the 'happy couple' were the Owen children from Southgate.

Below: A party at Llantrisant Cottage, *c.* 1945. The picture includes Dorothy Morgan, Sylvia Samuels, Leslie Waters, Mrs O'Malley, Mamie Morgan, Tudor Morgan (the dentist), Lena Davies, Trevor Doster, Tom Morgan, Megan Taylor, Pat Capron, Peggy Walsh and Lily Causon.

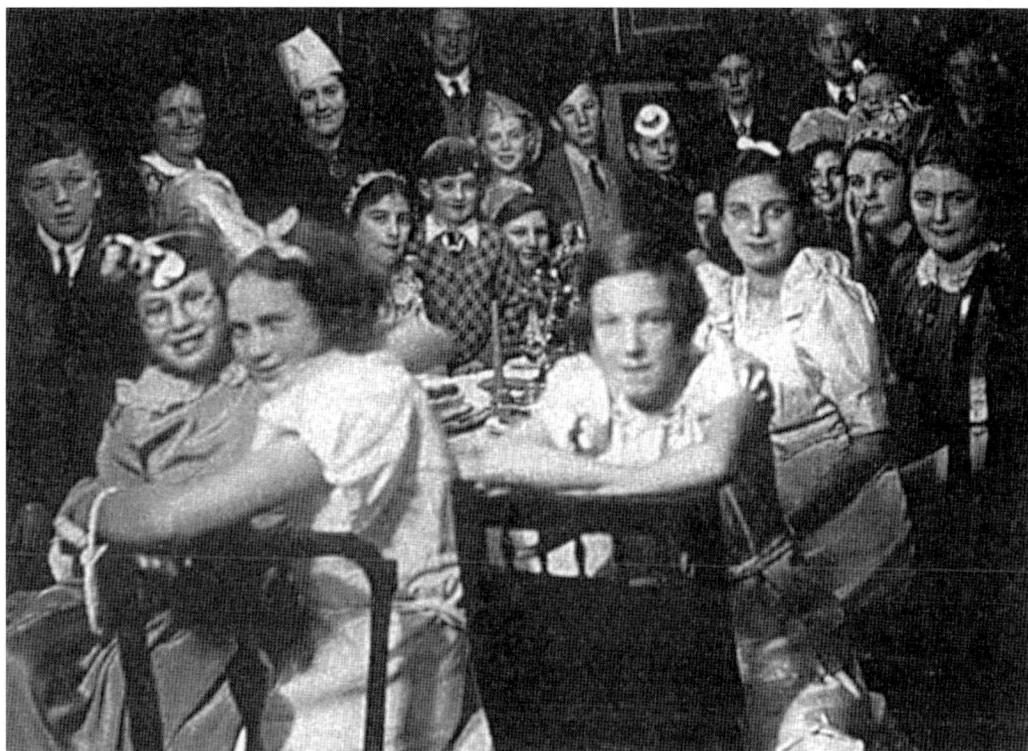

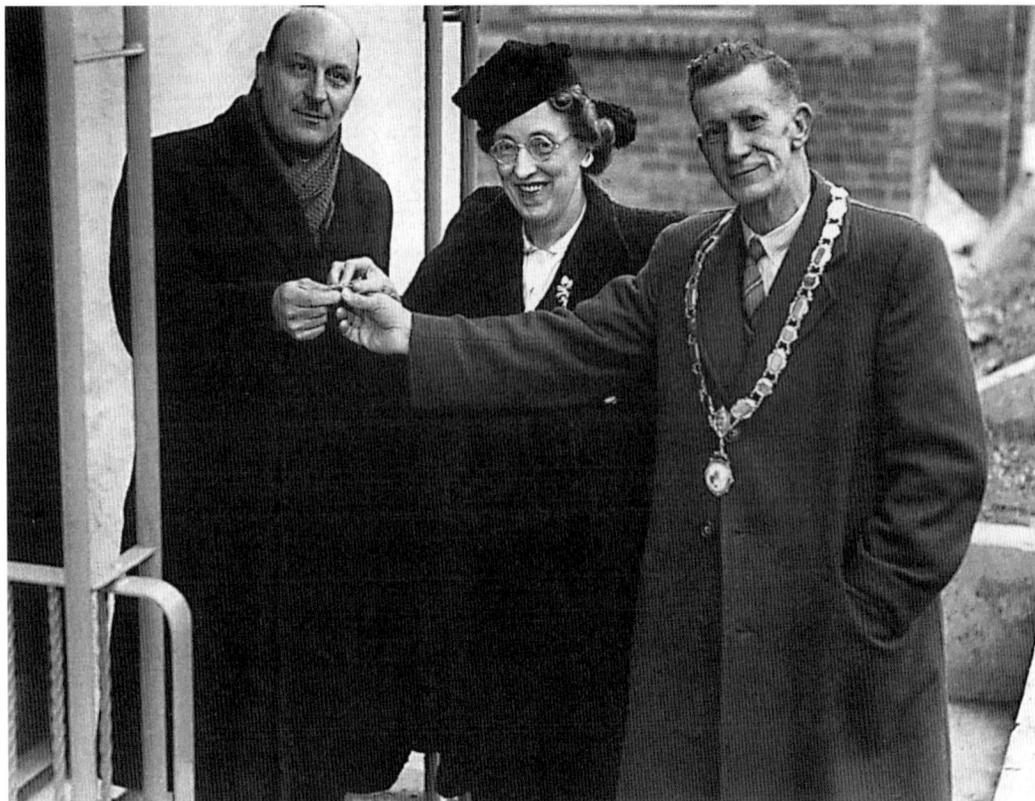

Above: Llantrisant councillor Ivor Jacob (right) with councillors Jack Clayton and Mrs Griffiths at the opening of Dancaerlan, 1947. Mr Jacob, then the council chairman, played a major role in purchasing land for the seventy-eight houses built following the Second World War opposite Newbridge Road.

Opposite above: A carnival along High Street, *c.* 1950. Notice that Bristol House, which once stood at the junction of High Street and Commercial Street, has gone, although the pavement remains. It was once occupied by Mrs Jenkins, Mrs Harvey and the Hoopers, but was demolished in 1948. Until then only a narrow lane existed to the left of the picture, called Y Gwt Bach.

Opposite below: Gwyneth Cornelius dressed in costume as a highwayman during a carnival in Llantrisant, *c.* 1945. The eldest daughter of William and Ann Morgan of Bull Ring Farm, Gwyneth married Edward Cornelius. An experienced horsewoman, she averted near disaster in the carnival when the horse bolted towards the crowd. Fortunately, she was able to restrain the animal and the locals thought it was part of the act.

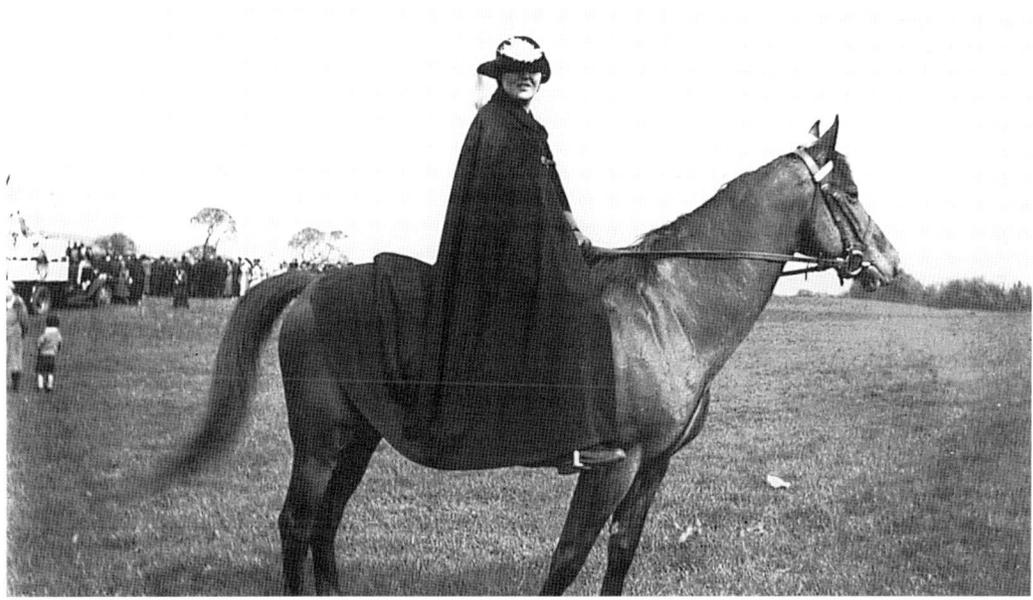

Above: A party outside the Butcher's Arms, *c.* 1950. Pictured from left are: Bronwen Harrison, Clydai Evans (of Northgate Cottage), Eunice Hill, Annie Dan, James Harrison, Morfydd Evans, Ruth Harrison, Ira Kendall and Maggie Ann Ferris.

Opposite above: New Inn Trip to Paris, *c.* 1950. Included in the picture are Illtyd Thomas, Lyn Jones, Tom Ferris, Trevor Thomas (secretary of Miskin Cricket Team), Tom Coleman (chairman of Llantwit Fardre RFC), Bill David of the Swan Shop and councillor Tudor John.

Opposite below: A presentation on the Bull Ring to commemorate Jenny James' swim of the English Channel, August 1951. The Pontypridd sportswoman completed the channel swim on 16 August 1951 in thirteen hours and five minutes. At the age of twenty-four, she was the first Welsh person ever to swim the channel.

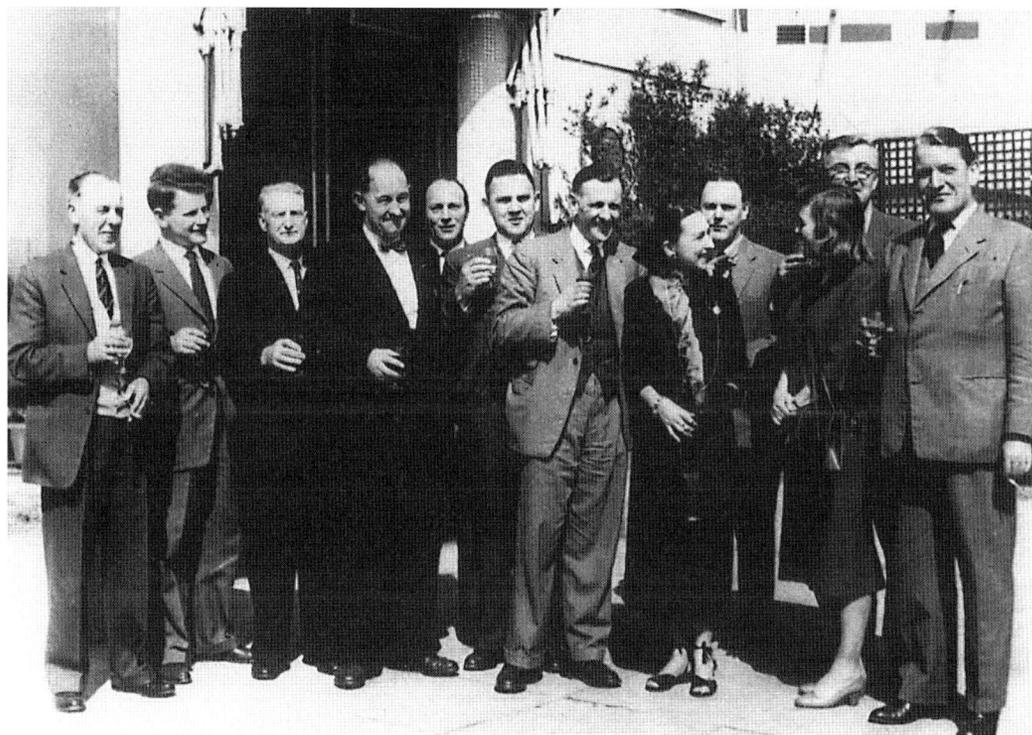

Top: Coronation party, June 1953 at St David's Place. This group of neighbours includes Queenie Akers, Ena Jewell, Mrs Maslin, Jack Hutchings, Mr Maslin, Annie Drew and Eddie Thomas.

Above: Coronation party, June 1953 at Heol-y-Sarn. The group includes Muriel Evans, Arthur Evans, Carole Evans, Yvonne Clay, Henry Alexander, Menai Perkins, Katie Perkins, Maggie Ann Francis, Diane Davies, Mrs Lynne, Vera Davies, Angela Davies, Ruth Harrison, Peter Evans, Wayne Kendall, Tricia John, Malcolm 'Sam' Evans, Vera Taylor, Billy Thomas, Ken James, Gwyneth Cale, Tony Cale and Mrs Stallard.

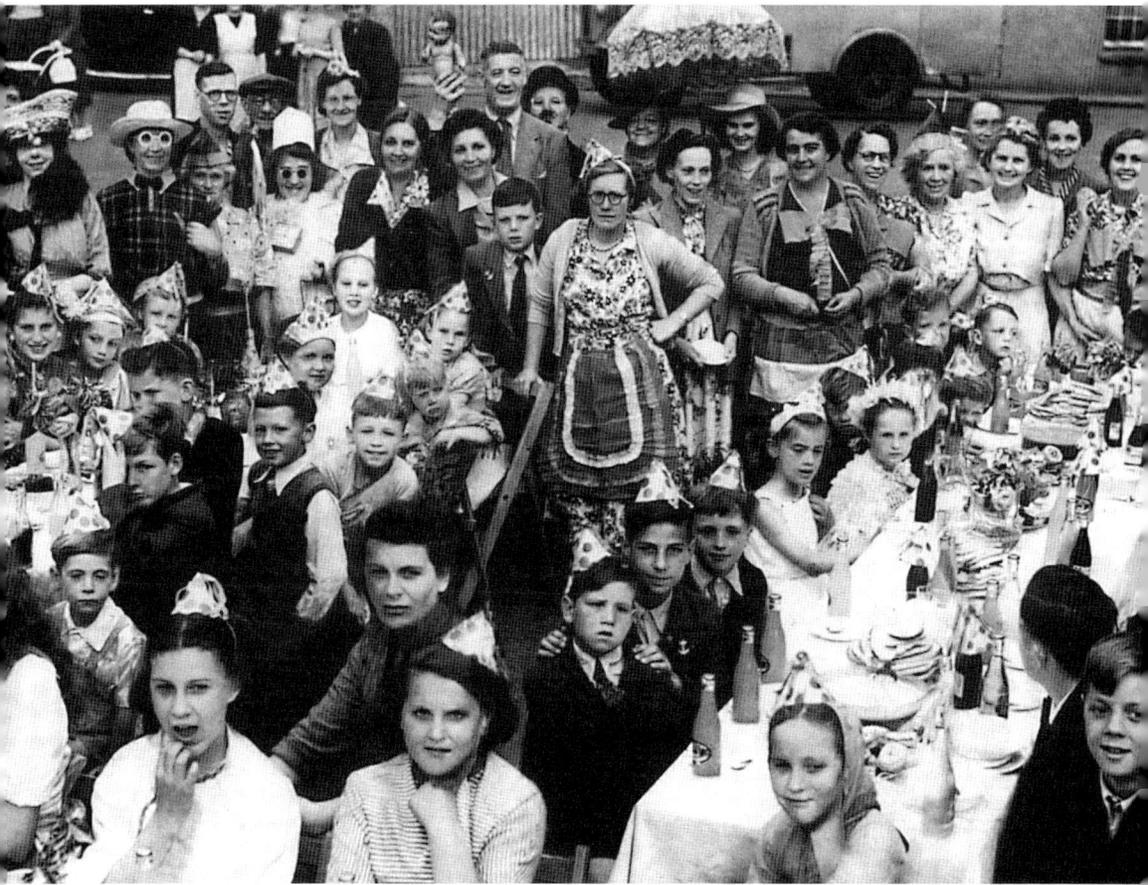

Coronation Party, June 1953 at the Bull Ring. Maisie Evans is pictured at the centre amongst neighbours from Swan Street, High Street and Heol Las. Some of the families represented in the party include the Clays, the Westcotts, the Ferrises, the Harrisons and the Evanses.

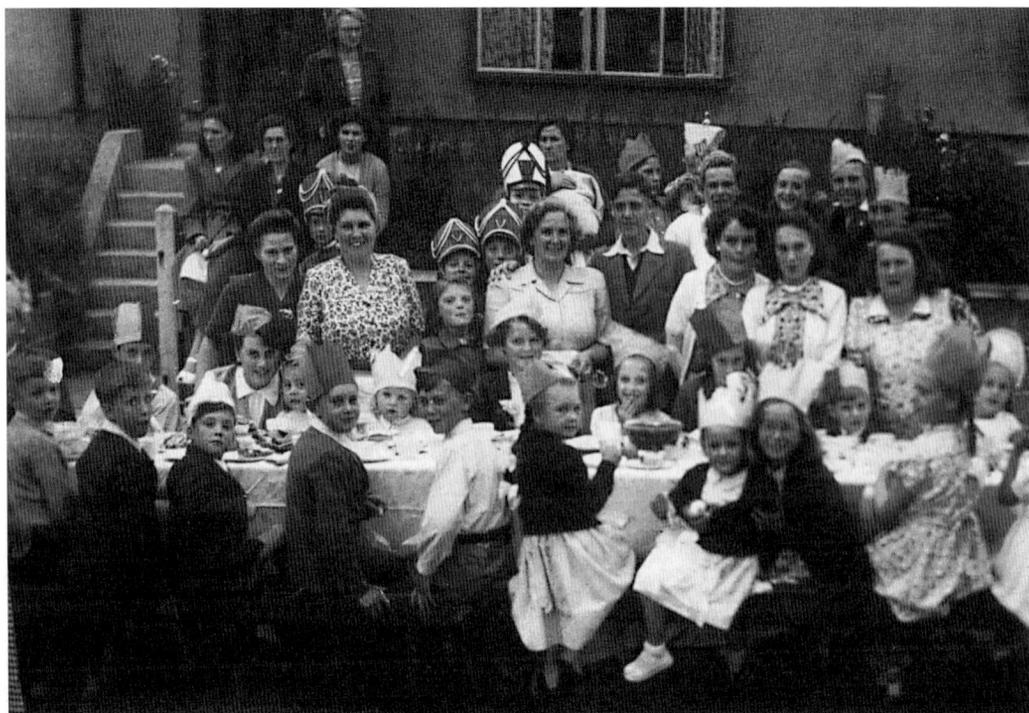

Above: Coronation party, June 1953 at Dancaerlan. Pictured are many of the neighbours from the top row of the estate built five years earlier. The group includes Gwen Clare, Brian Williams, Olwen Ashcroft, Colin Hooper, Gwyn Rees, Gwen Rees, Leighton Jenkins, Ena Jenkins, Mair Jenkins, Sheila Gillard, Blod Rees, Fred 'Flyo' Bryant, Margaret Bryant and Ann Stallard.

Opposite above: Coronation party, June 1953 at Church Street. On the day of this great celebration, the town was overshadowed by the news that Trevor Evans of Dancaerlan had gone missing in action, believed dead. A soldier in the Welch Regiment, he was dispatched to South Korea only weeks before when the Chinese launched a vicious attach on Hook Hill. Although badly injured, he survived and news arrived on 31 August 1953 that he was alive.

Opposite below: Llantrisant men on an outing, *c.* 1953. Pictured back row from left are: David Edwards, David Molly, Joe Osbourne, -?-, Gordon Jenkins, Jimmy Clay, Dick John, Cliff O'Neill, Mr John, Wyndham Edwards. Front row from left: Glynne Bendle, Ron Wietchurik, Bill 'Cowboy' Jenkins, Mickey Montague, Ivor Watkins, Dennis Hurley, Ivor Hurley and Bill John.

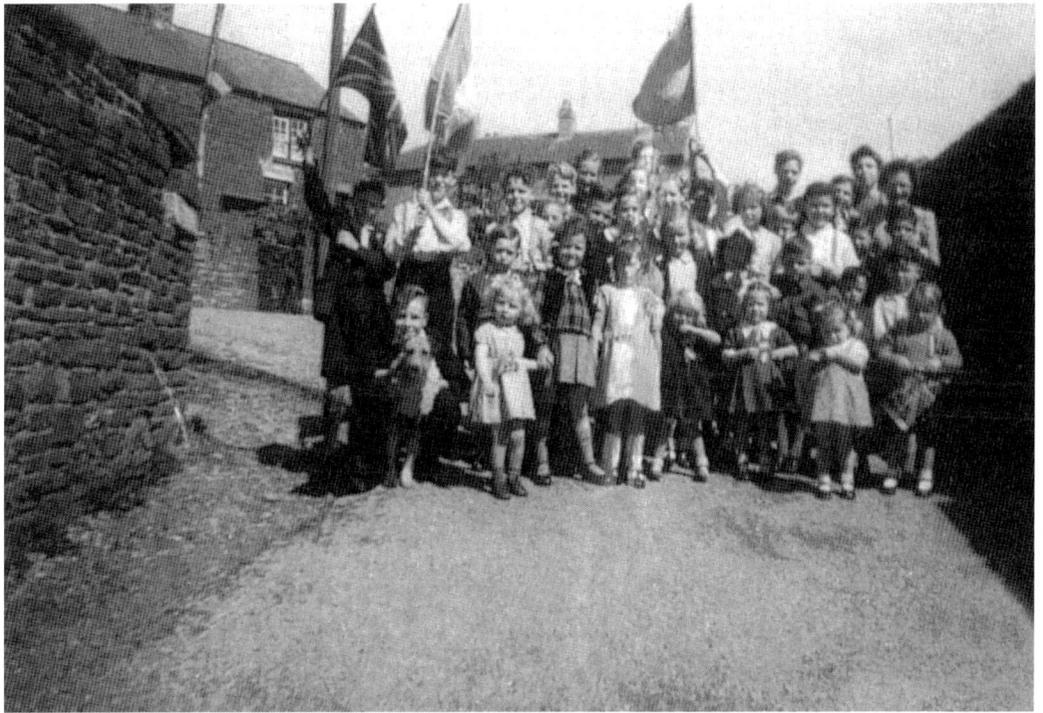

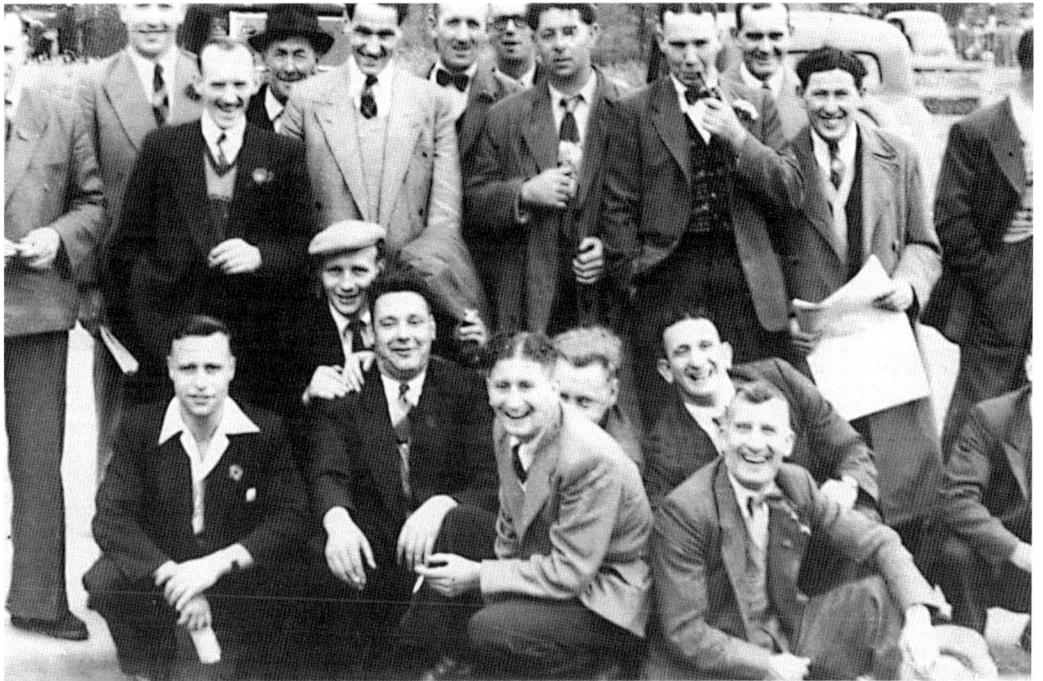

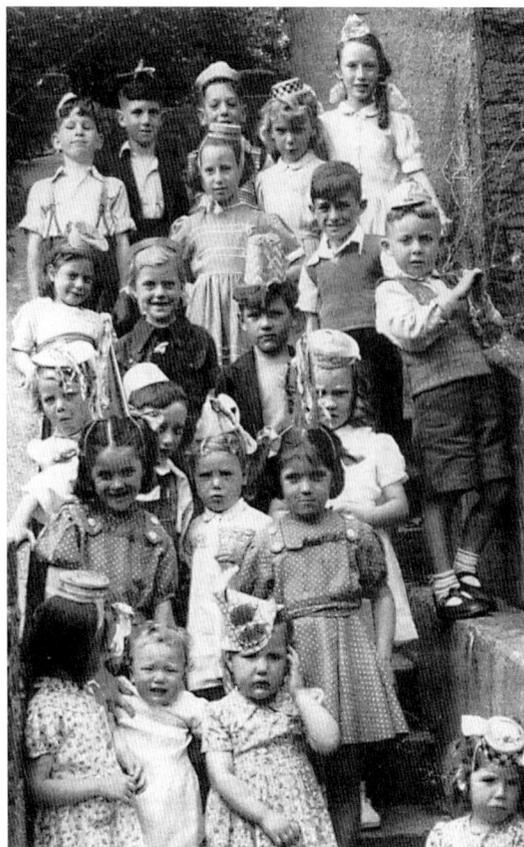

Children pictured outside the Social Hall ('The Hut') during the 1953 Coronation celebrations. Pictured back row from left are: Gareth Goronwy, David Jenkins, Gordon James, Gwlithyn David. Fifth row from left: Pamela Huish, Daphne Barratt and David Baker. Fourth row from left: Lynne Baker, Anne Baker, Haydn Rees and Gerald Kendall. Third row from left: -?-, Richard David, Sandra Thorne. Second row from left: twin sisters Gaynor Jenkins and Gillian Jenkins. Front row: Ann Bryant, others unknown.

Opposite below: Blackpool trip, *c.* 1956. The regular weekend trips on board Edwards Buses to Blackpool were organised by Sadie Williams at the cost of £3 each. Included in this picture are Marlene Williams, Oswald Raison, John Clay, Menai Perkins, Sheila Gillard, Maureen Woodward, Katie Evans, Ivy Raison, Sadie Williams, Richard Owen, Meryl Williams, Daisy Clay, Annie Groves, Colin Wheeler, Doreen Williams, Katie Perkins, Edwyn Williams, Doreen Williams, Jimmy Simpson, George Bendall, Gwyneth Courtney, Mary Williams and Joan Williams.

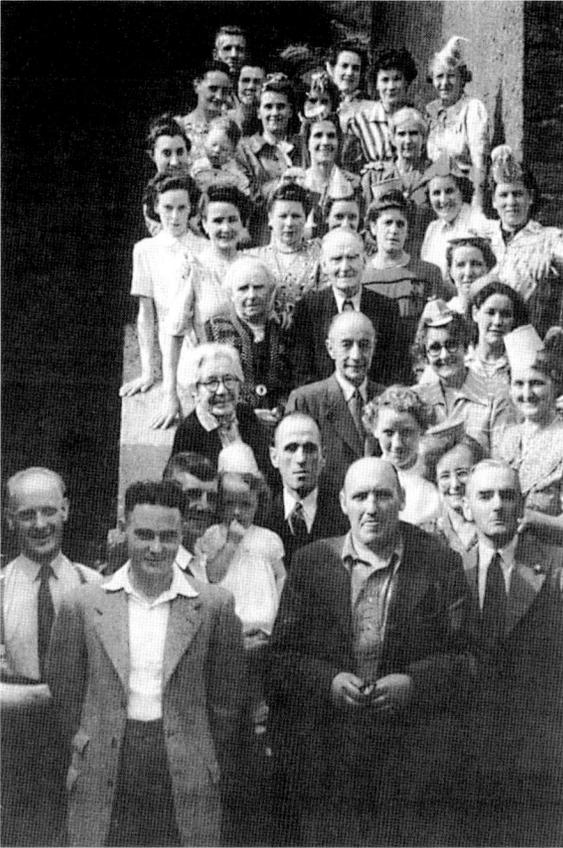

Left: Parents pictured on the same day as above outside the Social Hall in 1953. The pictured include Gordon Jenkins, George 'China' Birch, Winnie Jenkins, Nelly Daniels, Beatrice Hurley (three sisters), Mr Clay, Les Bryant, Watty Davies, Maisie Birch, Sarah Baker, Betty Thorne, Mrs Kendall, Mrs Davey, Mrs Clay, Mrs Huish and Mrs James.

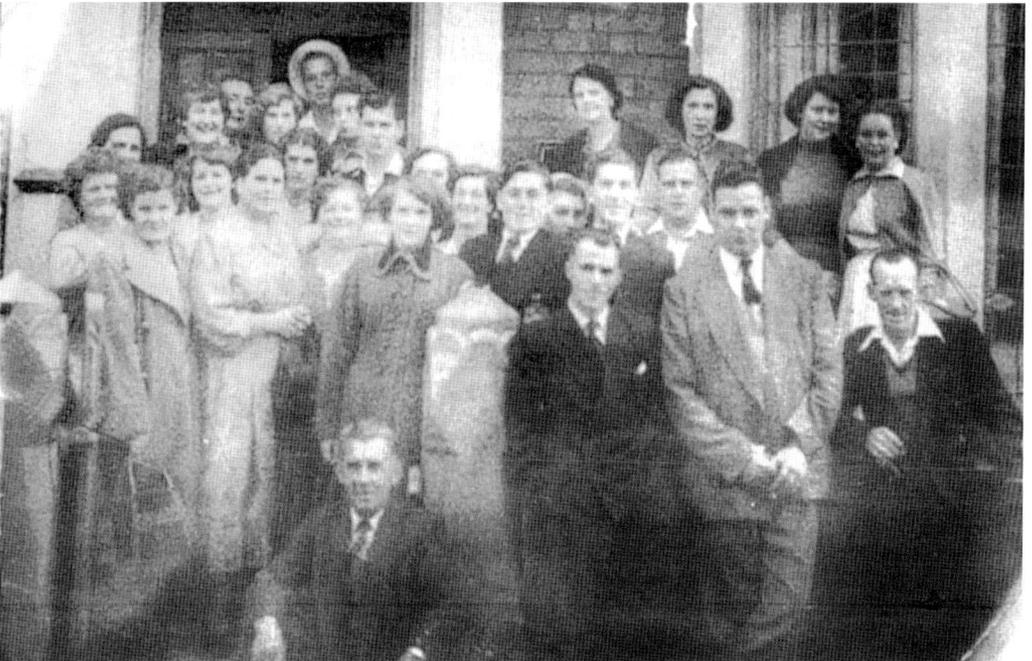

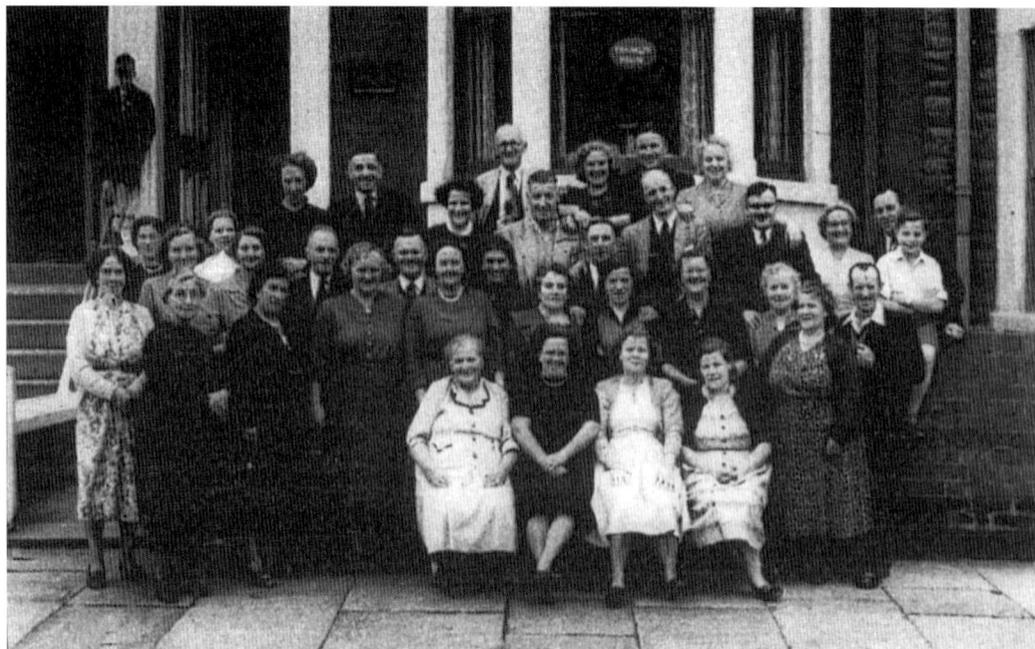

Above: Blackpool trip, *c.* 1956. Included in this group picture are Mrs Jenkins, Mrs Williams, William Williams, Eileen John, Arthur Evans, Maybury Owen, Mrs Jewell, Dai Morley, Mrs Davies, Gwyneth Ferris, Maggie Ann Francis, Jessie Francis, Amelia Rees, Morfydd Francies, Muriel Evans, Mrs Francies, Mrs Thomas, Annie Davies and Morgan Watkins.

Opposite above: Family and friends enjoying a Freeman's Dinner, *c.* 1956. Picture back row from left are: Reg Westcott, Blod Westcott, Bonnie Lewis, Mrs Fey, Fred Fey (owners of Fey's Record Shop, Pontypridd), Gwyneth Hooper, Colin Hooper, Cyril Crockett, -?-, Arthur Hooper, -?-. Front row from left: Brian Westcott, Dorothy Westcott, Carole Hooper, Marilyn Preston, Mrs Crockett, -?-, -?-.

Opposite below: The wedding of Yvonne Phillips and Gordon Miles, 24 August 1957. The happy couple met as teenagers when they both sang in the church choir. They were married at Llantrisant Parish Church and later settled into the houses alongside Llantrisant House where they raised their two daughters, Phillipa and Carolyn.

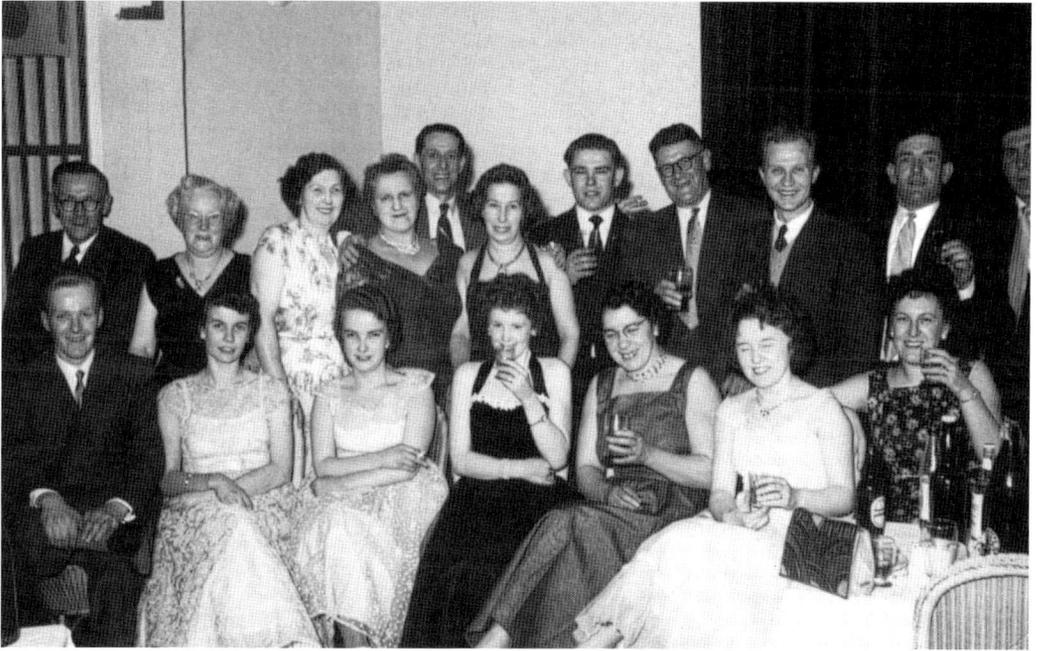

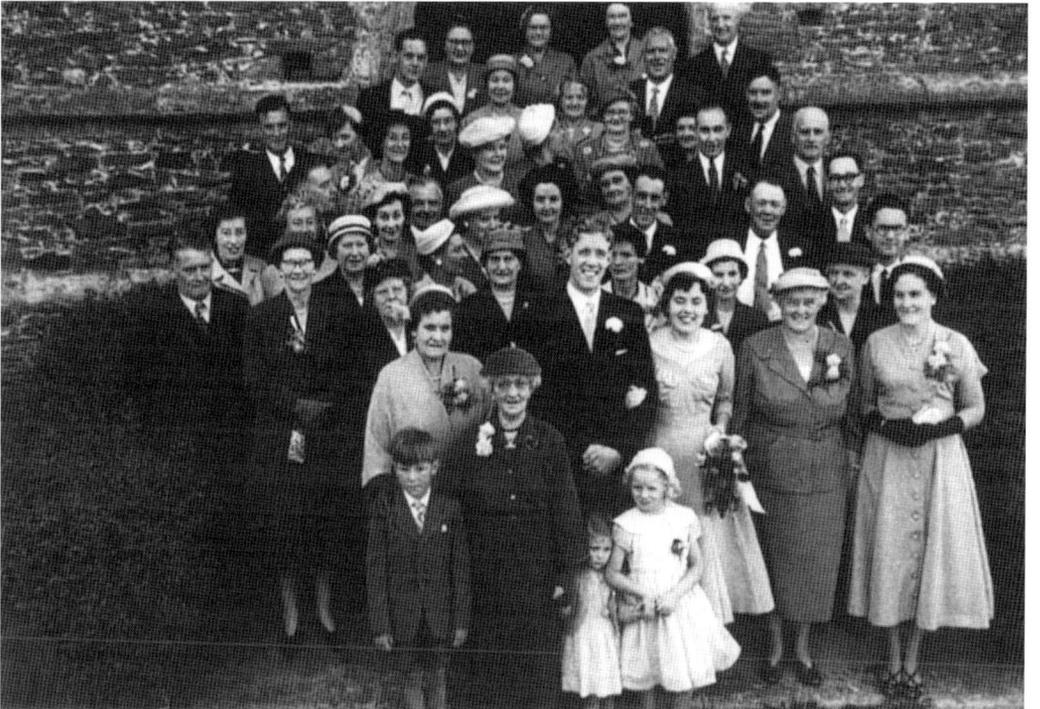

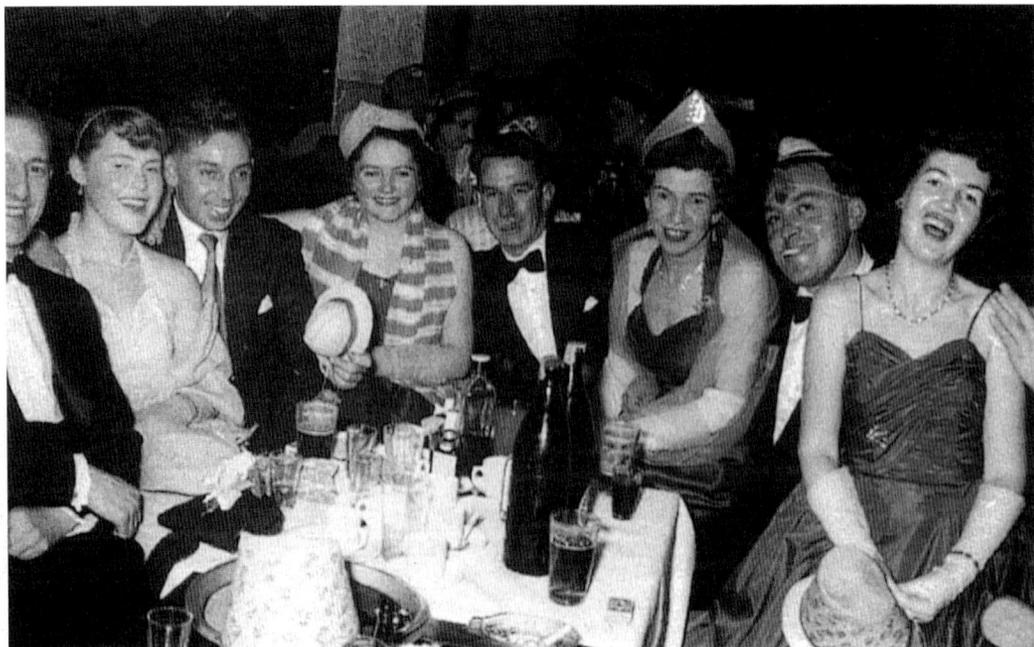

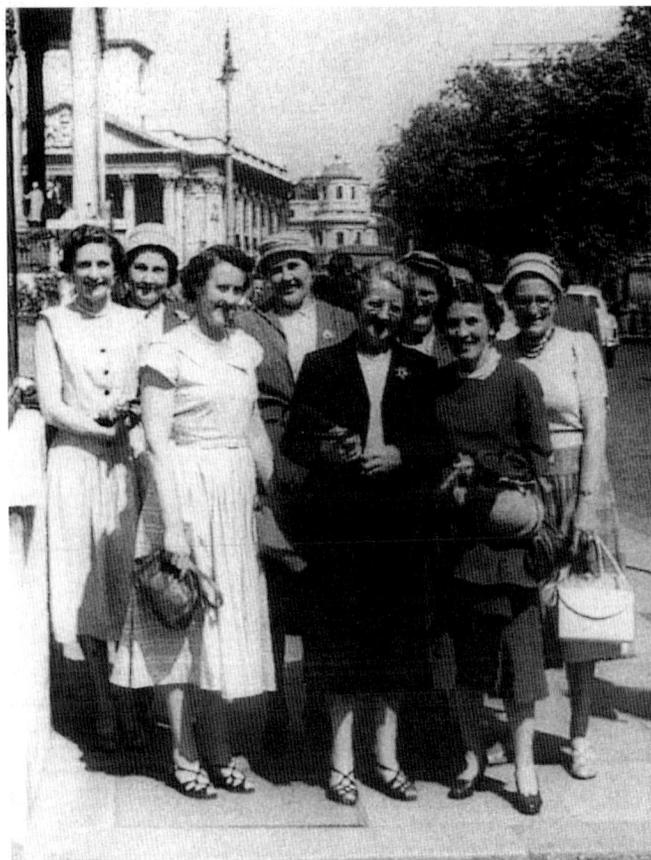

Above: New Year's Eve party at Bindles, Barry, *c.* 1958. Pictured from left: Tom Williams, Edna Little, Peter Little, Olga Little, Bill Rees, Mona Rees, Billy Little and Mary Williams.

Left: Llantrisant women on a day trip to London, *c.* 1965. Pictured from left are Dolly Sharp, May Salmon, Betty Sharp, Gwyneth Cornelius, Mrs Thomas, Betty Williams, Mary Jenkins and Ceinwen Bissett.

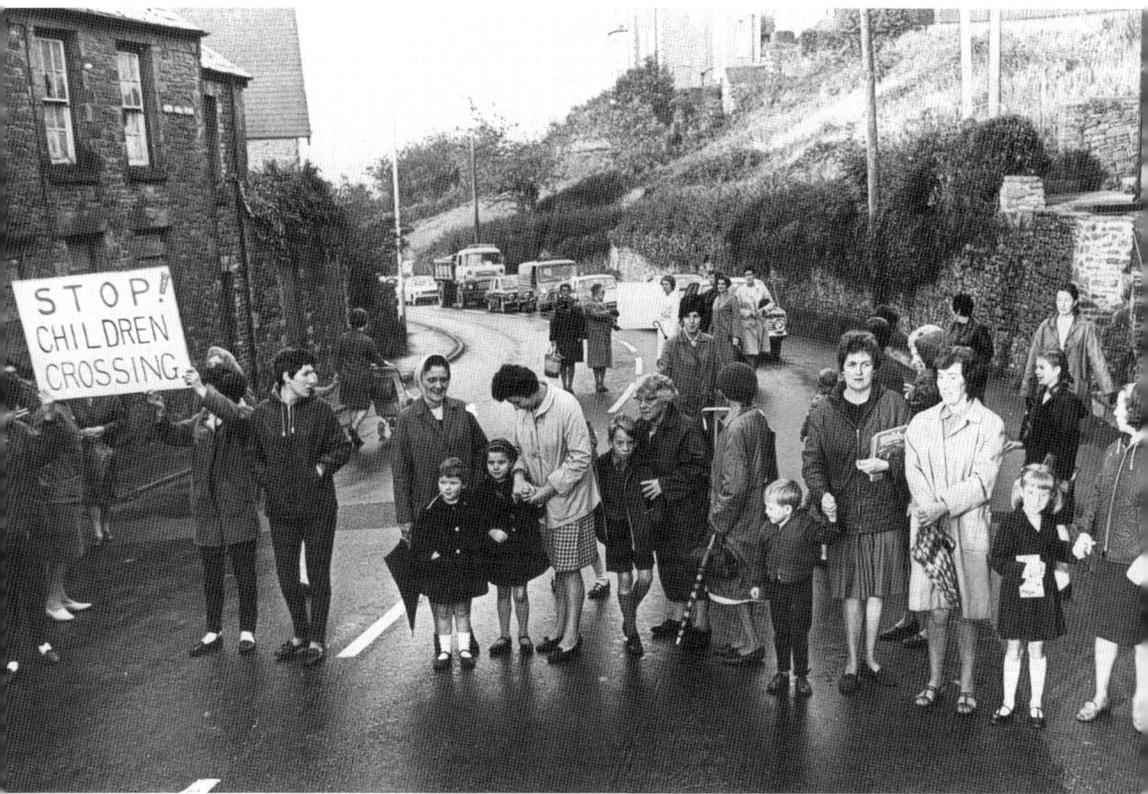

Above: Mothers and children blocking the main road at Southgate in protest of difficulties of children crossing the road in October 1968. To the left is the former Wesleyan Chapel, the ironmonger store and the homes lived in by Ernie Rex, Joan Stephens and Mr Owens.

Left: Llantrisant neighbours at a banquet in Cardiff Castle, *c.* 1975.

Above: Jack H. James, Deputy Master and Controller of the Royal Mint, 7 August 1967. Mr James visited the site to cut the first turf and mark the beginning of the new Royal Mint. On 19 February 1968, James Callaghan MP, Chancellor of the Exchequer, laid the foundation stone.

Opposite above: Clerk to the Town Trust, Trefor Thomas meeting Her Majesty Queen Elizabeth and the Duke of Edinburgh at the opening of the Royal Mint on 17 December 1968. The Queen pressed a button which set in motion the machine turning out the first of the new decimal coins to be produced in the new building.

Opposite below: A street party on Erw Hir, 1 July 1969. The group of children, mainly from Erw Hir and Llantrisant House are pictured celebrating the Investiture of Charles as the Prince of Wales. Some of the children pictured include Sarah Rees, Mark Rawlings, Phillipa Miles, Carolyn Miles, Jane Henley and Robert Henley. Celebrations lasted from April to October, and included dances at the Social Hall, a concert featuring Gilliam Humphreys, Brian Beaton and Llantrisant Male Choir in the parish church and a bonfire on the Graig.

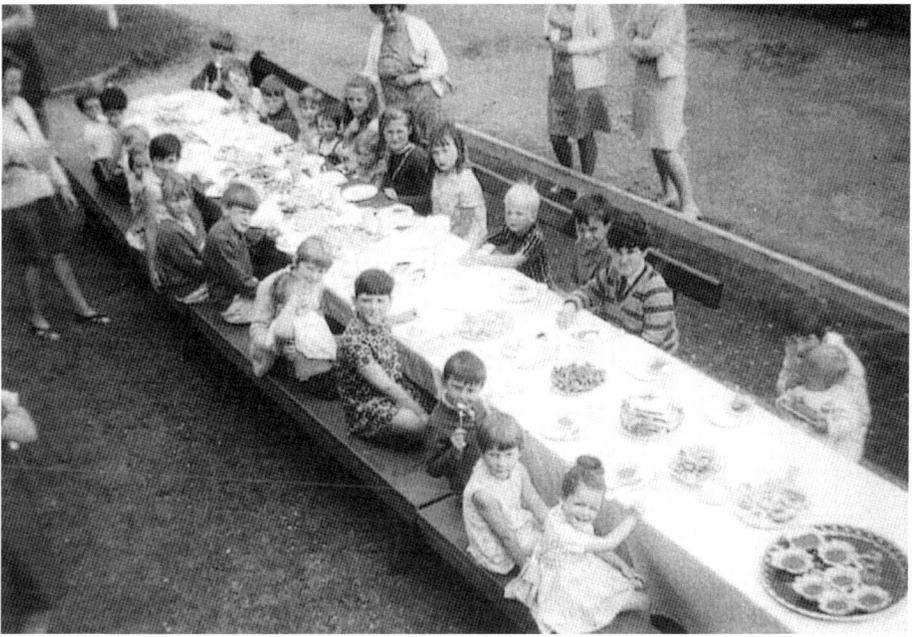

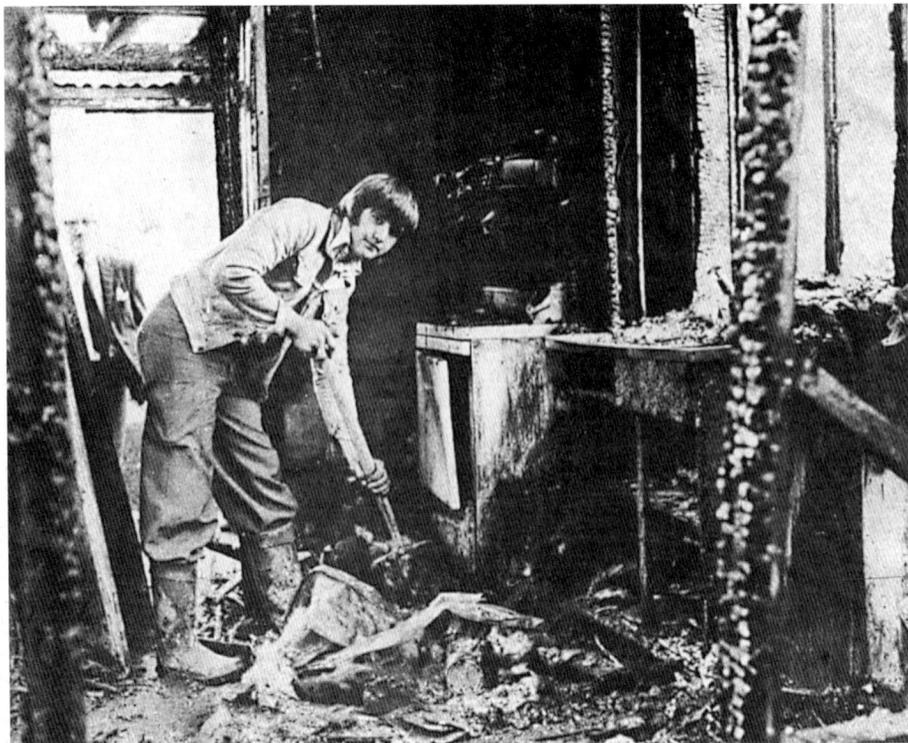

Above: Clive Causon cleaning the debris of his home in Dancaerlan which was gutted by fire in September 1975. His parents, John and Joan, were treated for shock after the incident at No.22, their home of the past twenty-seven years. Clive's brother and his wife, Mr and Mrs Vivian Shaw were upstairs getting ready to go out when the flames engulfed the house. It was neighbour Ena Evans who raised the alarm.

Opposite: Kelvin Eason expressing his concern that the water pump on Heol Las would be removed if a housing scheme went ahead in 1974. The pump was later restored in 1991 and is one of three (including the Town Pump on the Bull Ring and the second on Newbridge Road) which are maintained by the Town Trust. Since no one dared put a tax on water there are no official records of the wells but Llantrisant would have had an abundance of them. Kelvin Eason, the eldest son of Bill and Gladys Eason, was born in 1949 and grew up in Dancaerlan. He later enjoyed the distinction of being the youngest County Councillor in Great Britain. Despite a career at the Electricity Board, Kelvin remained a faithful public servant throughout most of his life. He was councillor of Llantrisant and Llantwit Fardre Rural Council from 1970 to 1972 and Glamorgan County Council from 1971 to 1974. Kelvin also served on Mid-Glamorgan County Council from 1973 to 1981 and Llantrisant Community Council from 1991 to 1999.

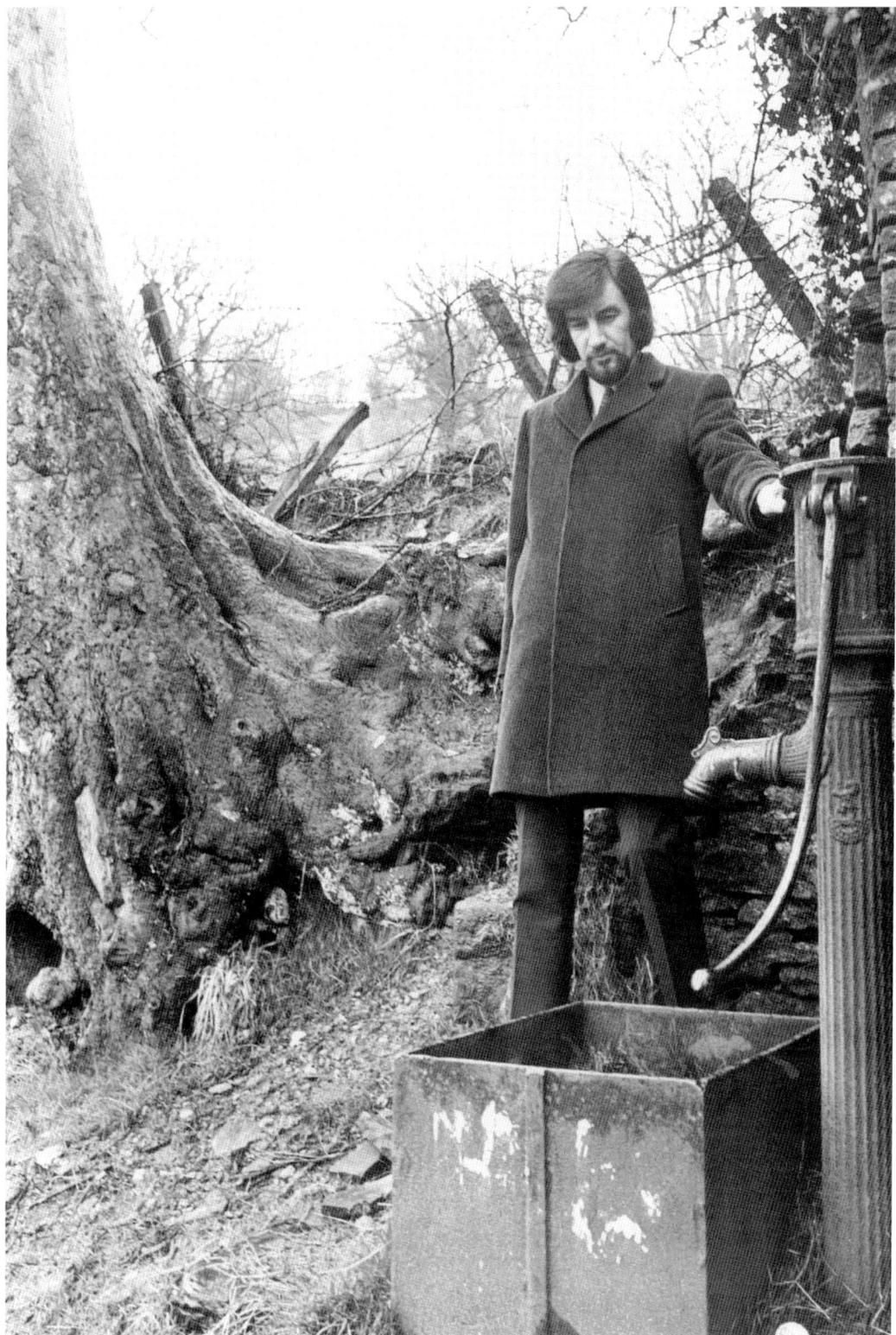

Above: Neighbours from Sunnybank pictured during the 1970s decided to recreate the scene of the carnival from more than twenty years before (see below). They include: Pat Alexander, Jean Greenslade, Ann John, Megan Holder, Muriel Evans, Sharon Greenslade, Lynne Alexander and Rhian Alexander.

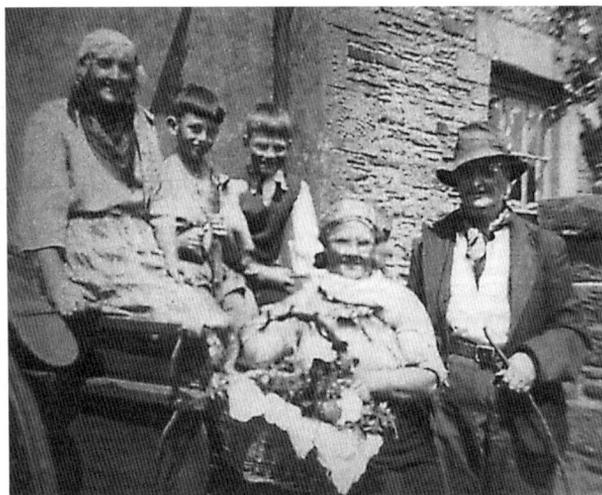

Left: Neighbours from Heol-y-Sarn celebrating a Llantrisant Carnival during the early 1950s. Pictured from left are: Celia Watkins, Henry Alexander, Malcolm Evans, Muriel Evans and Harriet Alexander.

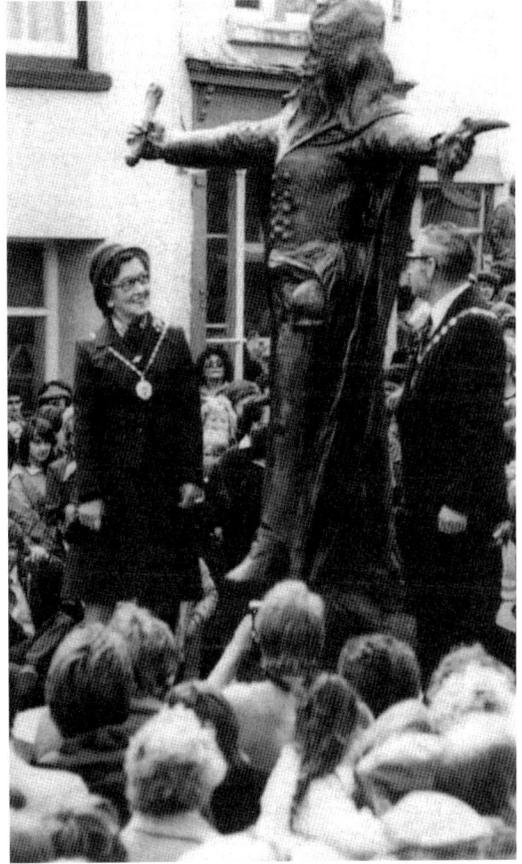

Right and below: Taff Ely Council Mayor George Preston and his wife Rhoswen unveiling the statue to Dr William Price at the Bull Ring, May 1982. Probably best known as Llantrisant's most eccentric character, almost a century earlier he burned the remains of his dead infant son (named Iesu Grist) on East Caerlan, causing a fury amongst the God-fearing residents. The doctor conducted his own defence brilliantly at the Crown Court trial, and was acquitted by Justice Stephens, paving the way for the passing of the Cremation Act in 1902. The unveiling marked a major festival in the town that attracted tens of thousands of visitors who enjoyed the many stalls, games, music and also a Beating of the Bounds ceremony. On the nearby Common the Sealed Knot reinacted a battle of four centuries earlier as a wonderful party-like atmosphere prevailed throughout the town.

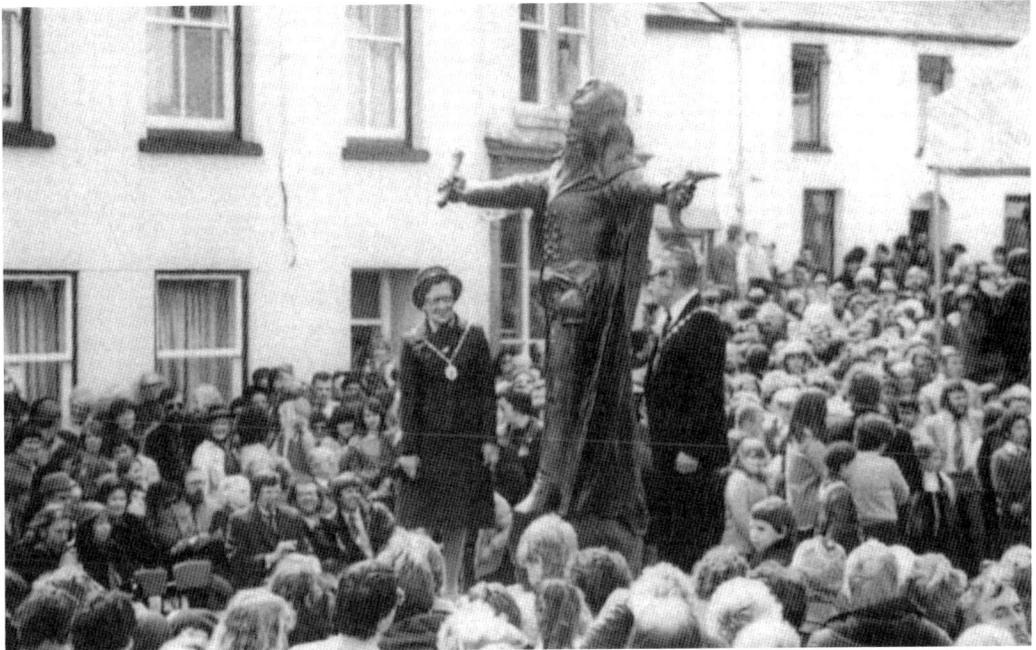

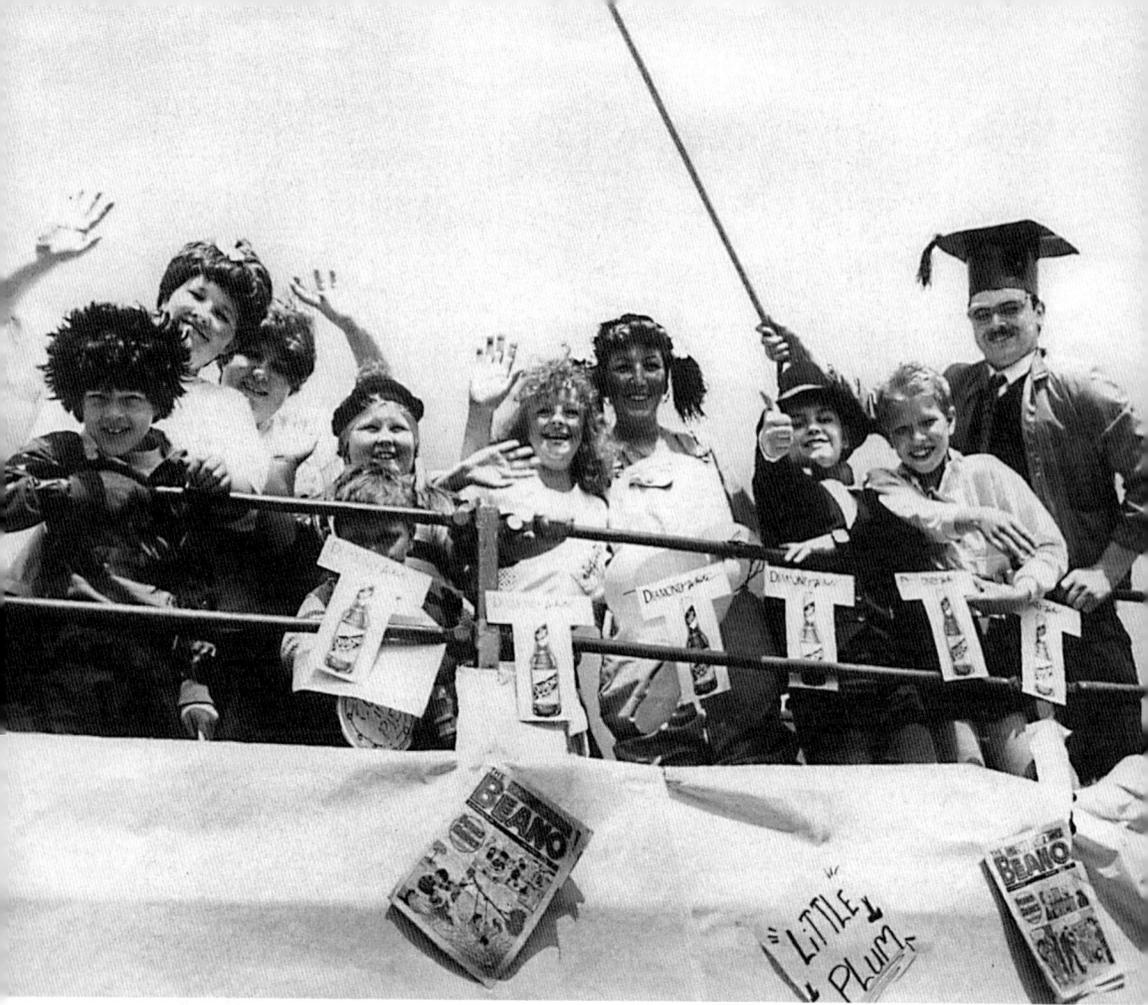

Above: Llantrisant Carnival's 'Beano' float, *c.* 1984. During the 1980s, Llantrisant was alive with the annual May Festival. With a main stage on the Bull Ring and a marquee on the castle green, it began as a fun-filled day of family entertainment. Pubs, schools and local groups got together to create a colourful display of floats for the carnivals, with roads lined with stalls and pig roasts by the local scout group.

Opposite above: Llantrisant wives dressed as a harem for Llantrisant Carnival, *c.* 1975. Mary Tintar was in charge of the group that included Mary Rees, Carlene Doster, Amelia Rees and Pat Alexander.

Opposite below: Schoolfriends in fancy dress for Llantrisant Carnival, *c.* 1985. Pictured from left are: Gareth Alexander, Sarah Buckland, Lynne Alexander, Jamie Wood, Sian Griffiths and Victoria Wood. A parade along Heol-y-Sarn, High Street and Newbridge Road eventually reached the rugby field at Cefn Mabley for a day of fun.

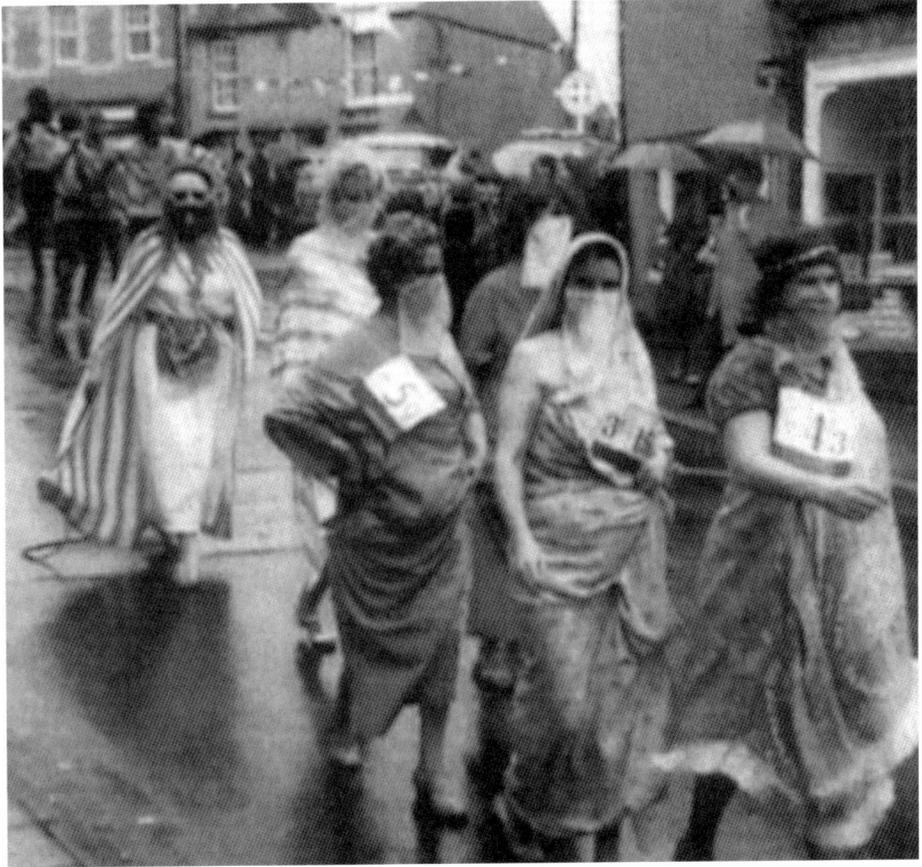

Midwife Shirley Penhallurick pictured in October 1987 with the Llantrisant rugby team players she delivered. Shirley delivered more than three-quarters of the seventy-strong Llantrisant squad of the first, second and youth teams. One day in 1987, she saw the youth team catching a bus to a game and realised that except for one she'd either delivered them all or attended to their mothers.

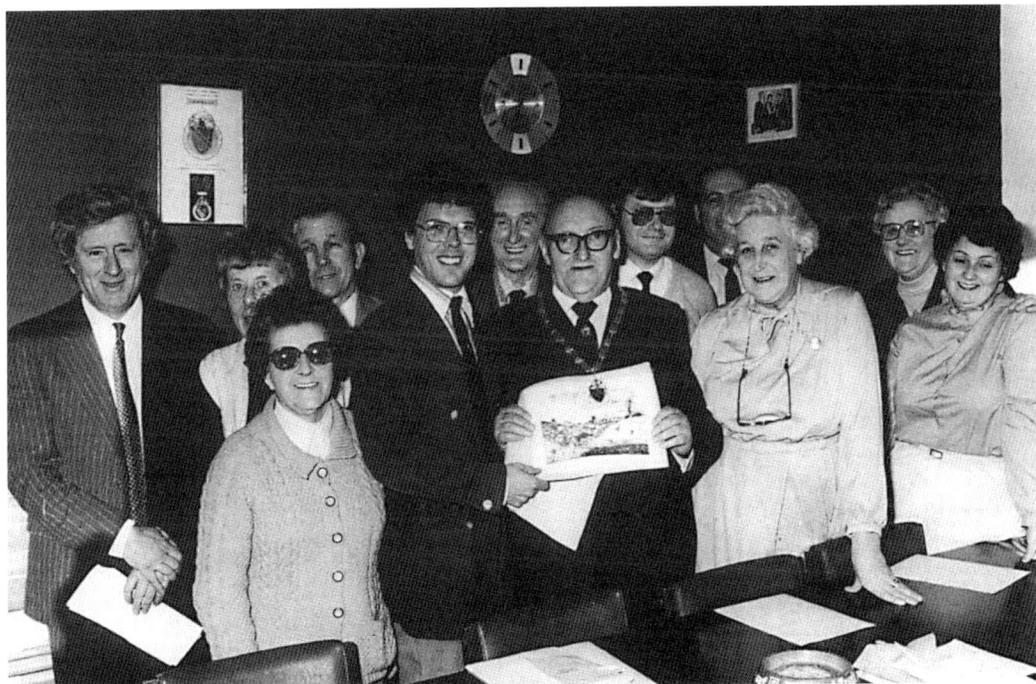

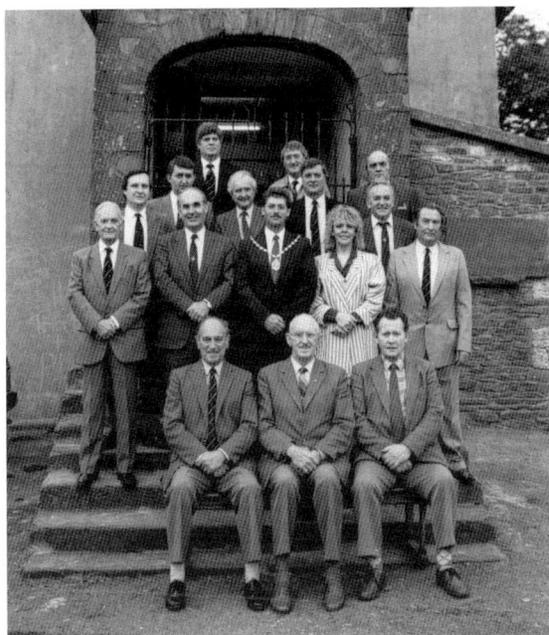

Above: A presentation of a sketch of Llantrisant by Dr Delme Bowen to Alcyn D. Ajax at the end of his year of office as Chairman of Llantrisant Community Council 1982/3. Pictured back row from left are: Dr David Morgan, Mrs A.G. Herbert, V. Pullin, E. Evans. D. Jones, R. Norman, E. Bunston. Front row from left: D. Powell. Dr Bowen, Mr Ajax, Mrs Stevens (clerk), Diane Baker (assistant clerk).

Left: Llantrisant Town Trust and Community Council celebrating the centenary of the Trust in 1989. Back row from left: David Thomas, Gareth John, David John. Third row from left: Martin Hooker, -?-, Trefor Thomas, Brian Groves and Roger Nott. Second row from left: Cledwyn Jones, Edmund Miles, Gareth Morris, Christine Nott and Gwyn Rees. Front row from left: Edward Thomas, Trefor Rees and Watcyn Jacob.

Opposite below: Llantrisant and Llantwit Fardre Rural District Council, *c.* 1972. The council was established by the Act of 1894. The parish vestry lost what remained of its authority and was only concerned with church matters. The new Rural District Council held its first elections on 17 December 1894 with Godfrey L. Clark JP, Evan John JP, and mining engineer Stephen Vivian representing the town ward. It remained in place until local government re-organisation in 1974.

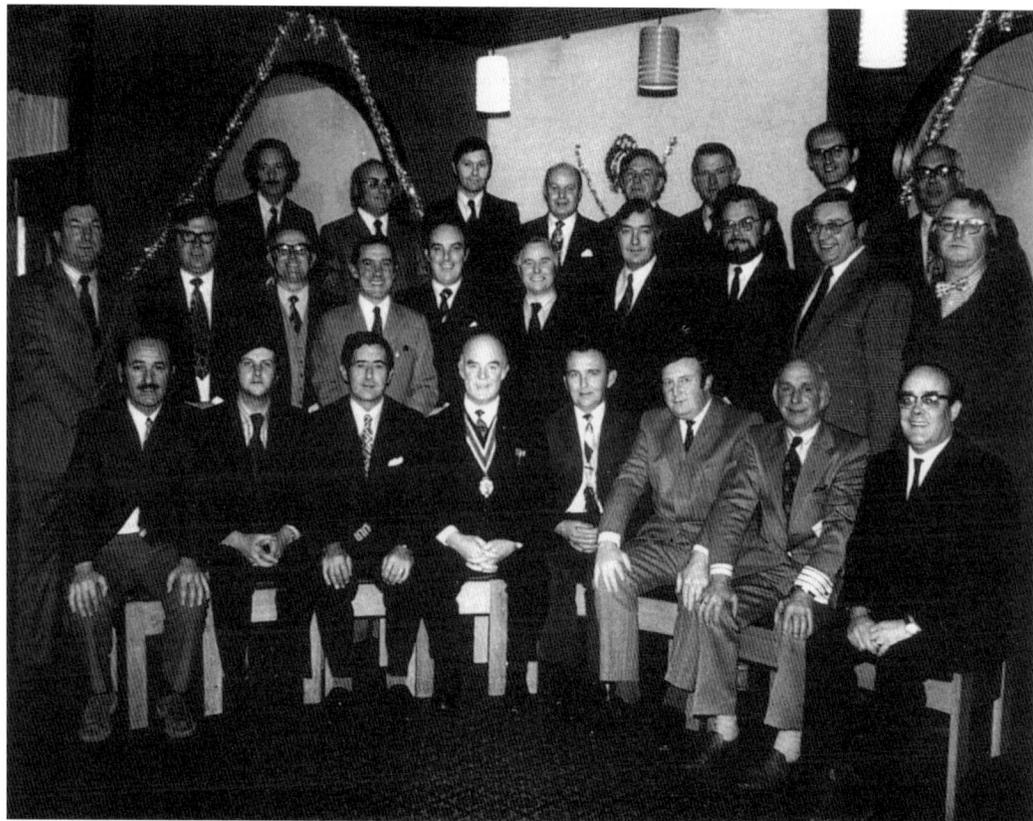

Above: Llantrisant Rotary Club, formed in 1973. The founder members met in the Castell Mynach Pub and raised funds for local charities. The first president was Allen Lewis, with Hywel Howells as the first secretary. Pictured back row from left: Roy Capener, Hubert Burridge, Bill Bridge, -?-, -?-, David Rees, David Lee and Dr Cliff Jones. Middle row from left: Brian Reed, Geoff Bell, Les Smith, Mervyn Collins, Jim Saunders, David Evans, Keith Lewis, Phillip Merrit, Kingsley Jones and Edwyn McGarr. Front row from left: Gordon Oliver, T. Turner, Hywel Howells, Allen Lewis, Robert Huxton, Gwyn Jones, Bill Taylor and David Napper.

Opposite: Town Trust bye-laws and regulations 1889. From the presentation of a Charter in 1346 to 1889 Llantrisant was a municipal borough, or corporate town. Under the Municipal Corporation Act, the borough was dissolved and became part of a wider administration. The dissolution brought into being the Llantrisant Town Trust, an elected group of trustees established under the Board of Charity Commissioners on 17 December 1889, to manage the common lands (Cymdda Fach and Cymdda Fawr) on behalf of the Freemen. As a free borough, it was a community of Freemen and its main purpose was to earn a corporate living. It was a trading and business community and to help it to succeed in a competitive world, its Freemen could trade freely without paying tolls into the town. They also enjoyed their own self-government, courts of law and control on markets and fairs. Records show the Court Leet on 1818 broke into a riot because the new clerk, Edward Priest Richards, could not speak Welsh.

LLANTRISANT TOWN TRUST.

BYE-LAWS & REGULATIONS

For the management of Commons and exercise of pasture rights of Common Lands—Cymdda and Graig—made by the Trustees of Llantrisant Town Trust, under authority of Scheme or Order of the Board of Charity Commissioners of England and Wales, dated 17th December, 1889.

1. No person unless authorised by the Trustees shall affix or post any bill, placard, or notice to or upon any wall, or fence, or upon any tree, railing, or seat on any of the said Lands.

2. No person or persons shall hold or take part in any meeting for the purpose of any political or religious demonstration or of any religious service, on the said Lands, without the permission of the Trustees.

3. No person shall cut any tree, sapling, shrub, underwood, or plant, or damage or deface, or in any way damage or remove any soil, turf, gates, notice boards, or other properties on the said Lands.

4. No person, except those entitled to the grazing rights on the said Lands shall cut any Fern or Gorse thereon, and persons so entitled shall cut only reasonable quantities for their own use, and not for sale, nor for the use of any other persons.

5. No person shall deposit any soil, refuse, or any substance whatsoever on any part of the said Lands, without the consent, and by the directions of the Trustees.

6. No person shall roll or throw stones, or burn Fern or Gorse, on the said Lands, nor shall any person do any acts thereon which may be dangerous to persons or animals.

7. The Trustees reserve the power to exclude all persons from the said Lands not being entitled to the rights and privileges appertaining to the Trust.

8. No entire horses or bulls over twelve months old shall be allowed on the said Lands.

9. No swine over two months old shall be allowed on the said Lands unless they are properly ringed.

10. No person shall turn any animal suffering from any disease on the said Lands.

11. No person shall be allowed on the said Lands in search of Game, Hares, or Rabbits, without the consent of the Trustees, except those entitled to the grazing rights.

12. The Trustees reserve the power to regulate the number of the Stock grazing on the said Lands and regulate the positions and portions of ground for grazing.

13. The Overseers or some other authorised persons are empowered to remove or impound any animals not in accordance with these regulations; or any stray animals not being the property of persons entitled to the grazing rights on the said Lands.

Every person who shall offend against any of the foregoing Bye-Laws will be proceeded against as the Law directs.

BY ORDER OF THE TRUSTEES.

Western Mail, Ltd., Cardiff.

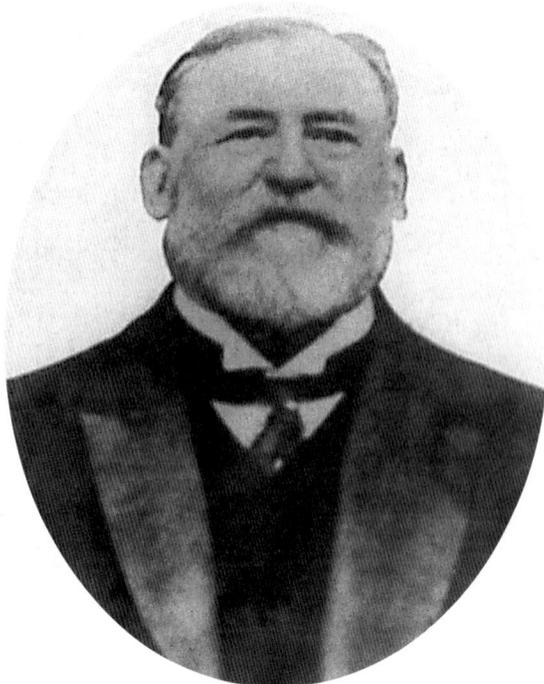

Above: Judge Gwilym Williams (1839-1906). Born in Aberdare to the son of a colliery proprietor, Gwilym Williams married into a Freeman's family and settled in the grand home of Miskin Manor. His wife, Emma Eleanor Williams, whom he married in 1866, was the daughter of William and Matilda Susan Williams. William Williams came from Aberpergwm and his family could trace its ancestry back to the last Welsh rulers of Glamorgan, Iestyn ap Gwrgan. Judge Gwilym Williams was enrolled as a Freeman in May 1904. Five years after his death his remains were taken from the parish church and re-interred at St David's Church, Miskin, no doubt because of the close association which existed between the family of the manor house and the villagers themselves. A statue was unveiled to Judge Williams in Cathays Park, Cardiff. His grandson was Sir Brandon Rhys Williams.

Opposite above: Beating the Bounds at Cross Inn, June 1954. Every seven years the Beating the Bounds Ceremony is held in the town and was reinstated in 1901 by Clerk Taliesin Morgan. Freemen and friends walk the seven-mile boundary of the ancient borough to commemorate the land where they were able to trade freely following the presentation of the 1346 Charter. Originally called Perambulation of the Bounds, it was designed so Freemen could ensure people were not trading within it without paying the toll. A second boundary march was also made by the clergy to collect the tithe from earnings of farmers.

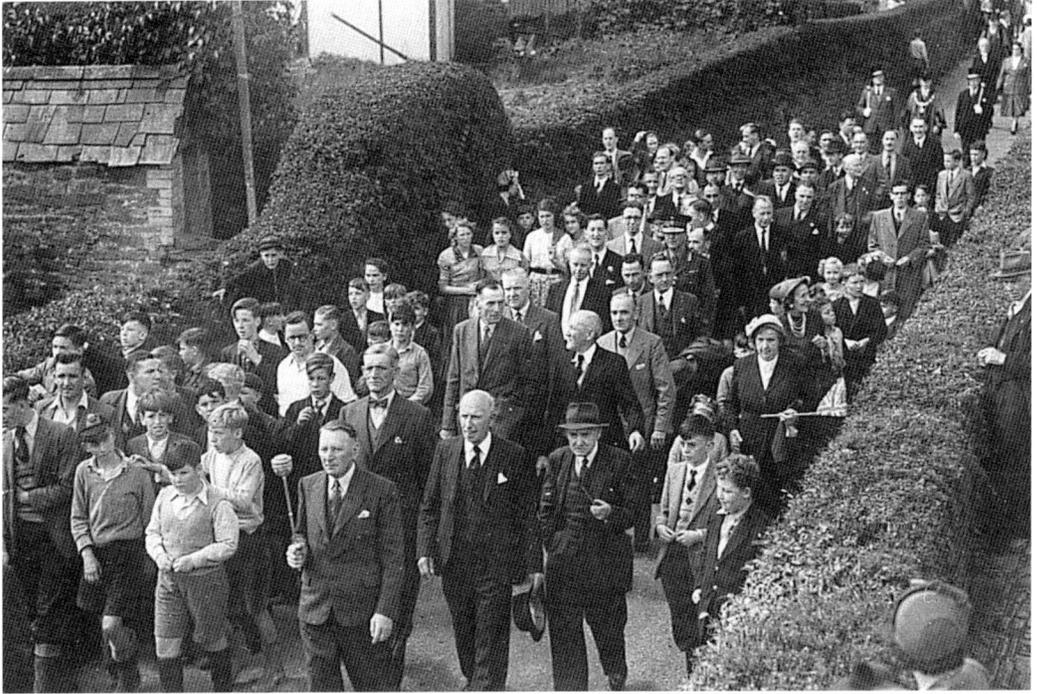

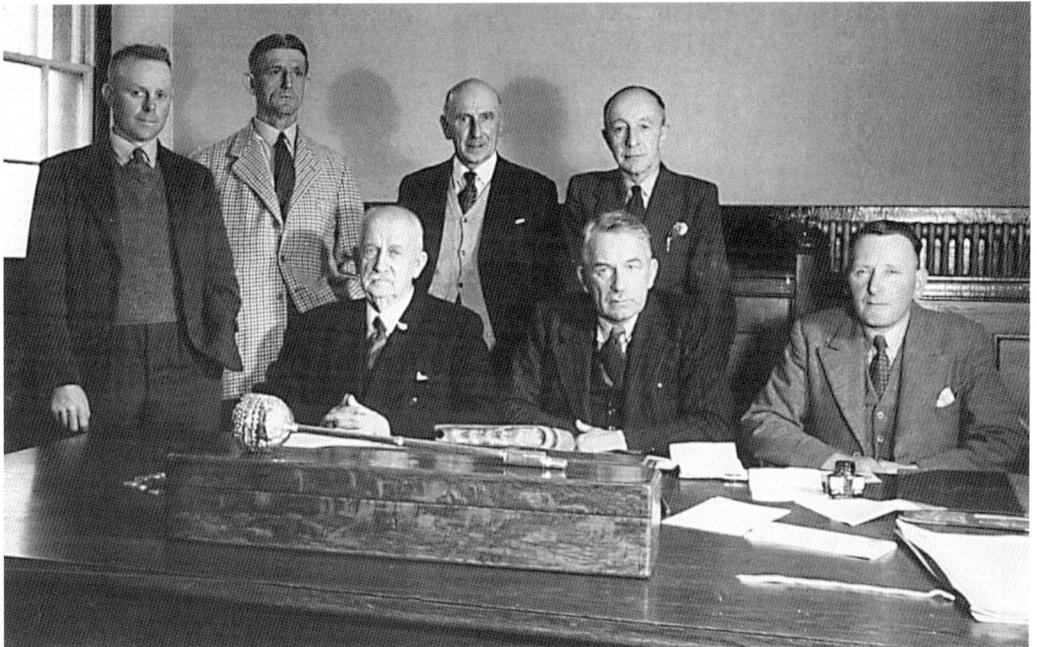

Above: Town Trust 1952. Pictured from left are: Harry Alexander, Glyn Morgan, Nathan Thomas, -?-, Tom Williams, -?- and Will Rees. During the 1950s, the Trust bought the freehold of Llantrisant Common from the Marquis of Bute for £500. They also bought Treferig Railway Line from British Rail and in 1957 secured the purchase of the castle green and the Town Hall. The Trust manages 300 acres of Freemen's land with ownership vested in the Charity Commission.

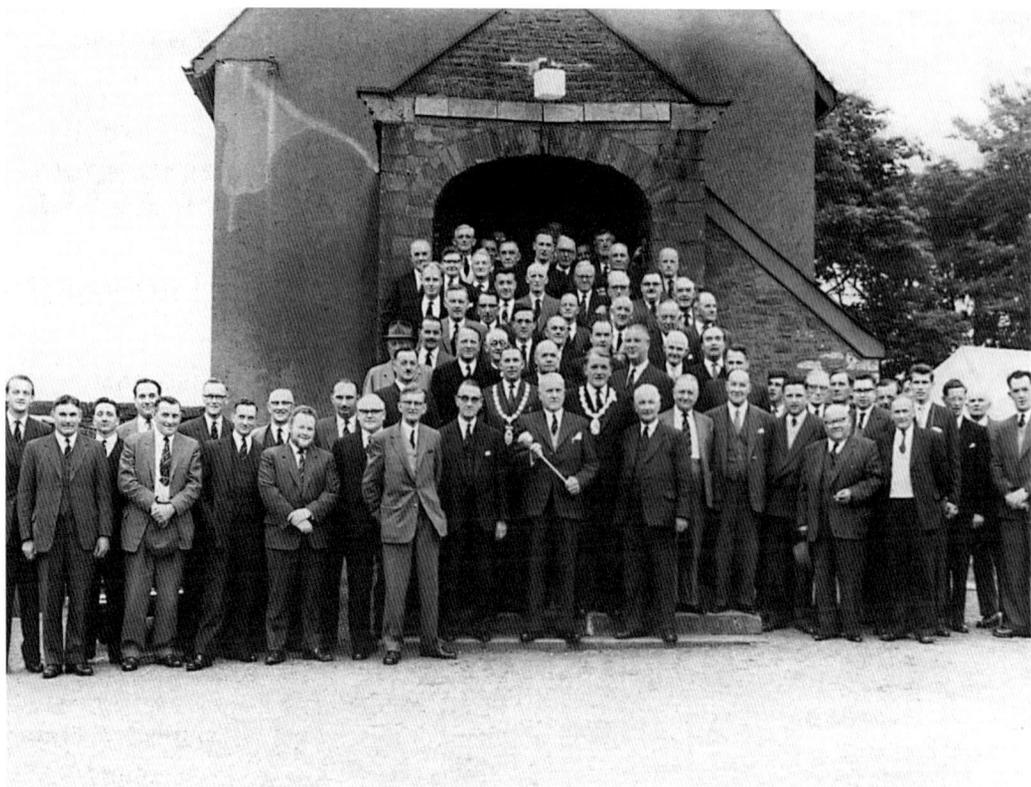

Above: Court Leet with clerk Thomas Vivian Rees outside the Town Hall, May 1960. Today a Freeman must be at least twenty-one years old and is only enrolled if he can prove to be the son or son-in-law of a Freeman. For centuries, two other methods of securing the benefits were by gift or by being an apprentice for more than four years to a Freeman.

Opposite below: Beating the Bounds, 1 June 1968. The ceremony was organised by Gwyn Rees but with only £50 available he decided to hold a series of fundraising events. With the help of his wife Mary (the sister of Henry Alexander), they sold programmes for 1s each and also held dances and suppers. On the day, which was opened by Lady Traherne, they organised a piano and china smashing contest on the castle green and also raffled a pony.

Right: Freeman's Meeting, December 1965. Entries in the few surviving documents from the eighteenth century make remarkable reading particularly illustrating the rapid decline of the town – both economically and morally. References are made to the court acting on instances of people playing ball on Sunday and breaking the Sabbath, and also on innkeepers for refusing the court from inspecting the ale measures and keeping untimely hours in the pubs. There are frequent references to widescale financial discrepancies and misconduct within the running of the tolls and markets. An entry for June 1786 reads: 'all owner of pigs ought to put rings in their noses for they make great damage to the Common.' Another entry in 1799 read 'persons have turned scabbed and mangy horses on the Common. They are fined each for that offence.' In 1966 the Model Aeroplane Flying Club began using the lower part of the Common for demonstrations every Sunday morning.

The Llantrisant Town Trust

Notice is hereby given that

A MEETING

of the

Freemen of Llantrisant

will be held at the

Town Hall, Llantrisant
On Thursday, December 16th, 1965

at 7 p.m., for the

Election of a Freemen's Trustee

This Meeting will be followed by a

General Meeting

at 7.30 p.m. approx.

" In conformity with order of the Board of Charity Commissioners of England and Wales" Section 7

By Order of its Trustees

Evans & Short Ltd. Printers, Tonypandy

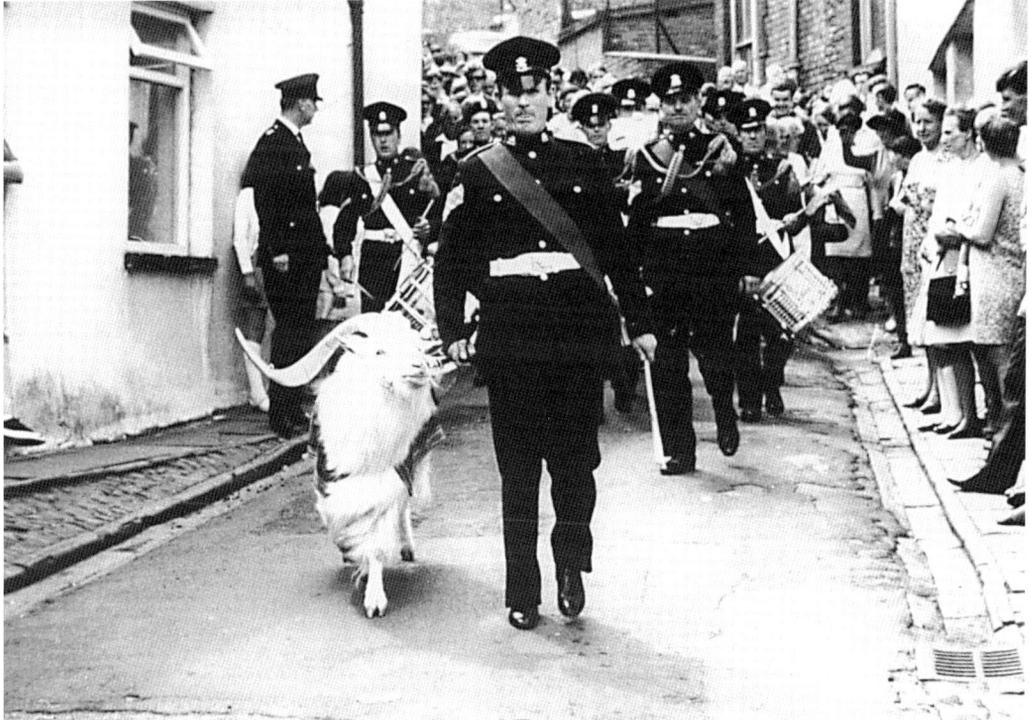

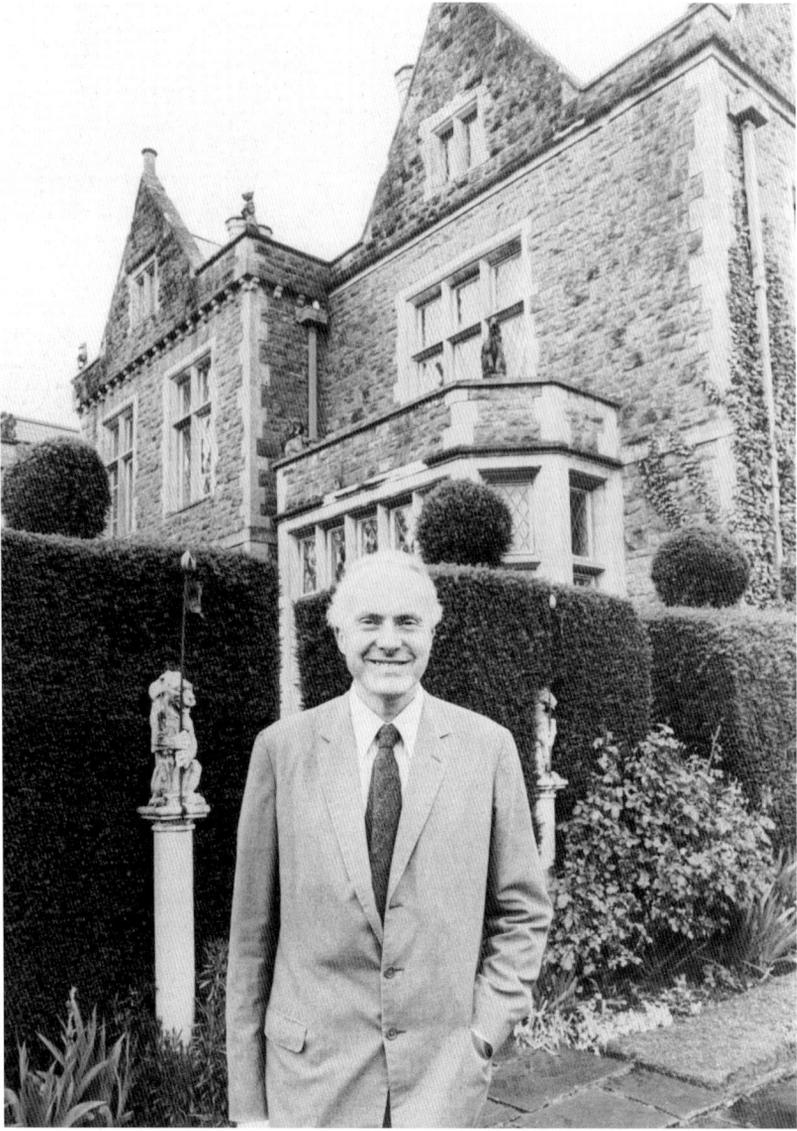

Sir Brandon Meredith Rhys Williams of Miskin Manor (1927-1988). The son of former Liberal MP Sir Rhys Rhys Williams (a junior member in Lloyd-George's cabinet) and economist Lady Juliet Rhys Williams, the 6ft 4ins Brandon was educated at Eton and Bolton Technical College and served in the Welsh Guards. He was made a Freeman in 1956 and served for many years on the Town Trust. Until 1962 he worked for ICI and for almost nine years was a management consultant for the Spastics Society. In 1968, as a Conservative candidate, he won the South Kensington by-election and remained in the forefront of social reform for pensions, child benefit and tenants of flats. In 1972, he joined the first British delegation in the Strasbourg Parliament and served as a MEP for London South-East from 1979 to 1984. His many public offices include chairman of the National Birthday Trust, vice-president of the London Choral Society and president of the Welsh Guards Association in East Glamorgan. He was married to Lady Caroline and the couple had two daughters named Miranda and Eleanor and a son, Gareth, who succeeded him to the baronetcy. Sir Brandon sold Miskin Manor a few years prior to his death at the age of sixty and lived in Groesfaen.

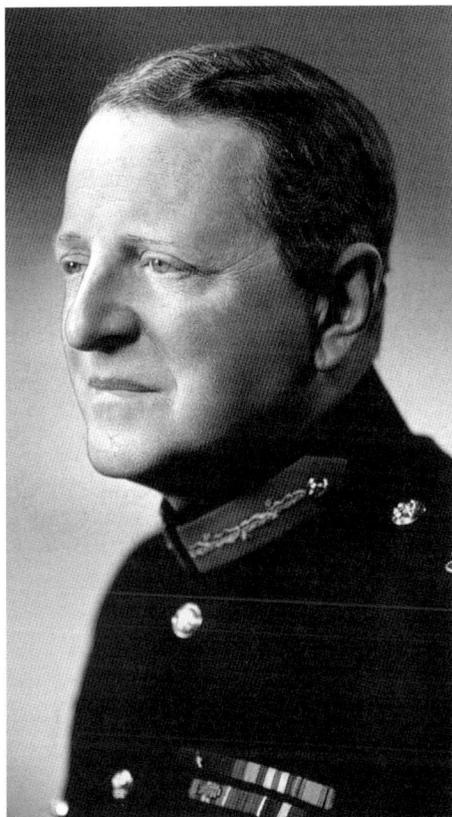

Above: Sir Brandon Rhys Williams MP presenting Sir Cennydd Traherne with a silver goblet to commemorate his being made Knight of the Garter, June 1971. The cup, fashioned in the form of the head of Llantrisant's silver mace, was presented as a gift from the Freemen. The Mace was taken to the foremost silversmiths in Hatton Gardens, who were asked to design a presentation gift fashioned on it. The result was the cup based on the head of the Mace.

Left: Sir Cennydd George Traherne KG, GCStJ, TD, MA, JP, (1910-1995). Born in December 1910 at Coedarhydyglyn, near Cardiff, he was educated at Wellington and Brasenose College, Oxford and trained as a barrister. In 1934 he married Olivera Rowena Binney. He served with the Royal Artillery and in 1942 was seconded to the military police. Later he was Deputy Assistant Provost Marshal in the 2nd Army and was early into France on D-Day. Unsuccessfully standing as a Tory candidate for Pontypridd in the 1945 elections, he was the Commissioner for South Wales Scouts and Chairman of the Cardiff Branch of St John's Ambulance. He was made a Freeman in May 1935 and a Trustee of the Town Trust in 1955. He became Lord Lieutenant of Glamorgan from 1952 to 1985, providing the link between Buckingham Palace and South Wales. He was knighted in 1964 and in 1970 was made a Knight Companion of the Order of the Garter – the first Welshman to achieve this honour.

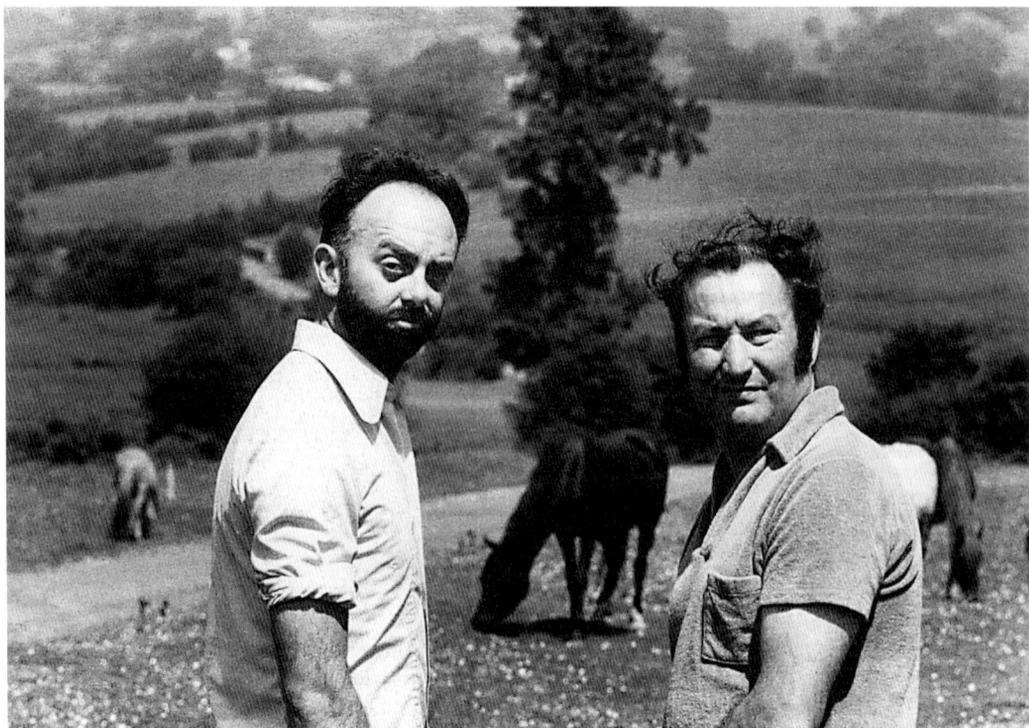

Above: Trustees Henry Alexander and Gwyn Rees on Llantrisant Common, 1971. Henry, the overseer of the Common, and his brother-in-law, Gwyn of the Fountain Shop were two of the fervent protestors against a threat by the National Coal Board to begin open-cast mining on the Common. Plans included open cast of eight or nine acres, taking 400,000 tons of coal from two separate seams. Fortunately, the scheme foundered. A similar scheme was discussed as far back as 1868 when the Marquis of Bute gave permission to Thomas Powell Esq to search the lands because he owned the mineral rights.

Right: Trustee Gwyn Rees and Clerk to the Trust Trefor Thomas bumping five-year-old Glyn Rees at the bumping stone, Maen Llwyd in Cross Inn, 28 June 1975, watched by Tom Richards. With the creation of the Ancient Borough of Llantrisant following the Charter of 1346, two distinct stones can be found to mark the ancient boundaries. Every seven years during the Beating of the Bounds ceremony, the sons of Freemen are bumped on Maen Llwyd in Cross Inn or Maen Brych near Talyfedw Farm to impress in their minds the ancient borough boundaries.

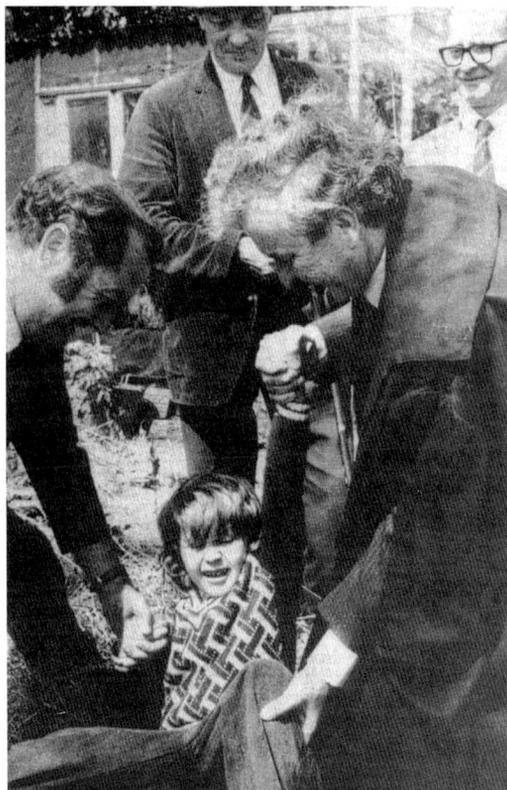

126

Tom Richards, Trefor Thomas and Brian Groves coming out of the culvert at Cross Inn during the Beating of the Bounds ceremony on 28 June 1975. At the church service earlier in the day, Llantrisant Male Choir sang *Llantrisant on a Mountain* written in 1892 for the visit of the Lord Mayor of London Sir David Evans, to the tune of *God Bless the Prince of Wales*. Coedely Colliery Brass Band marched the thousands of walkers through the old town, with many walkers delighted to reach Castellau where farmer Trevor John supplied them with cider.

Above: Trefor Rees, Clerk to the Town Trust from 1981 to 1989 with the Mace, 1989. The Mace is dated 1633 and has a Charles I five-shilling piece implanted in the head. It is older than the Mace in the House of Commons and has been carried in the ancient town for 350 years. Now it is only used at the annual Court Leet. According to local folklore the Mace was stolen in 1880 and found in a London pawnshop.

Opposite below: Cledwyn Jones, Clerk to the Town Trust from 1976 to 1981 with the Loving Cup. The Loving Cup was presented to the Town Trust by trustee Sir Brandon Rhys Williams of Miskin Manor. Its background has always remained something of a mystery but its origins stem from a British Rail deal to purchase part of the land at New Mill, Miskin. It was believed that Freemen had rights to grind corn at the Mill and since the railway would affect its right, they were obliged to compensate them for the land acquisition. The compensation money was used by Sir Brandon to purchase a Loving Cup for the Town Trust. It was actually designed by the same silversmith who created the Cheltenham Gold Cup and was made at Aspreys of Bond Street, London. The cup has the symbols of bread and fish to represent the Mill and its stream while the point of the lid has a mounted king with a sword to represent the Battle of Crécy. It is used every year at the Court Leet dinner, and otherwise is secured with the Mace in a bank vault.

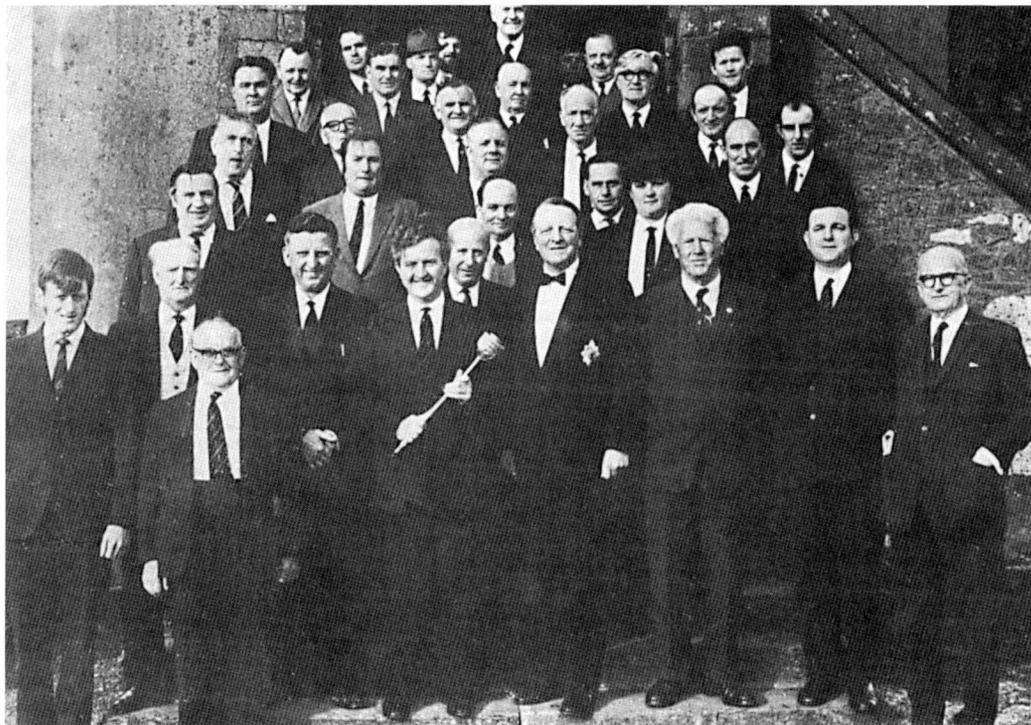

Above: Court Leet with Trefor Thomas as Clerk, *c.* 1976. Born at New Parc Farm in 1929, Trefor attended Cowbridge Grammar School, where he captained the rugby and cricket teams. He graduated with a degree in law from the University of Aberystwyth and spent two years on National Service in the Supreme Headquarters of the Allied Powers in Europe, based in Paris. He completed his three-year articles with Spicketts in Pontypridd. From 1969 until 1997 he worked in a variety of local law firms. He married Beryl in 1959 and the couple had two children, David and Alison. Trevor was clerk to the Town Trust from 1968 to 1977.

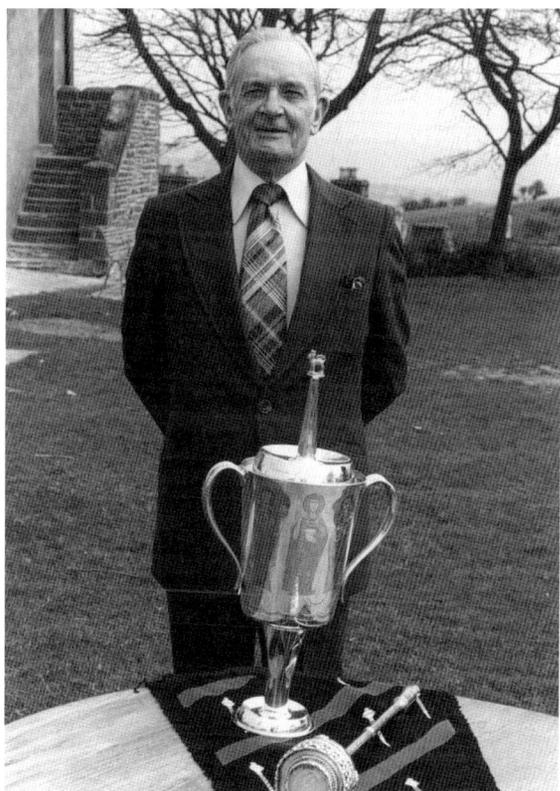

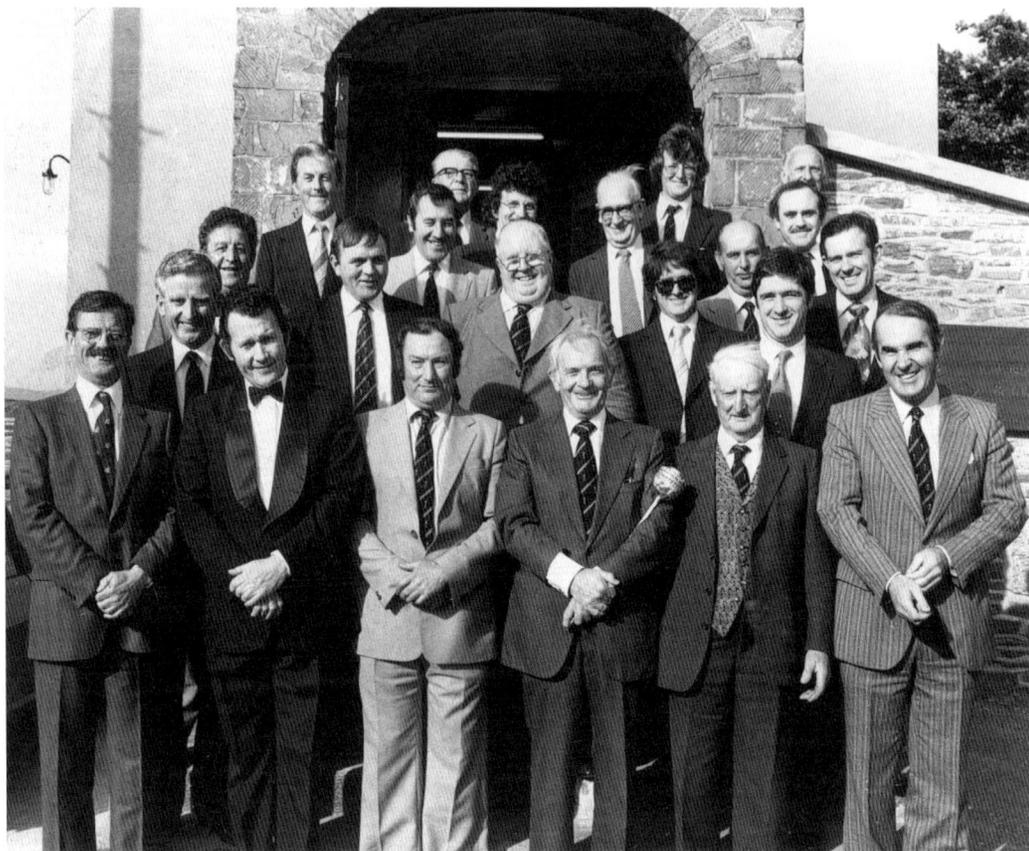

Court Leet, June 1981. Pictured with the Clerk to the Trust, Cledwyn Jones, is the newly enrolled Freemen along with trustees Dillwyn Lewis, Watcyn Jacob, Gwyn Rees, Tom Ferris and Edmund Miles. The Court Leet has remained the highlight of the year for the Freemen of the town and is carried out with the utmost distinction and respect for tradition.

Education
and Culture

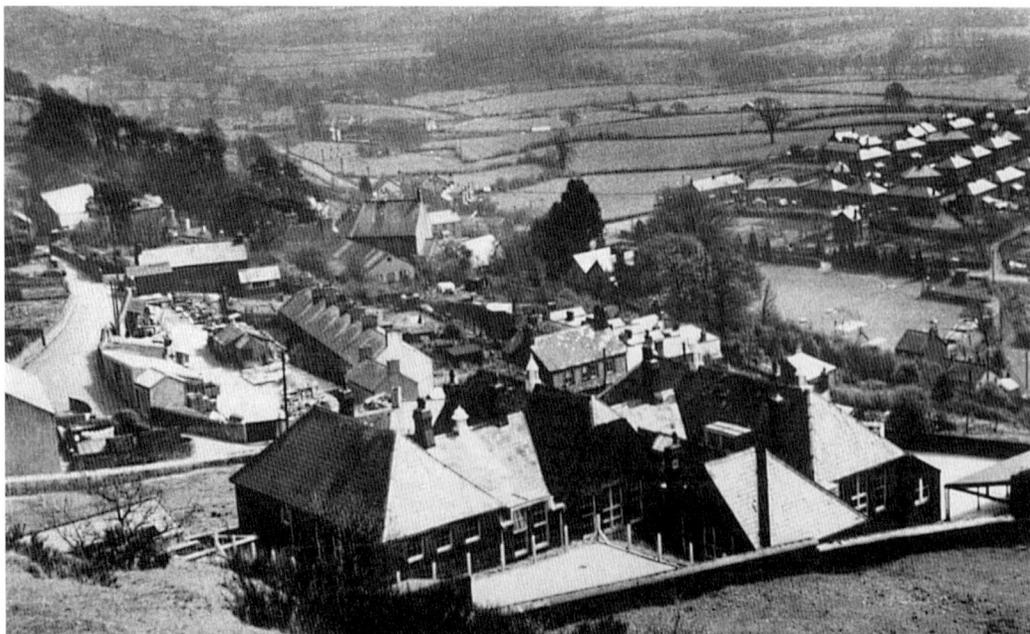

Llantrisant School, *c.* 1950. In 1865 Canon Powell Jones became Vicar of Llantrisant and during his incumbency the first school was established in the old town. The Llantrisant National School was opened at West Caerlan in 1867, on property of the Earl of Talbot and Shrewsbury, who presented the land for the use of a school, costing £2,000 to build. It was extended with what is known as the 'white school' in 1897.

Llantrisant schoolboys, *c.* 1951. Pictured back row from left are: Trevor Jones, George Jenkins, Malcolm Evans, Lyn Hayward, Ronald Williams, Dennis Clark, Bryn Williams, Stanley Rees, Islwyn Wilkins and Bobby Green. Front row from left: Gwynfor Greenslade, John Morgan Dai Thomas, Brinley John and Bryn John. This was schoolteacher Granville Norris' first class after leaving the army.

Llantrisant schoolgirls on a weekend trip to Ogmore with teacher Gwyneth Dickason, *c.* 1952. Pictured back row from left are: Pat Stoat, Marlene Williams, Valerie Streeter and Glenys Butterworth. Middle row from left: -?-, -?- and teacher Gwyneth Dickason. Front row from left: Margaret Harris, Marilyn Parry, Brenda Davies, Anne Bryant and Isabelle Truman.

Llantrisant Primary School children picture prior to their visit to Wells in 1954. Back row from left: Gillian Howells, Val Morris, Keith Ware, Neil Gibson, Ken James, Pat Cogbill, Jacqueline Land, Glynne Holmes, Hywel Davies, Steve Rawlings. Middle row from left: Tudor Osborne, Barbara Allen, Elizabeth Hurley, -?-, Anne Hicks, Sandra Thorn, Val Benyon, Elaine Greenslade, Bryn Noice. Front row from left: Anthony Maidment, Norman Evans, Gillian Perry, Myra Williams, Anthony McIntyre, -?-, Geoff Tarling and Bryn John.

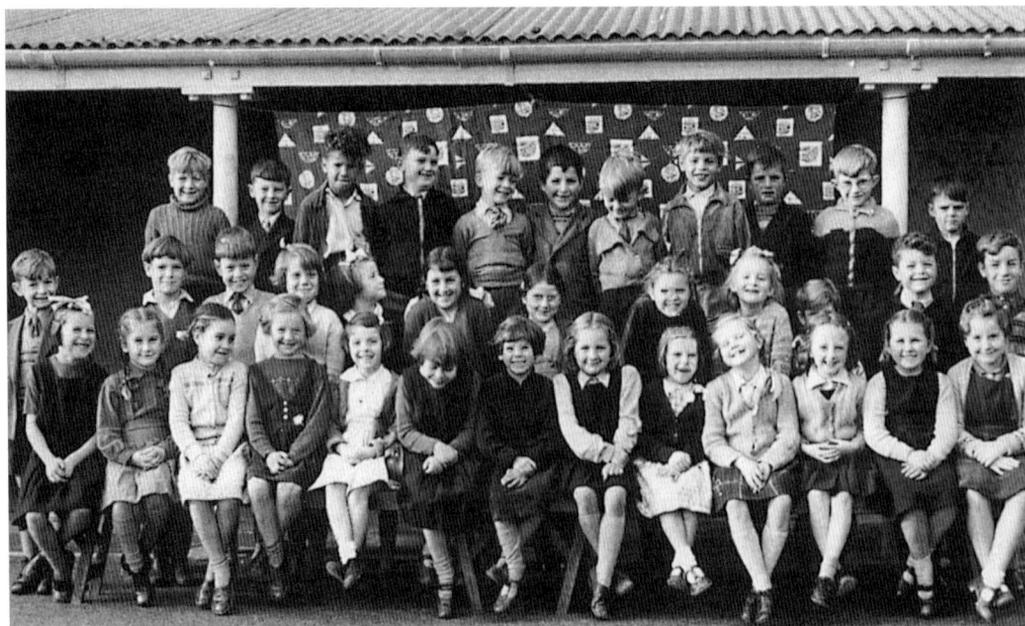

Above: Llantrisant Primary School, *c.* 1958. Pictured back row from left are: Michael Clay, William Thomas, Macdonald Haddock, Terrance Ward, Ronald Huggett, John Fraser, Robert John, David Haddock, -?-, Colin Barwick, -?-. Middle row from left: Raymond Evans, -?-, David Harris, Judith Barratt, Christine Harris, Shirley Williams, Carole Dobbin, Diane Aston, Diane Shephard, -?-, Richard David, Kelvin Eason. Front row from left: Barbara Clay, Margaret Wheeler, Rosalind Westlake, Lynne Doster, -?-, Ruth Tarling, Norma Wicks, Violet Rees, Cynthia Raison, Marie Wietchurik, Sheila Harris, Margaret Bryant and Diane Lamerton.

Opposite above: Llantrisant School, *c.* 1961. Pictured back row from left: Headmaster Mr Humphreys (father of soprano Gillian Humphreys), Pamela Harry, Karen Rowe, -?-, Cheryl Evans, -?-, Pamela Martin, John Watkins, -?-, Adrian Clark, Martyn Rees, Mr Rickard. Middle row from left: Anthony Rantsen, Andrew Giles, Sian Harris, Ian Watkins, -?-, Stephen Griffiths, Stephanie Griffiths, -?-, -?-. Front row from left: Teifion Rees, Brian Williams, -?-, -?-, Alison McCloud, Sandra Tookey, Sian Evans, Gail Doster, -?- and Christopher Benyon.

Opposite below: Llantrisant School, 1972. Pictured back row from left: Phillip Williams, Phillip Davies, Martin Reed, Nicholas Baldwin, David Evans, -?-, Richard Powell, Robert Henley, -?- and teacher Helen Jenkins. Third row from left: -?-, Deborah Thomas, -?-, Amanda Jones, Deborah Billett, -?-, Carolyn Miles, -?-, Gill Baker. Second row from left: Paula Ralson, -?-, Helen Flood, Helen Evans, Karen McKeen, -?-, Karen Holloway, Rita Jones, -?-, Front row from left: Steven Nichol, Andrew Griffiths, Hugh Dutfield, Glenn Evans, -?-, -?-, John Harry and Keith Greenslade.

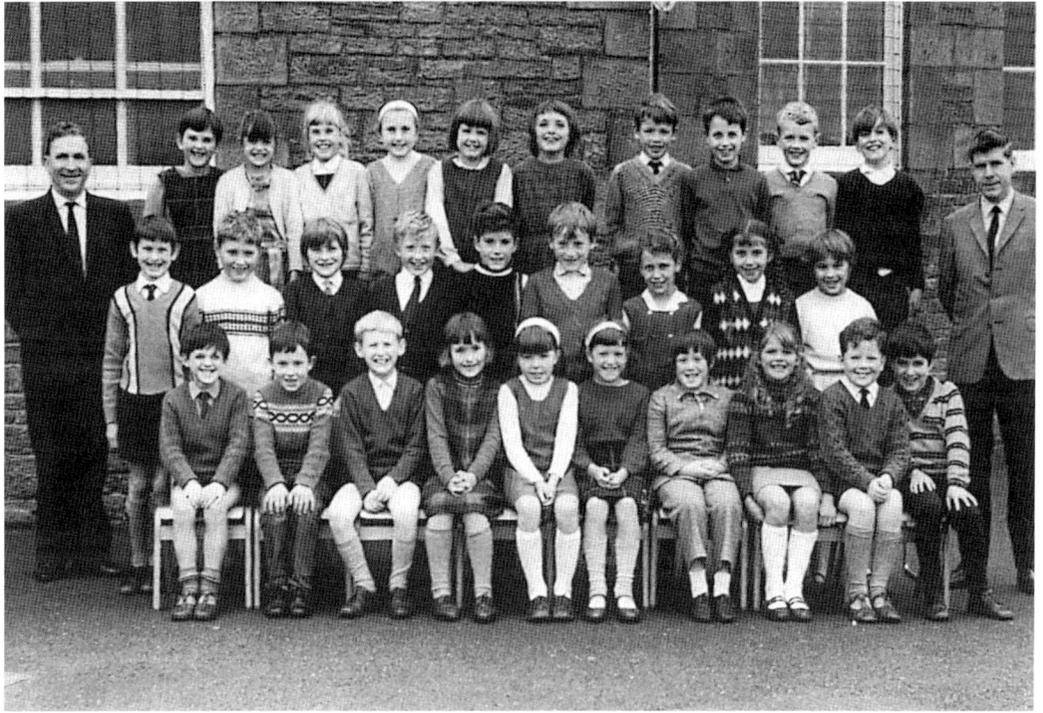

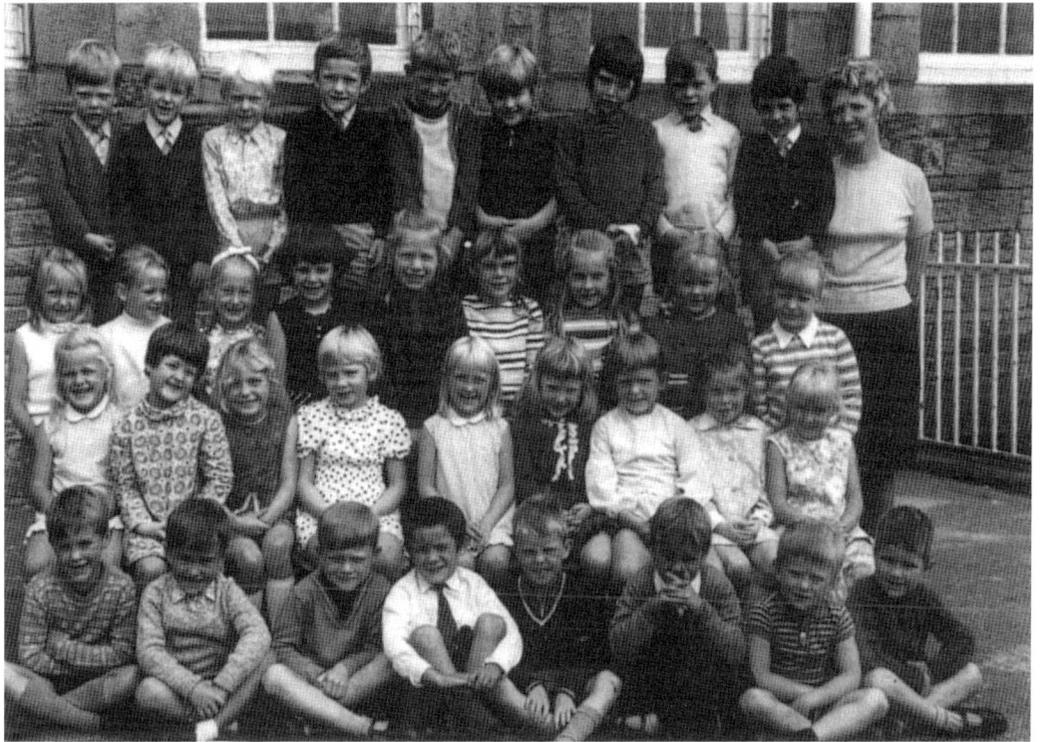

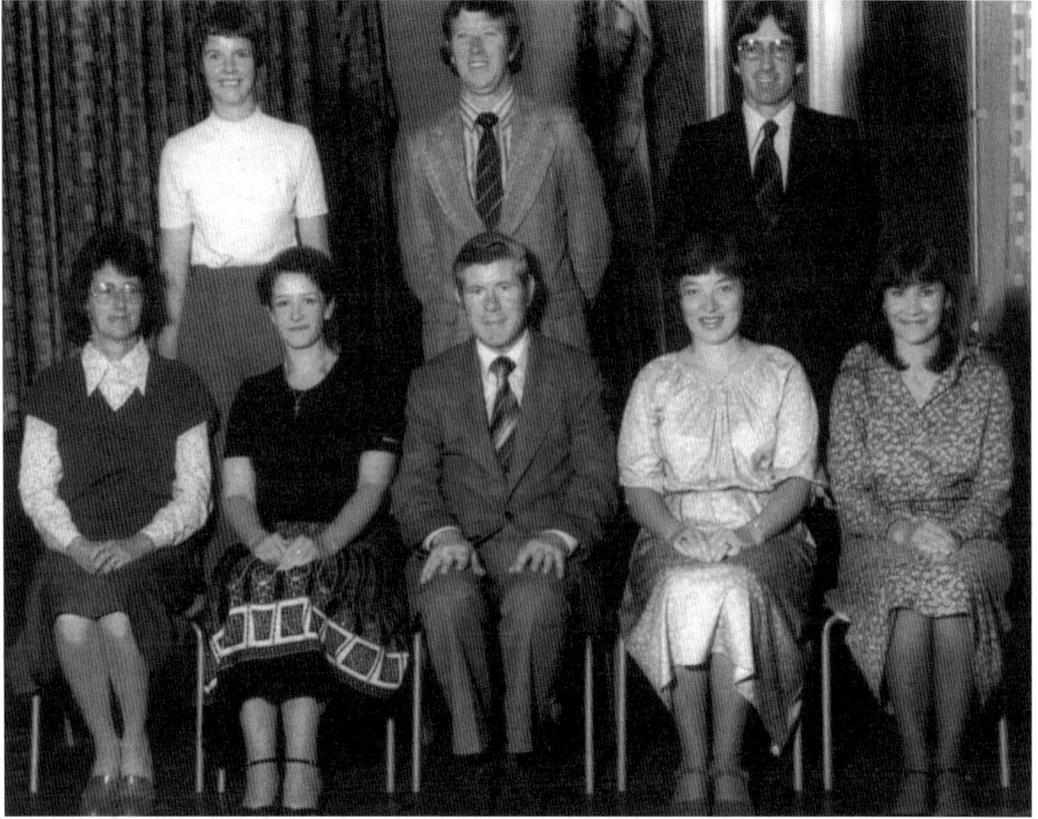

Above: Coed yr Esgob Primary School staff, *c.* 1979. Back row from left: Barbara Powell, Jeff Clark and Peter O'Donnell. Front row from left: Jill Jones, Lorna Pratt, headmaster Clive Rickards, Brenda Rouse and Sue Lloyd.

Opposite above: Ysgol Gynradd Gymraeg Llantrisant, 1977. The English school closed in 1973, with children transferring to Penygawsi Primary School. In September 1974 a new school was opened, called Coed Yr Esgob (Bishop's Wood) and built on land of the former vicarage, where Revd Joshua Pritchard Hughes once lived before becoming the Bishop of Llandaff. The new Welsh-medium school opened in the old Victorian buildings. The head teacher was John Pugh and alongside him is kitchen staff Mable Bressington and Barbara Thomas with teacher Margaret Manners.

Opposite below: Can Actol at Ysgol Gynradd Gymraeg Llantrisant, 1982. During the year this stage musical proved a major success when they won both the local and county Eisteddfod and entered the Urdd National Fisteddfod at Aberafon. Pictured back row from left are: Elain Haf, Heidi West, Dean Powell, Robert Hallett, Sharon Slocombe, Mr Eurof James, Gwin Kennard, Miss Thomas, Andrew Robinson, Justin Gibbons, Andrew Griffiths, Miss Hughes, Sheridan Nott, Carwyn Davies, Dewi Bowen, Bethan Rees, Scarlett. Middle row from left: Helen Calvert, Rebecca Lewis, Justine Collins. Front row from left: Miguel Williams, Cefin Thomas, Emma Mansfield, Lowri Devonald, Joanne Voisey, Hywel Rowlands, Ceri Traherne, Sara Lewis.

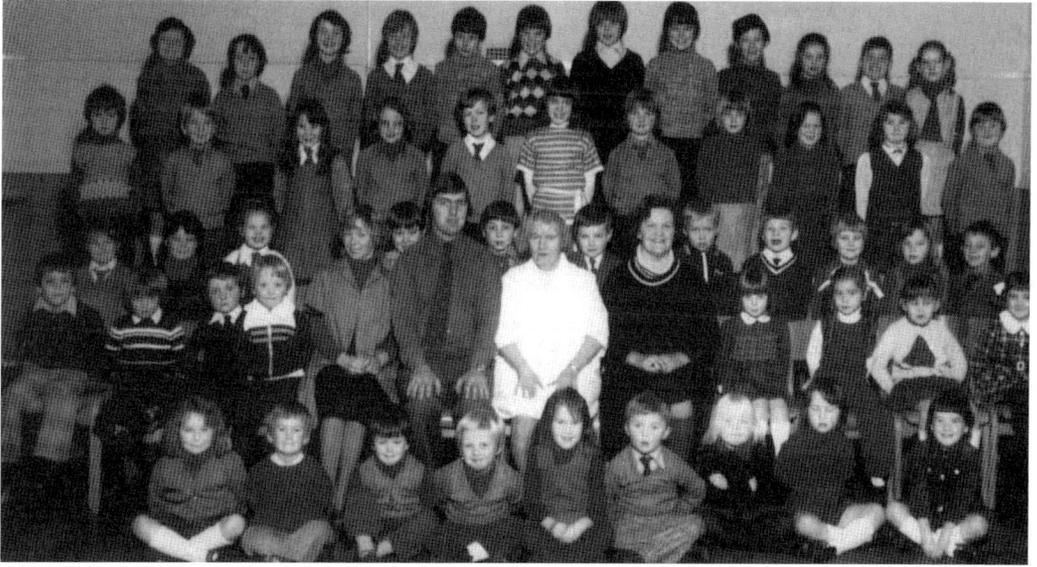

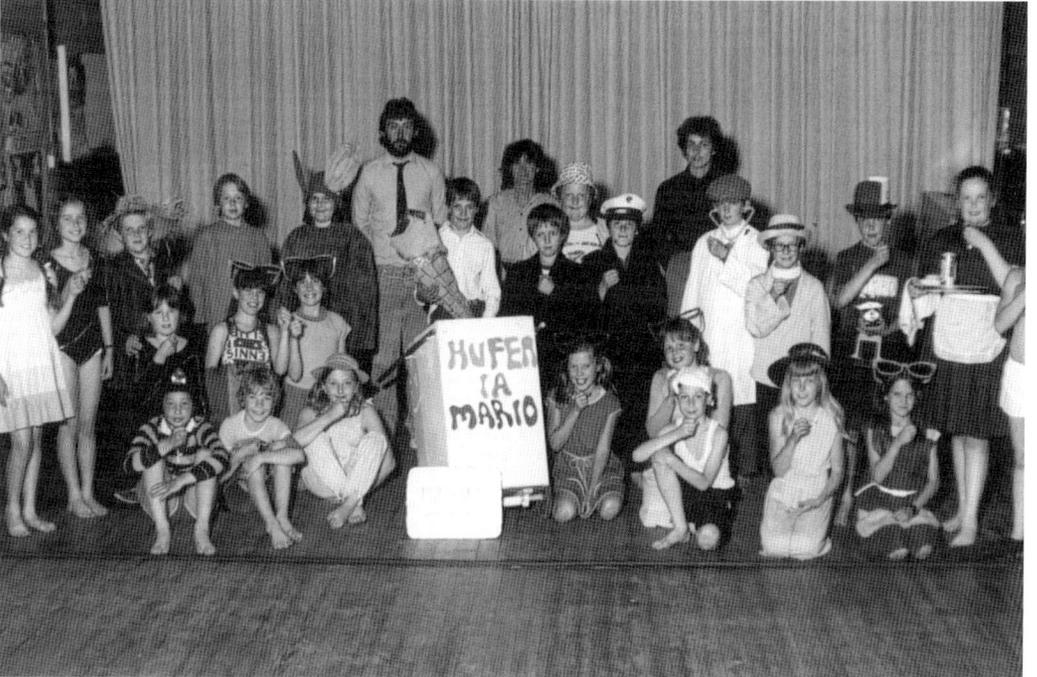

HUFER
TA
MARIO

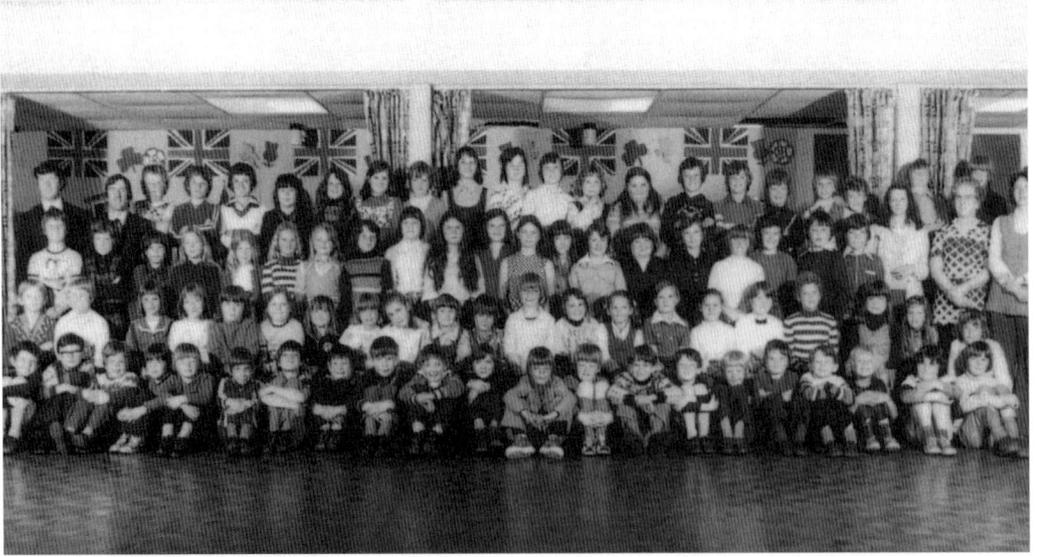

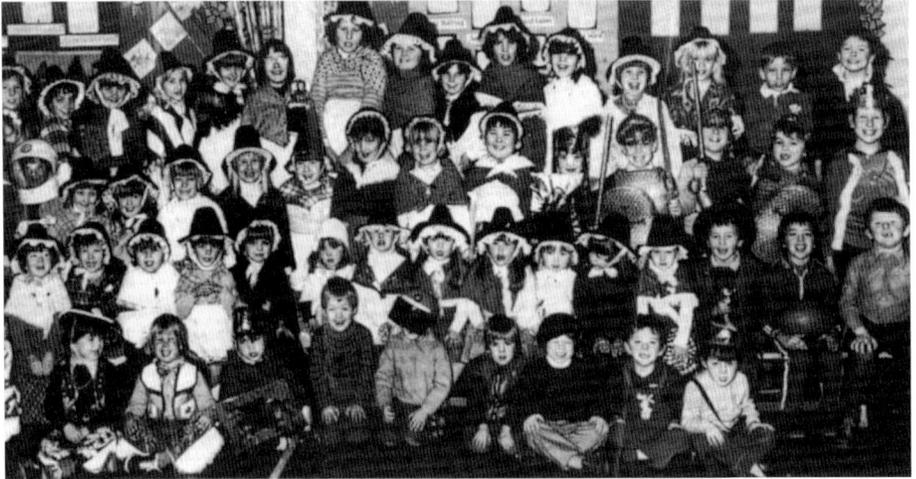

Top: Coed yr Esgob Primary School celebrating the Queen's Silver Jubilee in 1977. The head teacher at the time was Glenys Wakefield and like all school children throughout the area, the Coed yr Esbog pupils were each presented with a commemorative coin and mug. A carnival was held in the town with plenty of street parties taking place.

Above: Coed yr Esgob St David's Day 1984. For more than a century, St David's Day has been an annual celebration in the town. During the latter part of the nineteenth century, church and school records show the diverse parties that were held on 1 March. In 1896 it was a 'Pink and White Tea and Concert' and in 1897 a 'Japanese Tea and Concert' followed in 1898 by a 'Welsh Tea and Waxwork Exhibition and Concert'.

CHURCH HALL,
CREIGIAU.

THURSDAY, 27th FEB., 1930
At 7.30 p.m.

THE
LLANTRISANT
AND DISTRICT
CHORAL SOCIETY
(*Conductor* : Dr. J. C. R. MORGAN)
WILL PERFORM
THE
MESSIAH
(HANDEL)

SOLOISTS :
Soprano : **Mrs. HAROLD JONES.**
Contralto : **Mrs. RETTER.**
Tenor : **Mr. FRED PORTER.**
Bass : **Mr. MORGAN DAVIES.**

Accompanist :
Miss ROSIE SILKSTONE,
A.R.C.M.

Organist :
EDGAR H. DANIELS, Esq.,
F.R.C.O.

2800—DAVIES, PRINTERS, RADYR.

Llantrisant and District Choral Society Performance of *The Messiah*, at the Church Hall, Creigiau, February 1930. Dr J.C.R. Morgan formed the Choral Society a year earlier and enjoyed considerable success as its conductor. Culturally, Llantrisant has produced a number of fine singers and choirs. Artistically it continues to flourish and contributions to the world of literature are noted as far back as the seventeenth century. In fact, in 1771 Iolo Morganwg held an Eisteddfod in Garth Pentyrch and vicar of Llantrisant Robert Rickards was so sure the meeting was being held for illegal purposes, he also attended. When he realised otherwise and saw the beneficial results, he was ordained into the bardic circle himself! The Cymreigyddion Society met in the Swan Inn with the object of promoting Welsh literature, history, poetry and music. The Town Hall was filled in 1839 with a large eisteddfod which attracted many local poets to compete for the coverted Gorsedd.

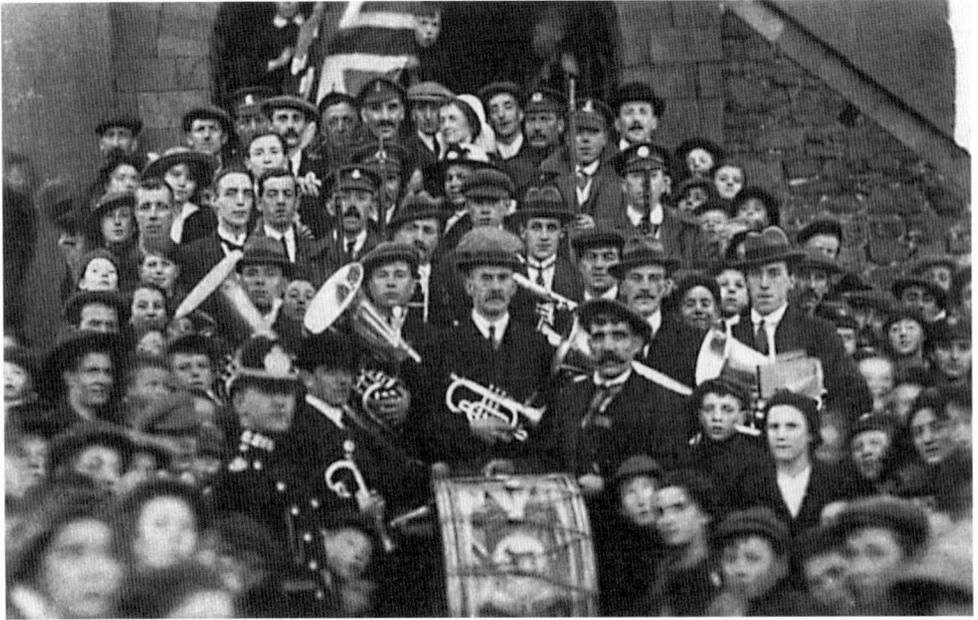

Llantrisant Town Band on the Town Hall steps during the celebrations to mark the end of the First World War, 1918. During the 1920s, the band was formed with players from Beddau, Cross Inn and Tynant and it rehearsed in the Cross Keys before moving to the former jailhouse below the Town Hall. The bandmaster was John M. Thomas of Tynant, succeeded by Oliver Williams and later Daniel Williams ('Dan the Band'). Its last performance was at the Armistice Parade in Beddau at the end of the Second World War.

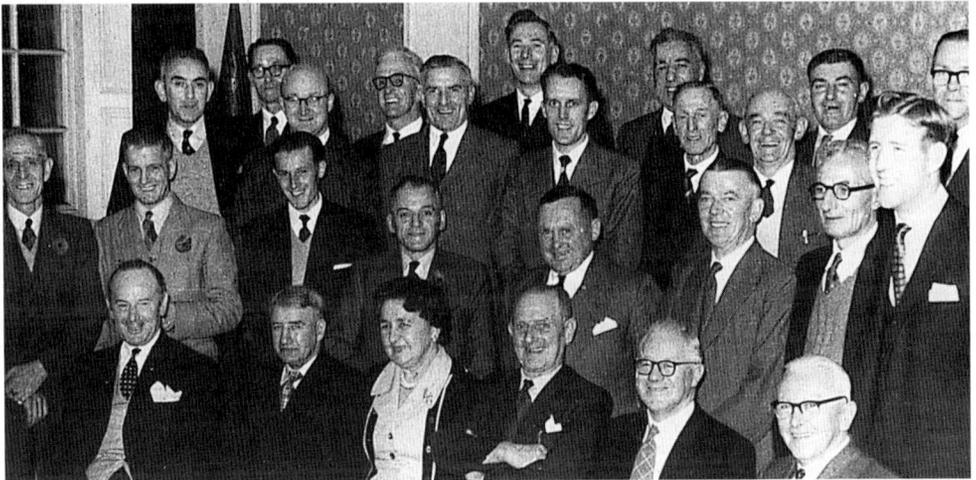

Llantrisant Male Choir, c. 1958. Pictured back row from left are: Mr Wheeler, Alf Phillips, Alf Davies, Will Evans, Doug Payne, Cyril Philips, Mostyn Thomas, -?- Captain Hicks, Tommy Cole, Reg Westcott. Middle row from left: Glyn Williams, Bill Michael, -?-, Crad Michael, ?, Mr Jones, Mr Ferris, Gordon Miles. Front row from left: Idris Evans (garage owner), Mr Edwards (bus owner), Winnie Jones (accompanist), Luther Jones (conductor), Haydn Davies and Ernie Cole (secretary from 1923 to 1961).

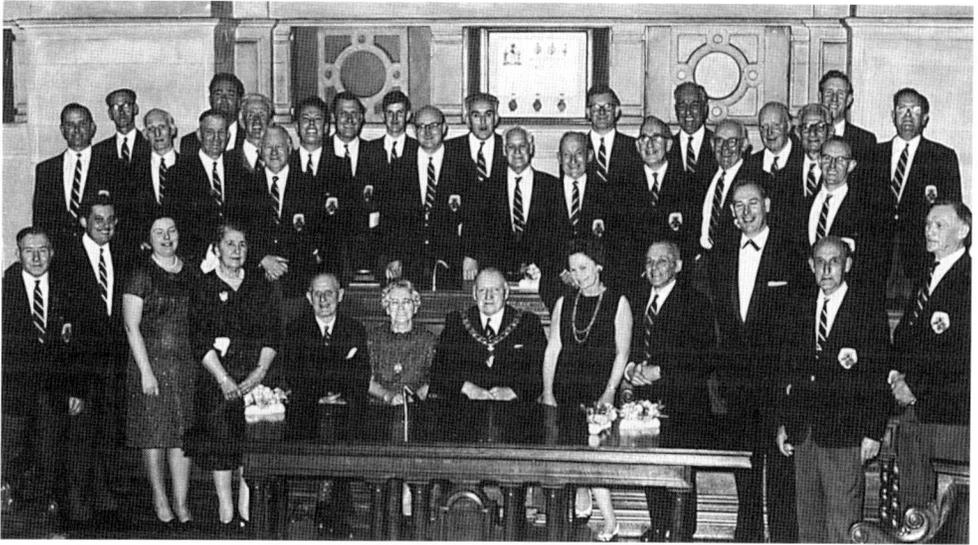

Llantrisant Male Choir at Cardiff City Hall. The first record of a male choir in Llantrisant was at a concert on 1 March 1898. The present choir was reformed in 1909. Its longest serving conductor was Luther Jones of Cross Inn who held the position for fifty-one years. He joined in 1920 and during his reign the accompanists were Lottie Williams of The Firs for forty-one years, followed by Luther's wife, Winifred for a further twelve years. Following his retirement the new conductor was chorister George Mumford, accompanied by his wife Mildred.

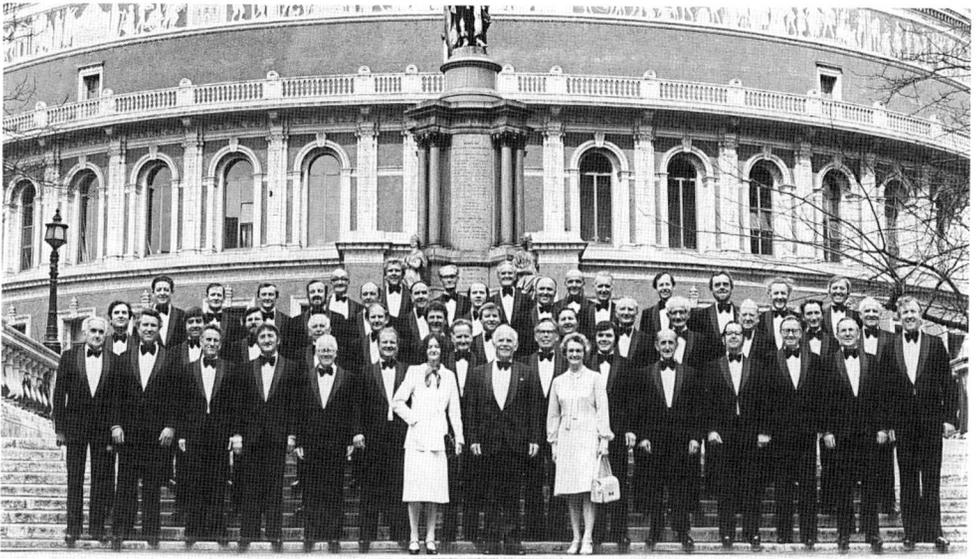

Llantrisant Male Choir outside the Royal Albert Hall with conductor George Mumford and accompanist Mildred Mumford, March 1978. They took part in the thousand voices, which was organised by the South Wales Male Voice Choir Association. As money was short, it was decided to hold a sponsored walk from Porthcawl to Llantrisant to help pay for dress suits and there was also money raised by the ladies' section, Friends of the Choir. On this occasion a long-service award was presented to Haydn Davies, who had been a chorister for fifty years.

Llantrisant Freemen's Golf Club.

RULES for SEASON 1925 to 1926.

No. *1*

Member's Name *Miss ⸺ ⸺*

Address *⸺ ⸺*

President :
D. JENKINS, Esq., Pontyclun.

Captain : Vice-Captain :
MR. D. LUKEY. MR. JOHN BARKLE.

General Committee :

D. LUKEY.	ISAAC MORGAN.
LEMUEL EVANS.	STANLEY THOMAS.
JACK MEGINS.	J. R. H. LEWIS.
TED SMITH.	D. A. LEWIS.
D. C. GRABHAM.	JACK PETERS.
DAN MORGAN.	REV. C. REES.
DAVID MORGAN.	G. T. DAVIES, J.P.

Hon. Members :

D. JENKINS. C.C. TOM JENKINS.

Auditors for this Year :
MR. H. H. PHILLIPS. MR. D. T. DAVIES.

Hon. General Secretary :
Mr. STANLEY THOMAS, Greenfield House, Llantrisant.

Hon. General Treasurer :
Mr. J. R. H. LEWIS, Church House, Llantrisant.

Hon. Secretary, Catering & Entertainment Committee :
Miss D. M. MOORE, London Terrace, Llantrisant.

Hon. Treasurer, Catering and Entertainment Committee :
Mr. DAVID MORGAN, Gwalia House, Llantrisant.

Above: Llantrisant Parish Church show at the Church Hall, *c.* 1960. The annual concerts proved a huge success and were later produced and directed by Gwyneth Dickason. Despite the passing of the years many of the stalwart members from this picture continued to take part such as Gwyneth 'Siams' Cornelius, Mary Morgan, Betty Hughes and Enid Lewis.

Left: Llantrisant Freeman's Golf Club Rules for 1925/26. A small civil war erupted in 1922 when the Town Trust controversially allowed golf to be played on the Common. Fiercely protective of the land, Freemen were furious at the decision and for more than five years the battle ensued. It was David Lukey, the local whipper-in, who pushed for the item to be passed. Mr Lukey, himself a trustee, was supported by David Grabham and both gentlemen would eventually play prominent roles in the club, with Mr Lukey becoming the first captain. It stretched for two miles, four furlongs and 200 yards and consisted of nine holes. The secretary was Stanley Thomas and the treasurer was Mr J. Lews.

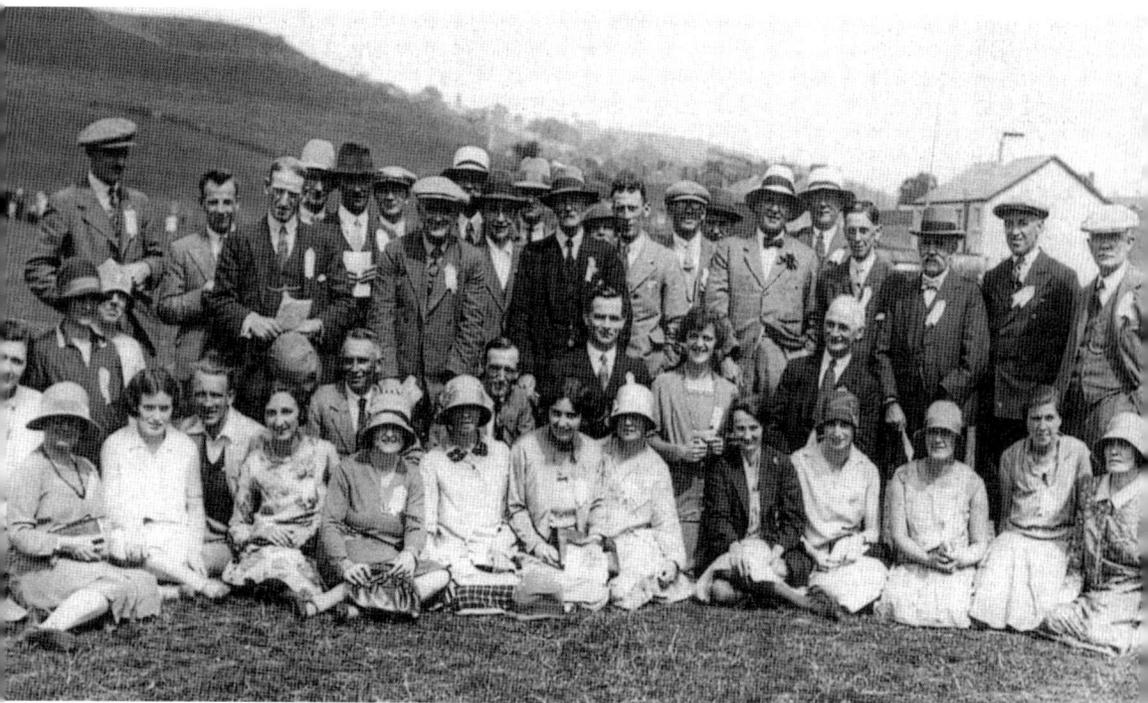

Above: Llantrisant Freeman's Golf Club, 1927. In July 1925, a deputation was invited to put their case before the Town Trust, who decided to uphold their original decision to allow golf to be played on the Common. Opposers to it held a public meeting at the Red Dragon and Freemen and their wives deliberately interrupted games. Freemen and their families attacked the course, smashing discs and cups, stealing balls and flags and throwing the items into the Common Pond and wives sat on the holes. The golfers too resigned themselves to the fact that they were no longer welcome, and in 1927 they secured land at Talbot Green.

FREEMEN

VIEWING WITH ALARM THE INCREASING DANGERS ARISING FROM THE PLAYING OF GOLF ON THE COMMON AND THE UN- EASINESS FELT BY FREEMEN WHO HAVE CATTLE GRAZING THEREON AND THOSE WHO ARE DETERMINED TO SAFEGUARD THEIR RIGHTS, PLEASE ATTEND

A MEETING

at the

RED DRAGON

On

SATURDAY JUNE 27th 1925

at 7.30 P.M

It is intended afterwards to ask the TRUST for A Special MEETING.

Left: A very rare copy of a public notice to stop golf from being played on Llantrisant Common in 1925. As the notice reads, a meeting was being held at the Red Dragon Temperance Public House on Greyhound Lane following the unease felt by Freemen who had cattle on the common at the time.

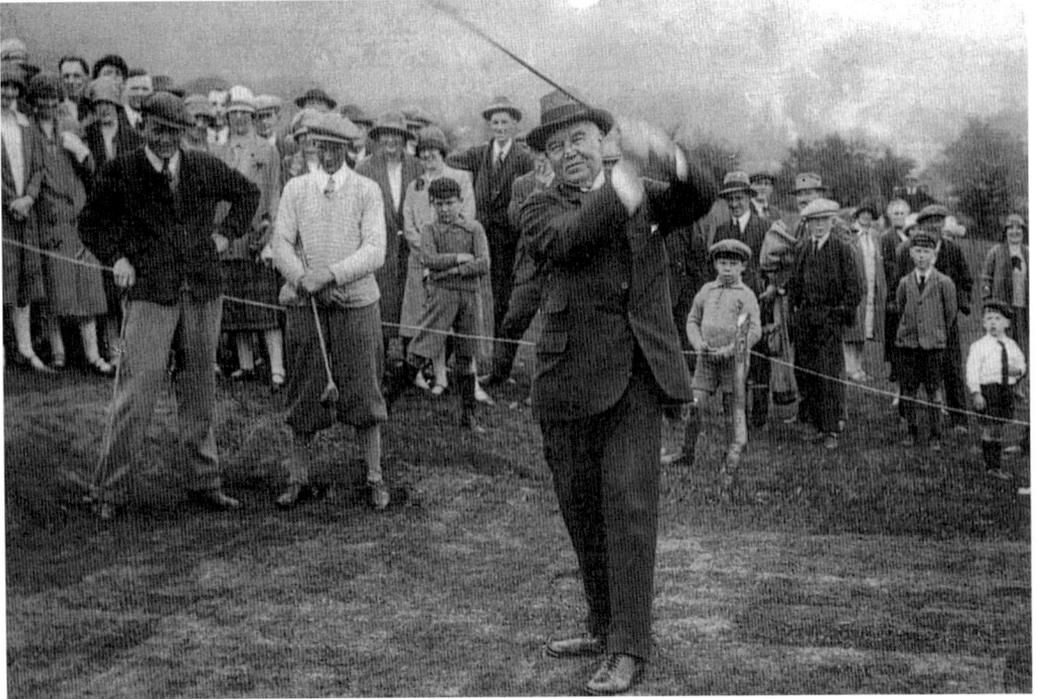

Above: Opening of Llantrisant Golf Club with Vice-President Gomer T. Morgan driving the first ball in the summer of 1927. A year after golf was stopped on the Common, a group of residents met to form a club in Talbot Green. It was agreed with farmer George Davies near Lanelay Hall to sub-let part of his land to use as a course. D. Ward David built a wooden-framed clubhouse and a nine-hole course was opened. Sir Rhys Rhys Williams was appointed president and Dr J.C.R. Morgan was the first captain.

Opposite below: Cliff Davies, Dilwyn Rees, Roy Thomas, Richard Wintle, Stuart Grabham and Tom Griffiths playing cricket below Bull Ring Farm c. 1930. The game of five courts was very popular in Llantrisant up until the 1920s. Three courts were built in the town, with the two surviving examples found behind the Pwysty on George Street and also behind the Workingmen's Club on Swan Street. Rubber balls were struck by the hand against a three-walled court, almost like today's game of squash, and it attracted hundreds of spectators. In one atmospheric final in 1875, Freeman Dr Ivor Lewis defeated Mr Lovett of Neath. The doctor was taken by his admirers to the County Club in Cardiff to celebrate, but he died there of food poisoning after eating mussel soup.

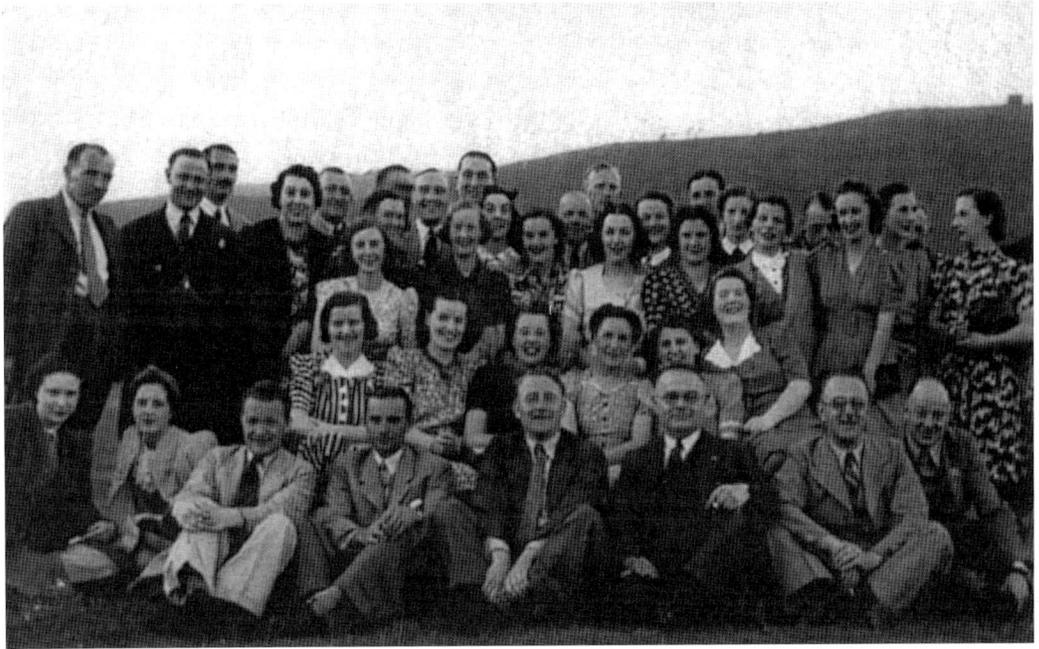

Above: Llantrisant Golf Club members, *c.* 1940. In 1932 A.W. Venables made the first hole in one. On 7 August 1940 the wooden clubhouse burned down and, despite war-time difficulties, a new club was built. The success of the club has continued, attracting professionals from around the world and a legion of local players. Three local players laid the foundation to a remarkable period of its history with the ongoing successes of Ted Davies, who won forty-six Welsh caps from 1959 to 1974; David Stevens won twenty-nine caps and many county titles whilst David Adams won twenty caps from 1969 to 1977.

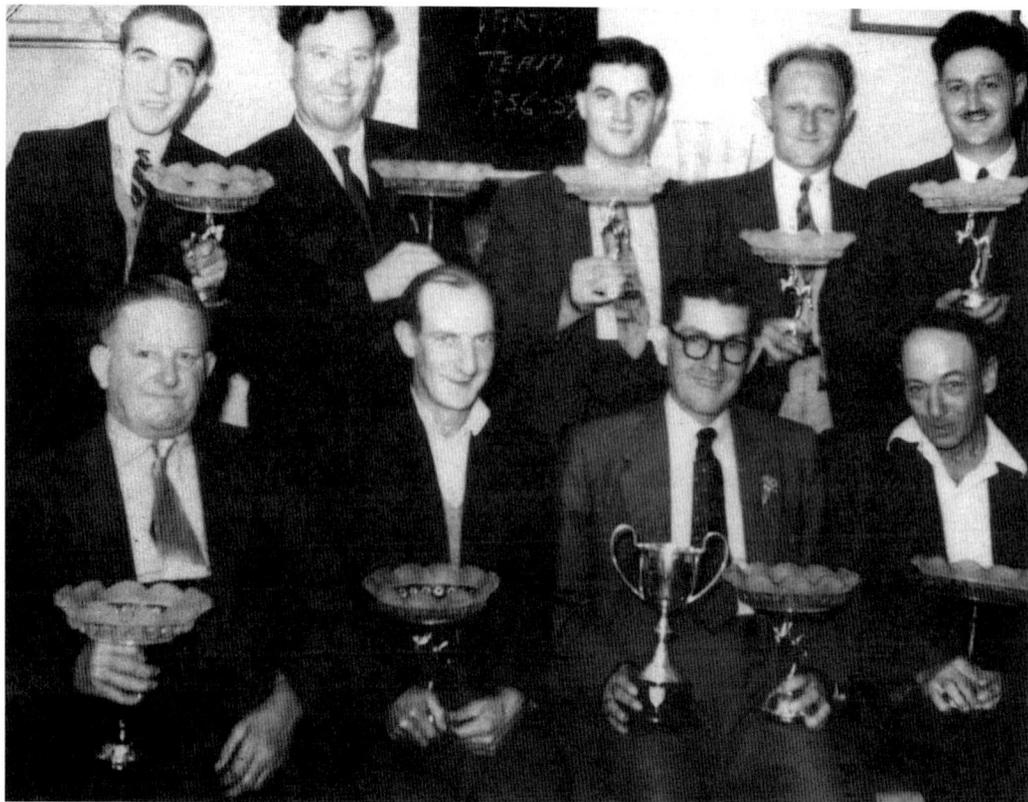

Above: Wheatsheaf Darts Team 1956/57. Pictured back row from left are: Bob Rees, David Edwards, Alcyn Williams, Haydn Williams, George Williams. Front row from left: Mal Bevan (landlord), ?, Jack Roberts, ?.

Opposite above: Llantrisant Workingmen's Club Darts Team, *c.* 1955. Pictured back row from left are: Bill Thomas, Trevor Williams, Dick Grother, George Bendle and Frank Clay. Front row from left: Glyn Hurley, John Williams John Eastman, Len Hurley and Viv Griffiths.

Opposite below: Llantrisant and District Bowling Club, *c.* 1931. The first meeting on 3 November 1931 at Trinity Chapel vestry saw a club committee elected. It was agreed the membership fee would be 2s 6d with one shilling paid immediately. The president was Thomas Jenkins while vice-presidents included Gomer T. Morgan, Dr J.C.R. Morgan, Peter Jeffries and Richard Grabham. The secretary was instructed to apply to the Welsh Bowling Association for membership and the colours would be Oxford blue with white trimmings. Nobody under the age of sixteen could apply for membership and the club asked the District Council for use of the pavilion at Southgate.

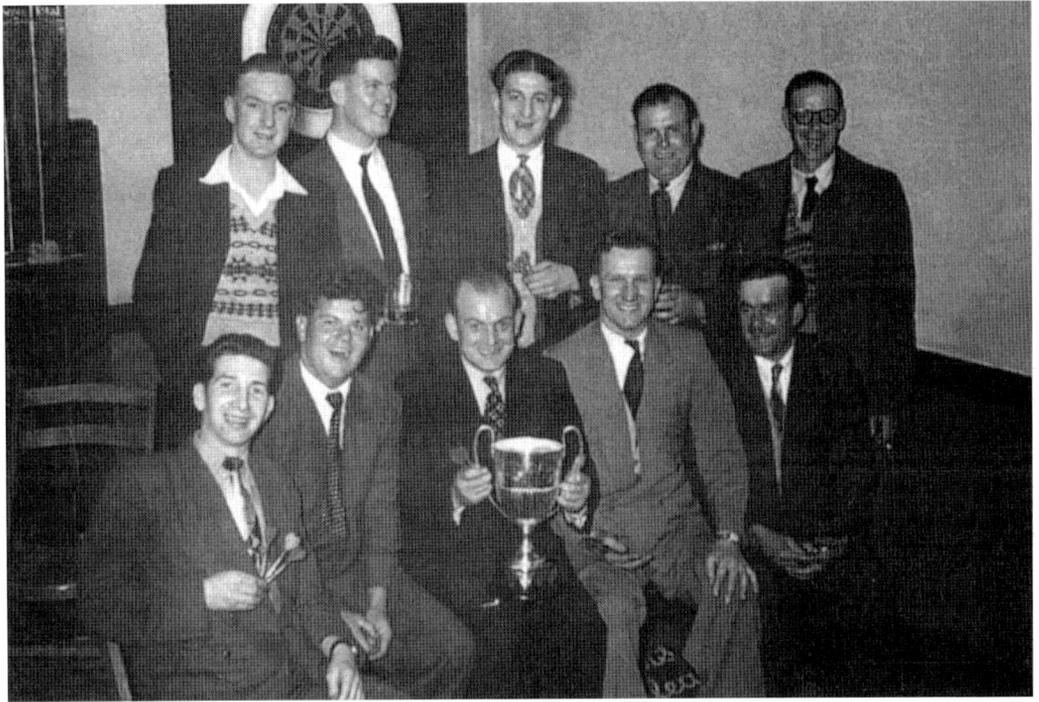

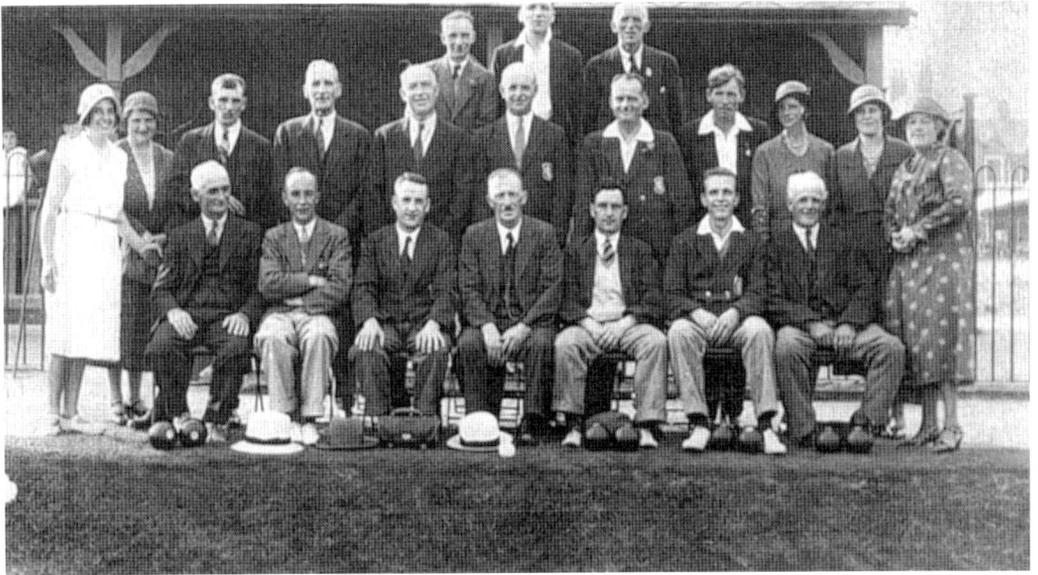

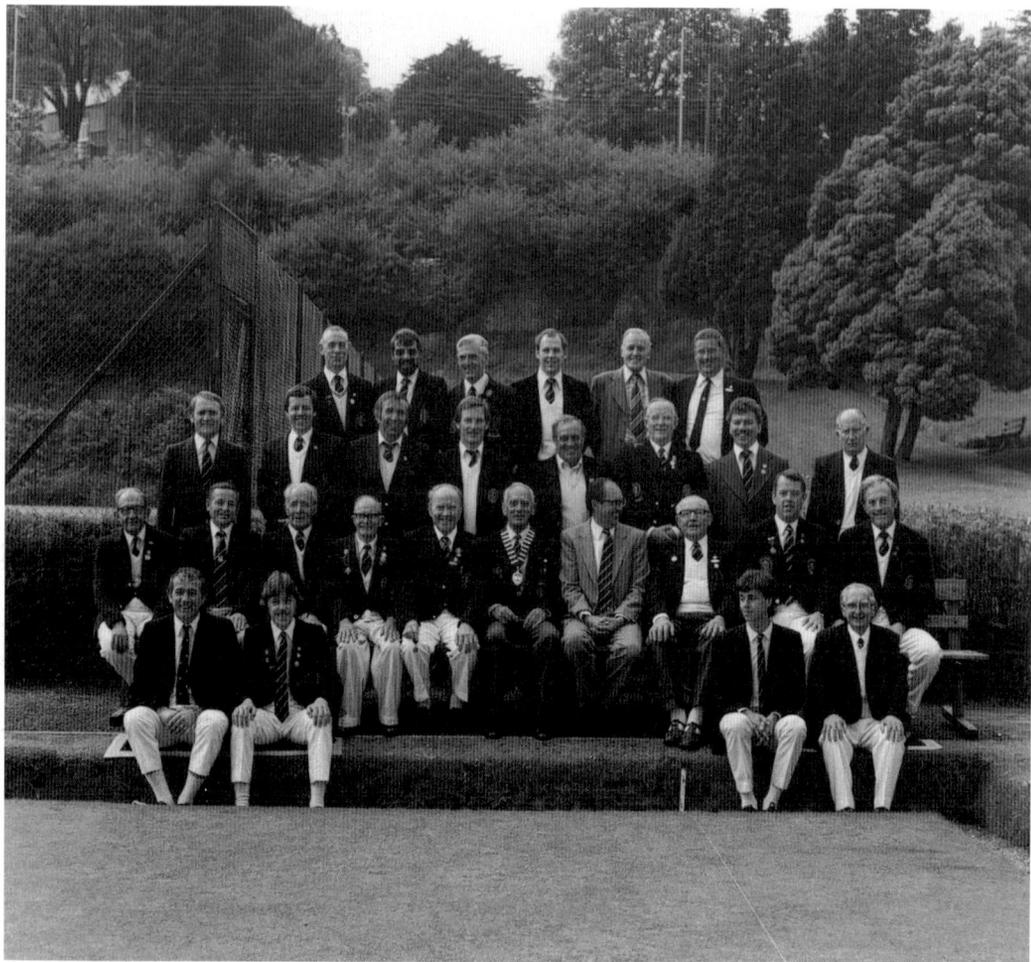

Above: Llantrisant Bowling Club, Golden Jubilee year, 1981. Back row from left: V. Holloway, D. Perott, G. Bailey, J. Thomas, H. Benyon, J. Lamerton. Third row from left: H. Evans, E. Tidman, G. Austin, M. Thomas, D. Bowen, L. Martin, A. West, D. Edwards. Second row from left: C. Penn, H. Thomas, T. Robins, A. Hollingshead, Keith Martin, S. Graves (county president), Dr. Michael Jones (club president) D. Williams, G. Jones, P. Ray. Front row from left: G. Jenkins, P. Holloway, E. Burdekin, Howard Westcott.

Opposite above: Llantrisant Bowling Club, 1966. Back row fron left: C. Penri, C. Frowen, I. Holloway, T. Robins, A. Pullen, L. Martin, J. Jacob, J. Francis, H. Westcott, H. Evans. Front row from left: T. O'Malley, R. Cale, A. Hollingshead, Viv Holloway, W. Tuck (president), Keith Martin, D. Davies, P. Ray and J. Owen.

Opposite below: Wheatsheaf Wanderers Football Team. Third row from left: Colin Preston, Mike Huish, Richard David, Nick Woods and Neil Williams. Second row from left: Jeff Thomas, Wyndham Thomas, Ronnie Woodland and Ryan Williams. Front row from left: Guy Oliver, Tony Hopkins and Mike Ward.

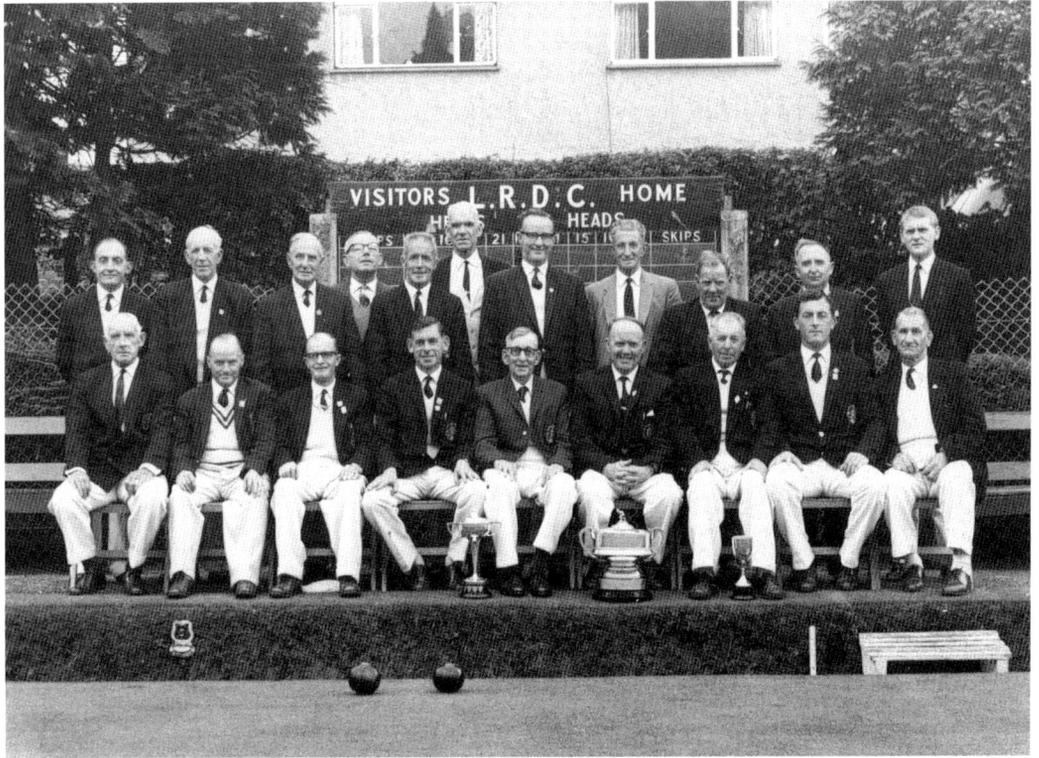

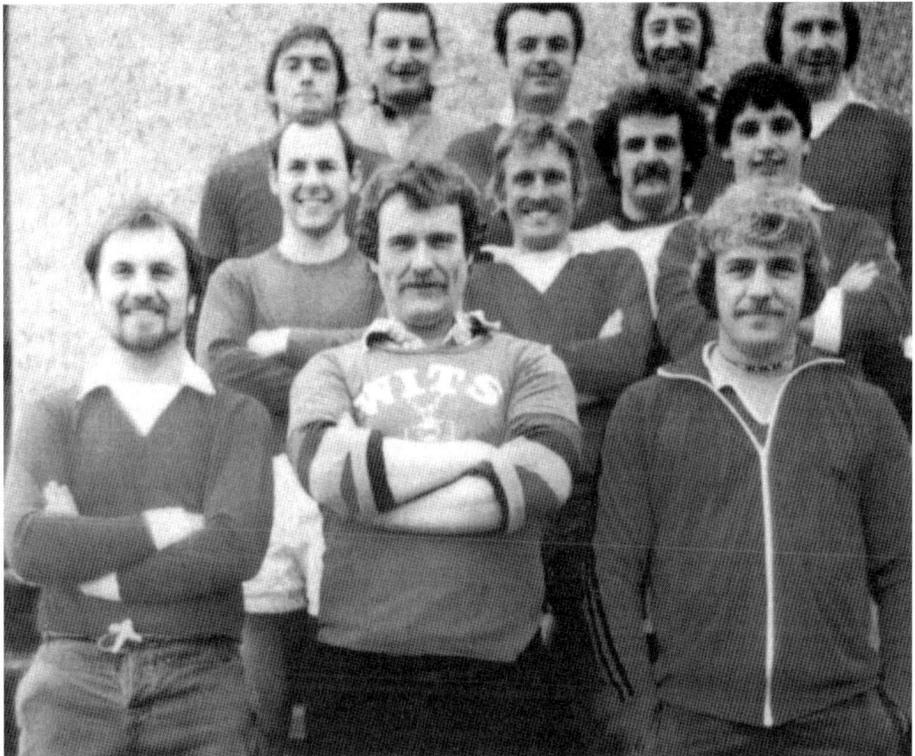

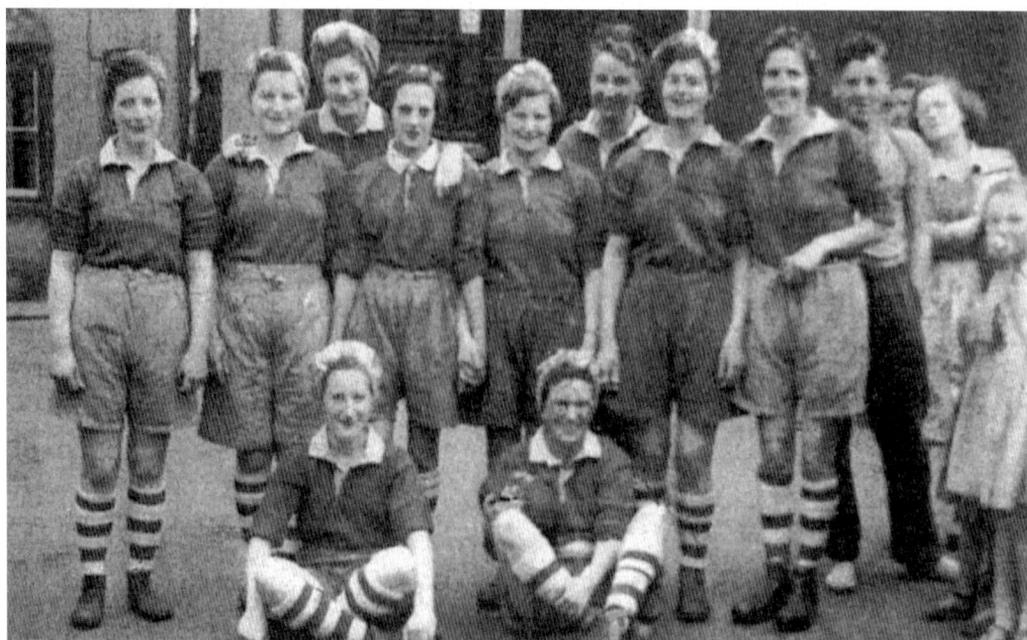

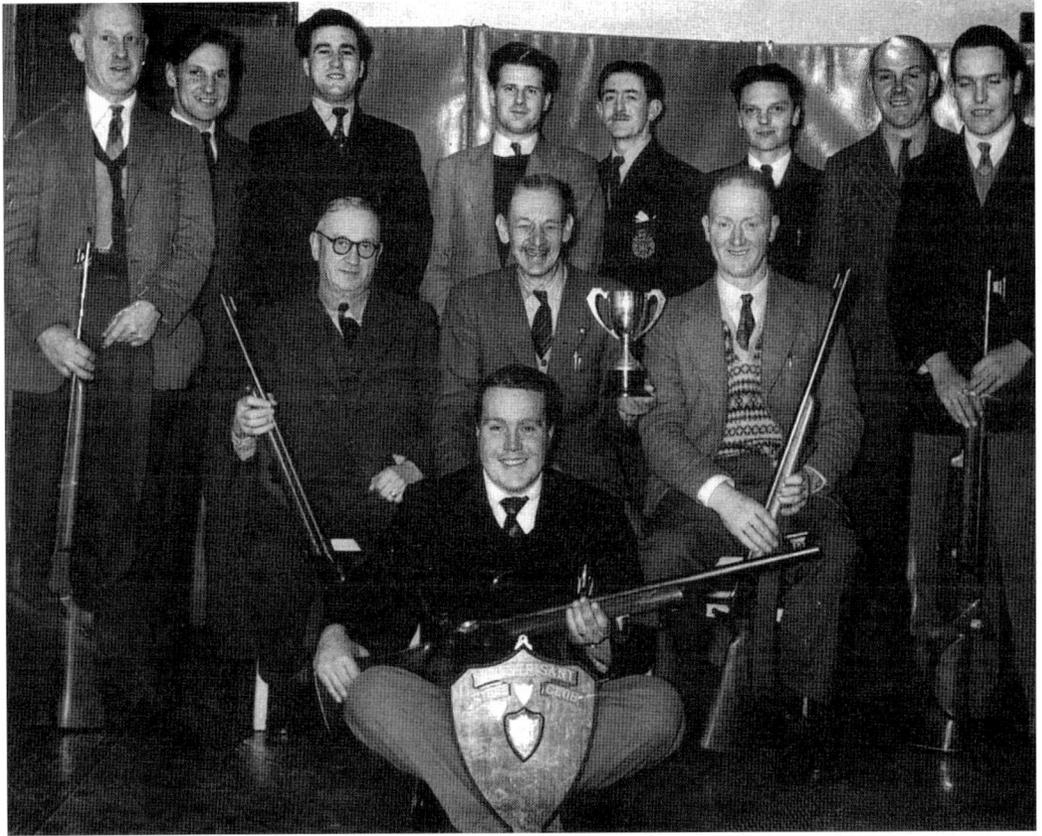

Above: Llantrisant Rifle Club, *c.* 1956. Formed following the disbanding of the Home Guard, members enjoyed the facilities in the shooting range at the old quarry on Erw Hir (Long Acre). They held their headquarters in the Wheatsheaf when the Bevans were landlords. Pictured back row from left are: Frank Davies, Peter Wiliams, Barry Morgan, Mr Humphreys, Ivor Herbert, Glenn Williams, ?, Bryn Griffiths. Middle row: all unknown. Front row: David Griffiths.

Opposite above: Llantrisant Women's Football Team at a carnival, *c.* 1950. Pictured back row from left: Gleys Corson, Vera Corson, Kitty Grother, ?, Mrs Holder, ?, Jessica Grother, Winnie Jenkins, Gwyn Grother and Morfy Francis. From row from left: Miss Corson and Doris Barwick.

Opposite below: Llantrisant Fun Run during the May Day Festival, *c.* 1982. In 1848 a foot race of three miles across the Common was held with the princely first prize of £20 being offered. The promoter was John Jenkins, landlord of The George. The race took place between John Morgan of Llantwit Fardre and an Englishman whose name cannot be traced. Sadly, the latter won!

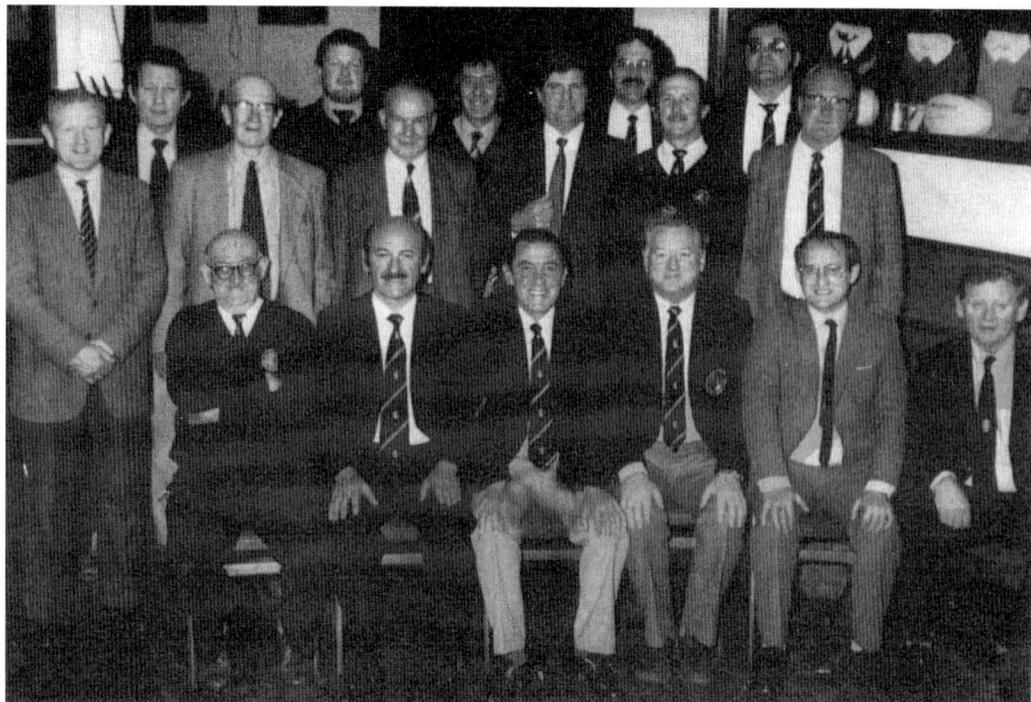

Above: Llantrisant RFC Committee, *c.* 1980. Back row from left: Gwilym Treharne, Watcyn Jacob, Gordon Jenkins, Allan Watkins, Cliff O'Neill, Nick Woods, David Thomas, David Jenkins, David Owen, Tony Kokinnos and Billy Thomas. Front row from left: Trevor 'Chippo' Davies, Gordon Oliver, Mervyn Collins, Roy Clarke, Wynford Benyon and Ivor Evans.

Opposite above: Llantrisant XV, 1899–1900. Back row from left: D. Owen, Dick Stamp, R. Davies, Evans the policeman, W. Williamson, ? Hodges, ? Warburton, -?-, B. Prior. Middle row: J. Lewis, J. Barkle, D. Lukey (captain), Tal Davies, H. Jury. Front row from left: A. Williamson, D. Francis, H. Lanam, D. Lewis, J. Williams, H. James.

Opposite below: Llantrisant XV, Mallet Cup Final in Cardiff Arms Park 1950 against Pentyrch RFC. Pictured are: C. Williams D. Williams, C. Hurley, I. Watkins, C. O'Neill, T. Rees, L. Raison, H. Williams, W. Lamerton, Ivor Evans. G. Jenkins, V. Phillips, Mr McCoy (ref), C. Jordan, D. Jenkins, Edward Thomas, Trevor Rees, D. Williams, T. Rees, D. Hill, Royston Collins, Bryn Williams.

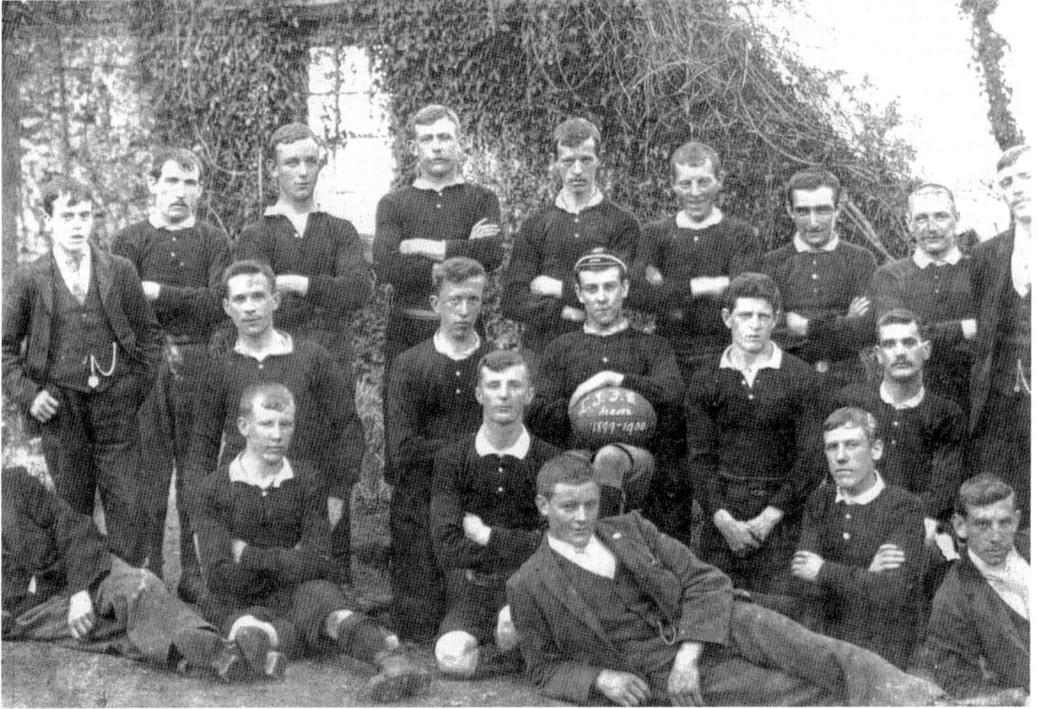

Above: Llantrisant Youth Team 1960/61, the Rhondda and East Glamorgan Cup runners up. Back row from left: H. Raison (touch judge), J. Evans, D. Griffiths, R. Hughes, R. Ware, T. Lewis, B. Honey, M. Taylor, R. Arnold, D. Williams (trainer), A. McIntyre. Middle row from left: B. Laskey, F. Taylor, Tony Kokkinos (captain), C. Langston, Clive Akers. Front row from left: J. Hughes, R. Shearan, G. Wilde, T. O'Leary.

Opposite above: Llantrisant Youth Team 1967/68. Pictured are: L. Raison, W. Haddock, S. Phillips, J. Davies, H. Raison, P. Aston, C. Harrison, J. Evans, W. Jacob, L. Groves (vice captain), A. Rees, R. Llewellyn, T. Ward, D. Williams, L. Williams, C. Bull, C. Haddock, D. Edwards, G. Jordan, K. Worgan, D O'Neill, J. Flowers, F. Owen (captain), G. Bryant, D. Davies.

Opposite below: Llantrisant XV, 1972/73. Back row from left: P. Davies, R. Llywellyn, A. Lamerton, D. Davies, J. Clayton, Frank Mercer, J. Flower, Howard Hughes, Colin Bull, Roger Lamerton, Layton Williams, G. Davies, Anthony Hopkins. Front row from left: D. Drinkwater, Robert Lee, W. Rees, Mick Wood (captain), Ken Worgan, Phillip Newton, D. Williams, M. Rees.

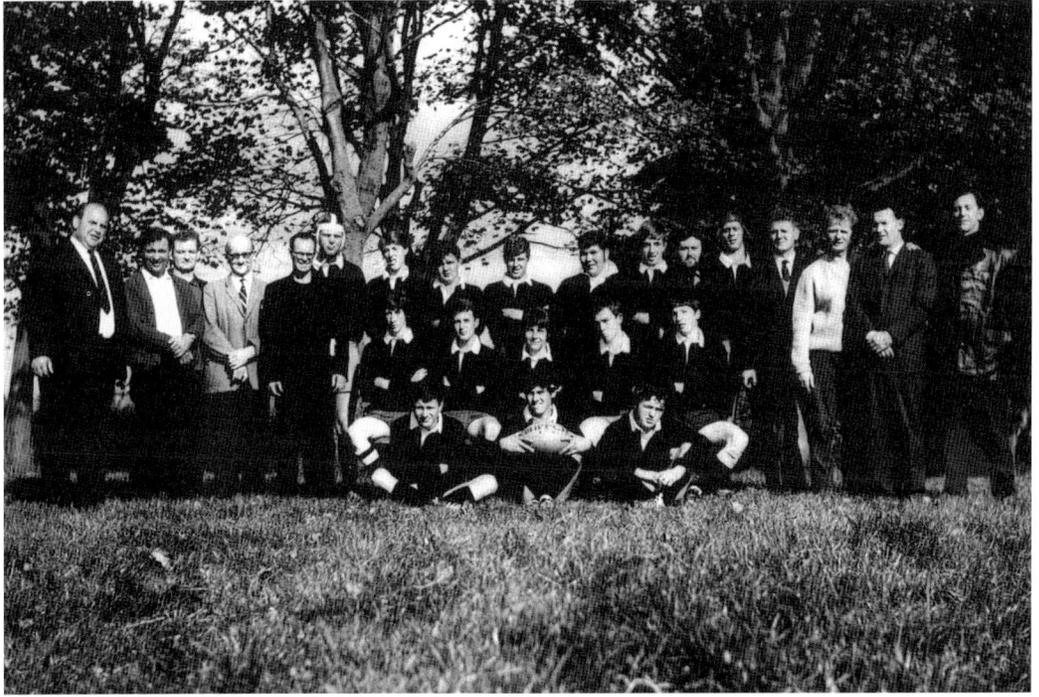
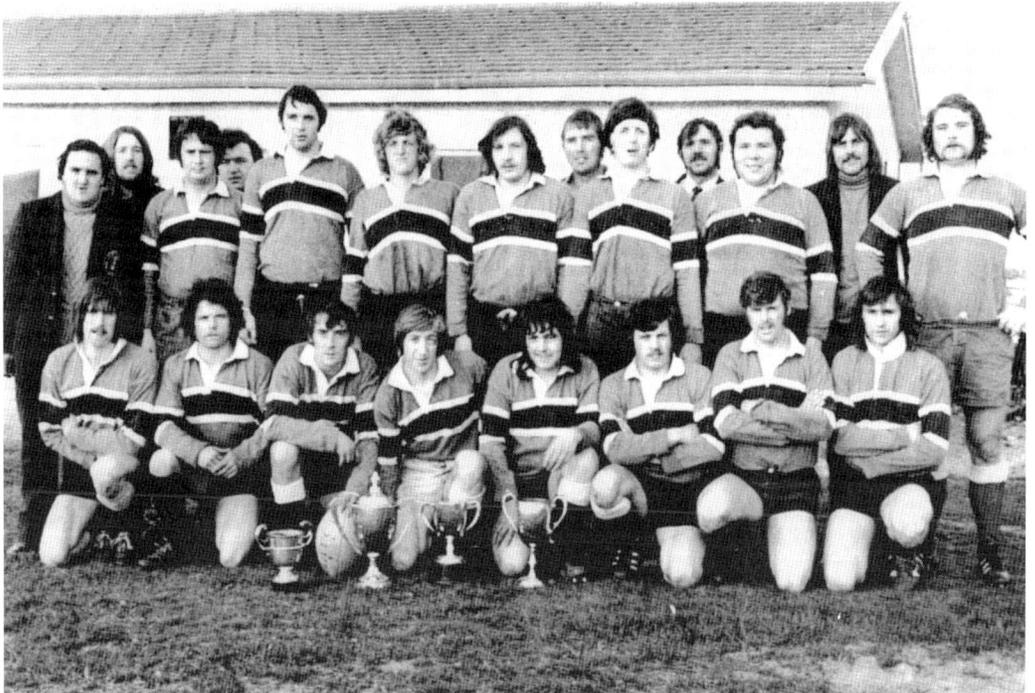

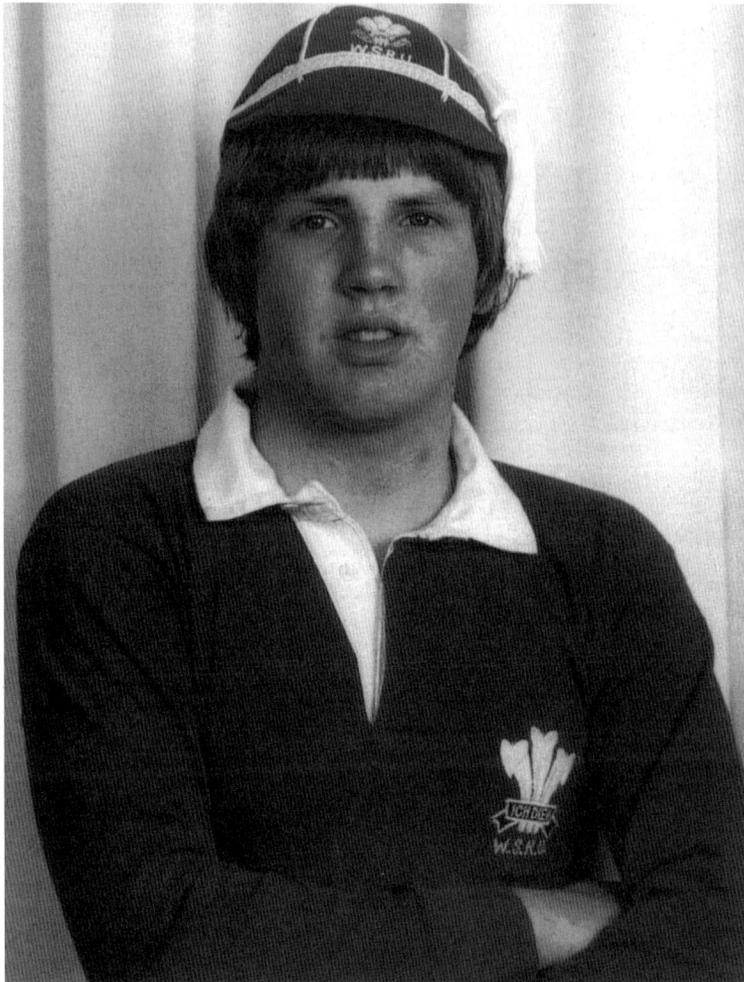

Guy Collins, Welsh Schools Rugby Union under-15s in 1981 and under-16s in 1982. His father, Royston Collins of Church Street was a gifted outside-half, who played for Llantrisant in 1950 and was later capped as a Welsh Schoolboy during the same year. He was capped a second time in 1953 for Welsh Secondary Schoolboys under-19s and played against England and Scotland. Born in 1966, Guy attended Llantrisant Primary School and transferred to Penygawsi when the Victorian school closed. He captained the District under-11s after attending at Y Pant Comprehensive, achieved the distinction of two Schoolboy caps, for the under-15s and under-16s, playing against England and Italy at the Arms Park. In later years he also played for Llantrisant, Llanharan, Swansea Institute and the Polytechnic of Wales in Pontypridd.

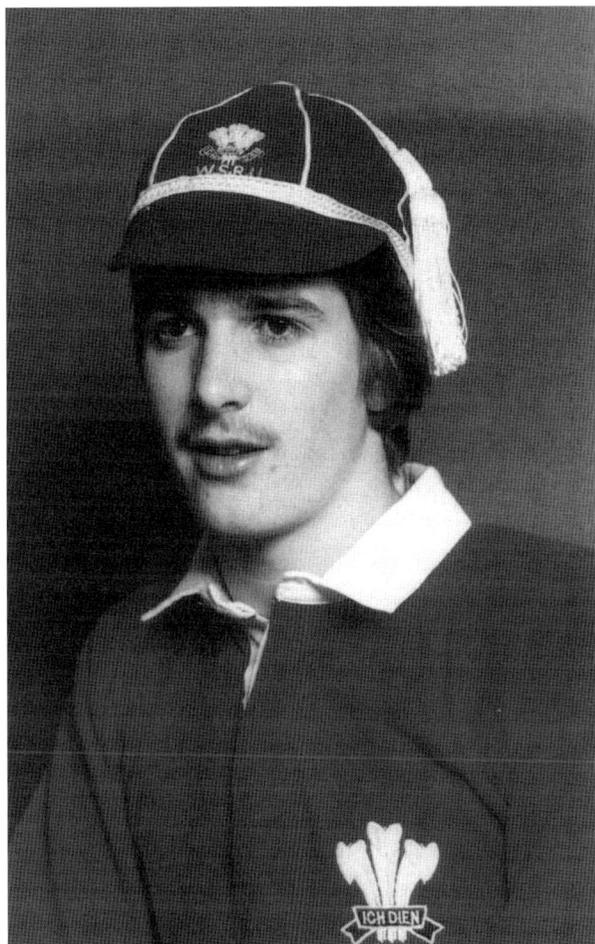

Above: Llantrisant XV vs Mike Knill's All Welsh Rugby International XV, 4 September 1979. Back row from left: H. Elliott, S. Fisher, Dennis O'Neill, Allan Woodland, Brandon Doster, -?-, S. McCann, G. Wilkins, Frank Mercer, Carl Groves, John Scott, R. Flower, Robert Pemberthy, Mike Huish, Ian Robinson, Gareth Evans, Tommy David, Davd Morris, G. Wallace, M. McJennett, Brynmor Williams, Ralph Evans, Elgan Rees, M. Close (ref). Middle row from left: D. Drew, Steve Fenwick, B. Williams, Gareth Davies, Ron Woodland, Mike Knill, Colin Preston, Ian Watkins, Mike Ward, Malcolm Borcher, J. Thomas. Front row from left: D. Barney, Mick Wood, Guy Oliver, Mike Thomas, Keith Holder and Anthony Hopkins.

Left: Phillip Davies, Welsh Schools Rugby Union under-15s B. He was captain in 1981 and of the under-16s in 1982. The son of Selwyn and Barbara Davies of Southgate, Phillip was presented with a cap by the Welsh Schools Rugby Union while a pupil at Y Pant Comprehensive School. He captained Llantrisant RFC Youth Team, which he joined in 1983 and later played for the first team until 1994.

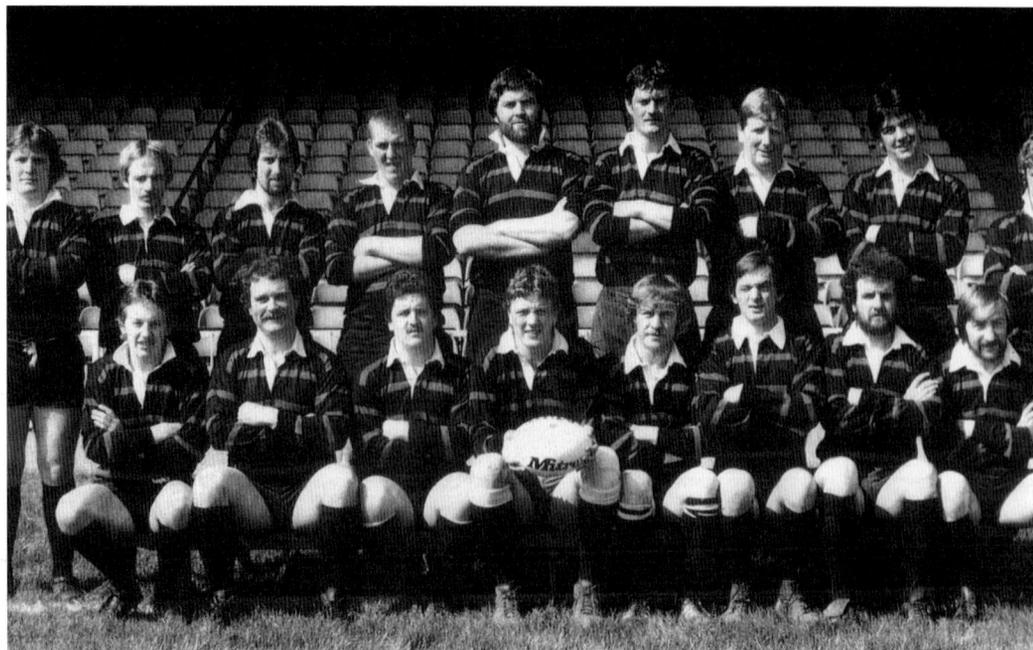

Above: Llantrisant XV, 1981/82 Welsh Brewers Cup winners at the National Stadium on 17 April 1982. The Black Army took on the unbeaten side of Glyncorrwg. It was the final of the Welsh Brewers Cup competition, one of the largest competitions of its kind in the UK with over 220 of the Welsh Districts Rugby Union clubs taking part. The team put up an awesome display of controlled forward play supplemented by secure back play. The Black-Army won by eighteen points to nine, with a try by Carl Groves and Gareth Bryant kicking the remainder of the points. Back row from left: Dean Akers, Brandon Doster, R. Scaplehorn, Andrew McIntosh, G. Wilkins, J. Grenfell, Gareth Evans, Steven Evans, Gareth Bryant. Front row from left: David Wood, Anthony Hopkins, K. Swarfield, Carl Groves (captain), Mike Ward, Colin Preston, Ron Woodland, Mick Wood.

Opposite above: Brothers Ralph, Vince, Steven, Neil and Glen Evans, *c.* 1985. Llantrisant RFC's end-of-season tour to France that year was especially significant for the Evans family. Four brothers, Ralph, Steven, Neil and Glen, all played in the senior team in the two games on the continent. It set up a new family record for the club as the previous highest record of siblings playing in the same match since the club was established in the nineteenth century showed that three Lamerton brothers had played together in the 1950s. The eldest brother, Ralph, played prop. Steven captained the side and was a flanker. Neil played at either full back or winger while Glen was a hooker. Also during the tour the youngest of the Evanses, Vince, another prop, captained a youth team.

Opposite below: Llantrisant XV, 1985/86. Back row from left: Ivor 'Springy' Evans (secretary), Allan Oliver, Dean Akers, S. Griffiths, Andrew Phillips, J. Grenfell, Ralph Evans, Colin Bowen, Phillip Davies, K. Mounter, R. Clarke (chairman), David Wood, -?-. Front row from left: Andrew McIntosh, Anthony Hopkins, Guy Collins, Andrew Griffiths, Steve Evans (captain), Adrian Ward, K. Swarfield, Gareth Bryant, Jeff Thomas and ball boys O. Hopkins, D. Drew, Jason Alford and C. Morrow.

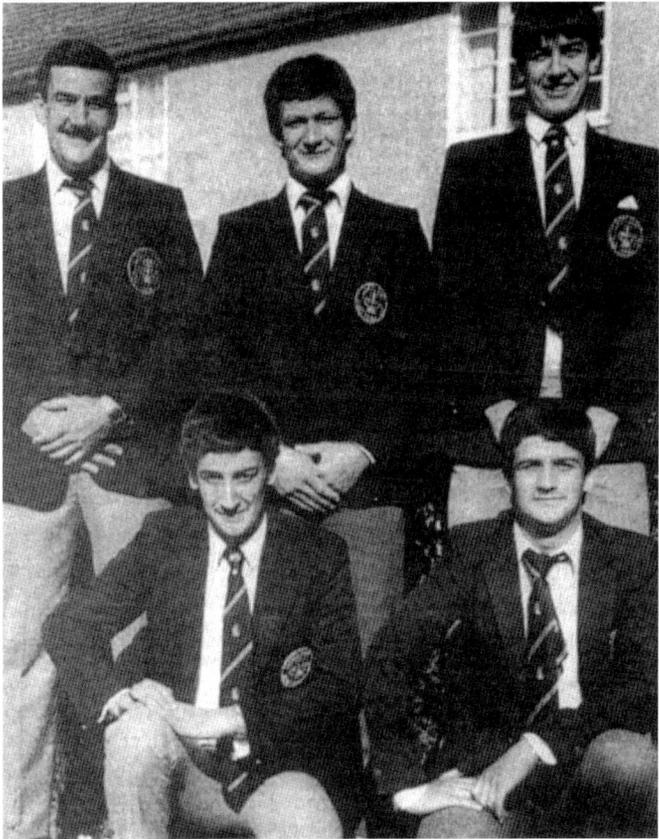

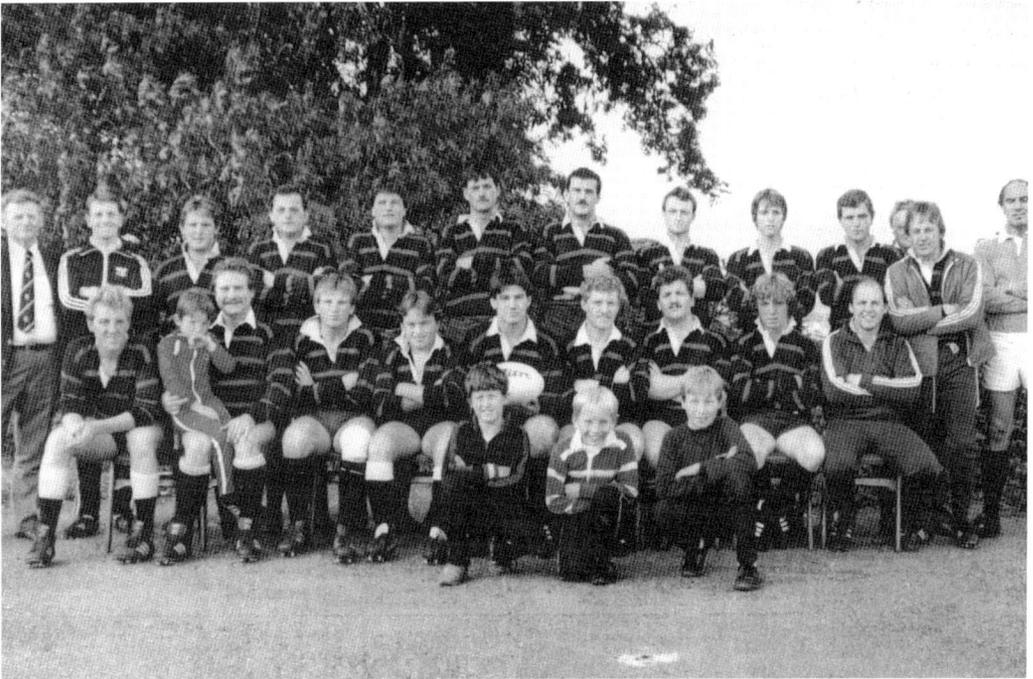

Other local titles published by Tempus

South Wales Collieries Volume IV
DAVID OWEN

This fourth volume of South Wales Collieries covers the central valleys of Merthyr, Glamorganshire, to the eastern valleys of Rhymney, Sirhowy, Ebbw and Afon Lwyd, including Big Pit at Blaenavon. a World Heritage Site and location of the National Mining Museum of Wales. It illustrates the area's industrial history during the past 200 years amd gives glimpses of both working and village life in the valleys.

0 7524 2879 9

Glamorgan The Glory Years 1993–2002
ANDREW HIGNELL

The period from 1993 has been one of the most successful in the history of Glamorgan CCC. A wonderful period for both the club and Welsh cricket in general, here memories are shared by many and supported by a collection of photographs by Huw John. With contributions from players both past and present, this book, edited by Andrew Hignell, the county's official statistician and historian, is a must for all Glamorgan CCC supporters.

0 7524 2747 4

Treorchy Male Choir
DEAN POWELL

The history of Rhondda's world-renowned Treorchy Male Choir is rich in the diverse features of Welsh valley life. That history is lavishly documented in this volume of over 200 photographs, cuttings and memorabilia from all who enjoy their performances and recordings. A fitting testimony to those denizens of the male choir tradition, it will delight those fortunate enough to know the Treorchy Male Choir, both as followers and as choristers.

0 7524 2238 3

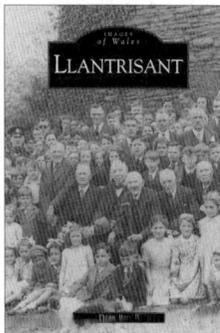

Llantrisant
DEAN POWELL

From its imposing vantage point high on the ridge of a hill, the town of Llantrisant has seen many changes in its long history. Blood-thirsty battles, uprisings, religion and immigration have all played a part in shaping the vibrant town of today, as have the generations of local people who have lived and worked there. This fascinating collection of over 200 old images explores the history of Llantrisant, offering a valuable record of the past.

0 7524 2497 1

If you are interested in purchasing other books published by Tempus, or in case you have difficulty finding any Tempus books in your local bookshop, you can also place orders directly through our website

www.tempus-publishing.com

or from **BOOKPOST**, Freepost, PO Box 29, Douglas, Isle of Man, IM99 1BQ
tel 01624 836000 email bookshop@enterprise.net